MODIGLIANI

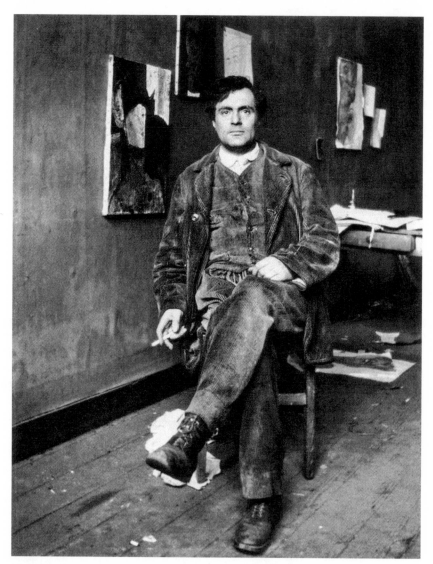

Modigliani, c. 1916

MODIGLIANI

A Life

MERYLE SECREST

ALFRED A. KNOPF

NEW YORK

2011

THIS IS A BORZOI BOOK
PUBLISHED BY ALFRED A. KNOPF

Library of Congress Cataloging-in-Publication Data
Secrest, Meryle.
Modigliani : a life / by Meryle Secrest. — 1st ed.
p. cm.
"A Borzoi book."
Includes bibliographical references and index.
ISBN 978-0-307-26368-1
1. Modigliani, Amedeo, 1884–1920. 2. Painters—Italy—Biography.
I. Modigliani, Amedeo, 1884–1920. II. Title.
ND623.M67S43 2011
759.5—dc22
[B]
2010045357

Front-of-jacket photograph of Amedeo Modigliani, c. 1906,
by Marc Vaux. Collection Dolly van Dongen, © Bibliothèque Kandinsky,
Centre Pompidou, fonds Marc Vaux. Snark / Art Resource, NY

Back-of-jacket image: *Caryatid* by Modigliani, 1913. Private Collection.

Jacket design by Carol Devine Carson

Manufactured in the United States of America
First Edition

for Tom

For the outer sense alone perceives visible things and the eye of the heart alone sees the invisible.

—RICHARD OF SAINT-VICTOR (d. 1173)

CONTENTS

—◆—

ILLUSTRATIONS

PREFACE AND ACKNOWLEDGMENTS

MODIGLIANI INTRODUCED US. When I began work on this project late in 2005 I started making plans to visit Paris and came across the name of Marc Restellini. He had been the director of a major exhibition on that artist, "L'Ange au Visage Grave," at the Musée du Luxembourg in 2002. The show brought together one hundred of Modigliani's works—a quarter of his total output, some never before seen in France—and was an enormous success, attracting 600,000 visitors.

Most French museums are government run and supported, and of the private museums, none was founded by an art historian. To universal astonishment, Restellini followed up this triumph by opening a museum of his own, the Pinacothèque de Paris, a year later; his first exhibition was the late work of Picasso owned by his wife Jacqueline. That was another *succès fou*. By the time I arrived in Paris Restellini was organizing new Modigliani exhibitions and writing a catalogue raisonné of the artist's oeuvre. He was also planning to move his museum from its spacious but impractical quarters in the former Baccarat museum on the rue du Paradis to a more prominent location on the Place de la Madeleine. Obviously, I should see him.

I finally tracked him down to the boulevard Saint-Germain, where he then maintained an office and, two floors above, had an apartment with his wife, Isabelle Corbier, a lawyer, and their son Hadrien. I was ushered into a living room with an ornate fireplace and boiseries and Louis XVI furniture, which also contained a modernistic, off-white, curved sofa, the kind of eclectic juxtapositions that seemed a propos once I met the owner. He is tall, was in his early forties, and was wearing blue jeans and an open-neck, immaculately tailored shirt,

his enviable high coloring in contrast to a shock of unruly black hair through which he periodically ran his hands. If he was occasionally noncommittal his eyes signaled a great deal: interest, amusement, disinterest, but also warmth. In my case his welcoming and friendly manner were in marked contrast to the frigid response, or lack of any, that I had received from other sources. Specialists seemed to guard their own fields jealously or, as I had discovered with a former study of Dalí, expected to be paid. Restellini, on the other hand, was open and accessible. He wore his erudition with ease and that, as was immediately evident, was considerable, from his detailed knowledge of Modigliani's works to his revisionist views about the artist's personality, art, and life.

Restellini is the youngest of three sons of a Catholic physician of Italian origin and a French Jewish mother, and grew up in Saint-Omer. Isaac Antcher, his grandfather on his mother's side, was a painter, and several of his rather somber works hung in the Restellini-Corbier apartment, including one of what seemed to be a small boy and his mother on a bridge. Antcher had been a client of Modigliani's dealer, Léopold Zborowski. So when Restellini entered the Sorbonne to study art history it was suggested that he specialize in the School of Paris. He wrote his master's thesis on Zborowski and, after graduating, began to lecture at the Sorbonne. It soon became apparent that he had a special gift for dreaming up exhibitions and the imagination and persistence to bring them about. Still in his twenties, he launched exhibitions on such painters and sculptors as Derain, Renoir, Soutine, Rodin, Boudin, Rouault, Monet, and Sisley, among others, with a special emphasis on Modigliani.

Restellini has authored over sixty shows in Europe and South America, with twenty in Japan alone. Since his museum opened at its new location in 2007, he has presented exhibitions on Lichtenstein, Soutine, Rouault, Man Ray, Jackson Pollock, and the Chinese warriors of Tsien, and was preparing exhibitions on Valadon and Utrillo, Morandi, Guardi, and Canaletto. His long-delayed catalogue raisonné is set for publication in 2011.

Restellini is the kind of art historian who can enlighten one about Mondrian, explain the Shamanistic Symbolism in a Pollock drip painting, or expose the hidden joke in a Modigliani portrait with a wave of his large and capable hands. Although he has special-

ized in nineteenth- and early-twentieth-century art he is equally at
home with modern American masters and the Baroque—his phone
answering machine plays an extract from Vivaldi's "Stabat Mater."
In common with the late British art historian Kenneth Clark, whom
he resembles in personality and interests, he has the gift of inspiring
others with his own enthusiasms and opening eyes to wider worlds.
The need for better education in the arts is, like Clark's, one of his
major concerns. He travels constantly and is capable of flying out at
short notice, whether to Moscow or Osaka. His powers of persua-
sion among collectors are legendary; he says the most difficult part of
his work is raising loans from banks. His career has brought admira-
tion and, in the small and contentious world of French art, some tart
comments. But whether phenomenon or enfant terrible, Restellini
by most accounts has become the leading authority on the work of
Amedeo Modigliani.

Restellini soon convinced me that the story of Modigliani's life had
been distorted out of all recognition after his death by the French lit-
erary world and that these inventions and gross omissions, the "leg-
end," had become fact through endless repetition. He said I should
bend every effort to uncover the truth. At first we envisioned writ-
ing a biography together but had to give up the idea as impractical.
Still, he would help me. Almost his first act was to introduce me to
a pivotal figure, Luc Prunet, the great-nephew of Jeanne Hébuterne,
Modigliani's last love, who committed suicide within days of his
death in 1920. This event, Restellini thought, had done most to fix in
people's minds the idea of a dissolute Bohemian, doomed to destroy
everything and everyone he touched, the "Modi" who was "Maudit,"
or accursed. And for some eighty years Jeanne Hébuterne's parents
and older brother André had repulsed all efforts to explain why their
daughter had been driven to take her own life. But her brother had
recently died. Prunet, a lawyer and André Hébuterne's grandson,
had inherited a sizable collection of his great-aunt's paintings, draw-
ings, photographs, and other memorabilia. He and Restellini were
organizing an exhibition in Tokyo that opened in the spring of 2007.
Prunet was most gracious and helpful, and he and his wife Nathalie
were the soul of hospitality on my numerous visits to their town
of Meaux, outside Paris. I cannot thank them enough. The resulting
catalog of the exhibition, "Le Couple Tragique," is illuminated by

Restellini's close study of the final six months of Modigliani's life and is a revelation.

Sadly, biographers have to face the fact that what seems eminently accurate and fair to him or her does not always appear that way to the family of the person in question. After seeing passages from this manuscript, Luc Prunet took strong exception to the portrait of his great-aunt that is presented.

However, he did not respond to repeated offers by the author to consider removing specific paragraphs.

Instead Prunet has said he will take legal action if illustrative material of any kind (i.e., photographs, drawings, and paintings) from the Hébuterne archive appear in this book.

As a matter of record, photographs of Hébuterne and her work have been published in art museum catalogs, biographies, and essays for over fifty years, notably in the Pierre Sichel biography of 1967. They appear in another major study, *Kiki's Paris,* by Julie Martin and Billy Klüver, of 1989; Patrice Chaplin's biography of Jeanne Hébuterne, *Into the Darkness Laughing,* of 1990; and four art museum catalogs published between 2000 and 2007.

The entries contained in *Amedeo Modigliani: L'Angelo dal Volto Severo* to accompany an exhibit of the same name at the Palazzo Reale, Milan, in 2003, are particularly voluminous and revealing.

Photographs of Hébuterne's drawings and paintings are easily retrievable via a Google name search and an entry in Wikipedia. Hopefully, the reader's curiosity will lead him to these universally available sources. In deference to Luc Prunet's wishes, no photographs of Jeanne Hébuterne, her work or family members appear in this book.

Through Marc Restellini I also made contact with Noël Alexandre. He is one of the surviving children of Dr. Paul Alexandre, Modigliani's first patron and collector. Noël Alexandre's catalog for the Royal Academy of Art, London, exhibition "The Unknown Modigliani," in 1994, is equally revelatory, not just for its documentation of the Alexandre collection of Modigliani's works, but for its insights into Modigliani's life and personality. I was invited to lunch more than once at the pretty country house in Sceaux by Noël Alexandre and his wife, Colette Comoy-Alexandre, and came away with convincing evidence of the man behind the legend.

Thanks to Restellini I was also introduced to Gerard Netter, son

of another major collector, and dined with François Berthier, who is at work on a life of Roger Dutilleul, another businessman and early enthusiast of Modigliani's work. I was given an introduction to Restellini's lifelong friend and mentor, the late Philippe Cazeau, art dealer and Modigliani specialist, who received me kindly and gave me some early pointers about how to spot Modigliani fakes.

Between the two of us Restellini and I tracked down the young couple living in the once derelict apartment in Montparnasse where Modigliani lay dying. Restellini will knock on anyone's door, and he and I were determined to see the apartment in which Jeanne Hébuterne's family had lived. We ended up making two or three tries, partly because I shrink from what are termed, I believe, cold calls. We also saw however, exhibitions together. We conducted interviews, laughed, and argued. He has been the best friend a biographer could ever wish for. I could not have written this book without him.

In the closed world of Modigliani scholarship, much more typical was the response from the Archives Légales Amedeo Modigliani, then in Paris, the website of which offered access to researchers, journalists, and the like. I wrote and sent e-mails for a year without response. I was to learn that the archive was headed by Christian Parisot, an art historian who had befriended Modigliani's only surviving child, called Jeanne after her mother. They met when Jeanne was launched on a career as an artist; Parisot became an expert on Modigliani and gave certificates of authentication, for a fee, claiming he was her legal heir. He had in fact inherited the archive Jeanne Modigliani began about her father when she was working on a book about his life. Parisot was close to Jeanne's younger daughter Laure, Modigliani's granddaughter. Repeated attempts to contact either of them were met with silence.

I was more fortunate elsewhere. Thanks to another friend I was able to contact L. G. "Nick" Modigliani, a successful mining engineer who had settled in North Andover, Massachusetts. I also visited Dr. Roberto Modigliani and his wife, living on the Île de la Cité in Paris, and learned more of the family's history.

Then I contacted Anne Modigliani, older sister of Laure, Modigliani's other granddaughter. She was living under the care of a lifelong family friend and confidant, Jean-Pierre Haillus, in Dieulefit. During two daylong visits I learned much more about Anne, her childhood,

and her parents' lives. She and Haillus both lent numerous letters and family photographs, which are published here for the first time. The complicated effect, on Jeanne, of the fact of her father's fame and sad fate, was described with particular sensitivity and nuance by them both. I am indebted to their generous help.

In such a quest, any biographer depends on the kindness of strangers and their help in finding others with further insights. I was fortunate in making contact with François Vitrani, a student of Jeanne's husband, Victor Leduc, who was particularly knowledgeable about their lives on the run from the Gestapo during World War II. Through Vitrani I also met René Glodek, who served in the Résistance with Leduc and Jeanne and provided valuable information about her capture and stay in prison. Through Vitrani I was also given an introduction to Dominique Desanti, journalist, historian, and novelist, who knew Sartre, de Beauvoir, and Aragon in the rarefied Communist intellectual circles to which Leduc and Jeanne also belonged. The curious parallels between Jeanne's life and that of the father who died when she was two years old form a kind of coda to this story. I am indebted to all these friends of Jeanne's and particularly to the keen insights of Dominique Desanti.

When it became clear that I could not afford to make the further European trips needed to explore all the tempting possibilities, the National Endowment for the Humanities awarded me a yearlong fellowship for 2008. I am indebted to the kindly interest the former chairman, Bruce Cole, took in my work.

Thanks to this fellowship I was able to make return trips to Paris and New York and, also, a pivotal trip to Rome. There I studied at the foundation established by Modigliani's oldest brother, the distinguished Socialist leader G. E. Modigliani, and his wife Vera. My indispensable guide was Donatella Cherubini, professor of political science at the University of Siena and biographer of G. E. Modigliani. She guided me through the fairly complicated files in the foundation and then smoothed the way for me to study at the National Archives in Rome, which contained more letters and photographs. I owe her my deepest thanks.

When your subject has been dead for almost a century you are lucky if you can even find grandchildren with some kind of family lore to

pass along, much less the letters of eyewitnesses. I was lucky enough to find two children whose fathers had known Modigliani well. In the case of Noël Alexandre, he was privy to the reminiscences of his physician father. Paul Alexandre had been Modigliani's first collector and had gathered information for the memoir he always wanted to write but never had, all of which gave his son a unique perspective. The other witness at one remove that I was fortunate to meet was the heir of Moïse Kisling, Jean, and now director of the Fondation Modigliani-Kisling. Jean Kisling also received me kindly, offered pointers about their artistic friendship, and lent little-known photographs.

My crash course on Modigliani fakes—he is one of the most imitated and copied artists in the world—was vastly informed by interviews with two former detectives of Scotland Yard, Tony Russell and Dick Ellis, who were particularly well versed in the ways European laws limit the scope of enforcement. Gil Edelson, for many years head of the Art Dealers Association in New York, shared similar reminiscences. John Myatt, a British artist who had a brief career of painting "genuine" Modiglianis before beginning his present career painting genuinely fake Modiglianis, was eloquent on the difficulties presented by that artist's seemingly easily forged style. Here again Marc Restellini, who has seen more fake paintings and drawings than he cares to remember, is an expert in all the ways a painting, as is said in the trade, does not look "right."

Modigliani died of tubercular meningitis, which, in the days before X-rays, could only be diagnosed by marked changes in behavior. In the absence of an actual medical record for Modigliani, and for guiding me through the likely possibilities, I am indebted to Dr. Ann Medinger, a specialist in pulmonary medicine. Dr. Medinger kindly read my work and counseled me about the symptoms and stages of this once deadly affliction.

Like Restellini, Kenneth Wayne, chief curator at the Heckscher Museum of Art in Huntington, New York, who also curated an exhibition focused around Modigliani for the Albright-Knox in Buffalo, took a generous interest in my work and made many helpful suggestions. Roy Slade, former director of the Cranbrook Academy of Art and the Corcoran Gallery, was equally selfless with suggestions and comments. Marie-Christine Joubert Thouvenin, formerly of the Wildenstein Institute in Paris, has a particular knowledge of the

subject and has helped me avoid many an inadvertent error. Michael Findlay, director of the Acquavella Galleries, and Lawrence and Peggy Steigrad, other New York art dealers, also listened to my cries for help with more patience than I deserved. So did Daniel Marchesseau, director of the Musée de la Vie Romantique in Paris, whose memory for detail is formidable and whose English, impeccable.

So many people took pity on me. Colette Giraudon, formerly with the Musée Picasso and biographer of Paul Guillaume, one of Modigliani's dealers, gave me a delicious lunch and some pertinent advice. Solange and the late Jean-Claude Kaltenbach—he was the biographer of Conrad Moricand, a friend of Moïse Kisling's—were kindness itself as I struggled to make sense of conflicting accounts. Godefroy Jarzaguet and Alexandra Marsiglia—he restored the apartment where Modigliani lived out his last months, and they later married—were willing to describe their adventurous love affair and its happy outcome. Emmanuelle Collas, Victor Leduc's publisher, pointed me in fruitful new directions; Mimi Gross, former wife of the artist Red Grooms, showed me an unknown Modigliani drawing; and Stark Biddle provided photographs of similarly rare drawings he had owned. Most of all I must thank Julie Martin. Her encyclopedic knowledge of the period, as I recount elsewhere in my book, is equaled only by her generosity of spirit.

For all those who also offered advice, encouragement, and concrete help, I want to extend further thanks: Georgina Adam, The Art Newspaper; Natalia Andrini, the Center for Jewish History, New York; Barbara Aikens, Judy Throm, and Wendy Hurlock Baker, the Archives of American Art; Dottore Aldo G. Ricci, sovrintendente, Archivio Centrale dello Stato, Rome; the Arts Club of Chicago; Dr. Mitchell G. Bard, executive director, American-Israeli Cooperation Enterprise; Karen K. Butler, Mellon Foundation Fellow, the Barnes Foundation; Prof. Edward Berenson, Institute of French Studies; Mme. Claude Billaud, conservateur, Bibliothèque Historique de la ville de Paris; Véronique Borgeaud and Dominique Bernauser, Bibliothèque, Musée National d'Art Moderne, Paris; Maria Morelli, archivist, Mugar Memorial Library, Boston University; Alain Bouret; Prof. Clifford Wolfman, Modernist Journals Project, Brown Univer-

sity; Nancy Hall-Duncan, senior curator, Bruce Museum; Richard Bumgarner; Dr. Anthea Brook, Italian School, Witt Library, Courtauld Institute of Art, London; Arnaude Charvet and Hélène Mouradian, Galerie Charvet-Mouradian; Dottore Rudy Chiappini; José Emmanuel Cruz and Nicole Cruz-Altounian; Guy-Patrice Dauberville, Galerie Bernheim-Jeune, Paris; Sue Bond, Estorick Collection, London; Ira Fabri, Francesca Giampaolo, Fattori Museum, Livorno; Marina Ducrey, Fondation Félix Vallotton, Lausanne; Simonetta Fraquelli, Royal Academy, London; Liana Funaro; Joan Sutcliffe, H. P. B. Library, Toronto; Duane Chartier, International Center for Art Intelligence, Culver City; Mason Klein, Jewish Museum; Philip and Mary Kopper, Michele Van de Roer; Jean Levi; Charles Maussion; Andrew Murray, the Mayor Gallery, London; Gary Tinterow, curator, the Metropolitan Museum of Art; Elizabetta Colla, director, Fondazione Giuseppe Emanuele e Vera Modigliani, Rome; Maygene Daniels, archivist, National Gallery of Art; Maxime Nechtschein; Jerry Nedilsky; James Oglethorpe; Michael Partington; Hélène Desmazières, Céline Thouroude, Laurent Guinamard-Casati, architect, Pinacothèque de Paris; Jean Rigotard; Franckie Tacque, Salon des Indépendants, Grand Palais, Paris; Tijenia Saustier, Kalima, Paris; Margaret Scott; Patricia B. Selch; John Tancock, Impressionism and Modern Painting, Sotheby's, New York; James Stourton and Philip Hook, Sotheby's, London; Hilary Spurling; Galerie Paul Vallotton, Lausanne; Jeffrey Weiss, former curator of contemporary art, National Gallery of Art; Harry Cooper, curator of modern and contemporary art, National Gallery; Nicholas Fox Weber; Catherine Wyler; Deborah Ziska and Anabeth Guthrie, public relations, National Gallery of Art.

As always, I am indebted to my editor, Victoria Wilson, whose advice and understanding have guided me through many a potential pitfall, and her indispensable assistant, Carmen Johnson. This book is dedicated to my husband, Thomas Beveridge, who knows why.

MODIGLIANI

———◆———

The Problem

Sigh out a lamentable tale of things,
Done long ago, and ill done.
—JOHN FORD, *The Lover's Melancholy*

MY SEARCH for Amedeo Modigliani began a few years ago in the East Wing of the National Gallery of Art in Washington. I had always known about this Italian artist, who lived in Paris at the same moment as Romaine Brooks did, an American expatriate with a similar passion for portraiture, about whom I wrote. Both took singular paths but moved in different circles, to put it mildly. There were other differences. Whereas Romaine Brooks's success in 1910 was immediate—Robert de Montesquiou called her "A Thief of Souls"—Modigliani's achievements took decades to be appreciated. Whereas Romaine Brooks is a minor art historical footnote nowadays, Modigliani's reputation continues to soar, to judge from the prices paid for his paintings. Romaine's work, with its monochromatic palette, came, as Hilton Kramer wrote, at the end of the Whistler inheritance; Modigliani's was outside every movement. Yet one could perceive a searching intelligence at work in both, infusing their images with

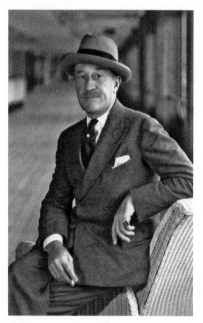

Chester Dale, c. 1930

the same rigorous intensity. I was slowly becoming as interested in him as I had been in her. Then I found his art.

In contrast to the neoclassical National Gallery created by John Russell Pope, with its elegant detailing and hushed, inviting galleries, the East Wing's rigorous spaces of pink granite, steel, and stone, and its chasms of glass, inhibit, rather than welcome, an aesthetic response. Machines for living are one thing, habitations of the spirit another, and so I wandered one day by accident into one of its rooms off the main concourse. There I came upon eight Modigliani paintings and one sculpture, tucked away unobtrusively in a diamond-shaped room. The matte-finish walls in a grayed-off cream, the ceiling spotlights, and the industrial-weight carpeting had the negative virtue, at least, of not competing with the presence of these hidden jewels.

The collection had been assembled by Chester Dale, who, like many other great collectors, was a genius at financial prestidigitation, was small, large-featured, and plain. Having a sense of style, he compensated for this handicap with flamboyant hats, heavy and expensive rings, and an indefatigable willingness to offer himself as a model to such artists as George Bellows and Diego Rivera. Perhaps the most telling portrait that resulted was by Salvador Dalí, who depicted the collector looking out complacently from the frame, bearing a solemn and unmistakable resemblance to his poodle. By then Dale was acquiring paintings as relentlessly as he had once pursued stock options, thanks to his first wife, Maud. She nagged and prodded her husband to buy Modiglianis by the dozen at a moment, in the early 1920s, when they could almost be had in job lots.

The Modigliani room was being patrolled by a taut-looking, gum-chewing guard with a Fu Manchu moustache and a wary expres-

sion. When asked how much he liked being in that room, he said, "I don't." A few people were wandering through, a couple speaking Russian and a short Japanese man in glasses and a black shirt. I stopped first beside Modigliani's portrait of Monsieur Deleu, painted in 1916, which I had seen in reproduction but which I could almost say I had never seen, since the work itself was so startlingly different. Instead of what looked, from picture books, to be an uninteresting study of a heavyset, black-haired man with a pursed mouth in flat planes of gray, black, and russet, this was a revelation.

Maud Dale, 1927

The expression, at first glance a caricature, was in fact full of dexterously applied details, such as a touch of light in the left eye, a shadow under an eyebrow, and the play of volumes around the mouth and chin. What had seemed superficial was in fact full of nuance. Was he frowning slightly, or mulling a point, or drawing back from life itself?

The sense of enigmatic intent extended to the dappled light and shade on the sitter's jacket and the close attention given to what is usually least considered, i.e., the background. Each stroke of the brush seemed to have been placed with a feeling of finality, even inevitability. Here was a powerful sensibility at work, at once assured, vital, and subtle, qualities which no reproduction could adequately convey.

I had the same sensation of seeing a work as if for the first time with the portrait hanging beside it, *Madame Amédée* (*Woman with a Cigarette*), painted two years later. This depiction of a heavyset woman in a black dress, hand on hip and a cigarette dangling between her fingers, gives little clue in reproduction to the force of her personality at a distance of five feet. That air of disdain, those raised brows, the puckered mouth—could there be a hint of self-doubt in

her pose? The impression is reinforced by the artist's sloping floor and the realization that his model is not actually sitting on her chair but floating above it. Hauteur, insouciance, pretense—all this melts before the penetrating gaze of the artist, who has made his feelings known with such delicate irony.

If it is clear that Modigliani disdained his subject, the same cannot be said for *Gypsy Woman with Baby*. This first attempt at a mother-and-child theme, painted in 1919, soon after Modigliani became a father himself, could not be more of a contrast. Instead of the heavy outlines and uncompromising pose, here are pastels that seem to float across the canvas. Fragile grays, going from blue to green, are harmoniously intertwined within outlines that have been softened and blurred, the paint broken up into thumb-like patches of color. The mother, hardly more than a girl, with her high coloring, skewed nose, pretty mouth, and sweet, lost look, presses her baby against her as if clinging to a life raft. The effect is poetic as well as endearing; no wonder it was one of the first Modiglianis Maud Dale persuaded her husband to buy. As a final, masterful touch, the artist has added, in his subject's otherwise neat coiffure, a single escaping wisp of hair.

I arrived at length at Modigliani's portrait of Chaim Soutine, who was still only a boy when he escaped from Russia and came to Paris to study art in 1913, meeting Modigliani shortly thereafter. Soutine, one of eleven children of cruel parents, barely escaped with his life. Penniless, crude, inarticulate, he was befriended by Modigliani, who painted his portrait a number of times. Here he is, staring out of the frame, a seated figure with tumbling hair and ill-matched clothes, his hands placed awkwardly in his lap, his eyes half closed and peasant nose spreading across his expressionless face. He is ugly, and yet. As Kenneth Silver wrote in *The Circle of Montparnasse*, "Modigliani manages . . . to convey a kind of poetic beauty in his sitter, that special brand of idealization for which he is justly famous."

This same ability can be found in Modigliani's chef d'oeuvre, *Nude on a Blue Cushion*, one of the painter's series of grand horizontals, painted three years before his death. Whatever I had seen or remembered of this work from catalogs was again a pale reflection of the work's power at close range; this one, in a frame of dull gold with inserts of black, dominated the room. The girl's limbs are

softly rounded, her thighs full, and the outlines of her breasts delineated with a fine black line, nipples blushes of pink. She is half lying, half-raised on one arm, and a hand touches her face, which is turned toward the viewer with a smile. This is a girl who wants to be liked and is not at all sure of the reception, as is suggested by fastidious painterly details, such as the light and shade around the forehead, a touch of pink beside the nose, and the hint of a line under one eye. At close range, one discovers so many of these unexpected touches: the smidgen of blue on a wrist which picks up the color of the cushion, the patch of pink on a knee, the dot at the corner of an eye, and the same judiciously considered background.

All master portraits have a sense of inevitability about them—one thinks of the personalities so brilliantly memorialized by John Singer Sargent—but as I looked around the room it seemed that more was being said than a probing of personality alone, or even painterly experiments in compositional techniques and simplified forms. There had to be a clue to the riddle. I looked again at the single piece of sculpture, a limestone head of a woman, standing on a pedestal in one corner of the room. The head, carved from a rectangular piece of stone, was consequently elongated, its nose radically long, mouth barely indicated, eyes enigmatic and impassive. One thought, as Bernard Dorival wrote, of the religious power found in Khmer and Chinese sculptures. Monumentality—otherworldliness—the transcendental—such thoughts rose to the surface and whirled around in my head. As I knew, an interior stir was the first sign that one's point of view would be turned upside down and transformed by a new experience. An artist capable of inciting such thoughts had to be something of a magician. And yet, was this someone one would have to know well in order to know him at all? I had to find out.

The response Modigliani's work had aroused in me was hardly unique. In the years immediately following his death in 1920, a few dealers, critics, and collectors were determined to educate a more or less indifferent public. Maud Dale saw to it that her husband Chester would become the largest single collector of Modigliani's work and wrote a monograph. So did Giovanni Scheiwiller, a critic and dealer, whose connections with Modigliani's family began soon after his

death. Paul Guillaume, one of his two dealers, wrote an appreciation, and others, among them Jean Cocteau, Adolphe Basler, and Louis Latourette, began to publish their own accounts.

In 1926 André Salmon, poet and journalist, published a seeming celebration of Modigliani's art that made frequent references to the artist's apparent addiction to drugs and alcohol. The same stories were repeated in *Artist Quarter* by Charles Douglas (the pen name of Lawrence Goldring and Charles Beadle), published in London in 1941. Biographers were divided between those who saw him as a true pioneer of modern art or, as with Gauguin, van Gogh, and Soutine, the prototype of an artist at odds with society. He was a visionary, a poet and philosopher, even a mystic. Or he was a minor character, whose romantic life story had led some to place more importance on his work than it deserved. His nickname was Modi, which Salmon was the first to transmute into *"maudit,"* i.e., accursed. This unrelenting view painted him as morally defective, one of those pathetic figures who disintegrate before one's eyes. Biographies, films, and plays following World War II were variations on the label that had firmly attached itself: *"maudit,"* accursed.

Modigliani, the youngest of four children from an educated but impoverished Italian Jewish family, came to Paris in 1906 at the age of twenty-two to make his fortune. Polite, well mannered, intellectual, he soon abandoned the conventional attire of the young bourgeois for the uniform of the Bohemian. Arthur Pfannstiel, writing in 1929, called him "this young Tuscan, this great lyricist, at once draughtsman, sculptor, painter." He was strikingly good-looking. "How beautiful he was, my God, how beautiful!" Aicha, one of his models, said. He was ardent, impetuous, and not very careful. At least three illegitimate children are likely and stories were told of a courteous, charming personality who became ugly when drunk, took off his clothes, picked fights, and, it was said, threw one of his mistresses through a window. He alienated and dismissed would-be collectors; he was his own worst enemy. Cocteau wrote, "There was something like a curse on this very noble boy. He was beautiful; alcohol and misfortune took their toll on him." The more he struggled, the more desperate he became. Kenneth Silver wrote, "The little Jew from Livorno becomes a good-for-nothing."

Modigliani's difficulties were not only confined to poverty and

finding a dealer. Romaine Brooks, whose milieu was the high intelligentsia, received full and flowery mention for her first one-man show, whereas Modigliani had no reviews at all for his in 1917, and few mentions in the French press during his lifetime. But she was rich, he was poor, and art reviewers were notorious for expecting to be paid.

Modigliani, aged thirty-five, died in agony and supposedly starving. His lover, Jeanne Hébuterne, then eight months pregnant, committed suicide barely two days later. His death was bad enough, but hers was almost Greek in its tragic dimension. They left behind a two-year-old girl. They were star-crossed lovers whose brief, haunted lives seemed made to order for the *"vie romancées"* and *"vie imaginaires"* so popular in the 1920s. Such fictionalized works were vastly preferable to the prosaic reality, Salmon wrote in *Modigliani, sa vie et son oeuvre* (1926) and expanded upon relentlessly for decades. In his biography of Beatrice Hastings, Simon Gray observes that Salmon's frequently quoted *La Vie passionnée de Modigliani,* written thirty years later, in 1957, is actually a novel but was abridged and reprinted as fact in 1961 under the title *Modigliani: A Memoir.* Those who were witness to events were appalled at the exaggerations, distortions, and imaginary dialogues that appear in Salmon's books about Modigliani. Pierre Sichel, a highly respected biographer who published his own account in 1967 when many of Modigliani's contemporaries were still alive, wrote of *La Vie passionnée de Modigliani,* "In this book Salmon . . . devotes well over ten pages to long, imaginary conversations that Modigliani, Ardengo Soffici, and Giovanni Papini had in Venice," and describes in minute detail the visit of the three to the Uffizi Gallery. Soffici subsequently wrote, "What my friend André Salmon has written concerning the relationship between myself, my friend Papini, and Modigliani contains so many inaccuracies that I must attribute it to failing memory."

Other authors were not so kind. Jean-Paul Crespelle, author of *Modigliani: Les Femmes, les amis, l'oeuvre,* of 1969, wrote, "One marvels that the energy he directed at evoking, in so many books, the figure and work of Modigliani has led him to accumulate inexactitudes and inventions. Can one attribute to a failing memory his assertion that Emanuele Modigliani conducted the funeral service . . . when,

as a socialist deputy in the Italian Chamber ... he was prevented from visiting Paris until a month later ... ? Everyone knew this to be true and a simple check would have prevented Salmon from making a monumental error of this kind. ... Examples of similar inexactitudes and a total indifference to the truth are numerous. Without any doubt André Salmon, who lived for many years in Apollinaire's circle, believed, like the poet, that 'the truth held no interest.' "

All this could be easily explained, according to Lunia Czechowska, friend of Modigliani's final years and subject of many of his portraits. She wrote, "Modi and Salmon detested each other. They refused to say a word to each other. Salmon was contemptuous of this 'drunken tramp' and never went to Zborowski's to see his paintings." Salmon's view of the "*peintre maudit,*" the "dear wounded prince," has influenced everything written about him since; it fitted too well into popular notions of art as synonymous with eccentricity and even derangement.

But perhaps the most destructive of the falsifications surrounding Modigliani's life was the French film *Montparnasse 19,* shown in the U.S. as *Modigliani of Montparnasse* in 1958. It was based on a novel, *Les Montparnos,* by another shameless teller of tall tales, Michel Georges-Michel. Gérard Philipe, a classically trained actor, versatile, charming, and boyishly handsome, seemed an ideal choice for the leading role, and the fact that he shortly afterward died, at the same age as Modigliani, lent the portrait a pathos no one could have anticipated. But, Bosley Crowther wrote in the *New York Times,* the film's proposition was "that its hero is a lush, sad-eyed, tormented garret dweller who is inexplicably bored and finds bleak comfort with a rich mistress ... the victim of idiots and ghouls." The inevitable death scene, Crowther wrote, "leads one to suspect the scriptwriters ... were more impressed by the commercial irony of the artist's misfortune than by his personal tragedy." Anna Akhmatova, the Russian poet who had a love affair with Modigliani, was another witness to events who was appalled by the distortions. The film was "extremely vulgar," and her comment: "It is so bitter!"

The characterization gave further weight to "an art historical mindset that survives to the present day," Maurice Berger wrote. A demonstration of his point appeared in a London review of the exhibition "Modigliani and His Models" at the Royal Academy in

the summer of 2006. The art critic for the *Guardian*, Adrian Searle, wrote, "Drunken, ranting and stoned on one thing or another—add hash, coke, ether and opium to the alcohol—Modigliani, the archetypal accursed artist" was someone he could not like and who only irritated him. No wonder, Silver wrote, Modigliani was "probably the most mythologized modern artist since van Gogh."

No one seems to have noticed that the fact that Modigliani was alive at all was something of a miracle. From childhood he had been beset by illnesses and two were life-threatening, and all this before he reached the age of seventeen. It was as if he, along with others in his family, were the survivors of some great catastrophe. Even biographers like Pierre Sichel, who tried to repair the damage caused by the casual distortions of Salmon, Carco, Georges-Michel, and others, and who knew about Modigliani's lifelong battle with tuberculosis, hardly mention it and seem oblivious to the toll it exacted: physical, emotional, and social. June Rose, another biographer who attempted to separate the reality from the inventions, did not find the illness significant. Neither did Jeanne Modigliani, who wrote his biography,

Trying to sell his drawings: Gérard Philipe in the title role of *Modigliani of Montparnasse*, 1958

Modigliani: Man and Myth (1958), and barely mentioned the disease that killed him.

As I knew, a biography can never be absolutely, objectively true, "definitive," as it used to be called. "The reflection cast back by any good biography resembles one of those compound faces made by newspapers for the amusement of their readers, blending perhaps an artist's eyes and forehead with a criminal's nose and mouth," Julian Symons wrote. "The features in a biography are all distinct enough, and they are recognizably the features of the subject: but the haunted eyes and the hunting nose, the wafer-thin mouth and rocky chin, are the biographer's own."

What I also knew was, as W. B. Yeats wrote, "There is some Myth for every man which, if we but knew it, would make us understand all that he did and thought." If it were possible to understand something of the trials Modigliani underwent in the struggle to create and the role his art played in the fulfillment of an ideal, then the enquiry would be worthwhile. As Yeats also observed, "The painter's brush consumes his dreams."

———◆———

The Clues

The gods of hazard lead us down
The backstairs of the universe
Dancing to fiddlestrings accurst
We go as other men have gone.
—GUILLAUME APOLLINAIRE
"La Chanson du mal-aimé"

A. J. A. SYMONS, who wrote a biography of a forgotten figure, an English writer who called himself "Baron Corvo," published his work in 1934. This experimental study, *The Quest for Corvo,* is still considered a model for authors seeking to penetrate an accepted image to uncover the actual human being behind a façade. In Corvo's case the disguise was self-invented. In Modigliani's case it came about almost immediately, with the clear goal of capitalizing on the tragic circumstances of his life and almost simultaneous deaths of himself and his mistress in 1920. Symons wrote of Corvo, "[H]ere was indeed a tragic comedy, more sombre and fantastic than I had expected or hoped . . . Frustration and poverty had been the condition of his early years as of his last; tutorships, odd jobs, and char-

The historians Julie Martin and Billy Klüver in Venice,
1988

ity were the actual lot of the dreamer who (in his dreams) had ruled
the world." The comparison seemed exact, even the summing-up of
Corvo's life by another observer: "A self-tortured and defeated soul,
who might have done much, had he been born in the proper era or
surroundings."

And yet. Was this really an accurate picture of the life I was study-
ing? For all the graphic descriptions of Modigliani's life and death,
could this withstand the evidence of the works he had accomplished
in his short career, particularly the masterful paintings—portraits
and nudes—created in the final period of his life, more than one a
week? The physical stamina alone needed to keep up with this pace,
combined with the rigor, economy, elegance, and confidence of those
final works, showed a man at the height of his powers. And in fact
such evidence, along with his paintings, sculptures, a few scrawled
notes, and photographs, was more to be trusted than the firsthand
accounts that emerged in the years after his death. Ernest Heming-
way, who did not always follow his own advice, once instructed
other writers that what was needed was "a built-in, shock-proof
shit-detector." This was hard enough to do when the witness was
alive, almost impossible once everyone involved was long dead. In
Modigliani's case, almost ninety years had passed.

Besides evaluating some wild stories of debauchery and deflow-
ering one needed to discover the direct heirs, who sometimes had

archives that had been kept private or overlooked. Then there were the research libraries, the heirs of friends, collectors, artists, and dealers, as well as experts in the circle of artists to which Modigliani belonged in the early years of the twentieth century. Here was a man who once rubbed shoulders with Pablo Picasso, André Derain, Robert Desnos, Moïse Kisling, Jacques Lipchitz, Chaim Soutine, Maurice Utrillo, and so many others, all living near the crossroads of the boulevards Montparnasse and Raspail on the Left Bank of Paris.

Among a group of scholars I was to meet, Julie Martin and Billy Klüver stood out as the éminences grises, considered with a respect bordering on awe for their encyclopedic knowledge and ability to pinpoint galaxies of complicated interrelationships among the artists, sculptors, poets, writers, and musicians in Paris in the early years. Their book, *Kiki's Paris* (1989), is an invaluable reference and a compendium of letters, photographs, poems, and anecdotes, amassed over a decade. I immediately contacted Julie Martin. (Billy Klüver has since died.) We agreed that the accepted view of Modigliani was no longer defensible but that nothing had replaced it so far. We both believed he was a remarkable man who had been dismissed as a clownish figure who just happened to have painted some unforgettable canvases. He was a remnant of another age, "the last Bohemian," even a lost soul who had committed slow suicide with alcohol. There had to be a reevaluation, and one was long overdue. She immediately pointed me toward some important contacts: first, the expert Marc Restellini; then Kenneth Wayne, who had curated another important exhibition about Modigliani; Moïse Kisling's son Jean; the art historian Colette Giraudon; Noël Alexandre, son of Modigliani's earliest collector; even a former chief of police in Paris.

Then Julie Martin suggested that I investigate a series of interviews conducted in 1963–64, when so many of the people around Modigliani were still alive. The interviews were commissioned by the American author Pierre Sichel for his biography of Modigliani. By the time he decided to write about Modigliani, Sichel had already written a novel based on the life of Lillie Langtry, *The Jersey Lily*, which was a best seller, and another about a Vermont poet, *The Sapbucket Genius*, that was loosely modeled on a life of Dylan Thomas.

Sichel originally planned to approach Modigliani's life in a similar vein. But then, thanks to an extraordinary series of interviews

conducted by John Olliver, his bilingual investigator in Paris, Sichel changed his mind and wrote a biography instead. It took him five years. After publication, Sichel placed his huge manuscript on deposit at the Howard Gottlieb Archival Research Center at Boston University, where he also deposited the interviews. This immediately interested me. I had often had the experience of consulting the identical sources as other authors and discovering overlooked possibilities, not to mention arriving at quite different conclusions. I at once set about getting copies.

Julie Martin also started me on the path of uncovering another treasure trove: "L'Histoire de notre famille," by Modigliani's mother, Eugénie Garsin-Modigliani. This account of her own and her husband's families, beginning at the end of the eighteenth century and continuing until Modigliani's birth in 1884, had long been known but presumably discounted. Jeanne Modigliani, whose own biography of her father, *Modigliani: Man and Myth,* was an attempt to uncover the truth, had access to the document. However, her excessively careful, almost bloodless, narrative makes very little use of it. There could be an explanation. Far from being the prosaic account one might expect, Eugénie's descriptions of people, places, and events have a lively and irreverent immediacy, perhaps the reason why her writings were so heavily edited. She is opinionated, unexpected, shrewd, and frank. In a confident, rhythmical hand, she sets down her observations about family members, describing their idiosyncrasies and shortcomings with the verve of a born novelist. No better observer could have been found to describe the particular influences at work on the complex personality of her son.

Eugénie's history begins with a description of the Garsins, Sephardic Jews who had lived on the Mediterranean coastline for centuries. One ancestor, based in Tunis, became an authority on sacred texts, which, according to Leo Rosten, he probably wrote in Arabic. He also founded a school of Talmudic studies. Eugénie and her son claimed to be descended from the seventeenth-century Dutch philosopher Baruch Spinoza, who had fled from Spain during the Inquisition. It was true that there was a Regina Spinoza in the family and she was certainly Spanish because, according to Jeanne Modigliani, her daughters spoke the dialect of the Spanish Jews. Jeanne added that, since Spinoza was childless, they could not be direct descen-

dants. But to judge from the way the Garsins insisted on their connection and their scholarly studies of the philosopher's writings, that they were somehow linked by family ties seems likely.

This was a family much more apt to take pride in intellectual prowess than financial dealings, although at the beginning of the nineteenth century the Garsins had opened a business in Livorno (Leghorn). As Sephardim they were heirs to a train of thought which had dominated Jewish culture from about 600 AD until Jews were expelled from Spain at the end of the fifteenth century. Sephardic Judaism, Leo Rosten wrote in *The Joys of Yiddish*, was "an exceptionally sophisticated blend of Talmudic thought, Greek philosophy, Aristotelianism, science and the ideas of Averroes, the great Islamic scholar." Unlike Ashkenazic Jews, who settled in central and eastern Europe and spoke Yiddish, the Sephardim spoke Ladino, were educated and cultured, and rose to positions of eminence in Spain, Portugal, and North Africa as doctors, philosophers, poets, royal advisors, and financiers. The Garsins were no exception. Jeanne Modigliani wrote that besides Spinoza, the family's heroes were Uriel da Costa and Moses Mendelssohn. That philosopher, grandfather of the composer Felix, was one of the leading lights in the Haskalah, or Enlightenment, an eighteenth-century movement which aimed to bring Judaism out of its self-imposed isolation into Western thought, and which emphasized assimilation. The Garsins, worldly, scholarly, fluent in languages, exemplified Mendelssohn's ideal as they moved with ease between cultures and social groups. These businessmen bought houses and kept servants, although the source of their income is not described in either Eugénie's or Jeanne's accounts. June Rose, who wrote a biography of Modigliani and interviewed his brother Umberto, believed that they ran a credit agency, with offices in Livorno, Marseille, Tunis, and London.

In a fascinating essay on the Garsins' British connections, the art historian Kenneth Wayne has established that Eugénie's oldest brother, Joseph Évariste Garsin, moved to London in 1877 and married Jessie, a girl from Plymouth; they had three children. Amedeo's father and uncles also had British connections in the development of zinc mines since their partner was another Englishman, William Gerard Gibson of the Crown Smelter Company in London. Eugénie, born in Marseille, has little to say about the turbulent times

through which she lived. But since the Garsins were doing business in Livorno in the nineteenth century they were bound to be affected by this most chaotic of periods in Italian history. That country, used for years as a battleground and subjected to periodic invasions by Austria and France, did not become unified until 1870. Livorno was a major port on the Mediterranean, and wars, bringing about plunging markets, currency exchange disruptions, and a tendency to wipe out speculative investments, are the kinds of events no businessman wants to deal with. When times were good the Garsins played the stock markets, took leisurely vacations, and bought houses. When they were bad they cut costs and moved in together, sometimes sheltering four generations at a time. Eugénie called it "our *smala,*" or circus.

The Garsin home base in Marseille was at 21 rue Bonaparte, a four-story house fronting on a large square, the Place du Palais de Justice. The house was bought in 1852, three years before Eugénie was born, and she grew up there. Her parents, Isacco and Regina (actually his first cousin, daughter of his uncle Isacco), eventually had seven children. After Évariste, the firstborn, came Eugénie, then Amédée, Clémentine, Laure, Gabrielle, and Albert. These brothers and sisters would figure, one way or another, in the life of Amedeo Modigliani. Eugénie has an early memory, when she was four, of going to meet her parents across the square as they returned from a holiday in Italy. Waiting at the door was her uncle Giacomo, wearing "his invariable red handkerchief half out of his back pocket, his gold-framed glasses on the end of his nose, and with his perpetual thin-lipped smile, always kindly but a little foolish," she wrote. Giacomo had a modest career as a dealer in men's furnishings before joining the family firm. He became the accountant, spending his days in a kind of cage with barred windows, which for some reason filled Eugénie with fear. Her uncle had saved a little money and wanted desperately to marry Nonnina, Eugénie's grandmother, who lived in the house with them. She, however, remained true to the memory of her husband Isacco, who took skirt chasing as his personal sport and died—of shock, or pneumonia—after having been discovered wearing only a shirt in the bed of somebody else's wife.

Her grandfather Giuseppe, "Nonno," head of the family, was blind and seldom left the house. He would wake every morning before

dawn and, despite his blindness, open the shutters of the windows
to their office, lifting the heavy iron bars himself. Then he would
dictate three simultaneous letters in three different languages, keep-
ing an effortless train of thought in each. Outside of office hours,
Nonno was ready to talk on all kinds of subjects, and was particu-
larly interested in philosophical and religious issues. In memory of
his wife, who died of cholera a few years before, Nonno kept the
old traditions; he fasted, prayed, and observed the holidays. But his
was the most benign form of Judaism, revolving around celebrations,
special cakes—the Livornese kind were his favorites—and vast holi-
day feasts at which the welcome mat was out to any passing stranger,
provided he or she was Jewish. He would tell the younger family
members that tradition was "all a bunch of nonsense," no doubt with
a wink, and if Nonnina recited the Sh'ma, or daily morning prayer, it
was only the first few verses.

Papa, who worked in the bureau with Nonno, was his equal as a
linguist, speaking Greek fluently and Spanish without flaw, in con-
trast to the kind of patois affected by most Sephardim. He was his
mother's favorite, very handsome, not particularly tall but well pro-
portioned and with clear, expressive eyes. Most of all, he had the air
of a natural aristocrat that, combined with beautiful manners and
elegant gestures, gave him an effortless distinction and social success
into old age. His only failing was his darting intelligence. He was too
ready to be distracted by worldly interests, for which his father, mat-
ter of fact and scholarly, acted as a natural brake. Both were regarded
with awe in the household and Papa, Eugénie wrote, was practically
considered an oracle.

One of Eugénie's aunts, named for her great-grandmother, was
"Regina Grande" to distinguish her from Eugénie's mother, called
"Reginetta." Eugénie does not describe the fate of Regina Grande,
but her daughter Margherita appends a note in which she sets down
Nonnina's memories of the woman she knew. Regina Grande was,
according to Nonnina, not particularly beautiful, because she had
red hair (an interesting comment) and her skin was blotchy. But, like
Eugénie's Papa, she had a natural air of command. She carried herself
regally, and a certain intimidation in her manner concealed, accord-
ing to Nonnina, a loveless childhood and an understandable hope for
a happier future. This seemed to offer itself in the shape of a wealthy

Livornese, who courted her assiduously. But then the Garsins went bankrupt in one of their periodic financial reversals and the suitor vanished. Regina Grande, much too proud to refer to the matter publicly, was, she confessed to Nonnina, terribly humiliated.

After the family moved to Marseille she received another offer: marriage to a dealer in wholesale jewelry with a promising future. The engagement went smoothly even if Nonnina wondered just how enthusiastic Regina Grande was about this marriage. Certainly no one in the family suspected that a close cousin was, it seemed, in love with the young jewelry dealer. The evening before her marriage Regina Grande, who suffered from an irregular heartbeat, had palpitations and said she felt ill. The next day she was vomiting. The family doctor being unavailable, a substitute was called, and he recommended some herbal teas. That night, Regina Grande died.

As she told the story Nonnina shook and tears rolled down her face. From the beginning the family suspected that Regina Grande had either taken poison herself or been poisoned, but nothing could be proved. Years later, when she was on her own deathbed, the cousin in question confessed to the crime.

Murder may be considered distinctly eccentric for most families, but for the Garsins, living in nineteenth-century Marseille, sudden death was all too frequent. One of the most important figures in Eugénie's childhood was her uncle Félix, then a medical student. He was the one who spoiled her, made her sing songs, showered her with presents, and called her "my good, dear, and tender friend." He had finely drawn features and a smile that transformed his face, very black hair, reddish side whiskers, and a gentle, almost embarrassingly hesitant manner, Eugénie wrote. After Uncle Félix married and opened a practice on the rue Sylvabelle, he continued to visit them at the rue Bonaparte so often that "he is at the centre of my childhood memories," she wrote. In one of their prosperous moments the family bought a house in a small French village. Eugénie was staying there with her grandmother in the summer of 1867 when there was an epidemic of cholera in Marseille and Uncle Félix fell ill. Eugénie later remembered that her mother took over the major share of nursing him back to health and how worried the rest of the family was about that. Many people died. Félix survived but never quite recovered, suffering from continuing intestinal problems and anemia. He

had lost his old verve, Eugénie wrote. A kind of pervasive sadness would be interspersed by a typically bitter Jewish humor.

All of them knew what chances they took whenever they set out to minister to diseases that struck without warning and for which there were no cures. Successive waves of cholera had swept through Europe since ancient times; in the nineteenth century, with increasing travel, the epidemic that almost took Félix's life in 1867 reached Europe by overland routes via Mecca and Egypt and spread as far as North America. Three decades later, in 1897, another outbreak took an even worse toll in the Mediterranean ports of France, Spain, and Italy.

The cholera bacillus had been identified as early as 1849, but its exact cause was not isolated or studied until the 1880s. It took years for the relationship between its spread and the contamination, by human waste, of water, food, and especially seafood such as oysters and shellfish, to be understood. Just how sanitary the house was at 21 rue Bonaparte, and where its waste went, is unknown. But even on the Right Bank in Paris, water on the upper floors was a rarity until 1865, and it was a decade later than that arriving on the Left Bank. Bathrooms hardly existed. As for flush toilets, these certainly existed, but people continued to think of human waste as a useful fertilizer, and night-soil men went on, as they had done for centuries, hauling their fetid loads out of the city. In A History of Private Life, Roger-Henri Guerrand notes, "In Marseille, 14,000 of 32,653 buildings in the 1886 census had no system for human waste disposal. Waste was simply accumulated in a potty on each floor and then disposed of in the gutter." City sewers were rare, wells became contaminated, and reforms took decades. This was still 1867. The arrival of a cholera epidemic must have looked like the vicissitudes of fate as families succumbed to the cumulative effects of diarrhea, vomiting, and prostration.

Inside its dark, picturesque old houses and along its labyrinthine, steep back streets, the ancient port of Marseille was also a fertile breeding ground for other illnesses. Diphtheria was common, babies died in infancy, and in 1850 the average life expectancy was thirty-eight for men and forty-two for women. Typhoid fever was such an ordinary, everyday kind of calamity that Eugénie's memoir refers to it without comment. Here again the culprit is raw sewage that

contaminates water, milk, vegetables, and shellfish. Typhoid fever's symptoms are particularly nasty, its convalescence usually prolonged, and before the availability of vaccines and modern medicines the only recourse was devoted nursing care. That, of course, was the role of the Garsin women.

Eugénie wrote, "Each of the Garsins was simultaneously a doctor and a pharmacist. Each of them had a personal remedy which he or she applied to certain criteria as absolute as those of the Faculté [de Médicine]." For instance, there was a horrible concoction containing camphor used on cuts and scratches, but it hurt so much the children never complained about injuries for fear of being subjected to this particular remedy. Digestive upsets were Eugénie's particular "specialty" since orchards surrounded their country house and she loved fruit. She would blame her stomachaches on the air coming in from the Mediterranean. Uncle Félix, with his best smile, would reply, "Yes my darling, it's the sea air, but next time, don't eat so many figs."

Then there was Nanette, a hairdresser who came to stay in the Garsin household, bringing her own homemade skin and hair preparations along with a great many folk remedies. She had the added skill of being able to set bones and deal with sprains. She had successfully healed a bad cut sustained by Évariste, Eugénie's older brother, who had scratched himself on a prickly branch and neglected to keep the wound clean. She knew how to make medicines from certain bitter herbs to cure indigestion and colic. Her most spectacular cure involved Eugénie's father, who developed an eye malady that was causing a rapid and disturbing loss of eyesight. The nightmare possibilities of having Papa become blind as well as Nonno roused the family to desperate measures. A specialist was consulted; he said nothing could be done. Nanette made up her magic potion of herbs and instructed Papa to sniff the liquid up his nose every day. Papa dutifully took his morning dose, and in the days that followed had violent fits of sneezing and all the other symptoms of an acute cold. Then his eyesight returned; it was as good as new. From that day on, Nanette was their miracle worker.

Despite, or because of, their faith in miraculous cures, a strain of superstitious belief ran through this proud, emotionally distant family of intellectuals. All of them had, Eugénie wrote, "[t]he credulity of ignorance and the blind obedience of the simplest folk. I shall

never be able to enumerate all that was tradition and an article of faith." One never cut one's hair during a waning moon, or nails on a Friday, and never in sequence. One should never sew a button on a garment one was wearing (a sensible precaution), and as for black-letter days, the list of obligatory rituals designed to mitigate its gods was endless.

Bernard Berenson, who came from the Pale of Settlement, was subject to the same curious propitiations. He felt compelled to look at the new moon, but never through glass, to make three bows and turn over the loose cash in his pockets, and did not seem to connect the observance with the *broche,* or blessing, that was a ritual of his early training. (For observant Jews, the *broche* must be recited on a host of occasions, including the first sighting of a new moon.) To Berenson the act remained an inexplicable quirk of his nature, "a drag towards superstition in any and every one who was brought up . . . in a magical world."

In 1870, the year of the Franco-Prussian War, Paris was under siege, and Napoleon III, having sustained heavy losses against Bismarck's fighting machine, had been deposed. Eugénie was just fifteen. Although Marseille was out of the direct fighting it was another of those moments for businessmen to make a prudent retreat. The Garsins, who had constantly shuttled between Marseille and Livorno, turned back toward Italy. After decades of struggle, Italy was finally unified, and Livorno presented fresh opportunities. It seems that Papa and Nonno put their heads together and came up with a future for Eugénie: marriage. The groom-to-be was a member of a prominent Livornese family.

As with art dealers into the twentieth century, who negotiated marriages between each other like minor principalities, the Garsins were always looking for ways to place their daughters in advantageous business unions; the younger and more pliant they were, the better. There was, of course, a dowry to be paid in yearly installments, but at the end there would be those lucrative and rock-solid business ties. The joke is that both families thought they were marrying for money at a moment when the fortune of each might take a disastrous downward plunge. Neither, for the moment, was aware of it.

Physically the Garsins were small and dark with "alert, expressive,

changeable faces," Eugénie wrote. They were subject to illnesses: liver disease (which suggests alcoholism), tuberculosis, and psychological disorders, as well. The Modiglianis were taller and well built, held themselves well, were of "phlegmatic temperaments," were robustly healthy, and lived into old age. Whereas the Modiglianis were "more inclined to enjoy life than strain their intellects," Eugénie wrote with her usual acerbity, the Garsins were almost fanatically well-read, eager scholars.

Eugénie might have noted, but did not, that despite her family's superior cultural sophistication, they never seemed able to hold on to money. In that respect they were at a disadvantage when compared with the culturally illiterate Modiglianis, who had a genius for business. The legend was that an earlier generation had made a fortune in banking and lent money to cardinals; they boasted of being "bankers to the Pope." Jeanne Modigliani's view was that the Modiglianis were never bankers (*banca* means bank) but ran an agency (*banco*). Pierre Sichel, Modigliani's tireless investigator, believed the family made money selling wood, coal, and hides.

Given the scale on which the Modigliani family lived, neither explanation is satisfactory, and, indeed, neither is correct. Recent research has established that the family's fortunes were based on shrewd business dealings in lead and zinc in Sardinia and Lombardy. As early as 1866 the Modigliani brothers, Isacco, Alberto, and Flaminio, were managing a lead mine in Sardinia. Then new prospecting in the province of Bergamo, where silver, copper, and iron had been mined since Roman times, established that there were still fresh veins to be exploited. The Modiglianis investigated and found some extremely pure deposits of calamine (hydrous zinc silicate), which they began to extract and export in the early 1870s. They built modern shaft furnaces, constructed cableways, and were soon employing large numbers of workers.

This, then, was the basis for the lifestyle that Eugénie Garsin described. The Modiglianis inhabited two palazzette, or large villas, presumably containing a maximum of space with a minimum of comfort. The house on the via Roma was "crawling" with servants, the meals were gargantuan, and there were receptions "en grand tralala" in and out of the suites of rooms (enfilades) and the ground-floor salon, its heavy doors opening onto flowering terraces. Guests

Flaminio Modigliani as a young man, no date

and family members came and went according to strict social ritual under the control of the family's head. Eugénie described Emanuele, her future father-in-law, as "very tall, very fat and short of breath." His authority was absolute; even married sons had to address him in the third person and ceremoniously kiss his hand. Eugénie's first visit came the year she was engaged, and her sharp little eyes missed little. The contrast between the elegant, cultured, and freethinking Garsins and this family of rich businessmen with their orthodox observances and empty minds was marked.

She had met her future fiancé when he dined with them in Marseille but he had made little impression on her, even though he was slim, dark, and already wealthy as a young mining engineer. In 1870 Flaminio, thirteen years her senior, was comanager of his family's mine in Sardinia as well as twelve thousand hectares (almost thirty thousand acres) of land with vast tracts of timber. In those days he spent most of the year in Sardinia, overseeing mining operations and also becoming something of an expert in forestry and farming. He

is thought to have helped found a school for peasants, showing an interest in education that he would share with his future wife. Their official engagement took place with so little fanfare that nobody bothered to tell Eugénie. It was a business arrangement. Eugénie wrote, "I didn't have enough character to rebel and not enough knowledge of the world to know what I was getting into. Where would I have gained the idea that I *could* revolt?"

She and Flaminio were married in January 1872. She writes, "Our married life began as drab and lifeless and stayed that way ... I can honestly say that my husband did not exist for me." She saw him for ten days every Easter and fifteen days every summer; for the remainder of the year she lived alone. "He did not understand me any more than I understood him. I wrote to him, as I did everything else, because it was expected of me, and my letters had to be sent unsealed to my mother-in-law for approval before they could be mailed." She resorted to the kinds of generalities one would write to a stranger. "I continued to be treated as a girl even after I had my first child." It is hardly surprising that she did not welcome motherhood. She continued, "[I]t took years for me to become the passionately involved mother I did finally become. My spirit and character developed bit by bit with no help from my environment. Those early days seemed to pass in a period of moral and intellectual stupor."

Her firstborn, Emanuele, arrived in the winter of 1872 and Reginetta visited her grandchild three or four days later. Eugénie had not seen her mother since the wedding, when she was in good health. She was horrified to discover that Reginetta, who had nursed a young maid ill with tuberculosis, had herself become infected. Her decline was rapid. "She was firm, without illusions," Eugénie wrote. They both knew she was dying. "[My mother] saw Emanuele for an instant and put her delicate white hand briefly on his head, knowing that she could not embrace him." Then she left. "I was in absolute despair, one made all the more agonizing because I could not go to see her."

Part of the problem, Eugénie wrote, was that her mother had always enjoyed good health and, when she began to feel ill, ignored the symptoms. Eventually they had to be taken seriously, and at this point their wonderful Nanette took over, the one who could cure anything. She administered one of her mysterious and magical potions. It had an immediate and drastic effect on Reginetta's diges-

tive system. The daily "cure" went on for months with no result except to make the patient much sicker. Finally Uncle Félix stepped in and insisted Reginetta enter a hospital for all that medical science could offer. This consisted of such treatments as blistering, cauterizations, and other assaults on the body which further weakened the invalid. Eugénie never saw her mother again. She died a few months later, in May 1873. Eugénie was eighteen and her mother, in her early forties.

Another kind of epidemic, one Eugénie did not describe in such detail, afflicted this gifted, cultured family. Reginetta's illness and death was taking place as the Garsin family was experiencing one of its periodic financial crises. Mismanagement (probably embezzlement) sent the London branch into bankruptcy; the family member involved promptly disappeared. The branch in Tunis was also compromised, and so was the Marseille business. The only branch not in a state of collapse just then appeared to be in Livorno.

One often sees in this family a curious and perhaps predictable link between crises, financial or otherwise, affecting the security of the group, and emotional as well as physical illness. In Papa's case the news arrived in the middle of Reginetta's illness and descended on him with hurricane force. He became wildly agitated and so irrational other family members thought he had gone mad. An unmarried sister, Laure, suffered from what was called "a persecution complex" and was hospitalized. Margherita, who also never married (later becoming a second mother to Jeanne Modigliani), was opinionated and biased and, according to one account, equally unbalanced. Umberto, Amedeo's brother, appeared to have suffered from depression as an adult. Emanuele, the future Socialist leader, was one of the few members of this brilliant, troubled family to escape mental distress.

The Garsin family was, of course, fiercely united. As Luigi Barzini wrote in his seminal study *The Italians*, the family was the first source of power, the only refuge in a life full of political upheaval, and the Garsins, with their tenuous alliances and fluctuating fortunes, felt the same imperative to close ranks. Eugénie's "*smala*" was, she wrote, a beehive in which each person's role was clearly ordained. "Every

member is duty bound to do all he can for [the family's] welfare," Barzini wrote, "give his property if needed and sometimes, when it is absolutely inevitable, sacrifice his life." In the Garsin household one of Eugénie's sisters had done just that.

It happened shortly after Eugénie's marriage and Reginetta's death. Several years passed before the Garsins were back on their feet financially. Évariste, sent to London in 1877, had made a promising start. After a period of idleness and uncertainty, Papa had regained his sanity and accepted an important job as manager of the Banque Transatlantique in Tripoli. But until that happened the Garsins had to struggle to make ends meet. Someone had to care for Amédée, Laure, Gabrielle, and Albert. The parenting role fell on Clémentine, then just twelve years old. She was not pretty, Eugénie wrote, but had a lovely smile and admirable dark eyes. They could not afford servants. Some hard physical work fell on Clémentine, who was frail, along with the severe emotional strain of dealing with her erratic and unstable father. She would be up until midnight overseeing Albert's homework. Then, after a few hours of sleep, she had to be at work because Papa rose early and expected his morning coffee, not to mention a stream of cheerful chatter. "Oh the heroism of those early morning conversations!" Eugénie wrote. Taking care of Papa would become the focus of Clémentine's short life. When he moved to Tripoli she went with him. She was there until she died at the age of twenty-four, overwhelmed by the emotional and physical demands. Eugénie gave her future son Amedeo the name of Clemente in her honor.

In 1881 the Modiglianis' zinc mining operations in Lombardy were considered the most important in the mining district outside Milan. This was the year that metals began a decline on the world markets. In 1882, the Modigliani brothers stopped mining. The price of metals continued to fall, and in 1883 they declared bankruptcy in Sardinia and were forced to begin looking for another buyer in Bergamo. The disaster came at a particularly difficult time. As was customary the Modiglianis had been marrying off their daughters with dowries calculated to the last decimal point to return the investment with interest. Olimpia, one of the daughters, had married Giacomo Lumbroso, wealthy son of a wealthy family. It was an advantageous match, and so the Modiglianis, including Flaminio, agreed to a hypo-

thetical clause in the marriage contract pledging all their houses and possessions as guarantee for her dowry. In 1884 the house of Modigliani was put into liquidation. The Lumbrosos moved to enforce the marriage contract. By then Flaminio and Eugénie had three children: Giuseppe Emanuele, Margherita, and Umberto. She was pregnant again with her fourth child and about to give birth. Everything—house, furniture, china, glass, silverware—was now owned by the Lumbroso family. Eugénie was beside herself.

Then the Modiglianis discovered an obscure Italian law that prevented the authorities from removing the bed on which a pregnant woman was about to give birth. One imagines the jewels, silver, clothes, laces, silks, curtains, bedspreads, blankets, linens, pillows, draperies, cushions, objets d'art, rugs, and much else piled upon the very large bed on which the mother-to-be presumably lay. The scene's aspects are worthy of opera buffa: the wailing family, the bailiffs methodically removing chairs, tables, beds, armoires, sofa, lamps, and pictures; the grunting men, banging doors, clinging children, and a groaning woman on a bed in a rapidly emptying room.

The house in via Roma where Modigliani was born in 1884. This later, undated photograph depicts the house in a state of decay. A plaque recording the fact of his birth is faintly visible between the second-floor windows.

Less farcical is the precedent that this calamity set in motion: the plunge from wealth to want that would haunt the lives of Amedeo and his descendants from the day he was born.

Somehow they managed to keep an enormous kitchen table with a black marble top. Amedeo ("Beloved of God") was born on it at 9:30 a.m. on July 12, 1884, before the doctor could arrive. As was customary he was circumcised by the *mohel* eight hours later and entered the world, in the Jewish calendar, in the year 5644. Eugénie wrote, "I celebrated his birth with tears and anguish."

"Dedo"

I am borne darkly, fearfully, afar . . .
—PERCY BYSSHE SHELLEY, "Adonais"

JEANNE MODIGLIANI's early memories of Livorno center around
that huge, black, marble-topped table in the kitchen, where, in the
first light of dawn, she drank her café au lait and reviewed her lessons
before school. She remembers the dining room where, between the
Benozzi Gozzoli reproductions, five fading drawings by her father
wilted in the lamplight and where, on a fake Renaissance table, a copy
of her father's death mask was displayed on a black velvet cushion.
She recalls the scrap of brown corduroy velvet, all that remained of
her father's jacket, now a humble shoe cloth. In family albums Jeanne
appears as a fat-cheeked baby, wearing a frilly lace cap and a bib, soon
after she had been taken in by her father's family. Two or three years
later she is seated on a balcony with her grandmother, her rounded
features expressionless, her hair tightly plaited and bedecked with
ribbons. Eugénie, now white-haired, sits beside her wearing a half-
smile, her chin defiantly lifted.

After the somber glory of the house at 38 via Roma, to move to

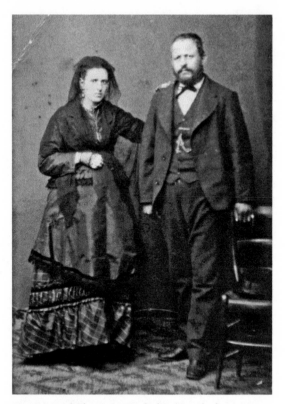

Eugénie and Flaminio Modigliani just before
Amedeo Modigliani's birth, 1884

modest quarters in a nearby street, the via delle Ville (now the via
Gambini) was a distinct demotion. Eugénie dealt with it with her
usual aplomb. The older she became, the more her rapidly expand-
ing form pushed past whatever shackles convention had placed upon
it. She might feel the humiliation intensely; she would never show
it. Flaminio, however, was clearly devastated. His wife was almost
used to the random malevolence of fate, which had visited so many
calamities on her from no fault of her own. He, however, in this par-
ticular case had played a central role.

In a photograph taken in 1884 at the height of the crisis and just
before Amedeo's birth, Eugénie is half-turned, away from the pho-
tographer; Flaminio's face is blank, shoulders slumped. His disgrace
was compounded by the fact that he had been one of the chief archi-
tects of the Lumbroso financial agreement. It was nobody's fault

exactly, but thanks to him his wife and children were penniless. Eugénie can be seen reaching across the gap between them to rest a conciliatory hand on his shoulder. Llewellyn Lloyd, who met Flaminio when Amedeo (called Dedo) was an art student, described him as "a fat little man who always wore a swallowtail coat and a bowler hat" and was very cultured, although how true this was seems in doubt. Some biographers thought that Eugénie and Flaminio eventually separated, although this is also a moot point. The letters of Giuseppe Emanuele—unlike Dedo, Eugénie's oldest son was a voluminous correspondent—reveal that his father was a continuing presence, even if their mother remained the dominating influence in their lives. When Flaminio died, a year after Eugénie, with what seems to have been an advanced case of Alzheimer's, Emanuele, searching for a generous summary of his father's life, remarked that he "was tenacious at work and at doing his duty." They could remember him as someone who always stood beside their mother, "her gruff, but faithful companion—a bit old-fashioned, but infinitely affectionate and deeply, passionately in love."

As they grew older Eugénie's younger sisters, Laure and Gabrielle, also took up residence in the Modigliani household, not that Eugénie was particularly happy about two more mouths to feed. Like Clémentine, Eugénie also played the role of little mother, and her diary makes it clear she had never liked her sisters (or, at least, being made responsible for them). Laure appeared in 1875 and Eugénie had nothing good to say about her. "She was pale and thin, poorly developed and anemic; already a hopeless dreamer, locked up inside herself." The word "hopeless" is instructive—Eugénie did not believe in this unpropitious cause. Here was the type of girl "without . . . any kind of inner goal, unsociable, solitary by nature and sickly." Why had Laure not moved in with Clémentine in Tunisia? She might have turned out better.

Nevertheless Laure stayed for three years, leaving just after Umberto's birth in 1878, and was replaced by Gabrielle. That was not much of an improvement either. One of Flaminio's relatives told Gabrielle bluntly, "They sent you here to get rid of you." It was unkind but probably true. What happened in the intervening

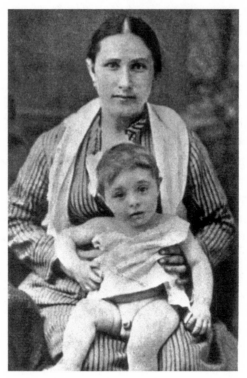

Dedo with his nurse

years is not recorded but by 1886, eight years later, both sisters were living with Eugénie and grudgingly tolerated. Laure was teaching French, so at least she was paying for her keep. Gabrielle was in charge of the household. "She is doing it well and since she's had the job it seems to me she is happier, more serene and puts up with little annoyances better," Eugénie wrote.

Since Flaminio's income had vanished Eugénie had transformed herself and her sisters into teachers of a language they all spoke with ease. Thanks to their social contacts they had attracted paying pupils. Meantime, the children were growing up. Emanuele, always called "Mené," at thirteen and a half was in high school, serious-minded, intelligent, and doing well. Margherita, aged eleven, was paler and thinner than her mother would have liked, but also making progress. Umberto, gentle and affectionate, was eight years old and not particularly interested in his work. As for the two-year-old, Dedo, he was a ray of childish sunshine. "A bit spoiled, a bit wayward, but "joli comme un coeur," she wrote. (As pretty as a heart.)

"Joli comme un coeur": the same had probably once been said of Papa, who had, like Laure and Gabrielle, arrived for dinner in 1886 and never left. Photographs of Eugénie's father Isacco have not been found, but her description of him as a young man, very handsome, not particularly tall but well proportioned and with clear, expressive eyes, is instructive. His beautiful manners, elegant gestures, and air of effortless distinction, that of a natural aristocrat—all this would come to be said of his grandson Amedeo. Eugénie must have noted the same regular, even features, the same prettily marked eyebrows, the pouting, perfect mouth, and the shock of black hair. If Emanuele, with his wide, square face and stolid build, was born to favor the Modigliani side of the family, it must have been clear to Eugénie that Dedo was a Garsin, quick-witted, energetic, full of charm, small, and slim. No wonder he was already being spoiled.

When written records are sparse the biographer is forced to fall back on whatever can be learned from photographs. The earliest has Amedeo, perhaps a year old, wearing only a shirt and no underpants, much less the diaper with which any self-respecting baby now greets the world. He is sitting in the lap of his nurse, who is wearing the traditional striped dress of her profession. Dedo has probably just come from his bath and looks with bewilderment on the world around him. No other photograph of the baby Dedo is available to us, but like many boys his appearance would have been feminized; boys wore the identical outfits of girls and their hair was not cut until they were three or four years old. They "played freely under their mother's or servant's skirts," and, then as now, their toys would have been scattered everywhere. In Dedo's case, having a nanny indicated a certain improvement in the family status, if not the platoons of servants once deemed essential for a Modigliani.

It is clear from Eugénie's diaries that her life had been transformed by the growing success of her teaching enterprise. Her little school was developing from language coaching into an actual establishment, employing other teachers and attracting children from ages five to about fifteen. As soon as he was old enough Dedo, too, was taking lessons, but at home. In Italy as in France, there were few schools for young children, and mothers routinely provided their early education. At age five Dedo could read and write and was probably

bilingual as well—in years to come, his command of French would be much admired, and he always wrote to his mother in French. As for the atmosphere of the house, nothing has been written, but one guesses it was tolerant enough. If earlier generations accepted corporal punishment as a matter of course, in bourgeois families, "exchanges of affection between parents and children were tolerated and even desired . . . Caresses were considered appropriate in many circumstances, an encouragement to the development of young bodies," Michelle Perrot wrote in *A History of Private Life.* The fact that the familiar "*tu*" was coming into use between parents and children, replacing the more formal "*vous,*" was another welcome development. Less emphasis was being placed on rote obedience and more on an enlightened awareness of the individual child's needs.

In a household run by women there were male figures to compensate for the lack of a strong paternal influence. The first was Rodolfo Mondolfi, a well-known teacher at a Livornese high school, who appears often in Eugénie's diaries, helping the boys with their homework, advising her on how to deal with Laure, and, most of all, acting as confidant.

"He is a dreamer," she wrote, "a man who lives only in books although the necessities of life force him to untiring efforts." Mondolfi was married with children of his own. "He gives 12 or 13 hours of lessons a day and in spite of it, his head is in the clouds. Very goodhearted, very discerning . . . He strives for good but does not always find the right road." Still, she would not judge him. "I love him very much, admire him even more and owe him my deepest gratitude. He was my friend during some sad times . . . and the one who pushed me towards teaching. To him I owe whatever peace of mind I have found." Her frank evaluation of Mondolfi's influence does not mention that he was a leading spiritualist, another strong point of contact. He was at the house so often one is led to posit that he was the ideal companion she had never found. Loving him, she loved his children. His son Uberto became Dedo's best friend and constantly there as well. Eugénie called him her "extra" child, perhaps expressing a more or less conscious wish.

Despite his years managing a bank in Tunis, Papa had been permanently scarred by the disasters of losing a wife and the Garsin business collapses. In 1886, after Clémentine's death, he also moved in

with Eugénie and stayed there until his death ten years later. As an influence on Dedo he presents a mixed blessing. One thinks of his easy charm, his delicious manners, his facility with languages: Italian, French, Spanish, Greek, Arabic, and some English. One thinks of his enormous erudition. There is also the fact that he was emotionally fragile, "an embittered, irascible old man, suffering from a persecution mania," Jeanne Modigliani wrote, someone capable of believing that he was being conspired against by a gardener. How many irrational outbursts, how many explosions of rage Dedo may have witnessed, cannot be known.

What is known is that Isacco was an important influence on Dedo's intellectual development until he was twelve. He had more time for him than his harassed mother, and they would take long walks along the harbor while Isacco gave full rein to his passion for abstract speculations about history and philosophy from which his grandson may have extracted some snatches of meaning. Isacco, who was a great chess player, may have taught it to Dedo, or recited passages in Dante, or sung Italian ballads, and saw to his religious education, preparing him for his bar mitzvah. Perhaps he taught him, as it is said, *Tova toireh mikol sechoireh*": "Learning is the best merchandise." His other grandsons, Emanuele and Umberto, found such subjects intensely boring. They sensibly preferred sailors, soldiers, ships, and guns; but in Dedo, Isacco had found a kindred spirit.

Although he appeared infrequently, Amédée Garsin is another figure who had a direct influence on Dedo. His name crops up often in "L'Histoire de notre famille" because he was Eugénie's favorite sibling. He was "so gentle, so delicate and so agreeable. He was a comrade. He understood me." When he did well in school she was delighted. Whenever he was ill—a bout with typhoid left him with a lesion on one lung—she panicked. She lived for his letters, and if she did not hear from him was full of anxious foreboding.

A photograph of Amédée Garsin as an adult shows him as dark-haired, with a broad forehead, deep-set eyes, and a neat moustache and goatee. Born in 1860, he was thirteen when the family crash came. He finished his studies at business school and was apprenticed at a young age. Like Clémentine, he was short and slim. But, unlike

An undated photograph of Uncle
Amédée Garsin

other Garsins, he had an effort-less ability to make money. Jeanne Modigliani wrote that whenever Uncle Amédée arrived for a visit in Livorno, "his passage always left behind a breeze of fantasy, generosity and warm enthusiasm." Thanks to him, Emanuele went to the University of Pisa and became a lawyer. Umberto took his engi-neering diploma at the University of Liège. Amédée took as much interest in them as if they had been his own sons, and since he never married, in a way they were. The handsome young uncle, who arrives loaded down with pres-ents and slips money into people's pockets, demonstrated how a successful actor deals with life. "[The show] is often enacted . . . for the promotion of the actor's interests and those of his family, friends and protégés," Luigi Barzini wrote in *The Italians*. "How many impossible things become probable here, how many insuperable difficulties can be smoothed over with the right clothes, the right facial expressions, the right mise-en-scène, the right words?" Everyone wanted to look well off even, or especially, if they were not. The art of appearing rich, Barzini continued, "has been cultivated in Italy as nowhere else." Nonskilled workers who achieved their first steady jobs spent their money on superfluous and gaudy purchases. "Apparently the things they want above all are the show of prosperity and the reassurance they can read in the eyes of their envious neighbors. Only later do they improve their houses, buy some furniture, blankets, sheets, pots and pans. The last thing they spend money on is food. Better food is invisible."

Amédée was rich, except for all the times when he was not. According to Margherita he made and lost three fortunes. There were factors at work here that she failed to understand: his reckless indifference to money and the way he seemed compelled to gamble it away. In that respect, Amédée Garsin was following a long tradi-

tion that reached its apogee in the eighteenth-century gaming salons of London, Paris, Bath, and elsewhere. Throwing money away was aristocratic. Throwing money away showed just how limitlessly rich you were. The daredevil coolness involved was admired, then as now, as evidence of manliness and superior breeding. A talent for acting; the cultivation of seigneurial indifference to money—such lessons were not lost on Dedo.

Uncle Amédée did not pay for Margherita's schooling because she did not have any. In the Garsin family, women were not completely ignored—they might be allowed to study, so long as it did not inter-fere with their roles as wives and mothers—but in all essential ways this was a family that was all for its sons and neglected its daughters. Women stayed in their assigned places, as Clémentine did. Eugénie also accepted these limitations until circumstances forced her to do otherwise. She went from being a liability to being a financial asset and acquired the confidence that accompanied her new status. She was lucky. She had male support and recognition, not just from Mondolfi, for the gifts she would continue to explore, translating Gabriele d'Annunzio's poetry into French and writing novels and short stories under a pen name. Her essays on Italian literature were good enough for an American professor to buy and publish—under his own name, of course. If she was ahead of her times her sisters, lacking the same emotional support and validation, were flounder-ing. Unmarried, they shuttled from house to house, feeling stifled, unappreciated, and blocked, taking refuge in a kind of neurasthenia common to intelligent women who have caught a glimpse of a wider world and then been barred from entering it.

The young Amedeo was being brought up in an atmosphere of gen-teel poverty. On the one hand there was the Modigliani heritage of palatial rooms, servants, meals, and the homage due to the reign-ing monarch of such an establishment. On the other, there was the reality of the cramped little house on a back street, the scramble for money, the menial chores, and the social status they nevertheless felt was their due; one sees it in the defiant tilt of Eugénie's head. The result seems to have been, for the Garsins, an intensified love of learning for its own sake. Books were Dedo's companions. He lived

among them, especially *Les Animaux peint par eux-mêmes,* a book
on animals illustrated by Gustave Doré. Dedo would spend hours
embellishing the original plates with his own color schemes, presum-
ably to general approval.

Commentators on Modigliani's life believe he showed no inter-
est in art until he was fourteen. This seems implausible, since histo-
ries of artists demonstrate that, like musicians, they begin exploring
their talents early in life. Modigliani's brother Umberto told June
Rose, one of Modigliani's biographers, that Dedo drew from child-
hood; lacking paper he would take over the walls and, presumably,
floors as well. His happy ability to improvise on anything and every-
thing, including china and furniture, bears witness to a natural gift.
Photographs of the period, requiring that the sitter remain motion-

Amedeo Modigliani, caught telling a joke to
Giovanni Fattori, grand old man of the Macchiaioli
school of Italian painting, with Fattori's wife

less, give one little clue to temperament. A school picture of about 1894 shows Dedo in a group with eight youngsters, all wearing a military-style shirt with button trims, belts, and dark pants. Dedo, hands at his sides, stands at attention, his face a blank. But there is a later photograph, blurred and undated, that is a revelation. Dedo has been caught telling a joke; his eyes dance with mischief and quicksilver charm. In the hunt to find the real person the smile is a minor but revealing clue. As for Eugénie, she knew Dedo was intelligent, probably spoiled as well. She wondered what kind of personality lay inside the chrysalis. "Perhaps an artist?" she wrote with prescience. Dedo was eleven.

The year before, in 1894, Dedo had entered his first school, the Ginnasio F. D. Guerrazi (grammar school), where Eugénie's friend Rodolfo Mondolfi taught. A boy who is not in school and goes on exploratory walks with his grandfather soon knows the map of a town like the back of his hand. Livorno, or Leghorn, would have been a rewarding discovery in Modigliani's childhood, but there is not much left of the old town nowadays. Livorno suffered heavy damage during World War II and has largely been rebuilt since. One imagines it as once like Marseille, a twisting network of streets leading off the old port. Livorno had been a major port on the Ligurian Sea since the sixteenth century and rose to prominence after Pisa, its Mediterranean neighbor twelve miles to the north, silted up. On the one hand it developed as a center for shipbuilding and heavy industry; on the other, as a tourist attraction, with massed banks of flowers along the promenades. Somehow Modigliani's birthplace on the via Roma has escaped destruction and is now a museum. There is a large synagogue, established in the sixteenth century. There is also a Protestant cemetery with tombstones bearing such names as Lockhart, Murray, Ross, and Lubbock.

Pisa and Livorno have a long and romantic history as magnets for a British colony of writers and poets. Tobias Smollett, who wrote *Humphrey Clinker* at nearby Antignano, died in Livorno in 1771 and is buried at the Protestant cemetery. Early in the nineteenth century it was fashionable for the British literati to explore the Ligurian coast in yachts, a vogue that was adopted with enthusiasm by Byron, who was eternally restless and wealthy enough to build his own. In pursuit of picturesque views and the perfect sailing waters the British

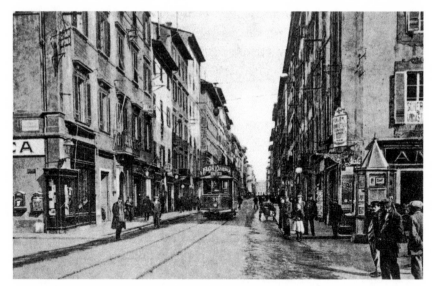

The via Vittorio Emanuele, one of the central shopping streets in Livorno at the turn of the twentieth century

poet wandered up and down the Ligurian coast, renting one spacious villa after another. In the summer of 1822 he and his entourage were ensconced in a villa in Montenero, a hilly suburb of Livorno that could only be reached by a funicular, with spectacular views over the Mediterranean. There Byron was joined by Leigh Hunt, poet, journalist, and critic, with whom he was engaged in launching a new magazine. Hunt, his wife, and six children settled in for a long visit, there to be met by Percy Bysshe Shelley, who had moved to Italy with his family and was living further up the coast in an unused boathouse at San Terenzo. Shelley was then working on his last major poem, "The Triumph of Life." He was twenty-nine years old.

Early in July 1822, Shelley set sail in a new boat, the *Ariel*, built for him by Byron, fast and luxurious but an open craft with no deck. He made the fifty-mile trip to Leghorn in about seven hours, and stayed for a week. Then he, a friend, Lieutenant Edward Williams, and an eighteen-year-old cabin boy set out on the return journey. There was a violent storm. The boat capsized and all three were drowned. Their bodies washed up on the beach at Viareggio ten days later and were cremated on the spot, with Byron in attendance. Shelley's partially decomposed body was recognized by a book of Keats's poetry that was found in his pocket.

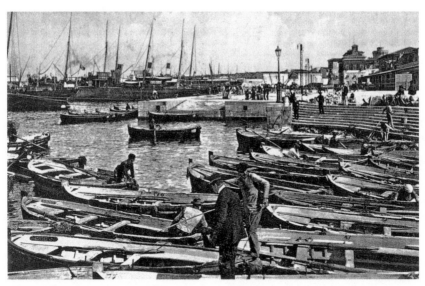

The port of Livorno, from a postcard sent by Modigliani to Paul Alexandre

Shelley had written an elegy, "Adonais," the name he gave to Keats, who had died of tuberculosis the year before at the age of twenty-four. Shelley's lengthy poem mourning the loss of a great poet ends with a curiously prophetic stanza:

> [M]y spirit's bark is driven,
> Far from the shore, far from the trembling throng
> Whose sails were never to the tempest given;
> The massy earth and sphered skies are riven!
> I am borne darkly, fearfully, afar;
> Whilst, burning through the inmost veil of Heaven,
> The soul of Adonais, like a star,
> Beacons from the abode where the Eternal are.

"I am borne darkly . . ." Judging by a photograph of the Ginnasio F. D. Guerrazzi student body presumably taken the year Dedo entered it (1897–98), the grammar school boys, ranging in age from ten to about fifteen or sixteen, were either split into small groups or in one large class, with individual curricula depending on their rates of progress. A report card for the same academic year shows that Dedo was studying the standard humanist subjects: Latin, Greek, and French, in addition to Italian, with courses in geography, math-

ematics, history, and natural history. Students were being graded on gymnastics, but that part of Dedo's report card is blank. In fact, the boy in the picture, squeezed between classmates in the front row, had already had his first serious illness.

Sometime in the summer of 1895, when he was eleven, Dedo developed a chest pain so sharp and persistent that it hurt to breathe. Perhaps he also had a moderate fever and a dry cough. Perhaps his lungs were filling with a clear fluid. The diagnosis was pleurisy and he was put to bed, a tape wound tightly around the lower part of his chest. Dedo slowly recovered, but Eugénie wrote in her diary that his illness gave her "a terrible fright." She might have known, or guessed, that this illness was an ominous sign.

During the next two or three years, Mené obtained his law degree, Umberto acquitted himself well at the University of Liège, and Margherita, aided by her mother, showed promising signs of becoming a scholar herself. Laure had taken up writing and translating. Gabrielle stayed with friends for awhile and then returned, but was in a stubborn mood. Eugénie wrote in the early summer of 1897, "Gabrielle neglects almost everything"—by that she meant her sister's household duties—"to give herself up to orgies of piano playing." It would seem Gabrielle had conceived the ambition of becoming a professional musician, and "in order to run after an impossible ideal, the poor child neglects to make herself useful. I have not the slightest influence over her; she flares up at the smallest word and even accused me once of deliberately trying to make her unhappy." Dedo's grandfather had died the year he went to school. Eugénie wrote, "My poor father had suffered greatly before dying. But he . . . left this world where he had so many blighted hopes with a serenity that comforts me, and makes me think his death was a deliverance." Meanwhile, two years after his attack of pleurisy in 1895, the thirteen-year-old Dedo had passed his bar mitzvah and was ready to launch himself into life, or so his fond mother believed. That year, Dedo did not do well in school, but then, he had hardly bothered to study. The year before, he had decided on his future career. She wrote in July 1896, "He already sees himself as an artist." He was now twelve years old.

Not enough is known about Laure and Gabrielle to explain their sad eventual fates. In 1915, the year Gabrielle committed suicide by

throwing herself from the top of a staircase, Laure was admitted to a mental hospital. The situation is complicated by the fact that, in the nineteenth century, calling a woman insane was often a convenient way of getting rid of her. A sense of frustration was seen as a perverse refusal to be happy, arguing with a husband a sacrilege, and rebelling against her natural roles as dangerous. As Michelle Perrot wrote in *A History of Private Life,* excuses of this kind were enough to lock up obstreperous women in mental institutions because of "a private tragedy or family conflict of which the physician was the sole judge and arbiter." Adèle Hugo and Camille Claudel, for instance, were "apparently . . . confined as a result of arbitrary decisions on the part of families intent on safeguarding the reputations of two famous men." It is worth remembering that, in France, women could not vote until 1944 and in Italy, until 1945.

One has to believe that whatever troubled Laure and Gabrielle was not understood and dismissed if only because the insurrection of daughters, sisters, and wives was a taboo subject. Eugénie's account omits all such speculations. Laure is hopeless, an introvert and a dreamer. Gabrielle, who ought to be helping them, is embarked on the ridiculous ambition to become a pianist. As for Margherita, despite Mené's loyal references to his pretty sister, she does not appear as attractive in photographs and did not marry. She is competing with three brilliant brothers, one of them ill so often that her mother can hardly think of anything, or anyone, else. And Eugénie was always prepared for the worst. She had seen too many people die not to view life through a prism of rage and loss. In 1891, when Dedo was seven, she wrote a poem that would seem to be the response to some kind of business disaster in her brother Amédée's life. He may even have been sent to prison. She called the poem "Fierce Wish":

> *I wish to proclaim the Kingdom of Force:*
> *To hang a Jew on every tree*
> *To loose from prison every thug,*
> *To flay every person of virtue.*
>
> *To snatch from Aunt Eugenia the pious Amedeo*
> *Who today soothes her every pain*
> *And compels her to smile sometimes.*

To drive all kindness from the earth,
To duck every abstainer in a wine-vat,
To put every clean person in a pigsty

And to annoy and upset my neighbor
And set light to his hayloft
So that his little son suffocates.

Unsure of her mother's love, Margherita turned in two directions. She was a dutiful daughter, contributing to the family income, caring for Dedo's orphan, and there to help when her parents became ill and died. But a sense of not being valued also led to a prickly readiness to find herself offended, the "Why me?" lash of her mother's poem. The family expectation seemed to be of automatic achievement. Failure led to recriminations and a willingness to wound. Ridicule was common and even Mené, the born diplomat, occasionally indulged: "Tell that *thing* who created us," he wrote, only half joking, "that if she decides to get upset every time things heat up . . . I will let a few days go by without writing." It was time to draw attention to his mother's rather prominent moustache. It reminded Mené of a wolf that had

A school play. Modigliani, hatted, is in the back row, second from the right.

lost its fur or a leopard that had changed its spots; even when he was trying, true invective was beyond Mené. Then he added the one thing that really was wounding. Their mother was always talking about how brave she was, when she was not brave at all.

Sometime around 1895 while Mené was still doing his military service, Dedo, then perhaps eleven, wrote to tell him about their mother's triumph; her Children's Theatre had won an award. Mené was ecstatic. How he wished he could have been at the Strozzi Theatre at that moment. In his mind's eye he saw

the white curtain falling, the drop curtain opening, and our mother appearing there and not leaving (because in the confusion she can't figure out how to get off the stage)... Mamma *must* have been wearing something black and perhaps a little bow on her left side (it's her passion!) and her face must have been very rosy... almost like Piticche [his name for Margaret] on a beautiful day... A simple bow of her head to this side and that—and inside, inside the laugh mother always has when she receives sincere compliments that make her blush and make her happy. And then she stops talking, straightens up and her eyes shine... and the handkerchief in her hand is not just for blowing her nose.

When Mené went to the University of Pisa to study for his law degree he was a monarchist, but by the time he left he had joined the newly formed Socialist Party and the well-being of workers had become a lifelong concern; he was elected a consigliere, or councilman, in Livorno when he was twenty-three. His change of heart was prompted by an awareness of the extent to which the Modigliani family, his father included, had grown rich by exploiting workers in their Sardinian mines. Now he was reaching across class barriers and his life would be devoted to liberal causes, his belief in the dignity of manual labor and votes for women, while his political stance was anticolonialist, pacifist, and dedicated to change from within. Mené imagined the middle-class audience gathered at their mother's moment of triumph and the polite applause that would have greeted

A portrait made in 1900 of
Modigliani's oldest brother, Giuseppe
Emanuele Modigliani

her because she was a wealthy lady who had been forced to work. The fact that they would have pitied her exasperated him. "Too much condescension from idiots!"

During the past year Mené had become aware of how much their parents had gained in a human sense from being obliged to work. "Think about this Dedo," he wrote. "You must love your parents just because they are your parents. But ... you must love them *much, much more* because they work for you! How many times I have felt like a stranger when I was with workers!" Now he is proud to say, "*I am the son of workers, too.*"

The fact that his parents worked was something Dedo, too, should be proud of, not ashamed of. Dedo must do whatever he could to make sure that future workers were valued and never forget that he, too, was the son of workers.

Mené was aware, as his letters to Piticche imply, that she, along with most other members of his family, did not share his Socialist views. Some of them would, he wrote, say he was a windbag and would scream at him for saying they were workers too. However much they might quibble with his ideas, when Mené was in trouble he could be sure his family would unite behind him. In 1898 Mené, then twenty-six years old, became editor of a progressive weekly paper in Piacenza at a time when the increased price of bread was causing rioting in the streets. When all of Tuscany was under martial law, everyone was under suspicion, and especially editors of radical papers sure to be fomenting unrest. On May 4, 1898, Giuseppe Emanuele was arrested and went to prison in chains.

"We don't know why he is there or what he is accused of," Eugénie wrote at the end of June. It was true Mené was an active and militant Socialist, but this was hardly a crime. "My poor darling, he

endures with simplicity and real heroism, something that must be doubly difficult, given his youth and expansive temperament . . . He consoles himself like a Benedictine monk in his cloister, with faith—faith in a very pure and elevated ideal—perhaps too beautiful and unrealistic—but since Mené is not only good but furiously reasonable, I am sure he will find inside himself the way to reconcile his dream with reality."

Not only good, but furiously reasonable—the evaluation was astute and to the point. In years to come this voluble, optimistic, and self-deprecating politician with a gift for conciliation would become a Socialist deputy and one of the most influential members of his party. But for the moment he was helpless. On July 14, 1898, he was sentenced to six months in prison plus a heavy fine. There were hints of worse to come.

The effect on his family of Mené's arrest, imprisonment, and sentencing cannot be overemphasized. Eugénie's diary makes it clear that of all the blows of fate she had endured, this was the worst. The day of Mené's sentencing she wrote, "The most agonizing day of my life. Today, judgement will be passed on Emanuele in Florence before a military tribunal. I am mad with fear and nervous prostration." As with all family crises, everyone was arriving. Umberto, in Liège, was cutting short his studies to return home. Laure, who had been in Marseille for two years, was on her way back. Gabrielle was running the household and Amédée, ever generous, was offering to pay Mené's fine. They all felt with Mené, agonized with Mené, and closed ranks for Mené. The fate of this brilliant young lawyer, already de facto head of the family, affected not just their financial and emotional security but almost their very existence. Eugénie did not collapse, but she suffered. Dedo, her closest and best, with his dawning awareness of the issues at stake, was just as frightened. A month later, in August 1898, he had another serious illness. This time it was typhoid.

It happened just after Laure returned. Dedo had been feeling listless, with headaches, no appetite, and an inability to sleep, but when he suddenly began running a fever the whole household knew what it meant. This was a fever that returned day after day for weeks on end, gradually climbing to a high of 103–104°F. Such a patient is restless, hot, and uncomfortable, his cheeks flushed and his stomach sore. At

the climax of his infection there will be great numbers of typhoid bacilli in the blood, and a characteristic skin rash, called "rose spots," pale pink or rose in color, will appear on his stomach, chest, and back. But the worst damage will be to his intestines, where bacilli attack the body, leaving areas of dead tissue and ulcers. Massive hemorrhaging into the bowel is a real possibility. Further complications are acute inflammation of the gallbladder, pneumonia, encephalitis, and heart failure.

Was Dedo hospitalized? There is no evidence one way or another. But since his recovery would have depended entirely on the quality of the nursing care, the odds are that he stayed at home where Eugénie, Gabrielle, Laure, and Margherita could take turns nursing him. He was hovering between life and death and delirious for more than a month. Then comes an episode that has been discounted as part of the Modigliani "myth." In a memoir she dictated to her daughter in 1924 Eugénie writes that, at the height of his delirium, "Dedo said he wanted to study painting. He had never before spoken of this and probably believed it was an impossible dream that could never be realized."

He had seen few actual paintings but plenty of reproductions of Italian Renaissance works. "He spoke of one of his nightmares: he missed the train that was supposed to take him to Florence to visit the Uffizi Gallery. He spoke of Segantini, the most popular painter of the day, with such insistence that his mother, who was nursing him, decided she had to satisfy him whatever it cost. One day when he was still in the grip of fever and delirium, she clasped both his hands and tried to hold his attention. She made him this solemn promise: 'When you are cured, I shall get you a drawing master.'"

This sounds like a fallible recollection made thirty years after the event. (The memoir was published in *The Unknown Modigliani* by Noël Alexandre in 1994.) Obviously, everyone already knew of Dedo's interest in art. And Eugénie's diary of July 1898 makes it clear that Dedo was starting drawing lessons on August 1, 1898. She further notes that he already saw himself as a painter. It is likely that lessons had begun, as Pierre Sichel believed, just before Dedo was taken ill. The essential facts, however, cannot be in doubt; the dream in which you have just missed a train, and an opportunity has passed you by, is too human not to be believed.

What seems likely is that Dedo had never talked so openly, and for the first time revealed his passionate longing to see the actual masterpieces rather than poor reproductions. That fateful year Eugénie had also written that she had been reluctant to give Dedo too much encouragement for fear that (like Gabrielle) "he will neglect his studies to pursue a shadow." This latest illness had obviously changed her mind and put the emphasis where it belonged, on his present happiness. Eugénie's account in 1924 ends, "The sick boy understood—confusedly—and from that moment began to get better."

Emanuele was released from prison in December of that year. It was four months after Dedo's illness. At that moment, Dedo's convalescence came to an end. He was back on his feet and ready to begin his life's work.

—◆—

The Blood-Red Banner

Nous nous sommes rencontrés dans un caveau maudit
Au temps de notre jeunesse
Fumant tous deux et mal vêtus attendant l'aube
Épris épris des mêmes paroles dont il faudra changer le sens
Trompés trompés pauvres petits . . .

—GUILLAUME APOLLINAIRE,
"Poême lu au mariage d'André Salmon"

ONE DAY in December 1898 the fourteen-year-old Dedo appeared as
a new student in the studio of Guglielmo Micheli. The teacher, son
of a printer, an orphan since the age of twelve, had worked his way
out of poverty by unremitting effort and was given a grant to attend
the Accademia delle Belle Arti in Florence. There he developed as a
skilled but unexciting painter, but one with a natural gift for teach-
ing and an ability to discover developing talent. Of the nine boys
in Dedo's class almost all became established artists. (There were no
girls.)

Micheli's school consisted of a large room well lit by three north-
facing windows on the ground floor of a villa in the via delle Siepi,

Livorno, across from a shoemaker's workshop. In keeping with its modest location Micheli's school taught the basics in everything from painting, drawing, and sculpture to nude studies and landscapes. It was elementary training but, for its day, far more advanced than what a beginner would have received in an academy. Micheli's master, Giovanni Fattori, was a prominent member of a group of artists working in Florence in the mid-nineteenth century, at a moment when Italy was struggling toward unification. Desperate times called for new horizons,

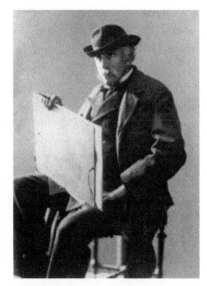

Giovanni Fattori, no date

in art as everywhere else. A group of artists had rejected the stale formulae of the academies and were dedicated to an art that would mirror the reality they saw around them. Like Robert Henri, founder of the Philadelphia Eight some decades later, another inspired teacher, Micheli and Fattori encouraged students to seek their inspiration in the contemporary scene. Fattori, who fought in the War of Independence of 1848–49, painted endless scenes of soldiers, whether camping or furiously engaged in battle, with a meticulous attention to detail and great delicacy of feeling, not just for his human subjects but their animals as well. Later, he turned to equally uncompromising studies of country life and was, when he died in 1908 at the age of eighty-three, one of the country's most admired artists.

The Macchiaioli took their name from their manner of painting. They applied their colors in short brushstrokes and dots of paint; "*macchia*" means stain or blot, and these were the "makers of patches." Like the French Impressionists who would follow them, they abandoned sterile studio studies for the outdoors, deliberately heightening the contrasts between light and shade. Adriano Cecioni, another prominent member of the group, recalled the almost religious fervor of their conversion to actual studies of real life. " 'Look, Banti, at the beauty of that white in the distance!' — 'Look, Signorini,

the tone of the wheels against the white of the road!'—'Look at the power of the vibrations of light!' All it took was the sight of laundry hanging out to dry . . . to drive them into a frenzy." But unlike the Impressionists the Macchiaioli took their cue from the muted, earth-toned palettes of Millet, Corot, and others of the Barbizon school. One of Fattori's maxims was *"Faites ce que vous sentez et n'aimez pas ce que font les autres"* ("Do what you feel and don't admire what others do"), which was not far removed from a subsequent injunction by Cocteau, *"Ne t'attardes pas avec l'avant garde,"* or "Don't lag behind the avant garde." This emphasis on originality was to have a lifelong significance for Modigliani.

Fattori, by then in his seventies, was often in Micheli's studio, taking a benevolent interest in student progress. On one of his visits "Dedo was doing a charcoal drawing on *carta intelaiata,* a still-life with drapery behind it; the technique of these drawings consisted in partly burning the paper and using the smoked parts as half-tints. Fattori saw the drawing and was very pleased with it," Silvano Filippelli wrote. Modigliani's classmates all had comments to make about him later. One described him as small and sickly looking, with a pale face and prominent, full red lips. Another called him "introverted and very shy. He would blush for no reason." If, however, something made him angry—and his anger was unpredictable—he would start throwing whatever was handy, and he was hard to calm down.

To others, he seemed owlishly old and knowledgeable—like them, had left the lycée to concentrate on art—spouting the poetry of Gabriele d'Annunzio and Charles Baudelaire, quoting from Friedrich Wilhelm Nietzsche, Henri Bergson, and Prince Peter Kropotkin's memoirs. That his elegant manners pointed to a good family was clear to them all. His classmate Renato Natali recalled that Dedo "belonged to a family that, to us, without a sou in our pockets, seemed rich but was probably only a little better off than we were." The fluent comments in French, Italian, and English, the paintings and drawings by Dedo around the walls, the references to obscure writings—they were in awe. So when Dedo discussed Nietzsche's theories about the death of God and the emergence of the Übermensch, and could quote from d'Annunzio's latest novel, *Le virgini delle Rocce* (1896), he was "the Professor," and "Superman."

Dedo seems to have spent little time in the studio, taking paint and

canvas into the fields surrounding Livorno with one of his classmates, Manlio Martinelli. According to Renato Natali, he disliked painting the natural world intensely. The impression is rather borne out by an early painting of a wide road stretching into the horizon bordered by fields, popularly given to Modigliani, and with the speculative date of 1898. The execution is careful and listless, as if the artist wanted to make his feelings about the exercise completely clear. According to Natali, what Dedo wanted to do was "stroll through museums adoring his favorite Old Masters, the Sienese, for example," referring to the artists of the Italian Renaissance. He added, "Amedeo hated the recent past." This was not quite true, because Modigliani had already expressed his admiration for Segantini (1858–1899), a painter of Alpine meadows, not to mention Fattori and the Pre-Raphaelites. But he was very selective.

The work of the Post-Macchiaioli movement disintegrated into genre scenes, landscapes, portraits, and pseudo-Romantic costume histories; to John Russell it seemed "a peculiarly dead-end art" (1965). Despite the Italian trend to see Modigliani as the logical heir to a great movement, it seems impossible nowadays to find the remotest resemblance between the mature work of Modigliani and his tutelage under the guidance of Micheli and Fattori. As for student work, too little of that remains to make any conclusion possible.

An exhibition in Venice in 2005, "Modigliani in Venice Between Leghorn and Paris," is a case in point. It showed several works said to be from his earliest period. These were discovered by the art historian Christian Parisot, the result of his research into the history of the Modigliani family in Sardinia. Parisot also studied Tito Taci, a Tuscan businessman who opened a hotel and settled in Sardinia with his wife and children. He wrote that the Modigliani and Taci families were friends, which is the basis for his belief that, since Flaminio Modigliani continued to have business ties in Sardinia, he would have stayed at the Taci hotel and might have brought Dedo with him. Parisot ascribes a profile portrait of one of the Taci daughters, Norma Medea, to Modigliani.

Parisot cites the canvas and supports as consistent with the period, along with the manner in which the paints are applied, some dates at lower left, a red hieroglyph, and a monogram with the letters AM on the front. Apparently the owners took the unusual step of cleaning

the reverse and discovered a signature, "a. modigliani." Questions remain, since signatures can be forged and no evidence is cited in the catalog by way of letters or photographs to prove Dedo ever visited Sardinia or, if he did, ever painted there.

Other paintings, grouped together as "Study Subjects," are also published without provenances. One, *Man with a Moustache,* which has the same date of 1900 as the Norma Medea portrait, is so clumsily executed that it is hard to believe the same artist was responsible for both paintings, whoever he or she might be. Other works, *Cowherd at Table* (1898) and *Young Man Seated* (1901), present identical problems of authenticity. In addition, the amateurishness of, for instance, *Man with a Moustache* is hard to reconcile to an earlier work that has been authenticated by Ceroni and appears in *I dipinti di Modigliani,* the single trusted source for the authentication of Modigliani's works. A pencil self-portrait is evidence of a rapidly maturing talent at a moment when Modigliani was aged about twelve or thirteen.

A new piece of evidence bears out this attribution to Modigliani, and it was discovered by accident. In the spring of 2008 I was working in the G. E. Modigliani archives in Rome, with the help of Professor Donatella Cherubini, his biographer. When materials known to be on deposit at the Italian Central Archives could not be identified from the office files, Cherubini sent me there.

After several days of work I had gone through eighteen boxes, not all of them relevant to my needs, and had arrived at the last box, Busta 19, the photo collection. I have always paid close attention to pictures on the reasonable assumption that the homegrown variety in particular are artlessly revealing about relationships and telegraph closeness or conflict, often before the participants know it themselves. Then the problem started with the words that strike terror into the heart of anyone who has ever worked at, for instance, the Library of Congress: "Not on shelf."

Never mind. It must be somewhere and two librarians went on the hunt. As they eliminated one possibility after another I was reminded of the incident Kenneth Clark relates in his autobiography when he was curating the Italian Exhibition in London in 1930 and a shipment of Old Masters had just arrived from Italy. They were in the care of another Modigliani, this one Ettore (no relation), and he

The photograph thought to be of Dedo found in G. E. Modigliani's archive. On the reverse, the partially obliterated signature begins with the letter "A."

Portrait of himself wearing a sailor suit by Amedeo Modigliani

had the only key. A party repaired to the ship's strong room to view the wonders it contained. As Modigliani approached the door, "a look of agony came over his face and his hands beat the air: 'La chiave, dov'è?' (Where is the key?)" Clark concluded, "Only those who have had long experience of Italian sacristans will enjoy this story."

The key was found in Modigliani's hotel bedroom. Similarly, the photographs were finally found on the shelf, but not in Box 19. There was no Box 19. They were all in Box 20. Of course, nothing was indicated in the records. Among the numerous pictures I found documenting Modigliani's career, the posed political committees, the studio portraits, the snapshots of G.E. and Vera in Venice, climbing the Alps and so many others, there were no pictures of Modigliani's grandparents. But there was a small photograph of a boy, perhaps aged eight or ten, with cropped hair and in a fashionable sailor jacket, perhaps a slightly younger version of the boy in the self-portrait. Written in a laborious hand on the reverse was, "Al mio caro, A . . ." Mené kept it all his life.

When in 1924 Eugénie Modigliani dictated an account of Modigliani's years studying with Micheli, the tone was disapproving. He went on long walks in the countryside. He spent time in idle conversation with friends. He neglected his studies. He started smoking. He was receiving lessons in the fine points of seduction from willing chambermaids. "This divided him from his brothers, who could not understand his behavior, which they saw as shiftless and idle." Jeanne Modigliani wrote that Margherita Modigliani always described her father in the same way. "The tone of voice, the gesticulations, the clipped phrases, all seemed to say: 'This is what geniuses are like—childish, rather silly, self-centred and impossible to put up with." This portrait of an idle son frittering away his opportunities has the usual bias of the person to whom it was dictated, i.e., Margherita. The term "*pauvre Dedo*" enters the family lexicon at this time, and whatever he did—being led astray by an older classmate who, for instance, introduced him to spiritualism—bears her stamp of disapproval.

Margherita's version is contradicted by another classmate, Gastone Razzaguta, who habitually met Dedo over a good bottle of

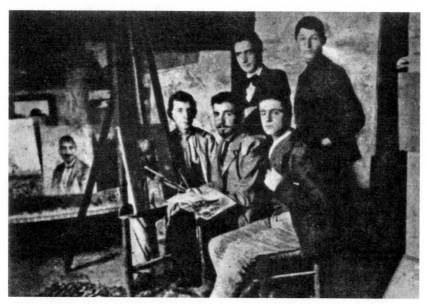

Modigliani at work in a studio in Livorno with a group of classmates, 1899

wine at the Caffè Bardi, the haunt of the artistic crowd. Razzaguta said that when Dedo was a student studying at Micheli's atelier, "he was distinguished, disciplined and studious, drawing with enormous care and without the slightest distortion. His manner of presenting the subject of a portrait, almost always with hands resting on knees, reproduced a certain natural attitude of repose, but with something typically Tuscan about it, and can be found also in the portraits by Fattori." The comment suggests that, even at this early stage, Modigliani was attracted to portraiture.

Margherita's version is also contradicted by an entry in her mother's diary in the spring of 1899: "Dedo has completely given up his studies and does nothing but paint, but he does it all day and every day with an unflagging ardor that amazes and enchants me. If he does not succeed in this way, there is nothing more to be done. His teacher is very pleased with him, and although I know nothing about it, it seems that for someone who has studied for only three or four months, he does not paint too badly and draws very well indeed."

Modigliani was learning in his own idiosyncratic way, following his omnivorous curiosity wherever it led. He went to readings. He attended concerts. He memorized poetry. He spent hours at art exhi-

bitions. His intellectual development was at least partly influenced by his aunt Laure, who had introduced him to Kropotkin and the works of Nietzsche and Bergson. Eugénie was translating d'Annunzio's poetry and had already had one novel published. Dante, Petrarch, Ludovico Ariosto, Giacomo Leopardi, and Giosuè Carducci—Dedo read them all and memorized what he read. Presumably as a reward for this eager determination to learn, Eugénie took him to Florence, where he visited the Uffizi and the Pitti Palace; then he talked about wanting to go to Venice and Rome. He was already in search of a certain autonomy, moving, at the age of fifteen, into a studio in the working-class district of Livorno that had been left to Micheli's students. The former young owner had died of tuberculosis. It was a bitter omen. In September 1900, within a year, three of the students working in that studio contracted tuberculosis. One of them was Modigliani.

Years later Margherita put it all down to Dedo's stubbornness. He should have remained with his master, like a conscientious student; as a punishment he contracted tuberculosis, which must have come up through the floorboards, to judge from her tone. The comment showed the extent of the fear that gripped ordinary men and women, faced with one of the most devastating diseases of modern times. Tuberculosis has been afflicting mankind for thousands of years, as demonstrated by evidence found in neolithic burial grounds. However, it appeared with new virulence at the start of the nineteenth century and was the cause of death for a quarter of the inhabitants of Europe. In the 1850s, half the population of Britain had the disease, and the situation was equally desperate in the United States. Tuberculosis was known by various names: phthisis, scrofula, hectic fever, inflammation of the lungs, consumption; these all referred to a disease that struck without warning, sometimes pursuing a violent path, at others, waxing and waning with long and unpredictable intervals. The most commonly used term was consumption, from the Latin *consumere*, meaning to eat up or devour, because that is what it did; immediately, or by slow degrees, it would consume the lungs and infiltrate the body until the flesh had been burned away and the victim could count his ribs. Keats wrote, "Youth grows pale, and spectre thin . . ." (1819).

Some indication of the terror consumption could cause is illus-
trated by an incident in Chopin's life. Along with George Sand, he
had gone to Majorca in search of a mild climate in about 1840. Almost
as soon as he arrived he became ill, doctors were called in, and the
word spread all over the island. Chopin was doomed. George Sand
wrote, "The owner of our small house threw us out immediately and
started a suit to compel us to replaster his house on the pretext that
we had contaminated it."

Arriving in Palma, Chopin had a massive hemorrhage. Again they
were on the move, condemned to leave the island on a steamship con-
taining a boatload of pigs. Once in Barcelona, "the innkeeper wanted
us to pay for Chopin's bed under the pretext that it was infected."

Keats and Chopin were hardly alone. The Rev. Patrick Brontë,
who nevertheless survived to a healthy old age, was thought to be the
source of contamination for his children: Maria, Charlotte, Emily,
Elizabeth, and Anne, who all died. Edvard Munch had a severe attack
in adolescence. Ralph Waldo Emerson wrote about "[a] mouse gnaw-
ing at my chest"; Jean-Jacques Rousseau and Goethe both had lung
hemorrhages in their youth and Schiller, Novalis, Carl Maria von
Weber, and Katherine Mansfield died of the disease. The list of well-
known poets, writers, composers, and philosophers goes on and on.

In the early nineteenth century the idea took hold that young men
and women with rarefied spirits were particularly at risk. Describing
John Harvard, founder of the university, who died of tuberculosis
at the age of thirty, Daniel Chester French observed that the illness
"gave a clue to the sort of physique that he had. It is fair to assume
that his face would be delicate in modeling and sensitive in expres-
sion." The frequency of deaths due to consumption led, perversely,
to a kind of vogue. Women were admired, not for their robust good
health, but for their interesting pallor, their languid airs, their vapor-
ous silhouettes, and something morbidly angelic about their looks.
Those Pre-Raphaelites Modigliani admired had elevated to goddess
status Elizabeth Siddal, who married Dante Gabriel Rossetti shortly
before her death at the age of thirty. With her spinal curvature, her
elongated silhouette, her pallor, and the glitter in her eyes, she was the
ideal model for the famous painting by Millais of Ophelia, drowned,
floating downstream. Siddal, wearing an exquisite gown spangled
in silver, posed in a bathtub for hours without complaint. After her
death she was replaced as the feminine ideal by Jane Burden, wife of

William Morris, who did not die of consumption but was often ill. Henry James found her "strange, pale, livid, gaunt, silent, and yet in a manner graceful and picturesque," and raved about her "wonderful aesthetic hair."

Perhaps the most famous example of the irresistible, doomed heroine was Alphonsine Plessis, who changed her name to Marie Duplessis and married a rich young Englishman. After he died young—of consumption—she took up the life of the heedless and brilliant young woman-about-town in Paris. There she met Alexandre Dumas fils, the playwright, and began an affair that would be immortalized in *La Dame aux camélias* and then Verdi's even more famous opera, *La Traviata.* By the time Dumas wrote his play she, too, was dead of consumption, at the age of twenty-three (in 1847). Mimi, the equally celebrated heroine of Puccini's *La Bohème,* had her real-life counterpart as well. She appeared in a semiautobiographical novel, *Scènes de la vie de Bohème,* by Henri Murger, before becoming the humble seamstress of the opera who meets a young poet and is warmed to life, however temporarily.

Some awful fate clearly awaited gifted people with their acute sensibilities. The poet Elizabeth Barrett Browning, herself a consumptive, overheard a visitor asking, "Is it possible that genius is only scrofula?" Such refined spirits, burning with an ever brighter flame as their bodies were consumed, were the chosen ones; they always died poetically. "Detach the delicate blossom from the tree. / Close thy sweet eyes, calmly and without pain," William Cullen Bryant wrote. (In "Consumption.") The reality was otherwise.

Despite Margherita's belief that Dedo was ill because of the studio, the likelihood is that he was already infected. The tuberculosis bacillus could be acquired from a carrier, often a nurse with no apparent symptoms, and remain dormant until adolescence. Modigliani contracted an inflammation of the pleura, the membrane lining the lung, or pleurisy, at least twice. Pleurisy can often be a precursor of tuberculosis, especially if accompanied by the development of fluid in the pleural cavity. "Since early tuberculosis is such a common cause of serious effusion . . . it must be assumed that all effusions of unknown cause are tuberculous unless proved otherwise." In September 1900,

Modigliani became ill with the pleurisy that developed into a life-threatening tuberculosis.

Modigliani's illness was not diagnosed until he was sixteen, but before the days of X-rays such diagnoses could be hard to make because tuberculosis in its early stages has diffuse symptoms. A dry, persistent cough, an ache in the shoulders, a sore throat, and a slightly accelerated pulse—even difficulty breathing after exercise—might spell nothing serious. Even in its second stage, a more severe cough, thick mucous phlegm, a painful throat, and fever might mean bronchitis; muscle pains might be caused by rheumatism or neuralgia. However, in the third stage, blood on the handkerchief, a "graveyard cough," night sweats, constant joint pain, and emaciation could mean only one thing.

"Different phenomena and degrees of suffering mark the termination of consumption," wrote Dr. William Sweetser, a noted nineteenth-century American physician and diagnostician. In some cases "life, wasted to the most feeble spark, goes out almost insensibly." In others, symptoms were prolonged and exhausting, including "excessive sweats and diarrhoea . . . with colic pains." The patient might feel as if he or she were almost suffocating from the matter accumulating in the lungs. At other times, "a profound hemorrhage comes on at once, pouring from the mouth and nostrils, and causing an almost instant suffocation." For most people, Dr. Sweetser noted, "the mind maintains its integrity to the last." So much for a poetic death.

No description of the course of Modigliani's disease has come down to us, but there are many parallel accounts of severe attacks in adolescence. In 1837 Howard Olmsted, son of Denison Olmsted, a professor of astronomy at Yale University, and apparently in excellent health, was stricken with a stubborn cough and persistent fever, and then had the first of several hemorrhages. One evening as he got ready for bed, Howard wrote,

> the hemorrhage returned in all its violence . . . I was seized with the difficulty of breathing, with coughing and spitting blood . . . Frank [his older brother] ran downstairs and called Papa, while Fisher [his younger brother] ran for Dr. Tully. The doctor came and gave me a powerful astringent that stopped

the bleeding, but my lungs were so that I could not lie down, but had to remain all night seated in my chair. The bleeding returned at intervals for several days, but gradually grew less and less until it ended. However for several weeks I could not lie down at night.

The Norwegian artist Edvard Munch also had a severe attack in 1876, when he was thirteen, and wrote about it later. The account vividly describes not only the author's terror but the fatalism of his deeply religious father, who believed Edvard was about to die. (He recovered.) Munch wrote, "Father said again, 'Don't be frightened my boy.' But I was very frightened. I could feel the blood rolling inside my chest with each breath that I took. It felt as if the whole inside of my chest had come loose and was floating around, as if all the blood had broken free and wanted to rush out of my mouth." This illness, he wrote, followed him throughout childhood; "consumption placed its blood-red banner victoriously on the white handkerchief."

As for the novelist Katherine Mansfield, three years before her death in 1923, at the age of thirty-four, she wrote: "I cough and cough, and at each breath a dragging, boiling, bubbling sound is heard. I feel that my whole chest is boiling. I sip water, spit, sip, spit. I feel I must break my heart. And I can't expand my chest; it's as though the chest had collapsed ... Life is—getting a new breath. Nothing else counts."

Katherine Mansfield's medical care had been assumed by George Ivanovich Gurdjieff, a forgotten figure whose Institute for the Harmonious Development of Man outside Fontainebleau enjoyed a brief and disastrous popularity among the European intelligentsia. As well as directing his disciples' emotional and personal lives, Gurdjieff pronounced upon their medical conditions. Mansfield was installed in the loft of a cow barn on the theory that breathing in a mixture of manure and urine would effect a cure. Shortly afterward, she died. Gurdjieff's remedy was no worse than any other being practiced at that time, and at least Mansfield was not bled, the way Modigliani's grandmother was. Perhaps Modigliani was not, either. He would certainly have been given antispasmodics such as morphine and heroin which were, in any case, freely available. Other remedies guaranteed to soothe the cough and stop the diarrhea included whiskey, brandy,

and laudanum (opium dissolved in alcohol). Roentgen, or X-rays, had been discovered in 1895 but were not in wide use until the 1920s. A cure for tuberculosis did not come until World War II.

A description of Modigliani's bitter struggle is confined to a single sentence from Eugénie, via her daughter: "In September he suffered a violent hemorrhage followed by a fever, and the doctor's diagnosis held out no hope." This laconic reference may partly account for the lack of emphasis given to Modigliani's second brush with death, in 1900, by his biographers. There are no diary entries by Eugénie which

Suffering from tuberculosis: Katherine Mansfield, 1918

might have given a better insight into those dreadful days; "L'Histoire de notre famille" trails off after 1899. There could, however, be an explanation for that. Thomas Mann's *The Magic Mountain*, a novel based on his observations of life inside a Swiss sanatorium in 1913, makes references to the "induction of a pneumothorax." This was an operation that had been perfected by Carlo Forlanini in Italy in 1895, five years before Modigliani's attack. In it, air was deliberately introduced into the pleural space so as to collapse the upper part of the lung, usually the most diseased area. This was designed to increase the blood flow in that area so that white blood cells would fight the infection. Sometimes it was successful. The damaged area would then scar over and heal; this happened often enough for the operation to become widely accepted in Europe and North America. The problem was that, because only local anaesthesia could be used, it was painful, did not always work, and could cause serious side effects. As a last resort an even more radical operation might be attempted. In it the surgeon would cut out the infected matter in the lung. There were no blood transfusions in those days, the patient could not be fully sedated, and if he or she went into shock there was no treatment.

Modigliani could have had the first, the collapse of one of his

lungs. His brother Emanuele made the offhand comment that Dedo only had "one and a half lungs," and patients in *The Magic Mountain* who underwent the ordeal were known as the "Half-Lung Club." If such a cure had been attempted and Dedo's condition worsened this might explain why the account of his crisis is so unrevealing. No one in the family would want a bad decision recorded. All we know is that, as an adult, he was terrified of doctors. We know that his fellow students died and that he survived.

Since everything hinged on the strength of the patient's immune system we can assume that Modigliani's was unusually resilient despite his frequent illnesses and the typhoid that had also almost killed him just two years before. Once on the road to recovery Dedo needed months of convalescence. To Europeans that had come to mean the mountain air of the Alps or the breezes blowing in from the Mediterranean. In the U.S., there was the same difference of opinion. One went north in search of pristine air that would not only clear the lungs but toughen up the invalid. Alternatively, one went south in search of gentle winds that would not irritate an already weakened constitution; you chose, depending on your views about how much further stress a consumptive patient needed. For Eugénie, there was no contest. It was the Mediterranean coast, but then there was the cost of an extended stay. Again, Amédée came to the rescue. As it happened he had been busy building his latest venture in Marseille, the Compagnie pour l'Exploitation de Madagascar, and for the moment there was money rolling in. He wrote back, "Consider your son as mine. I shall cover whatever costs you consider necessary."

As soon as Dedo could travel they set off for Naples and from there to Torre del Greco, spending the autumn and winter months beside the sea in a vast, almost empty hotel, the Santa Teresa. One can assume that, as Dedo slowly began to mend, he slept sitting up for weeks, if not months. One can also assume that his temperature was taken several times a day to keep track of the fevers that would abate in the morning and reappear every evening, with their unpleasant night sweats and disorientations, if not delirium. Wherever the patient was, the emphasis would be on absolute rest accompanied by nourishing food and plenty of it. In *The Magic Mountain*, Mann has given us a vivid portrait of life as an invalid in a Swiss sanatorium, as the day took its unvarying course. "When he had finished [eat-

ing] he would sit there propped up against his pillows, his empty
dishes . . . before him, and gaze out into the quickly falling dusk—
today's dusk, which was hardly distinguishable from yesterday's, or
the dusk of the day before yesterday, or of a week ago. There was
evening—and there had just been morning. The day, chopped into
little pieces by all these synthetic diversions, had in fact crumbled
in his hands, and turned to dust—and he would notice it now . . . It
seemed to him that he was simply gazing 'on and on.'"

After such a serious attack some people were never able to return
to normal life. By contrast, Modigliani's infection—with luck, tuber-
culosis went into a lengthy remission—declined relatively rapidly.
One of the great factors was his mother's selfless care. The other was
the right diet. The third may well have been psychological; Uncle
Amédée had thoughtfully provided a studio as well. He began sketch-
ing again remarkably soon. Then he was well enough to paint and
models were provided; an old beggar was a particular favorite. He
started visiting museums, always accompanied by his mother, who
slept in the same room. He was gaining weight and, as he entered his
seventeenth year, began to grow a light, curly beard.

Modigliani's actual instruction in technique ended relatively soon
but museums were his constant inspiration. Margherita describes
how he would sit transfixed for hours before an unfinished canvas
by Leonardo da Vinci analyzing every stroke, from background to
lightly sketched foreground figures. He was fascinated by the antique
bronzes he saw at the National Archaeological Museum in Naples,
with its collections of Greek and Roman sculpture, and visited the
churches of Santa Chiara, San Domenico, and San Lorenzo. Mar-
gherita's account refers to her brother's "haughty air" and "rather
cold manners," but this comment has to be taken with caution, given
her attitude toward her brother. Others describe him differently, as
having a certain aristocratic bearing that seemed instinctive, rather
than an effort to assert social status. As for his manners, these could
belong to a boy who was still shy and ill at ease with strangers. Per-
haps he no longer blushed when spoken to, but he had not yet devel-
oped the easy friendliness that was to become marked. Once drawn
into conversation he lived up to his sobriquet of "the Professor."
Margherita is probably right in thinking most people assumed him
to be much older than he really was. He was certainly looked on as

an artist with a future. "You must paint with intuition, imagination and concentration," an English tourist told him. This, Modigliani replied, was exactly what he intended to do.

The process by which Modigliani evolved from a gravely ill adolescent to someone committed to his talent and future as an artist is closed to us. We may guess at the pain and terror he endured as he was struck down by these terrible illnesses. We may guess at his agonizing recovery and what feelings he must have had for the mother who had used all her powers to keep him alive. There is considerable evidence that the experience of almost dying can have a life-altering, if not transfiguring effect. The American writer Katherine Anne Porter, who contracted tuberculosis during World War I and almost died in the Spanish influenza of 1918, is a case in point. She used the experience twenty years later in a story which forms the title piece for her collection of three short novels: *Pale Horse, Pale Rider* (1939). The reference is to a horse she rode when she was growing up on a farm in the American South. In her story, the horse comes to symbolize death.

Porter said later that the illness changed her forever. "It just simply divided my life, cut across it like that. So that everything before that was just getting ready, and after that I was in some strange way altered, ready . . . I had what the Christians call the 'beatific vision,' and the Greeks called the 'happy day,' the happy vision just before death. Now if you have had that, and survived it . . . you are no longer like other people, and there's no use deceiving yourself that you are."

One cannot know what Modigliani experienced or to what extent he shared Porter's "beatific vision." He certainly seemed infused with a new sense of purpose and almost giddy at the inner transformation. The evidence is contained in the letters he wrote to Oscar Ghiglia, the classmate eight years his senior who was already making a name for himself as an artist. Ghiglia was the one Margherita believed had started Dedo on the path of drink, drugs, and loose women. Whether or not this is true, it is clear that Oscar was Modigliani's confidant, they were dedicated to art, believed in a life after death, and studied arcane symbolism that would find its way into Modigliani's later work. Ghiglia had taken courses in the self-portrait with Fattori in Florence and was beginning to have early success in the genre that would become so important to his friend. Ghiglia's method was to

shut himself up in a room in Florence, painting himself in front of a mirror. He had a particular composition in mind, of himself seated, with brushes and palette in hand. The result, *Allo specchio* (*At the Mirror*), was shown to another of their classmates, Llewelyn Lloyd, who was so impressed that he entered the painting in the Venice Biennale. *Allo specchio* had been accepted in the spring of 1901 and the news had just reached Modigliani, who was convalescing on Capri.

He was there for the cure, Modigliani wrote without explanation—perhaps they both knew what that meant. He had painted nothing for four months but he was accumulating material just the same. He wanted to move to Florence and start work, "that is, to dedicate myself faithfully (body and soul) to the organization and development of every impression, of every germ of an idea that I have collected in this place as if in a mystic garden."

In his next letter, Modigliani expanded on his pleasure in Capri. He wrote, "Would you believe that I have changed in traveling here? Capri, whose name alone is enough to arouse a tumult of beautiful images and ancient voluptuousness in my spirit, appears to me now as essentially a springlike place." Once they were in Rome, he was even more enchanted. "Rome . . . is not only outside of me, but *inside of me* as I talk. Rome which lies like a setting of terrifying jewels on its seven hills, like seven imperious ideas. Rome is the orchestration with which I surround myself, the limited area in which I isolate myself and concentrate all my thoughts. Its feverish delights, its tragic landscape, its beautiful and harmonious forms—all these things are *mine* through my thought and my work." Exactly what were the truths of art and life? These were the ideas he was trying to come to grips with and had found them "scattered among the beauties of Rome." By that Modigliani evidently meant not only the monuments, buildings, and scenery, but the thrilling discoveries he was making in the museums and churches, the Borghese, the Palazzo Doria, the Terme, the Sistine Chapel, and so many more. "I will try to reveal and rearrange their composition—I might almost say their metaphysical architecture—to create my own truth on life, on beauty, and on art."

> *Bliss was it in that dawn to be alive,*
> *But to be young was very heaven!*
> —WILLIAM WORDSWORTH

His sense of giddy optimism pervades the letters, almost an exul-
tation. He added, "I would like my life to be a fertile stream flowing
joyfully over the ground." It was tempered by the very real possi-
bility that he did not have long to live, and a numb acceptance of
what seemed inevitable: "I am myself the plaything of strong forces
that are born and die in me." This was not too far removed from the
sentiment expressed in Shakespeare's *King Lear:* "As flies to wanton
boys, are we to the gods; / They kill us for their sport." Perhaps he
felt, as Edvard Munch did after a similar attack, lying flat on his back
in bed, his hands outside the sheets, "Now I could never be as before.
I looked at my brothers & sisters, and I envied them." Munch asked
himself, "Why me?"

Little by little the idea seems to have taken hold that he was marked
for some special fate. Like Frank Lloyd Wright a few years later,
Modigliani was clearly influenced by Nietzsche's theories about the
emergence of the Übermensch. The artist, as Superman, was divinely
endowed, therefore divinely inspired, for as Nietzsche also wrote,
the artist had his own truth, or a special kind of truth. "He fights for
the higher dignity and significance of man; in truth, he does not want
to give up the most effective presuppositions of his art: the fantastic,
mythical, uncertain, extreme, the sense for the symbolic . . . the faith
in some miraculous element in the genius."

As for Wright, after experiencing public censure for abandoning
his wife and six children to live with a married woman, he wrote,
"The ordinary man cannot live without rules to guide his conduct. It
is infinitely more difficult to live without rules, but that is what the
really honest, sincere, thinking man is compelled to do. And I think
when a man . . . has given concrete evidence of his ability to see and
to feel the higher and better things of life, we ought to go slow in
deciding he has acted badly."

Modigliani could have written that himself. In fact, he wrote
something very much like it to Oscar Ghiglia almost a decade before
Wright's letter. "People like us . . . have different rights, different val-
ues than do normal, ordinary people because we have different needs
which put us—it has to be said and you must believe it—above their
moral standards." As for Wright's defiant conclusion: "I am a wild
bird—and must stay free," that would have struck Modigliani as
completely logical and reasonable. "Do what you feel . . ." The art-

ist who is really serious about his work must "push his intelligence to its maximum creative power." There was a battle ahead, one he must be prepared to undertake, "facing the risks, carrying on the war with . . . great strength and vision." He must be prepared to suffer every hardship and "bring forth the most supreme efforts of the soul" in the cause of satisfying beauty's "painful demands." In his mind, fatalism and idealism, creativity and death, seemed intertwined.

The mold was set when Modigliani was seventeen.

———◆———

The Perfect Line

. . . and hence through life
Chasing chance-started friendships.
—SAMUEL TAYLOR COLERIDGE,
"To the Rev. George Coleridge"

CHILDREN WHO BEGIN as adorable cherubs sometimes have a disconcerting way of losing their looks, their first flowering of physical glory having been their last. Dedo began as perfection: pouting mouth, wide dark eyes, strongly marked brows, and straight nose, and never deviated from that classical pattern. Pictures of the young Modigliani illustrate the mysterious progression by which infant features can metamorphose into a masculine handsomeness without losing one iota of their allure: wider cheekbones, stronger, straighter nose, eloquently large eyes, and full lips. Perhaps because of his devastating illnesses, Modigliani remained what we would call short, five foot three, which was considered an average height for his generation and not regrettable, as it is now. He retained ideal proportions and during his brief career as a sculptor attained a powerful physique.

To say that he was loved by women is an almost laughable under-

statement. All his life, almost before one affair was over, another began. Perhaps he was also loved by men but there is no evidence of this. As soon as he was studying with Micheli this seemingly shy and delicate boy was turning the conversation to girls. Bruno Miniati, who later became a photographer, said Dedo used to make admiring comments about Micheli's maid, a pale little girl with eyes as black as coal. To another classmate he said one day, referring to the same girl, "Wouldn't you like to find a button in your pants because of her?" Still, he would not stay with the others when their walks took them to the via dei Lavatoi or the via del Sassetto, where the brothels were. "Dedo would always turn back. He was ashamed." Somewhat later, it is said, it was a point of pride for Modigliani to talk about how many brothels he *had* visited.

The painter Ludwig Meidner recalled, "I think it was in Geneva that a wealthy German woman, who was traveling with her young daughter, invited him to accompany them and Modigliani was quite happy to accept this offer. He had just come from home, and was at that stage immaculately dressed, a lively, good-looking young man of twenty-two years of age who subsequently paid less attention to the . . . mother than to her youthful daughter. It greatly amused him to flirt with the daughter without the mother noticing, and he never got tired of telling us about it."

He had, the art critic Adolphe Basler wrote admiringly, "that masculine handsomeness which one admires in Bellini's pictures." The blushing shyness, now replaced with calm confidence, demonstrated a polish that would again have reminded his mother of her dead father, along with his characteristic elegance and refinement. Thanks to the continuing generosity of Uncle Amédée, Modigliani at this stage enjoyed all the privileges of a young man of good family who does not need to work for a living, and his dress showed it. It was refined without being showy, while calculated for maximum effect. "A public man, the dandy, an actor on the urban stage, hid his individuality behind the protective mask of appearance, which he strove to make undecipherable," Michelle Perrot wrote. "He was fond of illusion and disguise and exquisitely sensitive to detail, to such accessories as gloves, ties, canes, scarves and hats."

What is significant about this observation is the link the author makes between status, costume, and the instinct to perform. Barzini

Recovered from his brush with death: a prosperous Modigliani, c. 1905

wrote of the Italian male, "Watch him promenade down the *corso* of any small town at sunset, or on Sunday morning after mass. How cocky he looks, how close fitting are his clothes, how triumphantly he sweeps his eyes about, how condescendingly he glances at pretty girls from the corner of his lowered eyelids! He is visibly the master of creation." Barzini might have said, but did not, that no one assumed the role with more enthusiasm than one of the poets Modigliani most admired. Gabriele d'Annunzio was equally small and, once his youthful looks had departed, pockmarked and ugly, but women continued to fall at his feet. He had presence, the actor's gift of entering a room. He had charm, he was a shameless flatterer, and he knew the importance of dressing for the part: first as a curly-locked adolescent poet, then a young man-about-town, then a successful dramatist, the World War I aviator, and, finally, a national hero, marching on Fiume to claim it for Italy in 1919. D'Annunzio cleverly attired his conquering band of fighters in uniform brown shirts, a flourish that was not lost on Mussolini, who merely changed the color, so that his soldiers marched in black ones. D'Annunzio and Modigliani—both wonderfully gifted, idealists to their toes, utterly dedicated as artists—were illusionists, hiding behind a façade. It is difficult to say who became the better master of that art.

By the spring of 1901 Modigliani and his mother were back in Livorno after an absence of six months.

At seventeen, Modigliani was at an age when most young men nowadays are still living at home. But in his generation, with its short average life span—by 1913, that had become forty-eight for men and

fifty-two for women—and when working-class boys in Britain left school at the age of twelve, seventeen would have been considered adulthood. Going home to live with mother did not suit him at all. Within days he had persuaded her to let him undertake formal studies in Florence. Ever agreeable, Uncle Amédée paid his expenses and Modigliani left Livorno. Ghiglia was in Florence, still studying with Fattori, and they presumably shared a studio. On May 7, 1901, Modigliani began taking life studies in the Scuola Libera del Nudo. He moved to Rome for the winter, returning to Florence early in 1902, presumably to rejoin Ghiglia. Not much is known about these first months of independence but we do know that on his return he contracted scarlet fever. Before the arrivals of penicillin and sulfadiazine this infection by haemolytic streptococci was considered more dangerous than measles and capable of causing serious complications. Scarlet fever, now fortunately rare, began with a fever, a sore throat, and a headache, followed by the arrival of small red spots, redder and more numerous than measles, hence the name. After these disappeared the skin was covered with a powdery substance that made it look as if it had been dusted with meal, and often peeled away. The neck was tender to the touch and the glands were swollen. Upon hearing the news Eugénie again rushed to Dedo's side. Vomiting, rapid pulse, delirium—these were a few of the possible complications. But this time symptoms were relatively mild and, Margherita records, her brother recovered "without any complications." Another convalescence followed, this time in the Austrian Alps, and Dedo's health was again restored.

Modigliani's exact movements in these years are not entirely clear. But it seems likely that before this latest illness he also studied with Fattori. He took an examination for the Accademia di Belle Arti in Florence and was given permission to copy paintings in its galleries. Eugénie's memoir, published by Noël Alexandre in *The Unknown Modigliani*, records that he never attended regular classes and, as before, continued to be largely self-taught. Early letters to the family of this period have been lost. However, they were aware that he spent a great deal of time looking at art books in the Biblioteca Nazionale. Margherita records an incident that took place there, presenting it as proof of her brother's autocratic and mulish character. She writes that, as he was there one day studying, a librarian accused him

of having stolen a valuable book. Modigliani replied with "a volley of insults." The director was called and was also given a piece of his mind by the eighteen-year-old upstart. The library took legal action and the case went to court. Modigliani's lawyer was able to prove, not only that his client was innocent, but that the real culprit, the man who stole the book, was the librarian who had accused Modigliani. Margherita was not pleased. She wrote that her brother, who had "abused" a civil servant, would not apologize. Why she should expect Dedo to apologize when he had been wrongly accused, tells us more about her than him.

Modigliani moved to Venice in the spring of 1903 and enrolled in the Scuola Libera del Nudo at the Accademia delle Belle Arti in May. All his life Modigliani made friends easily, and he was making contact with a distinguished group: Umberto Boccioni, the Futurist painter and sculptor, Fabrio Mauroner, with whom he shared a studio in the San Barnaba quarter and whose interests would include sculpture, painting, the graphic arts, and art criticism; as well as artists Mario Crepet, Cesare Mainella, Guido Marussi, Ardengo Soffici, and Guido Cadorin. Such encounters with the cream of intellectual and artistic life in Venice suggest assiduous cultivation. Perhaps it was in Venice that Modigliani learned the pivotal rule for the up-and-coming young artist, the right cafés at the right moment. In Venice it was the Florian, which never closed. Meanwhile he occasionally went to life classes, relying on his eye and the lessons to be had by daily visits to the great museums, studying the Bellinis and Carpaccios with concentration.

He had also met a young Chilean painter, Manuel Ortiz de Zárate, whose Italian was fluent and who liked to boast about his Basque origins. Sichel described him as "a hulking, muscular youth who, with his big head, deep brooding eyes and powerful features, looked older than his age." Even though he was only seventeen, Ortiz had already been to Paris and fired Modigliani with enthusiasm for this world center of all that mattered in art and sculpture. Like most of Modigliani's friends Ortiz was barely surviving and intensely envious to find Modigliani living in comfort and wearing a perfectly magnificent pair of pajamas. Modigliani was painting, but Ortiz was not impressed by the results; his work seemed lackluster. In any event, painting was not on Modigliani's mind just then. Ortiz recalled, he

"expressed a burning desire to become a sculptor and was bemoaning the cost of material. He was painting only *faute de mieux*. His real ambition was to work in stone."

Jeanne Modigliani, who writes with a delicate understanding of her father's work, thought he must have conceived the ambition to become a sculptor in Naples, visiting the churches of Santa Chiara, San Lorenzo, San Domenico, and Santa Maria Donna Regina, and discovering the work of Tino di Camaino, the thirteenth-century Sienese sculptor who was head of the works at Siena Cathedral and later worked in Florence. The discovery of Tino's work demonstrated the successful solution of "those plastic problems with which he would be dealing all through his short artistic career," she wrote. There was the "oblique placing of the heads on cylindrical necks, the synthesis of decorative mannerism with a sculptural density and above all, the use of line not only as a graphic after-thought but as a means of composing his volumes and holding his masses together in a way that even seems to accentuate their heaviness. From that time on, critics of Modigliani's work see it as a continual oscillation, which at its best results in a synthesis between the demands of his clean rhythmic line and his love for full, solid and rounded volume."

Modigliani's first attempt at sculpture was, however, unpromising. Accounts vary but he would seem to have traveled to the great marble quarries in Carrara, some thirty-five miles north of Livorno, in 1902 or 1903, setting himself in the studio of Emilio Puliti in Petrasanta, a little village five miles away. The fact that he actually accomplished a sculpture is demonstrated by a letter he wrote to Gino Romiti that enclosed photographs of the result, asking Romiti to make some enlargements. When marble proved to be too formidable, Modigliani turned to stone and came up with two or three studies. It was difficult, exhausting work, and so for the time being he abandoned the effort and went back to painting. His sculptures were, of course, all heads.

Eugénie wrote in her diary, "I can't see yet who he will become, but as before his health is the only thing I think about and in spite of the economic situation I can't yet give much importance to his future career." Meantime, her son continued to make friends. "I visited Venice for the first time in 1903," Ardengo Soffici wrote, and a colleague introduced him to Modigliani. "At the time he was a

handsome, kindly-looking young man, of average height, slim and dressed with a sober elegance. He was serenely charming to everyone and spoke very intelligently and calmly.

"During my stay in Venice we spent many pleasant hours together, either strolling round the wonderful city to which he acted as my guide, or in a cheap restaurant he took us to." Modigliani ate sparingly and drank little or no wine. "There, eating fried fish the strong tang of which I can still smell, my new friend entertained us with talk of his researches into the painting technique of the Italian primitives, his passionate study of fourteenth-century Sienese art, and, especially, the Venetian Carpaccio, of whom he seemed particularly fond."

Fabio Mauroner recalled that while in Venice Modigliani was painting a large portrait of a lawyer in the style of Eugène Carrière and making studies of the nude models usually to be found in his studio.

"He would spend the evenings, and stay late into the night, in the remotest brothels where, he said, he learned more than in any academy . . . After a while I had occasion to show him some volumes of Vittorio Pica's *Attraverso gli albi e le cartelle,* the first and perhaps the only interesting Italian study of modern engravers and graphic artists." Mauroner was trying to interest Modigliani in the graphic arts, but without success. "Already during those days," Mauroner wrote, "Amedeo was looking for the line, which he saw as having a spiritual value in its simplification, as a solution to his search for the essential meaning of life. But while he was in Venice this ambition was hardly more than a vague abstract idea in his mind. The experience of this, and its practice, was still a distant dream."

One never quite knew, with Modigliani, when a discussion of the practical problems of technique and composition would take a sudden turn and start examining the riddles of existence. One of his letters to Oscar Ghiglia ends with the comment that, when the time came for him to leave Venice, the city would have imparted some unforgettable lessons. What those were, he did not exactly say. "Venice, head of Medusa, with its many blue snakes with their pale, sea-green eyes, where the soul is engulfed and exalts the infini . . ." Such heady shifts of ground appealed to some friends and exasperated others. Llewelyn Lloyd, his old friend from their student days in

Livorno, ran into him one morning in 1905 on the Piazza San Marco. "He immediately began to talk about pictorial and technical problems, going from art to philosophy and other abstruse matters. The day was beautiful, the square enchanting, pigeons flew in great circles over our heads, the Venetian scarves fluttered in the breeze from the Lagoon. I couldn't take any more, and just left."

That was the year Dedo became convinced his future lay in Paris, and early that year Uncle Amédée, who had done so much for him, died. Eugénie's diary entry for February 1905 does not give the cause of death. She wrote that she had just returned from Marseille, where she had been dealing with the papers of her "poor dear Amédée." She could not bring herself to recapitulate the whole, sad history. "Nothing will fill the void he has left in my life. There was an affection that was too complicated, too often tested, made of pity and trust, and above all from such a complete communion of souls that nothing will replace it." But she had to keep reminding herself that "he could never be happy and that everything was for the best." This revelation that the man everyone loved, who was perpetually in a good mood, was actually incapable of happiness, is surprising, to say the least. If, as rumor has it, Amédée committed suicide, Eugenie's final thoughts support that possibility.

Just how Modigliani survived financially is another imponderable. Parisot writes that Amédée Garsin, then believed to be bankrupt, nevertheless left his nephew a small inheritance, on which he drew for the next three years, supplemented by a small allowance from his mother. It is certainly true that Modigliani arrived in Paris in style, as witnessed by numbers of his friends, who thought he had been left a fortune by a rich uncle. True, he was painting portraits—the subject of the large portrait Mauroner saw in his studio was probably a lawyer named Franco Montini—but how many were actually paid for is also a moot point. Other works, such as a portrait of Mauroner himself, have been lost. Modigliani knew a prominent Venetian family, the Olpers, through his sister—Albertina Olper had been Margherita's school friend—and is known to have visited them often. His sister also believed Dedo had painted a portrait of Leone Olper, Albertina's father. When the family wanted to sell the painting in 1933, Giovanni Scheiwiller, an early biographer of Modigliani's, was asked for help in finding a buyer. However, Ambrogio Ceroni

did not include this painting in his accounting of Modigliani's works, and it has not been listed by other scholars. Modigliani was famously unsatisfied by his own work and it is possible that, when the time came to leave Venice, and to avoid the expense of taking the canvases with him, many of them were destroyed.

Modigliani took very little with him to Paris in 1906; clothes, perhaps a few books, and picture reproductions. Fabio Mauroner bought his easels and "a few studio oddments." Before Modigliani left he told Mauroner that his mother had visited him. Curiously, she came to *him*, rather than the reverse. Was this a last-ditch effort to get him to come home with her? We shall never know. She did, in any event, give him some money for the trip. She also presented him with a handsome edition of a poem by Oscar Wilde, "The Ballad of Reading Gaol," which had been published seven years before, in 1898, and became a best seller in France and England.

Since this was a family that set a very high value on poetry, a work by the English dramatist, novelist, and poet, who was tried and convicted in 1895 for his homosexual relationship with Lord Alfred Douglas, and spent time in prison, was certainly not a chance gift but meant to send a message. That much seems likely, even if the message is not so easy to discern.

The poem is an ostensible account of the case of Charles Thomas Wooldridge, a trooper in the Royal Horse Guards who, believing his twenty-three-year-old wife to be unfaithful, slit her throat. He was hanged at Reading Gaol the year Wilde himself faced trial in London. But, as Richard Ellmann points out in his biography, the year 1895 had another significance for Wilde. That year he had rejected Douglas's article celebrating their love, and a few months later refused to accept Douglas's dedication of his poems. Ellmann wrote, "The gesture grew out of the feeling that Douglas had destroyed his life . . . Wooldridge as a real image, and Douglas and himself in parable, all conformed to an unwritten law." That law, often quoted, was: "For each man kills the thing he loves."

By another coincidence that presentation of a handsome volume of Wilde's final work was five years, almost to the month, since the poet had died in Paris. (In November 1900.) It was the same year that Eugénie's adored brother Amédée had left the world, for whatever reason, the man who never could be happy. Who then had killed whom?

Whatever the unconscious message, this parting gift of a poem by a doomed poet who had, as Ellmann also wrote, "the sense of a strange fatality hanging over him," was hardly an appropriate message for a son about to set off into life. Was someone "snatching away" yet another of Eugénie's dear ones, and was she responding in the same way again? Did she think that Amedeo was destroying her life as, by loving him, Wilde felt Douglas had destroyed his? In her diary of 1896, Eugénie wrote, "I am a reflection of other people's lives." Did she, at some unaware level, expect his life to become a reflection of hers?

According to Jeanne Modigliani, whose determination to correct a number of false assertions makes her more reliable than most about dates, Modigliani arrived in Paris in January 1906. Springtime in

Modigliani, soon after his arrival in Paris, c. 1906

Paris was, after all, the moment of moments. In March 1848 George
Sand wrote, "What a dream Paris is, what enthusiasm there is there,
and yet what decorum and order! I've just come from the city: I
flew there and saw the people in their grandeur, sublime, naive and
generous . . . I went many nights without sleep, many days without
sitting down. People are mad, they're intoxicated, they're happy to
sleep in the gutters & congregate in the heavens." Modigliani was
not sleeping in gutters, at least not yet, but comfortably installed in
a hotel near the Madeleine. Perhaps he was ready to start work but
feeling, as John Dos Passos did a decade later, that the day was "too
gorgeously hot and green and white and vigorous." He continued,
"How do people manage to live through the spring? I have never felt
it more insanely."

Or perhaps, like the American art student Abel Warshawsky two
years later (1908), Modigliani arrived one rainy night in the cheerless
darkness, loaded his luggage onto one of the newfangled horseless
carriages, and was driven along the rain-washed pavements, smell-
ing gasoline mingled with roasting chestnuts, turning and turning
into narrower and narrower streets while the driver honked his horn.
Warshawsky was arriving in the autumn and perhaps Modigliani did
as well. We have no diaries or letters to confirm the month, but Gino
Severini, the Futurist painter, states that he arrived in Paris in Octo-
ber 1906, and Modigliani had arrived just three weeks before him.
Paris in the autumn has charms of its own, as Dos Passos was to
describe, after spending "an atrociously delightful month of wander-
ing through autumn gardens and down grey misty colonaded streets,
of poring over bookshops and dining at little tables in back streets,
of going to concerts, and riding in squeaky voitures with skeleton
horses, of wandering constantly through dimly-seen crowds and
peeping in on orgies of drink and women, of vague incomplete adven-
tures—All in a constant sensual drowse at the mellow beauty of the
colors & forms of Paris, of old houses overhanging the Seine and
damp streets smelling of the dead and old half-forgotten histories."

The Paris Modigliani found during the Third Republic was a city
in dynamic flux, one of boundless opportunity. The ruthless hand of
the architect Georges Haussmann had wiped out whole sections of
the old city in order to introduce the grands boulevards with their
squares and circles that had transformed Paris. Haussmann died in

1891, but his influence continued as more boulevards, such as the Saint-Germain and Henri IV, were built, the Place de la République was reconfigured, the Opéra rose in the middle of its encircling roads, and in the emergence of new parks and handsome apartments. The façades of these were flat and harmonized in the Haussmann style and contained all kinds of miraculous conveniences like bathrooms, running water, gaslights, and central heating. Some 32 million visitors had attended the Exposition of 1889, the Eiffel Tower immediately became the symbol of the new Paris, and just as marvelous was the new underground railway with its sinuous Art Nouveau entrances designed by Hector Guimard. The cafés, the food, clothes, theatres, thés-dansants, opera, concerts, ballet, circuses, the plays, novels, poems, and musical compositions all testified to a new flowering of French genius, a new optimism, and a new prosperity.

Most of all, Paris was a city of art and artists, "apt to strike the newcomer as being but one art studio," May Alcott Nieriker wrote. "The combination of old and new building, the splendours of the new boulevards and the Bois de Boulogne, the profusion of cafés, the theatres, the contrasting opulence and seediness . . . the smells of the city . . . all these aspects . . . exerted a spell on visitors." As part of their transforming revolution the Impressionists—Manet, Monet, Caillebotte, Cézanne, Degas, Morisot, Renoir, and Sisley—brought a new sense of daily life, real people in real situations. The year of Modigliani's arrival Cézanne had just died—of hypothermia, after being caught in a storm at age sixty-seven—painters like Bonnard and Vuillard were developing their theories about flat planes of color, and an even more radical group, Matisse, Derain, Vlaminck, and Rouault, had introduced their own movement at the Salon d'Automne in 1905. Their resulting canvases quickly earned them the name of "Les Fauves"—"Wild Beasts." Picasso and his Cubistic conundrums were just around the corner.

Thanks to the fame of the Impressionists and Post-Impressionists, artists from all over the world were drawn to the city's schools, galleries, museums, and salons. Between 1870 and 1914 the number of artists living in Paris was said to have doubled; it was claimed that "there were more artists per square metre than in any location in the world." Warshawsky, picking up the latest thinking from his fellow students, was told that Monet and his school had ruined all sense of

Scene outside the Théâtre Sarah Bernhardt soon after Modigliani arrived in Paris in 1906: a contemporary postcard

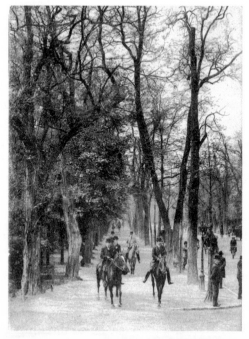

The Bois de Boulogne in 1905: a postcard

form in their single-minded pursuit of the effects of light, or so it was claimed. Before he left New York Warshawsky believed that the work of Robert Henri was the very last word in daring and avant-garde insights; in Paris, poor Henri could not even find a gallery prepared to show his work, and he had been rejected by the latest Salon d'Automne.

Even more than it is today, the life Modigliani found on his arrival was the life of the streets. Influenced as we are by the albumen prints of Eugène Atget made at the turn of the twentieth century to think of Paris in almost Surrealistic terms as a city full of deserted quais, empty chairs in the Tuileries, wet, winding cobblestone streets, and shuttered windows, the impression is deceptive. For the fact was that Atget made his living selling pictures of old Paris to artists and therefore set up his tripod and cameras before dawn, when nothing was stirring. Even so, somewhere in Paris someone was always awake. Anywhere near Les Halles the streets would be reverberating with the early sounds of delivery carts being hauled over the old stones, the shouts of drivers, the whinnying and snorting of the horses, the throngs of predawn buyers and sellers, and the groans of the porters, men who had proved their strength by carrying a wicker basket laden with two hundred kilos of cast iron for a distance of 250 meters. Only they had the right to unload but, on the other hand, they could get help from day laborers, called *"coups de main,"* who swarmed to Les Halles looking for work.

There were daily deliveries that would surprise today's city dweller, trained to forage for himself. First came the milkmen, well-built young men in blouses and tall caps with their milk cans, rattling along in their two-wheeled carts at four in the morning. Their appearance was the signal for street sweepers, men and women with highly desirable salaries of three francs a day, to arrive and begin raising their clouds of dust.

At five o'clock small, sturdy women from the boulangeries in aprons and leg-of-mutton sleeves would begin their day by removing dozens of newly baked loaves of bread from the oven and loading them into covered delivery carts. Each loaf was hand-delivered to the door of every apartment, meaning that, in the course of a single morning, the women might be climbing some eighty flights of stairs. Then there were the lady newspaper sellers who received the morn-

ing's news in great sheets, to be assembled into individual copies and neatly folded before they could be distributed by cyclists all over the neighborhood.

As dawn broke, armies of workers filled the streets: the locksmiths in blue smocks, masons in white aprons, flower makers, metal burnishers, knife grinders, glaziers, fishmongers, the peddlers of old clothes and rabbit skins, the organ grinders and sellers of lampshades and umbrellas in their shabby coats and fedoras. There were legions of girls, usually in from the country, working that humble trade immortalized by Mimi in *La Bohème.* At the bottom of the heap were the *"petites-mains,"* young recruits who ran errands for the couturiers. Then came the dressmakers and milliners and, ascending the social scale, the typists working in banks and offices. Such sartorial niceties between the working classes animate *The Colour of Paris,* an illustrated historic and social guide published by the Académiciens Goncourt in 1924. The theme, what it was like to be young and hungry, underlies this account. "What can they do . . . to earn a living—that is, literally to escape dying of want?" the authors ask. "They are thankful to accept any kind of work. Some of them turn *bagottiers,* the name given to the poor wretches who run after cabs at the railway-stations in the hope of being allowed to lend a hand unloading the luggage, and who usually spend their breath for nothing; others cry the morning papers, which are distributed among them at the *Croissant,* at the rate of two francs fifty the hundred. Advertising agents hire some of them as sandwich-men . . . to announce new wares, and at such jobs they average thirty sous a day." As for those pariahs of the needle, the makers of underclothing, if they were lucky enough to find any work at all, they earned one franc twenty-five centimes a day, that is to say, ten or twelve centimes an hour. Such were the harsh realities of being down and out in early-twentieth-century Paris.

We may imagine Modigliani sauntering out of his comfortable hotel near the Madeleine, "poured into his clothes, with plenty of cuff on display," as the poet Blaise Cendrars described him, strolling down the grands boulevards, humming and talking to himself occasionally, as André Breton did: "Toutes les rues sont des affluents / Quand on aime ce fleuve ou coule tout le sang de Paris."

He had signed up for classes at the Académie Colarossi in the rue de la Grande Chaumière, that street that would figure largely in the sad drama of his short life. The Colarossi, believed to be the oldest art school in the Quartier Latin, had attracted such pupils as Rodin, Whistler, and Gauguin and was favored by Ortiz de Zárate, who no doubt recommended it to Modigliani. Instruction was available, but most artists went there for the chance to draw from a model for a small fee. Marevna, a Russian artist who arrived in Paris in 1912, said the rooms were usually packed. Some of the models, usually Italians of all ages, were clothed, looking "out of their element in the chilly fog of Paris, most as though they had just disembarked from a voyage from Naples," she wrote. Other rooms had nude models, so these tended to be overheated and stifling; "the model perspired heavily under the electric light, looking at times like a swimmer coming out of the sea. It was like an inferno, rank with the smells of perspiring bodies, scent and fresh paint, damp waterproofs [raincoats] and dirty feet, tobacco from cigarettes and pipes, but the industry with which we all worked had to be seen to be believed."

Other artists enrolled in the Académie Julian on the rue du Dragon, popular with Americans who could not meet the entrance requirements at the École des Beaux-Arts. After the future muralist George Biddle graduated from Harvard Law School in 1911 he went straight to art lessons at the Académie Julian. He wrote,

> The school was in an enormous hangar, a cold, filthy, uninviting firetrap. The walls were plastered from floor to ceiling with the prize-winning academies, in oil or charcoal, of the past thirty or forty years. The atmosphere of the place had changed little since the days of Delacroix, Ingres or David. Three nude girls were posing downstairs. The acrid smell of their bodies and the smell of the students mingled with that of turpentine and oil paint in the overheated, tobacco-laden air. The students grouped their stools and low easels close about the models' feet. While they worked there was a pandemonium of songs, catcalls, whistling and recitations of a highly salacious and bawdy nature.

In common with students from the Sorbonne, struggling artists, called *"rapins,"* wore Bohemian costumes of wide-brimmed felt hats or berets, cloaks, and peg-topped trousers. Art was in an uproar.

Everyone was looking for the next style, but no one was quite sure which one would become the rage. "Between the pitiless iconoclasts and the defenders of the old order there was a small band of artists who tried to find a line of compromise," Warshawsky wrote.

One of their favorite devices was to paint a blue line around everything and it was strange to see how even a very academic painting could snap up with this blue outline.

But the younger element, in their mania to emphasize form, set out to deliberately distort it. Horrible monsters, with arms and legs in the last stage of elephantiasis, colored in crude green, violet or scarlet, were painted from slim, delicate, ivory-tinted models. Agonizing landscapes with writhing, reeling forms, as if afflicted with the dance of St. Vitus, were hailed by critics as symphonies of rhythm and plastic design. Totems and idols of jungle Africa were studied and imitated.

Meantime Modigliani was at work. In those days he was painting very small portraits on rough canvas or smooth card with thin colors, Ludwig Meidner recalled.

The results, which recalled somewhat Toulouse-Lautrec or, in their gray-green tones, Whistler's works, were markedly different from the pictures of the Fauves, which could be viewed at the exhibitions of the Indépendants. They had style and, compared to the latter, were measured and refined in both color and draftsmanship. In order to give these pictures depth and transparency Modi covered them when they were dry with colored varnish, to such an extent that some pictures were covered with ten coats of varnish and, with their transparent golden appearance, recalled the Old Masters.

He had produced enough of these early portraits to have three of them on display in December of 1906 at Laura Wylda's art gallery at the corner of the rue des Saints-Pères and the boulevard Saint-Germain. In his autobiography, *Pane e luna*, the artist Anselmo Bucci wrote that they were hallucinatory portraits of women with bloodless faces in a limited, almost monochromatic palette of red-

dish browns. None of them sold. Modigliani painted two portraits of Meidner and eventually exhibited at the Salon des Indépendants but, his sitter remarked drily, "they went largely unnoticed."

Modigliani was drawing continually, one of his sitters being Mado, a blond washerwoman who had been one of Picasso's models. Meidner was intrigued by Modigliani's practical and inventive approach to drawing. "He drew from life on thin paper, but before it was finished he placed another white sheet beneath it and a piece of graphite paper between the two; then he traced the drawing, greatly simplifying the lines . . . Whereas in later years he developed his own style of painting, his drawing remained essentially unchanged. Once he set to it, he could produce dozens of portraits in this way."

Bucci was intrigued enough by Modigliani's painting in Laura Wylda's window to go looking for their author and found him at the Hotel Bouscarat in Montmartre. Bucci was accompanied by a couple of friends, and Modigliani responded at once, hurtling down a steep staircase. "Here was a young man wearing a cyclist's red sweater, small, gay and smiling, with a splendid set of teeth and a mop of curly hair," Bucci wrote. The first thing Modigliani wanted to know was, were they all Italian painters? Bucci was already mentally cataloging his looks: "Young Jews often have classically shaped, even Roman heads; this was the head of Antinous"—a reference to a youth of such beauty and grace he became a favorite of the Roman Emperor Hadrian's and was later deified.

The three men started arguing almost at once. There was not a single decent painter in Italy, Modigliani said, with the exception of Oscar Ghiglia. As for France there was Matisse, Picasso, and, Modigliani almost said, "There is me," but did not quite. Bucci used to meet him at the Café Vachette, where they went to get warm, listen to jazz, and draw. Modigliani drew all the time and would study Bucci's folio with a seriousness and attention that the artist had seldom received from anyone. They were almost friends, but not quite, perhaps unconsciously competitive. "There was always between us a certain smile, typically Livornese, that was icy cold."

Modigliani had, of course, visited all the museums and an exhibition of the Fauves at the Salon d'Automne, where he was greatly impressed by the works of Gauguin. But, Ludwig Meidner wrote, "Modi was also interested in Whistler and his fine grey tones, even

though the painter was no longer in the public eye. He also admired Ensor and Munch, who were almost unknown in Paris, and of the younger artists he preferred Picasso, Matisse, Rouault and some of the young Hungarian Expressionists who were just coming into fashion."

His friends were, for the most part, those artists he had already met in Florence and Venice. Besides Bucci, one of his new friends was Gino Severini, who met him by chance outside the Moulin de la Galette. Severini recalls that Modigliani's search for style was as unsatisfactory as anyone else's. "Naturally, our conversations centred on the artistic preoccupations of the period," Severini wrote. "Impressionism no longer satisfied [us]; Picasso was too much of an intellectual . . . all this gave rise to much discussion. Modi never agreed with anyone. And in particular, he didn't agree with Futurism. Futurism was based on color relationships, on a certain impressionism. Modigliani didn't give a damn about all that. He was interested in the Genovese primitives, in Negro art, in the Venetians."

By the early winter of 1906 Modigliani had moved from the Madeleine to the Bouscarat, at the very center of the artists' quarter, the Place du Tertre in Montmartre. He rented a separate studio nearby at 7 Place Jean-Baptiste Clément. Several people remembered that studio, Severini among them. He wrote, "From the rue Lepic you could see a sort of greenhouse or glass cage on the top of a wall at the end of a garden. It was a small studio, but very pleasant. The two sides that were glazed meant that it could serve equally as a greenhouse or a studio without being precisely either. Anyway, Modigliani had arrived in Paris with a little more money than me, so he had been able to set up this small establishment, not very comfortable but adequate. He was not at all satisfied with it himself, though, and to tell the truth I liked my own sixth floor better."

The description, harmless as it is, makes one wonder how one can believe anything that has been written about Modigliani. This was a dwelling that others describe as lacking a single redeeming feature except, perhaps, for a cherry tree in the rue Lepic that one could see from a window. The studio was in the Maquis, a warren of back streets off the main square, of the kind described by Émile Zola in *L'Argent,* "wretched huts made of earth, old boards, and used zinc, like so many heaps of debris arrayed around an inner courtyard."

Rag and bone men lived there along with dealers in used furniture, foundry workers, and artists, who had moved in en masse, given the rock-bottom rents, and if only temporarily, since the slums were being cleared for new apartment buildings.

André Warnod described the Maquis as "a vast space covered with sheds made from recovered materials, scrap ends of wood, old planks, metal gratings and tinplate, all of it looking ready to collapse at a single push." Summer would place a merciful blanket over the piles of rubbish with scrub, weeds, a few wildflowers, and the distant cherry tree. There Modigliani lived with a few humble possessions. Louis Latourette, a poet and financial journalist, described the interior. "The shanty was in a state of wild disorder. The walls were covered with sketches, a few canvases lay on the floor, and in the corners were several sculptures. The furniture consisted of a couple of rush-bottom chairs—one with its back broken—a makeshift bed, a trunk used as a seat, and a tin basin and jug in one corner." Similarly Meidner described Modigliani's studio as "a tumbledown shack on a treeless, ugly scrap of ground, and although it was furnished in the most spartan manner, oppressive and neglected like a beggar's hovel, one was always glad to go there for one found an artistic atmosphere in which one was never bored." His host painted the cherry tree, one of the famous lost paintings. Supposedly Modigliani took it with him when he set off on his endless search for temporary quarters, and at some point it disappeared.

What Meidner remembered best were so many evenings that winter when they used to meet in a dark Bohemian café on the Butte Montmartre called the Lapin Agile. "For four sous you could sit there with a cup of strong coffee and engage in heated discussions about art until dawn. As day broke we would go home through the narrow lanes." This, for Meidner, was the crowning glory of life in Paris. He would, he wrote, never experience anything like it again.

———◆———

La Vie de Bohème

Mon Dieu, mon Dieu, la vie est là,
Simple et tranquille!
—PAUL VERLAINE

THE LAPIN AGILE, a combination café and watering hole on the steep northern slopes of the Butte Montmartre, played a pivotal role as a meeting place for artists at the start of the twentieth century. At the intersection of the rue Saint-Vincent and the rue des Saules, its origins went back for centuries, and in previous years the rustic cottage that became a tavern had appealed to the Bohemian students of the Romantic movement. With its outdoor terrace, its fresh air, its superb views over the city, and its historic associations, the louche charms of the café, once called Les Assassins, seemed the embodiment of Henri Murger's *Scènes de la vie de Bohème*.

By 1903 the café was in danger of being demolished to make way for speculative development. Aristide Bruant, the cabaret singer whom Toulouse-Lautrec had immortalized, bought it. Bruant commissioned a comic artist, André Gill, to paint a suitable scene, that of a rabbit wearing a sash, bow tie, and porkpie hat, balancing a

wine bottle, and jumping out of a frying pan. That was the "Lapin à Gill," Gill's rabbit, which soon became the "Lapin Agile," a name that suited it just as well. Bruant knew everybody and quite soon everybody arrived. Along with the small-time criminals who had frequented Les Assassins, there were poets like Guillaume Apollinaire and Max Jacob, writers like Francis Carco and André Salmon, and, most of all, artists: Picasso, Braque, Derain, Vlaminck, Valadon, Utrillo, Gris, and so many others. With his usual perspicacity Modigliani at once attached himself to the list.

Returning years later, Carco would discover that not much had changed. "Here behind the wall of the old Calvary graveyard are the big trees, whose leaves in autumn covered the illustrious slabs and fell into our glasses. Here are the innumerable lights of Paris and the same wind which makes them twinkle as before."

Recollection had transformed what was a modest dwelling, hardly more than a single large room with a low ceiling, some long rough tables, and wooden chairs, into a magical space. The Lapin Agile would become part of the "true" Montmartre before the tourists arrived, where the meaning of art was earnestly debated, where poems were recited, songs were sung, and the last guests left at dawn. Carco wrote, "And indeed, under the lamps veiled with red

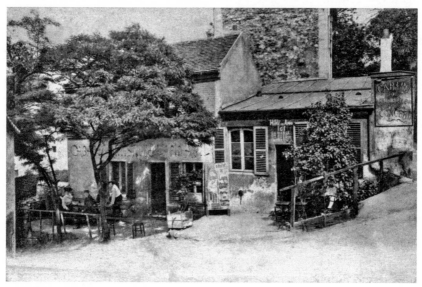

Cabaret du Lapin Agile

silk handkerchiefs, . . . where Frédéric sang, who did not feel as if drugged with some powerful opiate? No dream nor pleasure even approaches that sensation . . . A very special sort of intoxication, mixed with fancies and depression, uncertain and voiceless . . . It really rained on those nights, while the drunkest lay stretched upon the benches and innocent white mice, friendly yet cautious, trotted along the mantelpiece."

Part of the allure was provided by the proprietor, Frédéric Gérard, known as Frédé, a man of unsuspected talents who began on the street selling fish before scraping together enough money to buy a small cabaret and then the Lapin Agile. Frédé had an unkempt beard, straggling hair shoved under a fur hat, a sweater, and boots, and was essentially a cabaret artist. Le Zut, his previous nightspot, had been frequented by the young Picasso, who had helped white-wash the walls. One night after several sangrias Picasso had painted a mural, the *Temptation of St. Anthony.* When Frédé set himself up in a new location, Picasso came with him. Frédé would play and sing, his daughter would pass the hat, and bit by bit the walls would fill up with paintings, the accepted unit of exchange for artists down on their luck. Picasso contributed *Arlequin et sa compagne,* there were some early Utrillos, drawings by Steinlen, a statue of Apollo Mus-agetes, a Hindu God, and a gritty anonymous sculpture of Christ on the cross that everyone autographed. Frédé was the soul of good humor, greeted each arrival by name, and would invariably wish his regulars a good digestion. This, Philippe Jullian quipped, they needed in order to "swallow his special cocktail, a mixture of Pernod and grenadine."

Nina Hamnett, the English sculptor, recalled that they drank kirsch with small plums inside and, although she conceded Frédé played a fine guitar, was one of those who did not warm to him and always ended up in an argument whenever she went to the Lapin Agile. It would seem that the portrait of Frédé, as fondly delineated, has been extensively retouched.

"The picture of 'le brave Frédé' that emerges from the more nos-talgic memoirs of the period—singing his famous repertory of street songs, playing the cello, clarinet and guitar by ear . . . baking pottery in his kiln, helping his Burgundian wife . . . serve up appetizing din-ners (wine included) for two francs a head and being a supportive

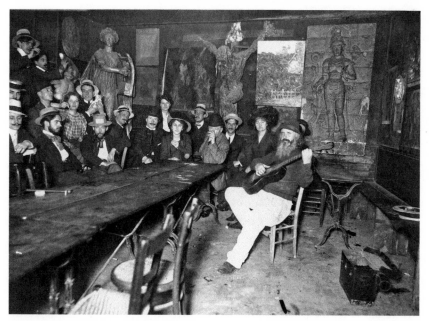

A typical evening at the Lapin Agile

father-figure to one and all—is too good to be true," John Richardson wrote. " 'Frédé was a ruffian,' Picasso said." And if Frédé one day succumbed to the lure of tourism and selling cheap souvenirs, he had at least given the artists of Montmartre some unforgettable memories. Part of the café's charm, Carco continued, "came from the surroundings of confused bric-à-brac, from the obscene mouldings, from the immense plaster Christ, from Picasso's canvases, Utrillo's, Girieud's . . . And Frédéric with his guitar . . . the dampness of the walls, the hidden despair of us all, our poverty, our youth, wasted time, completed the atmosphere."

Modigliani, making himself a part of the new crowd with ease, had the rare gift of being perfectly delighted in any company. One sees this in a series of candid camera photographs taken by Cocteau during World War I and published by Billy Klüver and Julie Martin in *Kiki's Paris*. Modigliani is all eager attentiveness as Picasso explains a joke to André Salmon to which, no doubt, he is about to add an irresistible coda. This ability to make friends was a consequence, per-

haps, of having grown up in his mother's *"smala,"* when one never knew which relative or dear friend might be sitting down to dinner with the family or have arrived for an indefinite stay. Modigliani is the subject of so many accounts, as he meets a friend by chance, or appears at a sidewalk table, or invites a third to his studio and a fourth to a musicale, that one believes he was seldom alone.

Meidner wrote, "At this time he was not ... the gloomy, cynical and sarcastic person his biographer [Arthur] Pfannstiel describes, but rather lively and enthusiastic, always sparkling, full of imagination, wit and contradictory moods ... I was overwhelmed by his open attitude towards everything, in particular whenever he spoke about beauty. Never before had I heard an artist speak with such ardor."

The writer Ilya Ehrenburg thought his work showed "a rare combination of childlikeness and wisdom. When I say 'childlike' I do not, of course, mean infantilism, a native lack of ability or a deliberate primitivism: by childlikeness I mean freshness of perception, immediacy, inner purity." "I can see Modigliani now," Maurice de Vlaminck wrote in 1925, five years after his death, "sitting at a table in the Café de la Rotonde. I can see his pure Roman profile, his look of authority; I can also see his fine hands, aristocratic hands with sensitive fingers—intelligent hands, unhesitatingly outlining a drawing with a single stroke." Gino Severini said, "He did not need stimulants to be brilliant, alive and full of interest every moment of his life. Everyone loved Modigliani."

In those days artists were expected not only to dress distinctively—hence the uniform of *"les rapins,"* with their corduroy trousers and capes—but set the fashion. Picasso inspired a rash of early imitators with his pair of faded and patched blue overalls, red-and-white-dotted cotton shirt, espadrilles, and cap. Quite soon after arriving in Paris Modigliani seems to have abandoned his expensively correct clothes for something more appropriate. He chose a suit of chocolate-brown corduroy with a matching vest, an open-necked shirt, and a red kerchief. It was, in fact, an outfit that harked back half a century, since the sculptor Auguste Clesinger (1814–1883), who was photographed by Nadar in 1860, was wearing the identical outfit.

Roger Wild described the effect as somewhat careless but with calculated intent. There was the suit of faded velvet, the shirt of blue

and white check, "the only one he owned but that he washed out every night, and a tie that was always awry. He would have found it shocking, it seems, to wear a tie on straight like the rest of the world." Still there was something about him, an eclectic kind of style setting, according to a friend quoted in *Artist Quarter.* "He was the first man in Paris to wear a shirt made of cretonne . . . He had colour harmonies that were all his own." Picasso did not hide his admiration for Modigliani's sartorial style. "There's only one man in Paris who knows how to dress and that is Modigliani." Abdul Wahab, another artist in Modigliani's circle, recalls that Picasso and his friends were seated at a sidewalk café when they saw Modigliani approaching. He was with a friend not known for his sartorial attention to detail. Picasso said, "Look at the difference between a gentleman and a parvenu." He was, Jean Cocteau wrote, "our aristocrat."

The "true Montmartre" in which Modigliani found himself in 1906 was still, in all essential respects, a village. It was one that Haussmann's zeal to obliterate had spared, and was being minutely documented by Eugène Atget at a moment when the buildings were in a picturesque state of decay, old windmills still dotted the landscape, its slopes were still covered with grape vines and vegetables, and nights were absolutely silent. By the time Modigliani arrived anyone who was anyone, with the exception of Vlaminck and Pierre Matisse, was already living there. Marcel Duchamp, Jean Renoir, and Théophile Alexandre Steinlen lived on the rue Caulaincourt. Edgar Degas was on the rue de Laval, Pierre Bonnard on the rue de Douai, André Derain on the rue de Tourlaque, Marie Laurencin on the rue Léonie, Georges Braque on the rue d'Orsel, and Francis Picabia on the rue Hégésippe Moreau. Picasso, Kees van Dongen, and Juan Gris were living in the Bateau Lavoir. This squalid tenement began life as a piano factory and, later, a locksmith's workshop, before being turned into artists' quarters in 1889. The Bateau Lavoir was, presumably, so-called after the laundry boats moored along the Seine that always smelled of wet, dirty clothes. Philippe Jullian wrote, "[T]he huge building, with walls made of brick and timber pierced by enormous windows, was on four floors built against the side of the Butte, facing a narrow courtyard flanked on its other side by a blackened retaining wall." Richardson, Picasso's biographer, observed, "The place was so jerry-built that the walls oozed moisture . . . hence a

The Bateau Lavoir, Montmartre

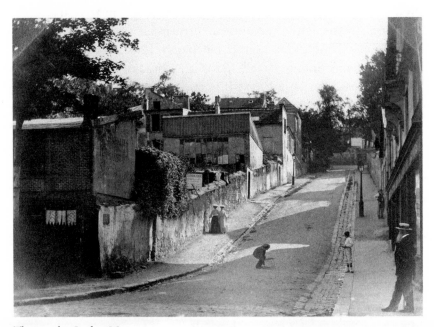

The rue des Saules, Montmartre

prevailing smell of mildew, cat piss and drains . . . On a basement landing was the one and only toilet, a dark and filthy hole with an unlockable door . . . and next to it, the one and only tap." But the rent was cheap—only fifteen francs a month, compared to one franc a night for the most modest hotel, and Picasso moved in. Later, so would Modigliani.

Most of the young and aspiring tenants of the Bateau Lavoir were inured by conditions which, in the days before plumbing and central heating, were common, even in middle-class habitations. What counted most was seeing and being seen, within walking distance of those impromptu meeting places and vital centers of warmth, the Chats Noirs and Lapins Agiles of the shifting moment. Besides, despite the builders, Montmartre was still a village, albeit an ancient one, inhabited since pre-Roman times. After the Romans moved in they erected temples to their gods. In the Middle Ages abbeys were built there, including windmills that were ecclesiastical property, and it was probably then that the Mont des Martyrs, or Hill of Martyrs, acquired its name. Montmartre also became associated with the underworld as a consequence of the gypsum quarries that had been worked since the sixteenth century. By the nineteenth the hillsides were riddled with labyrinths, an ideal refuge for rogues and vagabonds. On the outskirts of Paris, but a part of it: Montmartre was the refuge of nonconformists and rebels, the indigent, the working poor, and all the other untouchables.

After 1860 when the commune of Montmartre became incorporated into Paris, a raffish bunch of musicians, painters, and poets arrived, attracted by the light and the cheap rents. "It was in Montmartre that the cult of the artist, the artistic manner evolved from the writings of Baudelaire, developed," Jullian wrote. "The artist had none of the preciosity of the Anglo-Saxon aesthete; he had a taste for Beauty certainly, but he was free to find that beauty in scenes of misery and among the dregs of humanity." Of course, they all knew each other. "Montmartre was, above all else, a society of friends; everyone was in and out of each other's houses all the time and the girls [models] went from one studio to another."

The exact moment at which Modigliani left his hotel, the Bouscarat on the Place du Tertre, and moved into his shed in the Maquis, has not been recorded, although it must have happened sometime in

1907. André Utter, an amateur painter who married Utrillo's mother, Suzanne Valadon, met Modigliani one day by chance. He was outside painting a street scene when Modigliani walked up to him and started talking. In the course of the conversation Modigliani said he had just returned from London, which would put the probable date as late in 1907, and even claimed to have exhibited with the Pre-Raphaelites.

It appeared that Modigliani was penniless and his bill at the hotel weeks or months in arrears. The proprietor was holding his paintings as security, and Modigliani did not know what to do. In short, his days as a young man of means were ending. It is repeatedly asserted that Modigliani was a spendthrift. Although so many claims about his behavior are suspect, this one rings true, if only because of his family's history and the Garsin predilection for taking advantage of good times and drowning in debt in lean ones. Breeding, bearing, seigneurial largesse—these were the lessons they had imparted. Prudence was not one of them. So Amedeo spent with a free hand and endured when he did not. On the other hand, times of want called for ingenuity and planning, in which he was also schooled. An early lesson arrived fortuitously at the Bouscarat. One night the ceiling plaster of his room fell on his bed with a crash. He was unhurt. But Modigliani, at his most ingenious and inventive at such moments, talked about head injuries and the prospect of lawsuits. The proprietor said, "Oh get to hell out of it and take your rotten junk with you." This wonderful piece of luck never happened again, but it gave Modigliani an idea.

It seems that Modigliani was never actually destitute since Eugénie and Mené contributed a small stipend. Even so he often went hungry. To have reached the limit of one's resources was described in 1903 by James Joyce. He wrote from Paris: "Dear Mother, Your order for 3s 4d of Tuesday last was very welcome as I had been without food for 42 hours. Today I am twenty hours without food. But these spells of fasting are common with me now and when I get your money I am so damnably hungry that I eat a fortune (1/-) before you could say knife ... If I had money I could buy a little oil stove (I have a lamp) and cook macaroni for myself with bread when I am hard beat." Joyce's attempt to find fame and fortune in Paris ended when, two months later, he returned to Ireland for his mother's funeral.

Before he became well known, Carco knew more tricks than

Joyce did on how to survive in Paris. For instance, *L'Intransigeant* was the preferred newspaper for stuffing mattresses because it had six more pages than the other dailies. As for breakfast, the trick was to creep into buildings just after the morning milk and rolls had been delivered but before the owners were awake. Finding lunch and dinner was harder even if you were prepared to root around in the gutters of Les Halles after the morning's market. On the other hand, food was cheap, and three francs a day, the wage paid to municipal street sweepers, was a fortune. Carco wrote, "In the Rue de la Montagne Sainte-Geneviève, where . . . I . . . was learning to set type and print books . . . meals cost twelve sous. Bread, ten centimes; meat, thirty centimes; vegetables, fifteen; hot chocolate, one sou, so that from three francs there was enough left for luxury." Nevertheless the cheapest meal costs too much when you have no money. Modigliani had a solution for that.

The uncharming Rosalie Tobia enters the story at this point. She had posed in the nude for Bouguereau, Carolus Durand, and Cabanel and had lovers. At that stage it was impossible to imagine since she was completely shapeless, with sagging breasts, a dirty dress, and some sort of net or Neapolitan kerchief covering her stringy hair. Rosalie was owner of a tiny restaurant, Chez Rosalie, on the rue Campagne Première, narrow, smoky, and dimly lit, reeking of boiled cabbage, which she ran with her son Luigi. While she stirred the soup with a wooden ladle, Luigi, in shirt sleeves and wrapped in a blue apron, would be drying glasses and dishes with a filthy rag.

Chez Rosalie advertised itself as a crémerie, serving café au lait and chocolate, but was, in effect, a kind of personal charity. Rosalie would trudge to Les Halles before dawn each morning to buy the day's provisions, returning on the Métro with a sack on her back. She had a quick temper, one that concealed a warm heart. Any stray dog or cat at the door was sure of a meal. She also fed mice and the rats in nearby stables, to the exasperation of her neighbors. Starving artists were another specialty. She would assemble a group at one of her four marble-topped tables, disappear into her minute kitchen, and appear with an enormous bowl of steaming spaghetti, then bang it down in the middle of the table. There would be cheap wine and few leftovers. Those who could pay, did. Those who could not, ate anyway.

Lunia Czechowska, who knew Modigliani in the last years of his life, explained that Rosalie had her protégés but Modigliani was in a category all his own, "her god." He liked the Italian dishes she favored with plenty of oil and would say, "When I eat an oily dish it's like kissing the mouth of a woman I love." If he had nowhere to stay he would bed down on sacks in the back and, on good days, help Rosalie peel the potatoes and string the beans. On bad days, she would try to get him to pay his bill and he would reply, "A man who has no money shouldn't die of hunger." That would start a fight. "Dishes and glasses would be thrown and sometimes Modigliani would rip his drawings off the wall," Martin and Klüver wrote. According to Czechowska, Modigliani's solution would be to start talking in French, which Rosalie barely spoke, and that would end the matter.

Payment was simple: another drawing, Rosalie complaining all the time that she had too many already. The legend, probably true, is that she kept them, covered with grease, in a kitchen cupboard, the rats gnawed away at them, and when she thought of cashing them in it was too late. But then, art appreciation was hardly Rosalie's strong

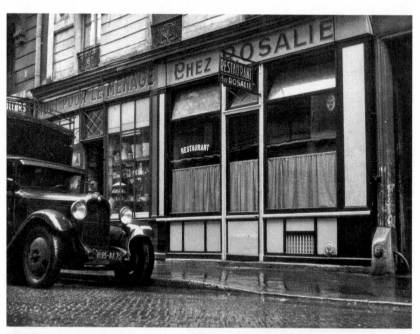

Chez Rosalie, where Modigliani could always be sure of getting a meal

point, despite the Modiglianis, Kislings, Picassos, Utrillos, and the like on the yellow-stained walls. Marevna tells the story that, to atone for some of those free meals, Modigliani once painted a fresco on one of her walls. Rosalie was so disgusted that, next day, she made Luigi cover it up with white paint.

Modigliani's descent from comparative wealth into want, like that of his parents some twenty years before, was enough for friends to notice but an indignity he endured in silence. Meidner wrote, "Modigliani seemed to be in the direst of financial straits. I often heard him barter with his acquaintances on this account, but we never discussed money. Although I was not badly off at this time Modigliani never addressed such requests to me—I don't know why. He was very proud in this respect. A year later, when his plight was quite desperate, he would absent himself for days on end in order to find some money, either by selling his drawings or by selling the works of another artist to a dealer." Perhaps some artist's model would take pity on him and stand him a drink or dinner. In the meantime he lived where he could for as long as he could, choosing the right psychological moment to disappear into the night. He would surface in a new quarter, with a new landlord, a new address, and a fresh neighborhood of restaurants where he could run up more bills. Researchers are still trying to list all his addresses and puzzle out the reason why he moved so often, which would have given him a laugh.

Louis Latourette provides an invaluable insight into the life of the young man with whom he strolled the boulevards in 1906–07. "As we left the restaurant I was astounded to see [that my companion] was carrying a copy of a book by [a philosopher], Le Dantec," Latourette wrote. " 'I adore philosophy,' he told me. 'It's in my blood,' " explaining the family legend that put him in a direct line with Spinoza.

"In the course of a long evening walk on the terrace of the Sacré-Coeur, he recited numerous passages from Leopardi, Carducci and above all the *Laudi* of d'Annunzio, about which he was passionate. Then he launched into an ostentatious discussion of the works of Shelley and Wilde." (This, it should be noted, was a conversation with a poet.) "There wasn't a single word about painting," Latourette said.

Another friend, Roberto Rossi, who became a well-known sculptor in Italy, discovered Modigliani's equal responsiveness to music.

Rossi said, "I would often go to the 'Concerts Rouges' in the rue de Tournon. You could listen to the program there for 1 franc 25." One evening soon after his arrival in Paris, he happened to be sitting near Modigliani for a program of the music of Boccherini. "We quickly realized we were from the same country. When Modigliani and I were together we spoke our Italian, flavored with Florentine expressions . . . Our first conversation was as much about friends we had in common in Florence as it was about the music of Boccherini. I would tell he had a deep sensibility by the way he half-closed his eyes when he spoke about the music."

Modigliani was sure of his talent but had not yet found a sense of direction. Louis Latourette thought he might even have been disoriented by the multiple possibilities. When the poet went to visit the painter, the studio was in chaos, its walls covered with canvases, its floors littered with paper, and boxes overflowing with drawings. Modigliani's mood was despairing: he was going to throw everything out. Perhaps it was the fault of his Italian eye; he could not get

Rosalie

used to the subtle watercolor light of Paris. "You can't imagine how many times I've started again with themes in violet, orange and deep ochre." Max Jacob, a poet and writer who was also an artist, understood why Modigliani was struggling. What he was seeking was perfection itself. He wrote, "Everything in Dedo tended towards purity in art . . . a need for crystalline purity, a trueness to himself in life as in art . . . [T]hat was very characteristic of the period, which talked of nothing but purity in art and strove for nothing else."

Among the litter was a piece of sculpture, the torso of a young girl; it reminded Latourette of an actress who used to recite Rollinat's verses at the Lapin Agile. Modigliani treated it with scorn. "It's nothing! Imitation Picasso, a wash-out. Picasso would kick this monstrosity to pieces." But a few days later, when Modigliani announced that he had destroyed almost everything except for a few drawings, Latourette noted that the sculpture had been saved. Modigliani was half thinking of giving up painting and going back to sculpture. Curiously enough, the young Henri Gaudier-Brzeska was coming to the same conclusion at about the same moment. "Painting is too complicated with its oils and its pigments, and is too easily destroyed," he wrote to a friend. "What is more, I love the sense of creation, the ample voluptuousness of kneading the material and bringing forth life, a joy which I never found in painting; for, as you have seen, I don't know how to manipulate colour, and as I've always said, I'm not a painter, but a sculptor . . . [S]culpture is the art of expressing the reality of ideas in the most palpable form."

Unlike Gaudier-Brzeska, Modigliani did not work from clay but directly from stone in the Italian style. Still, one may assume he shared similar sentiments. He wanted sculptural density and weight, he wanted roundness and monumentality, the exhilaration of creation and the feeling of the stone against his hand. He had begun experimenting again in that direction, his invariable plan being to court the masons working on new buildings over a bottle of wine and then make off with a block of stone. He was not yet ready to concentrate on sculpture alone; that would take another two or three years. Meantime he began to refine his already formidable techniques for eating without paying.

Gino Severini, the Futurist painter, recalled that he was having dinner one evening in a Montmartre café when Modigliani appeared,

sans le sou and looking very hungry. Severini invited him to join him, and Modigliani ordered a meal. Severini, however, had no money either and was eating on credit. As the end of the meal approached Severini became more and more anxious. What was he to do? Modigliani knew him well enough to know that, once under the influence, Severini would collapse with laughter. So Modigliani quietly slipped him a small amount of hashish. It was an instant success. When the bill was presented Severini immediately saw the funny side. He smirked, he giggled, he let out a belly laugh. It really was a joke. It was a riot. He cried with laughter. He was doubled up. He almost rolled on the floor. Evidence that he made a total spectacle of himself was not long in coming; the owner threw them both out.

At that moment Modigliani was exhibiting, trying to sell his work, and looking for a dealer. No longer was the Salon, that fortress of the artistic establishment, the only place an artist could exhibit, or even the Salon des Réfusés, established by the Impressionists in the 1860s. Now there was the Salon des Indépendants, established by such artists as Georges Seurat, Odilon Redon, and Paul Signac. And there was yet another anti-establishment venue, the Salon d'Automne. The creation of a prominent architect and writer, Fritz Jourdain, the Salon d'Automne attracted a socially prominent crowd when it opened its doors in October 1903. At the Petit Palais, Proust, in white tie and tails, mingled with the politician Léon Blum and the aristocratic Comtesse de Noailles. It was a success on every count and became at once a major goal of every young unknown. In 1907 the Salon accepted seven works by Modigliani: the portrait of Meidner, a *Study of a Head,* and five watercolors.

Again, nothing sold. But in this case, it hardly mattered. The event also exhibited forty-eight oils by Cézanne, the master of Aix who had died the year before. His watercolors were concurrently on view at the Galerie Bernheim-Jeune. Modigliani was taken by storm. "Whenever Cézanne's name was mentioned, a reverent expression would come over Modigliani's face," Alfred Werner wrote. "He would, with a slow and secretive gesture, take from his pocket a reproduction of 'Boy With Red Vest,' hold it up to his face like a breviary, draw it to his lips and kiss it." That was the year that Modi-

gliani visited Picasso's studio in the Bateau Lavoir and saw *Les Dem-oiselles d'Avignon,* historically considered the birth of Cubism. The painting of four naked whores in a brothel met with puzzled incomprehension when it was first viewed. Richardson wrote, "Although friends sympathized with his aspirations, none of them was capable of understanding the pictorial form that these aspirations took. When he allowed Salmon, Apollinaire and Jacob to see the painting, they . . . took refuge in embarrassed silence." Modigliani admired Picasso without reservation. "How great he is," he once remarked. "He's always ten years ahead of the rest of us."

The fact that, unlike Picasso, who was only three years older, his work was not selling, did not disturb Modigliani, at least not outwardly. After his older brother Umberto, now on an engineer's salary, sent him some money, Modigliani's letter of thanks was calm and optimistic. "The *Salon d'Automne* has been a comparative success and acceptance en bloc, practically speaking, was a rare occurrence since these people form a closed clique," he wrote. He hoped to exhibit at the Salon des Indépendants in the spring of 1908. "If I give as good an account of myself at the *Indépendants* I shall certainly have taken a first step forward."

Noël Alexandre is a middle son, one of eleven children of Dr. Paul Alexandre, who saw Modigliani almost every day in the years leading up to World War I, as friend, confidant, and his first collector. Noël Alexandre is also author of a landmark study, *The Unknown Modigliani, Drawings from the Collection of Paul Alexandre,* that accompanied an exhibition at the Royal Academy of Arts in London in 1994. The exhibition was in the nature of a revelation since it not only showed some four hundred drawings that had never been exhibited before, but contained previously unknown letters, photographs, an account of Modigliani's life sent by his mother in 1924, letters from Jean, Paul Alexandre's brother, Paul Alexandre's own letters and reminiscences, and a totally fresh view of Modigliani's personality and the development of his talents.

One spring day I was invited for lunch in the country house in suburban Paris owned by Noël Alexandre and his wife, Colette Comoy-Alexandre. We lunched in their light, airy living room, its French

Colette Comoy-Alexandre in her country garden, Sceaux, outside Paris

windows opening onto a country garden with apple blossoms scenting the air. The lilacs were in bloom and Colette Comoy had placed vases of them ascending the steps of a curving staircase. It was the first of what would become several illuminating encounters in which Noël Alexandre explained that the "legend" of Modigliani had led him to revisit the story from the beginning. These stories were canards, completely at odds with everything he had learned from his father. He was determined to destroy the false image of Modigliani that had been created down through the decades.

Paul Alexandre, born in 1881, was the son of Jean-Baptiste, a prosperous pharmacist living in an hôtel particulier in Paris that has since become an embassy. (The address then was 13 avenue Malakoff, now avenue Raymond Poincaré.) He and his younger brothers, Pierre and Jean, went to a Jesuit College in the rue de Madrid. Paul became a dermatologist and Jean, a pharmacist like their father. Paul's interest in art began at an early age. He loved visiting the Louvre, and when his parents decided to redecorate their large living room Paul persuaded them to employ Geo Printemps, a young artist friend of his. Printemps brought someone with him to help, a budding sculptor named Maurice Drouard. Paul and Maurice became fast friends, and the young medical student was embarked on the other passion of his life, art, and artists.

Through Drouard, Paul Alexandre met a whole group of painters and sculptors that included Henri Doucet, Albert Gleizes, Le Fauconnier, and, in particular, the sculptor Constantin Brancusi, who was to play an important role in Modigliani's life. In those days Paul Alexandre was renting a room in the rue Visconti and sharing it with two brothers of a friend from the Jesuit College, Louis de Saint-Albin. This was fun, if a bit cramped, so they used to meet at a

café nearby, Mauguin's in the rue de Buci, which was famous for its two-centime coffee and usually jammed. Then Paul Alexandre had the idea of renting a private room on the first floor of a nearby restaurant and inviting his friends there once a week. After awhile that was too small as well. Then Paul Alexandre decided to rent a house.

Noël Alexandre said, "My parents had the first floor on the avenue Malakoff [American second]. My grandmother was on the second floor. We children had the third floor, and on the fourth, there was an enormous salon with grand pianos at either end where

Noël Alexandre, a son of Paul Alexandre, Modigliani's first patron

my father's friends would come to practice for their concerts. It was a liberal atmosphere but still, my father was living with his parents. When one is between twenty and thirty, one wants to be a bit more independent."

Then, in 1907, Paul Alexandre discovered a pavillon at 7 rue du Delta. Thanks to his collection of photographs, just what the house looked like has been preserved in handsome detail and is revealed as a picturesque two-story semiruin. Its twelve rooms and floor-to-ceiling shuttered windows were oriented toward a plot of wasteland fenced off from the street. The house was owned by the city of Paris and was slated to be demolished. Paul Alexandre pulled some strings and rented it for a trifling sum for the next six years. It evidently represented a retreat and an escape, but it was more than that. Perhaps it was the discovery of just how desperate for money young artists could be that influenced him. The young doctor, gregarious by nature, in love with art and generous in spirit, created a meeting place for artists who came and went, knowing they had a place out of the rain, a bottle of wine, a meal, and somewhere to sleep, even if it was only the floor.

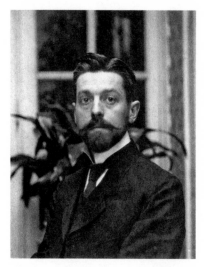

The young doctor Paul Alexandre in
1909

The first tenants, Drouard and Doucet, stayed on and on, Drouard until 1913. They brought Centore and he brought another sculptor, Guiraud Rivière. Gleizes, who fell out with his wealthy parents, arrived accompanied by some expensive-looking furniture. By then Paul Alexandre had started a clinic in a working-class part of Paris five minutes from the house. Even though a dermatologist, he wrote that "I was called out for anything. I used to be astonished at the maturity of the youngsters in this district, who played in the gutters but who, when their parents were ill, knew how to adopt adult language to fetch me and speak to the doctor. Then they would go back to their gutters." Every moment not spent caring for the sick was devoted to the rue du Delta.

There were "Delta Saturdays" when everyone came. There were chess games and gatherings with plenty of high-minded talk. Little by little the wasteland behind the house was cleared, tables and chairs set out, flowering vines climbed the walls, and there was a stab at a lawn. There were plays, film scenarios, and racy theatricals in which Raymonde, wearing a saucy pair of high boots and nothing else, appeared from behind a curtain at the bidding of Alexandre's baton. There were "pagan dances" with the sheets from Drouard's or Alexandre's bed that Brancusi in particular enjoyed. There were readings of Villon, Mallarmé, Verlaine, and Baudelaire and afterward Alexandre would analyze what it all meant. There were musicales, and each year's "Quatz' Arts" costume ball called for months of preparation.

There was plenty of wine and there were drugs. The public menace represented by drunkenness was well understood and a law of 1873 made its public display a crime, although it was unevenly enforced. On the other hand, where everyone had wine with a meal, abstinence was unknown. "The consumption of alcohol, an accepted

The ruined, barely habitable, but romantic villa on the rue du Delta where Paul Alexandre housed a small colony of artists, as seen in 1913

sign of virility, helped create an individual's image," Michelle Perrot wrote. As for drugs, Richardson wrote that they were, as now, a way of life. Pharmacies sold ether legally for thirty centimes a dram and its excessive use was known to have hastened the death of one of Picasso's friends, the playwright Alfred Jarry. Another friend, Max Jacob, was "so addicted to this drug that he was obliged to conceal the smell by burning incense in his Bateau Lavoir studio."

Absinthe, the milky opalescent green liquid known as "La Fée Verte," was, in particular, a drink so favored by the smart set that the cocktail hour became known as *"l'heure verte."* Alfred Jarry, whose play *Ubu Roi* had made him famous but not rich, also indulged. Sacha Guitry wrote, "He inhabited a miserable, dilapidated hut on the edge of the river. You could still read on the walls the words 'Cleaning and Mending.' It had an earthen floor, and a bicycle hung from the roof, 'to stop the rats from eating the tyres,' explained the seedy-looking writer, a 'proud little Breton' with a droopy moustache and long hair which had a greenish tinge acquired from drinking strange concoctions." Despite its adherents, including Oscar Wilde, who claimed that absinthe led to wonderful visions, the conviction took hold that

A theatrical evening at the rue du Delta; Paul Alexandre, at right, is master of ceremonies. A study for Modigliani's *The Cellist* is on the wall above; from left, Luci and Henri Gazan (on the sofa), and Henri Doucet and his wife (center). The model is known as Raymonde.

"it was believed to damage the brain cells and cause epilepsy," and it was banned in France in 1914.

No such concerns were raised over the *fumeries* in Montmartre where one smoked opium; Picasso was a regular visitor. Richardson called Alexandre a "Svengali" for introducing Modigliani to hashish. But this was also legal. "Montmartre, at this time, had become infected by the craze for dope, principally hashish," Charles Douglas wrote in *Artist Quarter*. "Everyone took the fashionable drug, even the village lads. Only the apaché element resisted the new temptation. As good businessmen . . . they realized that if they succumbed it would be bad for trade."

Marevna, arriving in Paris in 1912, experimented along with everyone else. "We ate the paste in little pellets or mixed it with tobacco and smoked it. The effect on me was usually a desire to laugh, followed by a fit of weeping or chattering about everything I saw (or thought I saw). At first I liked the drug because of the extreme, almost frightening lucidity I gained from it. Then one day I jumped

through a window to the roof of the next house, imagining it was just below (it wasn't). I escaped with only a sore behind."

Alexandre's hashish parties began because he knew that the drug, cannabis, extracted from dried hemp, also caused startling visions; he thought that would be marvelous for painters. He had tried it himself. "Late one night, as I walked...all along the Champs-Élysées or the Quai d'Orsay, I could see the gas lamps rise up in tiers like notes of music on an imaginary stave and I began to sing the tune written there. From the Place de la Concorde the rue Gabriel appeared...like a magical vision. The trees, lit from underneath, seemed like the climax of a firework display."

Modigliani appeared at 7 rue du Delta one day in November, a month after his first appearance in the Salon d'Automne. He had been evicted from the Place Jean-Baptiste Clément and, it would seem, had nowhere to go. A mutual friend, Henri Doucet, brought him to the house to meet Paul Alexandre. Modigliani was accompanied by Maud Abrantes, an elegant, worldly friend who appeared to have transported the entire contents of his studio—clothes, books, and sketchbooks—in her car. Very little is known about her. She was American, married, living in Paris, and cultured, but how they met and their exact relationship is unknown. Modigliani made several studies of her and painted her portrait in grayed-off pastels. Her features, well marked and handsome, are notable for the eyes, which are disproportionately large, and smudged with blotches of paint as if to indicate mute suffering. What is curious about Modigliani's arrival at the rue du Delta is that, although supposedly homeless, he never took up lodging there and spent that particular night in a hotel on the rue Caulaincourt. Apparently the lady was paying.

Modigliani was looking for studio space, and after finding it nearby he came and went like a member of the household. Paul Alexandre wrote, "Modigliani charmed everybody immediately. He trusted any stranger we might introduce to him, and was completely open, with no pretences, inhibitions or reserve. There was something proud in his attitude and he had a good firm handshake. Modigliani was more than an aristocrat, 'une noblesse excedée' ['surpassingly noble'], to use an expression of Baudelaire's which fits him perfectly."

Modigliani became Alexandre's latest cause. The latter introduced him to everyone and began commissioning portraits. Alexandre

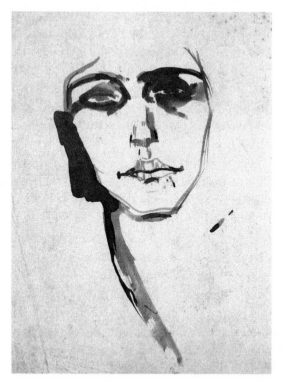

Modigliani's study in watercolor of Maud Abrantes

wrote, "He already had a deep-rooted confidence in his own worth. He knew that he was an innovator rather than a follower, but he had not as yet received a single commission." Alexandre's first project was a portrait of his elegant, reserved father. As was his custom Modigliani made a number of delicate sketches before trusting himself to paint a portrait of Jean-Baptiste Alexandre, seated, in black, with a high collar, in tones of bluish charcoal, grayed-off greens, and pinkish maroons. The old man confronts the viewer with grave distinction, his white beard precisely trimmed to reveal a pink bottom lip, his eyes tired but calm. He has a natural authority and so does his son, who strikingly resembles him. In one of several paintings by Modigliani Paul Alexandre is standing against the same background. His hand is on his hip, there is the same-shaped face, the same steady, unsmiling look, the same air of reserve. There is no hint here of the admirable qualities of both men: a high-minded, idealistic view of life and a spontaneous benevolence. In Paul Alexandre, young as

he was, Modigliani had found someone with an eighteenth-century concept of the patron who recognizes, and nurtures, a rara avis. He was twenty-six; Modigliani was twenty-three.

They became inseparable. As long as the drawing show of Cézanne's work was still at Bernheim's they returned day after day. Alexandre wrote, "I remember an anecdote about his visual memory, which was extraordinary: once, to my great astonishment, he drew from memory and at a single attempt Cézanne's 'Boy with a Red Waistcoat.'" At Vollard's gallery in the rue Laffitte they studied a series of Picasso's Blue Period paintings. At Kahnweiler's in the rue Vignon Modigliani was transfixed by an unobtrusive watercolor of Picasso's that, curiously, represented a young fir tree, turning green, encased in blocks of ice. When they went to visit Henri (Le Douanier) Rousseau, who died shortly thereafter (1910), Modigliani drew Alexandre's attention to one painting, *The Wedding* (1904–05), in which a family group, transfixed as if posing for a camera, stands expressionless under a bower of trees. Whether assessing Nadelmann's bronzes or the work of a young unknown, Modigliani gave it the same concentrated study and generous praise. There was "no trace of envy or disparagement," even if the owners did not return the compliment.

As Picasso's fir tree in ice would suggest, Modigliani, with his actor's instincts, was fascinated by the boundary line between fantasy and reality. Unexpected juxtapositions and intense visual sensations interested him in particular. They used to go to the old Gaité-Rochechouart, which had mirrored walls, meaning that, if one sat in the right seats, the performance at center stage would be split into a million tiny reflections. Modigliani was just as dazzled by the circus, which presented so many unexpected possibilities: clowns with gaping mouths, acrobats dangling and twisting from wires, harlequins with grinning faces and, in particular, Columbines, a series of lovely brazen women wearing skirts and not much else. Modigliani was famously dissatisfied with his drawings. Alexandre observed that when an image attracted him he would work on it with demonic speed, drawing it over and over again. The line had to begin in just the right way and continue with the right assurance and verve. "This is what gives his most beautiful drawings their purity and extraordinary freshness." Anything less than perfection would be tossed on

the floor. This is where Alexandre made, perhaps, his ultimate gift to posterity: he picked them up.

One of the drawings in the collection, curiously, not given to her but to Paul Alexandre, was of Maud Abrantes writing in bed. Her classical, almost Roman profile is revealed as she concentrates on a letter, which is barely indicated. The drawing is concerned with her intensity of focus and the expressive curve of her shoulder as she bends over her task. Paul Alexandre cautiously sketches in his own bare outline: she sat for Modigliani, came regularly to the rue du Delta for about a year, and drew when she felt like it. She returned to New York in November 1908. There is one postcard from her to Alexandre, written in French on the ocean liner *La Lorraine.* It says simply, "Are you still reading Mallarmé? I couldn't tell you how much I miss all those charming evenings we all spent together around your warm fire. Oh what a wonderful time!" She was pregnant. Alexandre wrote, "We never saw her again."

Several biographers have asserted that Alexandre acted as Modigliani's doctor. His son Noël denies this. There was no reason for any medical attention; Modigliani's tuberculosis was in complete remission and he was seldom ill. The other assertion, popularly made, that he either became an alcoholic on arrival in Paris or already was one, was also not true. Numerous witnesses, Soffici and Ludwig Meidner among them, make it clear that he only drank in moderation. Charles-Albert Cingria, a writer, said, "Certainly he drank . . . but no more nor less than others at that time." Latourette said that he liked Vouvray or Asti, but in moderation. Noël Alexandre said, "You know when one is poor and the work is hard, a glass of wine is just the thing. It is nourishing and gives you back your strength. It's what poor people do."

As for drugs Modigliani experimented with hashish along with everyone else. Once while under its influence he drew a series of marionettes, so-called, formally posed figures reminiscent of Rousseau's *The Wedding,* in which the participants have become so abstracted they look like statues. The crowd in the Delta also liked the idea and experimented with it. However, Modigliani seldom drew while taking hashish, preferring to recall his visions in sobriety with the

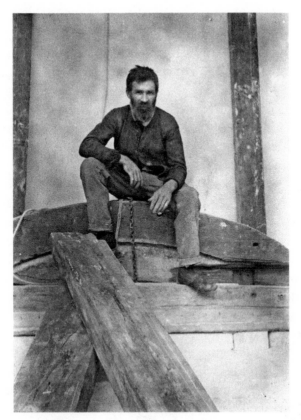

Brancusi, 1905

aim of reproducing the heightened effect. Sometimes the borderline between sobriety and intoxication was blurred. Alexandre remembered the night when they were on their way back to Montmartre in the Métro and a train burst onto their station platform. "It was as if an amazing orchestra with millions of extraordinarily powerful cymbals had swept in like a whirlwind." There are, from time to time, references to a small amount of cocaine that Modigliani was said to have carried. Again, this was an age when drugs were in general use, treated like snuff and used accordingly.

The person who did need Alexandre's professional help was another close friend, Constantin Brancusi. This sculptor, now considered "one of the most original, persuasive and influential sculptors in the history of art," was that rarity, an authentic genius from a peasant family, minimally schooled, unintellectual, and intuitive.

He began by learning the traditional methods of working in wood in his native Romania and showed such promise that he was awarded a scholarship to the National School of Fine Arts in Bucharest. At the end of his studies, his goal was Paris. He actually walked most of the way, via Vienna, Munich, Zurich, and Basel, working as a farm laborer in exchange for a meal or a bed for the night in a barn. He arrived in Paris in 1905 when he was twenty-nine and enrolled at the École des Beaux-Arts, then began to exhibit at the Salon d'Automne.

Brancusi never lived at the rue du Delta but he and Alexandre would walk in the woods at Clamart, talking constantly about art. In contrast to the Cubists, who wanted to break up and rearrange the visual image, Brancusi believed with Nicolas Boileau, a seventeenth-century French poet and critic, that *"rien n'est beau que le vrai"* — nothing is beautiful but the true. His whole effort was "to preserve the integrity of the original visual experience," Herbert Read wrote, and to reduce the object to its essentials. One of his first success-ful sculptures, *The Kiss* (1908), directly carved from a single block of sandstone, was passion reduced to its essentials, the unity of two locked in a single embrace. Read wrote, "The egg became, as it were, the formal archetype of organic life, and in carving a human head, or a bird, or a fish, Brancusi strove to find the irreducible organic form, the shape that signified the subject's mode of being, its essential real-ity." Searching for the reality behind appearances: this, in Modiglia-ni's case, was wedded to his belief in art as a magical force offering the path to exorcism and transfiguration. "Then glut thy sorrow on a morning rose." Brancusi and Modigliani were destined to be friends.

Brancusi had taken a studio in the Cité Falguière, rue de Vaugi-rard, a ramshackle huddle of artists' studios that had, as its few com-pensations, some north-facing windows. He was scraping together a living in restaurant kitchens, perhaps as a *plongeur,* that miserable existence described by George Orwell in *Down and Out in Paris and London.* Brancusi, who looked, Anaïs Nin wrote, "like a Rus-sian muzhik" with his Santa Claus beard, found work unloading at the docks, polishing floors, and doing other manual labor. According to Latourette Modigliani occasionally found part-time work making photographic prints and retouching paintings. Alexandre denied that Modigliani ever did any kind of work. "He was a born aristocrat. He had the style and all the tastes. It was one of the paradoxes in his life:

loving wealth, luxury, fine clothes, generosity, he lived in poverty if not misery. It was just that he had an exclusive passion for his art."

One suspects that the notion that because he was so brilliant others should support him became a conviction. If so it was a viewpoint Alexandre supported by giving him special treatment. The only work on display at the rue du Delta was Modigliani's—no one else's, and obviously resented. It led to a fierce argument during which Modigliani broke some sculptures by Drouard and Coustillier. Alexandre is probably right in thinking Modigliani had "a taste for danger," as splendidly exemplified by Uncle Amédée. In common with Frank Lloyd Wright, a crisis seemed to be regarded as a personal test; it almost seemed a necessity. Speaking of such special personalities, Anthony Sampson wrote in *The Changing Anatomy of Britain,* "[T]hey have to feel they've got their backs to the wall to perform properly. If they make a lot of money they have to get rid of it, like gamblers, so they're at risk again." Such an explanation would, to some extent, account for the reckless ease with which money flowed through Modigliani's fingers, his courting of dangers within and without, his self-defeating behaviors, and his ability to endure.

There was another reason. Modigliani's attitude, rare nowadays, was perfectly acceptable in his day, almost commonplace. In *Bohemian Paris,* Jerrold Seigel writes that the poet Chatterton, who died in poverty, and whose life was celebrated in Alfred de Vigny's play of the same name, had lost status at a time when trade and the profit motive had supplanted all other values. In a former age artists might never be rich, but they could count upon the patronage of the church or the aristocracy and were honored and valued. Now art had become a commodity, to be sold for whatever the market could bear, and the artist a sort of tradesman with no special claim to respect or status.

Nevertheless, the belief that art was still a noble cause, in stark contrast to the grubby, money-focused goals of the bourgeoisie, went to the heart of the Bohemian creed. Ordinary men and women, destined to spend their lives in numbly repetitive work, looked at the Bohemian and saw a man frittering his life away in idleness, indulging in drugs, drink, and loose women. From the other side the view was equally uncompromising. Any artist who put himself up for sale was prostituting his talent and had lost his soul. Most people could not possibly understand what inner demons drove the artist toward

heights he would, perhaps, never attain. The fact that he was not bound by bourgeois standards of love and morality meant nothing. The artist's standards for himself were higher, on a more elevated plane. He was the true hero of the age in *La Dernière Aldini*, by George Sand, a novel loosely based on the career of her son-in-law, the sculptor Clesinger. As it turned out she had chosen a particularly bad example in this profligate personality whose derelictions included abandoning his wife. Never mind. An artist could not be judged, since his allegiance was to a larger cause. Balzac wrote, "Bohemia has nothing and lives from what it has. Hope is its religion, faith in itself its code, charity is all it has for a budget."

At the rue du Delta on New Year's Eve of 1908 they had prepared for a big party for weeks. The house had been decorated by Doucet. A barrel of wine, of some nondescript vintage, was hauled in and there was all kinds of food as well. There was also hashish, which, as Dr. Paul Alexandre recalled, took the evening quite out of the ordinary. He remembered seeing Utter dancing, his blond hair flying, and he could have sworn that flames were flickering around his head. He also recalled seeing Jan Marchand stretched out on a sofa. His arms were wide open and he was moaning and weeping. Someone had told him that, because of his beard, he looked like Christ on the cross. Having had too much hashish, he believed it. Modigliani, Alexandre added as if that went without saying, dominated the evening.

It did not seem to matter to Modigliani that he was hounded by debts, sleeping on the run, with no money for food and no buyers for his drawings. He was surviving somehow. Occasionally he curled up in the street, as his friends discovered one morning. He had found a cosy corner underneath a table on the terrace of the Lapin Agile and was dead to the world. Perhaps he shared the feelings of Henri Gaudier-Brzeska when he was launched on his real work at last. The sculptor wrote from Paris in 1910, "I am right now in the midst of Bohemia, a queer mystic group, but happy enough; there are days when you have nothing to eat, but life is so full of the unexpected that I love it."

———◆———

The Serpent's Skin

The morning is wiser than the evening.
—Russian proverb

DURING THOSE EARLY YEARS in Paris Modigliani's ability to find friends who made it their mission in life to care for him was, as ever, unparalleled. It was a testament to the appeal of his personality but also the persuasiveness of his convictions and the sense that here was an important artist. This made it possible for him to subsist on the margins in Paris even though (incidentally) it did nothing to curtail his ability to empty his pockets. He had not yet found a dealer or sold his work on the open market. One day he would; it was only a matter of time. Meanwhile there was always a fire at the rue du Delta, there was a meal and a glass of wine, and, when all else failed, there was a bed with the mice and rats in Rosalie's kitchen.

Just how seriously Paul Alexandre in particular took his self-imposed role is a case in point. Early in 1909 he left for Vienna, where he planned to spend a year conducting research in his specialty, dermatology. But he was not going to leave before asking his brother Jean to "keep an eye" on Modigliani, meaning, make sure

Paul Alexandre's younger brother Jean, who was destined for an early death

he was eating. Jean, two years Modigliani's junior, then studying to be a pharmacist, was living at home and working part-time. The assumption that Jean would take over the care of someone older than himself was probably accepted good-naturedly. But Jean lacked his brother's rueful awareness that, with Modigliani, whatever could go wrong, would. Shortly after Paul's departure, Jean wrote to say "I let three or four days go by without going to his studio. On the fifth day I found my Modi in desperate straits, three sous in his pocket and nothing in his stomach. I could just imagine the rest, so I lent him 20 francs."

That spring of 1909 they saw each other often. They went boating on the Marne and Jean often treated "my Modi" to an evening at the theatre. They went to the Odéon to see Marivaux's *Fausses Confidences,* whose psychological subtleties appealed to the artist. The other play on the bill, a medieval drama by Calderón, much admired by Jean, left Modigliani cold.

There were almost daily visits to exhibitions, trips to the Salon des Indépendants, an exhibition of their friend Le Fauconnier's in the rue Notre-Dame-des-Champs, Durand-Ruel's, where there was a spectacular exhibition of Renoirs, to Brancusi's studio and much else. Jean, who was working part-time and studying the rest, could not understand why Modigliani "trailed around" so many galleries, neglecting his work. If only he would stop wasting his time and pull himself together—this was an underlying theme of the two or three lengthy letters of Jean's that have survived. Jean referred to the "instability you were aware of before you left," a tantalizing reference that is not explained. He was becoming irritated by Modi's ability to make money disappear and then embarking on "the usual credit system" at his paint supplier's and restaurants. He would then

appear at Jean's door with empty pockets, and Jean, after all, only had his weekly wage.

How simple it would be if Modi could be persuaded to work! Jean knew plenty of artists who managed. Henri Gazan, habitué of the Delta, had a standing agreement to create drawings for the influential magazine *Gil Blas* and other "neighborhood rags," which helped with the monthly bills. Jean knew the editor of *L'Assiette au Beurre,* an illustrated weekly magazine of political satire that employed several artists to provide caricatures accompanied by pithy and amusing descriptions. It seemed logical to introduce the two men. But, Jean wrote, "I don't need to tell you that Modi, faced with the prospect of having to submit his drawings, never wants to go back there." The issue had been settled long before. As Modigliani wrote to Ghiglia, "Your *real* duty is to save your dream."

Jean was aware that "my Modi" was already receiving support from his family in the form of commissions. There was the matter of a portrait Modigliani was painting of him. He had also been commissioned for a portrait of Jean's aristocratic girlfriend, the Baroness Marguerite de Hasse de Villers, an accomplished horsewoman. Modigliani had begun work on both commissions, was making preparatory sketches, money had been advanced, and Jean, whose interests centered around his exams, Marguerite, the next Quat'z Arts ball, and not much else, could have been forgiven for thinking his caretaking duties had been discharged.

When he visited the studio, Jean wrote in March 1909, Marguerite's portrait had been sketched onto the canvas and looked as if it would make a wonderful composition. "As for my portrait, it would have been better if Modigliani didn't attach such enormous importance to it. I had great difficulty in preventing him from chucking it on the fire ... But I'm afraid he doesn't use his time very well, and without counting the times he's completely broke (like last week) when he can't get anything done, there are others, like yesterday, when he spends the whole day out of doors."

Jean knew that a daily progress report on what Modigliani was painting was of intense interest to his brother. Paul had helped Modigliani prepare for the twenty-fourth Salon des Indépendants in the spring of 1908. Modigliani showed a drawing, a study, *Idol,* two nudes, and a painting, *The Jewess.* This curious work shows a

woman, naked from the waist up, who may or may not be wear-
ing a hat, with a broken nose, coarse lips, and heavily lidded eyes.
The composition is set down in pastel blues and outlined with crude
brushstrokes in black, on the verge of caricature. Its title and the
manner of its depiction would suggest that some self-loathing was
involved. At any rate, it is entirely out of character with any portrait
that comes before or afterward. If Modigliani had hoped to make a
mark, as he had so calmly expected in the letter to his brother, he was
disappointed. There was no review and nothing sold.

The caricatural approach to character displayed by *The Jewess* is
entirely absent from the portrait of Jean Alexandre, painted in 1909.
The young student who, with his wide cheekbones, low forehead,
full lips, and deeply set eyes, bears scant resemblance to his father
and brother, sits facing the viewer. He supports his head against an
arm, and his look is pensive. Although Modigliani struggled with
the portrait the implication, from Jean Alexandre's letters, is that the
one of Marguerite, *The Amazon,* gave him even more trouble. Jean
wrote, "The portrait seems to be coming along well, but I'm afraid
it will probably change ten times again before it's finished." The sit-
ter, obliged to pose for hours in the Cité Falguière studio, to which
Modigliani had moved to join Brancusi, was becoming mutinous. So
Modi finally agreed to transfer the sittings to Jean's room in the rue
du Delta, where Marguerite could at least change into a riding habit
and back again with some semblance of privacy. She finally gave
Modi an ultimatum. She was leaving in a week's time and he had to
finish. So he complied. The resulting portrait of her, hand on hip, has
bold conviction but is not sympathetic. Perhaps the artist saw her as
men of his age would have done, that is, too independent-minded for
comfort.

Modigliani painted Maurice Drouard, another habitué of the rue
du Delta. His compelling study in blacks and strong background
blues heightens the effect of Drouard's almost hypnotically blue-
eyed stare. There was another beautifully realized study, of Joseph
Levi, a painter and picture restorer in Montmartre. Levi often lent
Modigliani money, and the artist reciprocated with a forceful portrait
of almost tactile strength and immediacy, in slashes of scarlet, ocher,
and black. The blunt brushstrokes suggest a brief experiment with
Fauvism, probably after a close study of Matisse and Derain.

Modigliani's style was constantly shifting. There was the seated nude of a young girl, slumping forward as if shrinking from the viewer's gaze, the whole Gauguinesque in its sumptuous use of pastels: soft pinks, mauve-grays, blues, and blue-greens. Modigliani thought so little of this small masterpiece that he used the back of the canvas for something else. The influence of Toulouse-Lautrec, evident in his drawings, can also be seen in an early profile portrait of a girl and of Cézanne in *The Beggar of Leghorn*. The unpromising subject has been transformed by a virtuoso display of color: high blues and grayed-off greens.

Modigliani was also experimenting with nude studies and, since sitters were expensive, was looking for compliant subjects wherever he could find them. One was "La Petite Jeanne," another waif the Alexandre brothers had taken under their wing. A young girl recently arrived from the country, Jeanne was working as a model in art schools and had had the bad luck to be infected with a venereal disease for which she was being treated. Just then she was in the hospital with a case of German measles and being visited by Jean and Modigliani. The artist assumed the role of immortalizing her in paint. There were two nude studies, one of which was sensitively analyzed by Jeanne Modigliani. "The reserved expression of the sulky little face on its cylindrical neck, the calm solidity of the forms, the slightly asymmetrical displacement of the figure to the left, the extremely simple but shrewd organization of the background into two zones ... her two breasts, one perfectly round, the other conical ... all these make a perfectly balanced work whose style is thought out to the last detail."

Perhaps the most fully realized of his portraits at this period is *Beggar Woman*, an example of the "cool purposefulness" and economy of means that Modigliani was beginning to display. The lowered eyes, droop of the head, and particular set of the mouth speak volumes about the misery and pride of this anonymous daughter of the people. Before Modigliani finally finished Jean's portrait he gave the painting to the latter and dedicated it to him "to keep him happy." Jean hung it on a wall of the rue du Delta along with all the other Modiglianis (interspersed with photographs of Raphaels), to the resentment of other inhabitants. The Quatz' Arts ball was imminent, but so were Jean's exams. Parties had fallen off at the Delta

along with Paul's Saturday gatherings. Everything was uncharacteristically quiet. Besides, Paul had his suspicions about how well Modi was being looked after. Three months later, to parental astonishment, Paul cut short his Viennese studies and came home.

With his probing and sensitive studies of character as exemplified by his portraits of the Alexandre father and sons, Maurice Drouard, and others, Modigliani had demonstrated his mastery of the delineation of character at an early stage. He was arriving at the end of a long line of masterful portraitists from Whistler and John Singer Sargent to Mary Cassatt and Cecilia Beaux. But the ways in which any artist could make his mark in this genre—once considered second only to large-scale narrative painting or depictions of the lives of saints—was coming to an end. There had to be a new approach, and Gauguin, Cézanne, Matisse, and Picasso thought they had found it. The secret was to be revealed in African sculpture. Most of it, from the west or central areas of the continent, had been arriving in Europe in vast quantities since the 1870s and was so little valued that it could be picked up for small change in any flea market.

Artists, however, were beginning to look at these curious objects with fresh eyes. Gertrude Stein recalled that Matisse had discovered a Vili figure from the Congo in a curiosity shop in her *Autobiography of Alice B. Toklas* (1913). Barely a year later, in 1907, Picasso began making repeated visits to the African collections at the Musée du Trocadéro. Like Matisse, Gauguin had also been attracted to the fragmented, Cubistic shapes, the pictorial flatness, and the spiritual component that they both recognized in the work, all of which suggested startling new possibilities.

Modigliani's own interest began when he saw samples of African art in the shop of an art dealer, Joseph Brummer. Then he, too, went with Paul Alexandre to the Trocadéro to see the Angkor exhibition in the Occidental wing.

Alexandre wrote that what appealed to Modigliani about these primitive sculptures with their masklike faces had to do with simplification and purification, i.e., a search for the irreducible organic form. "I remember that he would stop . . . in the place Clichy to admire those naive coloured pictures that were sold by Arabs, always

showing the same landscape: a small bridge between two mountains. This search for simplification in drawing also delighted him in certain paintings by Douanier Rousseau or in Czobel's figures from fairground stalls."

Frank Burty Haviland, himself a collector, painter, and friend of Picasso's, whom Modigliani would paint, owned an extensive collection of African sculptures. According to Adolphe Basler, "they captivated Modigliani; he could not see enough of them. Soon he could think only in terms of these forms and proportions. He was transfixed by the pure and simple architectonic forms of the Cameroonian and Congolese fetishes, of those attenuations found in the elegantly stylized figurines and masks along the Ivory Coast."

The comment reveals that Modigliani also intuitively understood the mask's symbolic possibilities. These objects, after all, were embodiments of ancestral spirits that they represented. They were, as Picasso wrote, "magical objects . . . The Blacks were intermediaries, 'intercessors' as I have since learnt. Against everything, against unknown and threatening spirits." Masks were amulets that protected one from the very evil they summoned up and represented. They were powerful in themselves, and they conveyed power.

It is axiomatic that the dandy and the actor had much in common; both are concerned with the protective mask of appearance. With Modigliani it is always hard to say which impulse dominated since both were marked traits of character. So it is not surprising that the theme of the mask should make a dramatic appearance at this time. Like the Baule sculptures from the Ivory Coast which they resemble, their slender silhouettes are elongated, faces triangular, with dominant noses, puckered lips, low foreheads, and eyes spaced far apart. Hair is pulled into tightly controlled shapes, sometimes embroidered with geometrical designs, ears are barely suggested, and the head is balanced on an exaggeratedly long neck. Like Modigliani's marionette studies, inspired by Rousseau's painting of a wedding party, the stonelike stares are unreadable. Yet something important has been achieved. Worship and sacrifice had endowed these African models with an uncanny potency. Modigliani had almost died, and something of that peril and suffering had, perhaps, infused his own

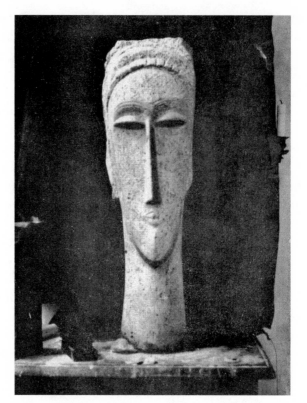

One of Modigliani's early experiments in sculpture

creations with a premature gravity. The results, according to Alfred Werner, showed a "majesty and greatness . . . in a way reminiscent of ancient Egyptian or archaic Greek sculptures." The masklike heads with their locked expressions were silent witnesses to Modigliani's most secret concerns, the mysteries of life, death, and rebirth. Modigliani was not alone in attempting to go far beyond literal pictorial or sculptural representation. Honour and Fleming describe Monet's semi-abstract painting *Water Lilies* in the same way. The painting's "almost spaceless views downwards, on to and through the surface of the pool" bear "intimations of infinity." Much the same poetic insights give depth and dimension to Modigliani's wonderfully strange sculptural experiments, his own investigations into "an endless whole."

. . .

Modigliani began his short career as a sculptor with the passion and determination that showed in everything he did. "The intensity of his attention to forms and colours was extraordinary," Alexandre wrote. "When a figure haunted his mind he would draw feverishly with unbelievable speed, never retouching, starting the same drawing ten times in an evening by the light of a candle." He sculpted in the same way. First he made endless sketches. Then, as before, and unlike Brancusi, who modeled first in clay, he worked directly on stone blocks that often were "liberated" from building sites and taken back to his studio in a wheelbarrow. Technical advice was always available, either from Drouard at the Delta or, most likely, from Brancusi, his neighbor at the Cité Falguière. Almost all of the twenty or so known sculptures are carved in a limestone known as "Pierre d'Euville," quarried near a small town in eastern France, which is softer and easier to carve than marble. A few were in wood, also scavenged (or so it is also said) from the railroad ties being stockpiled for a nearby Métro station at Barbes-Rochechouart. And almost all are heads. There exists a sixty-three-inch statue of a woman, her arms cradled to suggest a Madonna sans baby, that may be a witness to the fact that the artist had ambitions he could not afford to realize. Given Modigliani's chronic dissatisfaction with his work, the fact that he was constantly on the move and that sculptures are heavy, the wonder is that any survived. As it is these images seem to have sprung from his imagination almost fully formed, which, according to Alexandre, would not have satisfied him. He was looking for the "definitive form" that, Alexandre believed, he never attained. "He never abandoned an idea. But a finished work, if it was successful, soon left him indifferent. He would immediately move on to another."

The sculptor Jacques Lipchitz, who visited Modigliani often in his studio at the Cité Falguière, wrote,

Modigliani, like some others at the time, was very taken with the notion that sculpture was sick, that it had become very sick with Rodin and his influence. There was too much modeling in clay, too much "mud." The only way to save sculpture was to start carving again, direct carving in stone. We had many very heated discussions about this, for I did not for one moment believe that sculpture was sick, nor did I believe that direct carv-

ing was by itself a solution to anything. But Modigliani could not be budged; he held firmly to his deep conviction . . . When we talked of different kinds of stone—hard stones and soft stones—Modigliani said that the stone itself made very little difference; the important thing was to give the carved stone the feeling of hardness, and that came from within the sculptor himself: regardless of what stone they use, some sculptors make their work look soft, but others can use even the softest of stones and give their sculpture hardness. Indeed, his own sculpture shows how he used this idea.

It was characteristic of Modigliani to talk like this. His own art was an art of personal feeling. He worked furiously . . . without stopping to correct or ponder. He worked, it seemed, entirely by instinct—which was however extremely fine and sensitive, perhaps owing much to his Italian inheritance and his love of the painting of the early Renaissance masters.

The British sculptor Jacob Epstein knew Modigliani well and, at one point, spent months with him looking for sheds where they could work together in Montmartre in the open air. "Our enquiries about empty huts only made the owners . . . look askance at us as suspicious persons," Epstein recalled. "However we did find some very good Italian restaurants where Modi was received with open arms. All Bohemian Paris knew him. His geniality and esprit were proverbial . . . His studio at that time was a miserable hole within a courtyard and here he worked. It was then filled by nine or ten of those long heads which were suggested by African masks and one figure. They were carved in stone. A legend of the quarter said that Modigliani, when under the influence of hashish, embraced these sculptures."

As for Lipchitz, "I can see him as if it were today, stooping over those heads of his, explaining to me that he had conceived all of them as an ensemble. It seems to me that these heads were exhibited later the same year (1912) in the *Salon d'Automne,* arranged in step-wise fashion, like the tubes of an organ, to produce the special music he wanted." Artists were the first to recognize that Modigliani was doing important work. Augustus John, who saw the same heads at about the same time, was equally impressed. "The stone

heads affected me deeply. For some days afterwards I found myself under the hallucination of meeting people in the street who might have posed for them, and that without myself resorting to the Indian Herb. [A reference to hashish.] Can 'Modi' have discovered a new and secret aspect of 'reality'?"

Modigliani paid several return visits to Livorno in the next few years, the first in the summer of 1909. Even Jeanne Modigliani, who had the benefit of cross-references in the private family correspondence, decided that the situation was hopelessly muddled. No one knew exactly how often he returned in the years before 1913, not to mention the precise state of his health.

Writing in 1941 in *Artist Quarter,* Charles Beadle, a sporadic witness to actual events, described the day when friends found Modigliani collapsed and unconscious in a studio and contributed the money to send him home, dating this as the summer of 1909. Other evidence has established that this incident, which certainly happened, must have come later. A postcard from Eugénie to Emanuele's wife Vera, announcing Modigliani's return, adds, "He seems very well." Other correspondence, with Paul Alexandre, establishes that Modigliani was in Livorno for three months, returning to Paris at the end of September.

Dedo might have been slightly run-down. He certainly needed a new wardrobe, and Caterina, the family's dressmaker, known for her foul mouth and expert tailoring, came in by the day. She was put to work on clothes for Dedo, although Margherita claimed that her brother "was extravagant and ungrateful. He shortened the sleeves of a new jacket with one slash of the scissors and tore out the lining of his Borsalino to make it lighter."

By then Dedo had become a drain on the family's purse with no end in sight. Douglas also states that Umberto Brunelleschi, a painter friend of Dedo's youth, hearing of his desperate state, sought out Emanuele Modigliani in Rome to present the story. Brunelleschi reported that Emanuele was not sympathetic: "Je m'en fous. I don't give a hoot. He's a drunkard and his drawings make me laugh."

Given the notorious unreliability of reported speech it seems possible, just the same, that any appeal to Emanuele for more money

would not have been well received, since he and Umberto had been helping to support Dedo for years. There seemed to be precious little to show for the economic sacrifices they were all making. Any sensible artist/sculptor would have found some part-time work, if only out of desperation. Emanuele took matters into his own hands, Douglas continues. He found his brother employment as a sculptor, working on marble in Carrara, all expenses paid. Dedo still refused to take the hint. It is not surprising that Emanuele did not bother to find out what was remarkable about his brother's art—if anything.

That summer Dedo was spending his days at the atelier of his friend Gino Romiti, writing philosophical articles with his aunt Laure, and painting, although just how many canvases he produced is unknown. He wrote to Paul Alexandre early in September: "I sent you a card from Pisa where I spent a *divine* day. I want to see Siena before leaving. Received a card today from Le Fauconnier. He wrote four absolutely extraordinary lines of nonsense about Brancusi which pleased me enormously." He wanted registration forms for the Salon d'Automne and told his "very dear Paul" where to get them. He tried to appear offhand: "To exhibit or not to exhibit, deep down it's all the same." Nevertheless he wanted news of the Salon. He was in high spirits and secretly thrilled to be returning to Paris soon. Paul would find him *restored*, he wrote, not just physically, but sartorially as well—underlined.

There is reason to think that while in Livorno Modigliani was also sculpting. Gastone Razzaguta, who believed he met Modigliani in about 1912 or 1913, recalled that the latter passed around photographs of his sculptures. He was evidently proud of them and expected compliments but, "we didn't understand them at all." When Modigliani told Razzaguta he needed a large room where he could go on sculpting, "we thought it was just another of his crazy ideas." But Modigliani kept asking and finally a room was found. His friends even obliged by carrying in some blocks of raw material, actually paving stones.

"Dedo, who was like a ghost with us, who appeared and disappeared, from the day he got that big room and the stones . . . we didn't see him again for some time. What he was doing with those stones we never knew. But he must have been doing something because when he decided to return to Paris, he asked us where he could store the

sculptures." Razzaguta claimed that Modigliani's friends never saw the results, but Bruno Miniata said that he had indeed shown his work around.

> Dedo had arrived late at the Caffè Bardi where we used to meet. It was hot—summertime. We left and were walking along beside the Fosso Reale (Royal Moat) toward the Dutch church. At some point Dedo pulled a stone head with a long nose from its newspaper wrapping. He showed it to us as if he was showing us a masterpiece and waiting to hear our opinions.
>
> I don't remember exactly who it was—Romiti, Lloyd, Benvenuti, Natali, Martinelli or even Vinzio Sommati. There were a number of us—the usual crowd. Everyone burst out laughing. They were teasing poor Dedo about that head. Without a word Dedo threw it over his shoulder into the water below.

It could have been a single head or two or three. Some said that Modigliani had piled a wheelbarrow full of sculptures, pushed them down the via Gherardi del Testa, and dumped the whole thing in the canal. The accounts varied, but the point of the story was how ridiculous the work was and how its creator had been shamed into destroying it.

One art historian, Vera Durbè, curator of the Museo Progressivo d'Arte Contemporanea in Livorno, believed that the story was true. In 1984 the city fathers were marking the centenary of Modigliani's birth with exhibits, conferences, and seminars. Why not seize the opportunity to dredge the Fosso Reale? What a coup it would be if three unknown sculptures could be found. The council agreed and work began.

To everyone's astonishment, a battered wheelbarrow and three sculptures emerged from the murky water. They were in stone. They had the eyes, the elongated noses, and the enigmatic expressions of Modigliani's mature style. They were suitably blackened by mud and blotched with rust, apparent proof of decades of immersion. They had to be real. Vera Durbè wept when she saw them. Numerous prominent art historians rushed into print. The sculptures were "treasures," "magical faces," "splendid primitive heads," no less than "a resurrection."

A preparatory sketch for *The Cellist,* 1910

So much for expert opinion. In a few weeks three young pranksters: a medical student, a business student, and an aspiring engineer said they had built the fakes themselves using hammers, chisels, a screwdriver, and a Black and Decker electric drill. They described how they had "aged" the fakes. The critics, their reputations at stake, demanded proof. The forgers, on television, reconstructed new masterpieces in about four hours. Vera Durbè collapsed and was hospitalized. Everyone else had a good laugh. Black and Decker subsequently ran some sly commercials juxtaposing the drawing of an abstract head with the comment, "It's easy to be talented with a Black and Decker."

Whether Modigliani was really a sculptor who painted, or a painter who experimented in sculpture will never be settled. What is clear is that, even at the height of his absorption with sculpture he was still

painting. Late in 1909 he completed a canvas which caused a genuine stir when it was exhibited at the Salon des Indépendants in 1910. Some powerful preparatory sketches of a seated cellist in Chinese ink and black crayon have survived in the Alexandre collection. The unknown sitter—believed to have been renting a room next door to Modigliani's in the Cité Falguière—is young, bearded, and completely absorbed in his task. The sketches show that the composition was diagonal from an early stage, the details simplified to their essences, an idea which continues to the finished work, which Modigliani painted in two slightly different versions. The artist's focus is on the communion of artist with his instrument and the background: the addition of a fireplace, mirror, wallpaper, and bed, is subordinate. Jeanne Modigliani called it "one of the most complex and significant works of a period in which all his contradictory tendencies met. The contrast and balance between the cool harmonies of green, blue and gray-white and the warm browns, reds and ochres; the composed lines of the face and the interminable curve of the arm; these all balance the volumetric density of the cello." The influence of Cézanne is clear enough, but as Werner Schmalenbach observed, it is an influence more transmuted than direct and already on the wane.

Along with *The Cellist* Modigliani exhibited five other paintings at that exhibition: the *Beggar of Leghorn, Lunair,* two studies, and *Beggar Woman,* the painting he had given to Jean Alexandre. The poet Guillaume Apollinaire singled him out in a column for *L'Intransigeant* and André Salmon did the same in *Paris Journal.* Two people had seen fit to distinguish him from the pack—there had been six thousand entries. He was on his way. Or was he? If Modigliani had hoped to find a dealer he was disappointed; nothing sold. Paul Alexandre was still his only patron.

Modigliani continued to create new heads. Roberto Rossi had a studio opposite his in the Cité Falguière for a time and remembered the terrible heat of the summer of 1911, when it was too hot to do anything but they hammered away anyway. Each day he would find Modigliani outside on a small embankment, at the same task. As the days wore on the resulting heads became increasingly abstract until the Modigliani nose, simplified to a triangle and longer by the hour, was almost all that was left.

Each day Rossi would say teasingly, "Amedeo, don't forget about

the nose!" and Modigliani would refuse to laugh. After Rossi moved to the boulevard Quinet in the fourteenth arrondissement they would meet over a glass of wine at a small café in front of the Cimetière du Montparnasse and Modigliani would invariably ask for a loan. At one time, Rossi said, he was owed a considerable amount of money, but was good-naturedly in no rush to call in the debt.

"One day he knocked at my door with a roll of drawings under his arm. He wanted me to accept them in payment of his debts . . . and, to overcome my resistance, threw the roll on my desk. I gave them back to him, assuring him he did not owe me anything. He would not listen. Once again he threw the roll on the desk and headed for the door." It was clear that the payment was far in excess of the money owed. He adroitly threw the roll at Modigliani's feet. Modigliani conceded defeat and retrieved it, "muttering his usual 'Porca Madonna,'" Rossi concluded. "And that's why I don't have a single memento of my friend."

Rossi recalled another occasion when he and a woman friend went to see an exhibition of paintings by Baron Antoine-Jean Gros at a fashionable gallery on the rue La Boétie, where the entrance was being guarded by "a costumed servant with a half-moon face." They happened to appear just as Modigliani was about to go in. Rossi and his friend were respectably dressed; the artist was in a wrinkled shirt with no tie. The servant held up his hand, as if prepared to eject him by force. "Porca Madonna . . . Se lo vada a pigliare in culo!" Modigliani swore, and left. Whether or not the servant understood the insult is not recorded.

In the spring of 1910 an unknown poet, aged twenty-one, arrived in Paris for her honeymoon. She had been born Anna Gorenko, daughter of a naval engineer, and began writing poetry at a young age. When her father objected, she took the name of a medieval Tatar prince, Akmat, a descendant of Genghis Khan, whom she claimed as one of her ancestors, becoming Anna Akhmatova. This self-invention could have been one of the factors that attracted her to Modigliani when she, wife of a prominent older poet, Nicolay Gumilyov, not yet famous herself, made her first trip to Europe.

Her reputation as "a legendary beauty of Bohemian prerevolu-

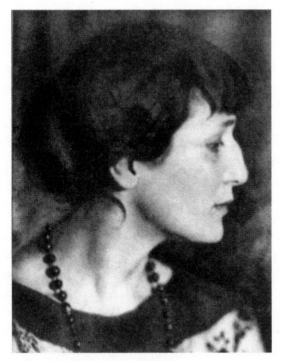

Anna Akhmatova, 1910

tionary St. Petersburg" was deserved, to a point. Luminous gray eyes, an expressive mouth, and wide cheekbones guaranteed that she would be a beauty, except for one feature: an emphatic nose with a pronounced bump. The result was unexpected and somewhat unsettling, as if some stigmata had marked her for a prominent and menacing fate. Proudly, almost defiantly, she sat for portrait after portrait, none of which glossed over the truth of that singular nose. She lived through the turbulent unfolding of the Russian destiny: the revolutions, wars, tyrannies, and Stalinist firing squads. Her husband was shot on a trumped-up charge, her son endured years in labor camps, and she herself somehow survived the Siege of Leningrad. Under these terrible pressures, in the face of agony and loss, she wrote haunting poems that have assured her a lasting fame. After Leningrad, she wrote,

> *That was when the ones who smiled*
> *Were the dead, glad to be at rest.*

And like a useless appendage, Leningrad
Swung from its prisons.

She was tall, slender, and quiet, a woman of education and art-
less self-assurance, whose feelings were kept in check by an almost
superhuman self-control. Her themes were love, loss, and helpless
endurance; like haiku poetry, her verses give sudden glimpses into an
abyss of pain. Such superb economy of means, along with a natural
elegance of manner, marked her as someone quite apart, and Modi-
gliani would have instantly recognized a kindred spirit. How they
met is not recorded in a memoir that is charmingly direct and typi-
cally reticent.

What Modigliani might have found fascinating about her, she
wrote, was a certain ability to "read other people's thoughts, to dream
other people's dreams . . . He repeatedly said to me: 'On communi-
que.' [We understand each other.] And often, 'Il n'y a que vous pour
réaliser cela.' [Only you can manage that.]" He also said matter-of-
factly, "J'ai oublié de vous dire que je suis Juif." [I forgot to tell you
I'm Jewish.]

For her part, she continued, it is likely "that neither of us under-
stood one essential thing: that everything that was happening was
the pre-history of both our lives: his—very short, mine—very long.
The breath of art had not yet charred, not yet transformed our two
existences; this should have been the light, bright hour that precedes
the dawn. But the future, which as we know casts its shadow long
before it appears, knocked at the window, hid behind lampposts, cut
through our dreams, and threatened with the terrible Baudelairian
Paris concealed somewhere nearby. And all that was divine in Modi-
gliani only sparkled through a sort of gloom."

Curiously, she too thought he had the head of Antinous, "and in
his eyes was a golden gleam." He was, she concluded, "unlike any-
one in the world. I shall never forget his voice." She was on her hon-
eymoon, but her husband was involved in lectures and conferences,
and Modigliani was an eager presence. A year later, in the summer of
1911, she returned and they saw each other constantly.

And fame came sailing, like a swan
From golden haze unveiled,

While you, love, augured all along
Despair, and never failed.
— "TO MY VERSES" (1910)

To her, he seemed very lonely. There was no girl in his life just then, and he seemed to know almost no one, even in the Quartier Latin, where everyone more or less knew everyone else. He had the most perfectly exquisite manners. Published in the 1960s, just before her death, her memoir was, in part, an indignant defense against the prevailing view of Modigliani; she never saw him drunk, she wrote firmly. What she could not understand was how he had survived. Although the child of middle-class parents, she knew something about poverty, the vaporous atmosphere of the slums, as an English teacher, Alexander Paterson, described them in 1911. "It is the constant reminder of poverty and grinding life, of shut windows and small inadequate washing basins, of last week's rain," and the soft, relentless shower of dirt, "which falls and creeps and covers and chokes." When they met for the second time, he had endured a harsh winter. He was thinner and his mood was somber.

They used to meet in the Jardins du Luxembourg. Renting a chair cost a pittance but it was more than he could afford, so they shared a bench. They sat in the warm summer rain under his enormous, battered black umbrella and recited Verlaine to each other, thrilled to discover that they both knew the same passages. She did not know then that Modigliani also wrote poetry, but he read hers; he confessed charmingly that he did not understand them but was sure they were very fine. Passersby pointed out the particular path in the gardens that Verlaine, followed by a crowd of admirers, habitually took. He was on his way to a café where he wrote his poems and ate lunch. He was no longer walking that path (he died in 1896), but another great man was, wearing a beautifully tailored overcoat and with the red ribbon of the Légion d'Honneur in his lapel: Henri de Regnier. Modigliani loved Laforge, Mallarmé, and Baudelaire and would recite them by the hour, although not Dante, she thought out of consideration for her, since she knew no Italian. He also recited *Les Chants de Maldoror*, the then-obscure work by the self-styled Comte de Lautréamont.

He took her to the place where he worked, "the little courtyard behind his studio; you could hear the knock of his mallet in the

A period view of the Luxembourg Gardens, where Modigliani and Akhmatova
met to recite poetry to each other. From an old postcard

deserted alley." When his sculptures went on view at the Salon des
Indépendants in 1911 he asked her to go. So she went and found him
there, but he did not approach her, she thought because she was with
a group of friends. The walls of his studio were lined with "incred-
ibly tall portraits" that seemed to stretch from floor to ceiling and
which she never saw again. He was full of enthusiasms, except for
whatever was in vogue at the moment. This included Cubism, which
was "all-conquering but alien to Modigliani." He took her on a tour
of the Department of Egyptian Antiquities at the Louvre; nothing
else, he said grandly, was worth her attention. Then he made a draw-
ing of her dressed as an Egyptian queen; he was passionately inter-
ested in all things Egyptian.

He drew her repeatedly. At one time she owned sixteen of his
drawings; Modigliani told her to frame them and hang them around
the rooms of her house in Tsarskoye Selo. They were lost when the
house was ransacked during the Russian Revolution. Others have
survived, showing that she posed for him in the nude, drawings
which hint at her almost divine status in his eyes. The winter she was
in Russia he wrote her long and beautiful letters. He said, "You are
for me like a haunting memory." He said he would like to hold her
head in his hands and cover her with his love.

She would never have revealed her feelings in so many words but

she did it in other ways. She knew that in the dead of night he would prowl the streets for hours. Sometimes he took her with him, on nights of the full moon, for instance, when they would walk behind the Pantheon and explore the old Paris. She also knew that he sometimes walked under her windows; she would recognize his step and watch his shadow lingering across the glass. One day she arrived when he was out, carrying a bouquet of roses. When he did not come to the door she threw them, one by one, through an open window. They fell on the floor so artistically he was convinced she must have arranged them herself.

Akhmatova arrived in mid-May of 1911 and returned to Russia two months later, perhaps by the end of July. At that point Modigliani's aunt Laure appears in his life in a curious way. That was the summer that Apollinaire, working in a bank, sold a few pictures for him. This may have led Modigliani to mention something to Laure about making a visit to the French countryside. Whether this happened as Akhmatova was leaving, or just after she left, the sequence of events is intriguing. According to Jeanne Modigliani, Laure Garsin found a small house for rent at Yport, a village in the Seine-Inférieure not far from the coast, and invited Modigliani there for a rest cure. He arrived in early September, in an open carriage through which he had driven in heavy rain. Naturally, he was soaking wet. But instead of resting in the cottage he insisted on making a trip to Fécamp to see the beaches. And it was still raining.

Laure was appalled at this cavalier attitude toward his health. What if he got ill again? The house could not be heated. Suppose he became bedridden? How would she find a doctor? She was in a panic and cut short their stay. Meantime, Modigliani could not understand what the fuss was about. He felt fine. Or was he only acting, as usual? What feelings of despair was he concealing? "He went out, reeling; / his mouth was twisted, desolate," Akhmatova wrote in one of her poems of that period, "I Wrung My Hands." He had watched her leave and had no way of knowing whether they would ever meet again; as it happened, they never did. There is a real possibility that she wanted to stay in Paris, but was as badly off as he was and there was no way he could possibly support her. What he needed just then was someone who could support *him*. That possibility is suggested by her comment, in old age, that "Modigliani is the reason for the tragic consequences of my life—of my whole life."

Caryatid is one in a series of drawings, watercolors, and oils that absorbed Modigliani's attention for two or three years (1911–13). This particular version shows a standing figure, her long nose, diminutive mouth, and almond eyes precariously balanced on a cone of neck, nude save for what could be ropes of precious stones girdling her waist and falling over her hips. She is, like his sculptured heads, expressionless. She stands, one leg slightly bent, against a background of black brushstrokes superimposed on pink flesh tones, and bending harmoniously to the outlines of her waist and full thighs.

She could be anyone—a goddess, a wood nymph, a priestess—but she is actually one in a series of female figures whose arms are raised to hold up—something. Just what is never clear. Basler wrote, "For several years Modigliani did nothing but draw, and trace round and supple arabesques, faintly emphasizing with a bluish or rosy tone the elegant contours of those numerous caryatids that he always planned to execute in stone. And he attained a design very sure, very melodious, at the same time with a personal accent, with great charm, sensitive and fresh." The woman as prop and buttress: this was Modigliani's repetitive image, now standing, now crouching, now bent under the weight or lightly poised beneath it.

Caryatids, in the *Encyclopædia Britannica*'s definition, were draped female figures used as supports for entablatures in Greek, Roman, and Renaissance architecture. *The Merriam-Webster Dictionary* adds helpfully that the word derives from the Latin and Greek, *karyatides,* literally "princesses at the Temple of Diana." That goddess, usually depicted as about to go hunting, wearing a tunic and carrying a bow and arrow, was also that of fertility, pregnancy, and childbirth, and sometimes that of the forest and wild animals. One of her very early temples, before 495 BC, was discovered on the northern shores of Lake Nemi, on a stone terrace with niches cut in the back wall that apparently served as chapels.

Modigliani's grand scheme was to create a "Temple of Beauty." Since he and Brancusi were working together closely at this period it is perhaps no coincidence that Brancusi, whose own grand scheme included complete sculptural environments, also came up with the idea of a temple and worked on it for decades. Brancusi's most elaborate design, sometimes called a *Temple of Love,* or a *Temple of Meditation* and *Temple of Deliverance,* was commissioned by Yeshwant

Holkar, maharajah of Indore in the 1930s. Brancusi envisioned a completely enclosed space with a vaulted ceiling, a pool, and sculptures placed so as to be spotlit, at certain times of year, by sunlight focused from a ceiling opening. (It was never built.) Modigliani's own grand schemes, if they were ever committed to paper, have not been found. But like Brancusi he was using his studio as an impromptu stage on which to calculate the precise placement of his sculptured heads, along with the caryatids, only one of which exists. (It is three feet tall and at the Guggenheim.)

One finds at least one other common theme between the work of the two men. As early as 1911 Modigliani was using a curious motif, a column decorated with geometric designs, seen in a portrait of Paul Alexandre. A symbol of the quest for the infinite, the *Endless Column* is an idea Brancusi took up six or seven years later. In his work it became a sculptural *Tree of Life,* the pillar supporting the firmament and the axis mundi on which the world turned. Restellini wrote, "Was Modigliani the originator of one of Brancusi's major creations?"

For Modigliani the repetition of the caryatid theme would suggest allusions to death and fertility and the idea of woman as divine intermediary. Like Brancusi's, his experiments with sculpture had a broadly ambitious goal even if his temple, too, was never built. It was an incantatory circle of stone, meant to protect and guard, sustain and inspire. The festival of Diana took place in mid-August during a full moon, and she was worshipped with torches. One of Modigliani's girlfriends recalled dining by the light of a guttering candle, fixed to the head of a sculpture. When Epstein visited the studio it was already filled with nine or ten long heads and a single figure. Modigliani, who had spent so many nights of his young life hovering between life and death, was justifiably afraid of the dark. Epstein said, "I recall that one night, when we had left him very late, he came running down the passage after us, calling us to come back like a frightened child." Each evening, candles fixed to each stone head would transform a squalid studio into a sacred space. One imagines him seated there in the darkness, safe in the magic circle of his imaginary temple.

———•———

"What I Am Searching For"

A fool sees not the same tree that a wise man sees.
—WILLIAM BLAKE, *The Marriage of Heaven and Hell*

IN THOSE YEARS before the outbreak of World War I, Modigliani and his benefactor, Paul Alexandre, were in close contact, one that continued until the day in 1914 when the latter was mobilized by the French army and marched off to the front. The rue du Delta continued its happy, improvisational way of doing things, with another plate at the table for Modigliani, until the summer of 1913. That July the city of Paris reclaimed its ramshackle villa and Alexandre moved to a spacious nearby apartment at 10 Place Dancourt, next door to the Théâtre de Montmartre. This was furnished with the usual élan from whatever happened to be handy. The Moulin Rouge windmill was being demolished, so Alexandre bought a balustrade to install on what seems to have been a balcony, as a protection. He also acquired a small crystal chandelier. Things were obviously looking up at the new quarters, which had elegant high ceilings. Then Alexandre invited Modigliani to do the interior decoration. Modigliani said, "For it to be really good we need to accentuate the feeling of height." Alexan-

Modigliani's studio at the Cité Falguière

dre wrote, "And so we started to saw off the table legs and also lower the few miserable chairs we had. This gave it style. Whereas poor stylists minimize contrast, good stylists heighten contrast. Right up high, on a level with the chandelier, which we had also shortened, we hung Modigliani's large red figures." This tantalizing reference is to works that have never been brought to light. Alexandre concluded, "But we did not enjoy the place Dancourt for long."

Although an habitué, Modigliani was not resident there either. His move to the Cité Falguière in the spring of 1909 had been at Brancusi's suggestion and he was lucky enough to get a ground-floor studio, which staved off the drudgery of hauling blocks up and down stairs, and one with an outdoor patio. Foujita, who also lived there, said that the now-demolished building "had a wide entrance on the rue Falguière and you went through a court to a small door at the

back which led to our studios. You had to cross a sort of bridge, like the approach to a medieval fortress, though the building was anything but fortress-like." The studios were cheap and had plenty of light but like artists' accommodations everywhere in Paris, impossible to heat. Warshawsky wrote of his own, "The building in which we were, of recent construction, was a flimsy affair of thin bricks and stucco, through which the dampness from outside penetrated, with the result that, despite the fact that the exterior temperature was nothing like so low as it would be in America, I actually suffered more intensely from the cold than I had ever done before." They all knew where you went to spend every waking hour not devoted to work: to the cafés. And Montparnasse had two outstanding destinations, facing opposite each other at the corners of the boulevards de Montparnasse and Raspail: the Dôme and the Rotonde. The Dôme, much frequented by the Americans, was already open when Modigliani arrived. The Rotonde, opening in around 1910, was immediately adopted by Picasso, Diego Rivera, Ilya Ehrenburg, Marevna, Ortiz de Zárate, Max Jacob, Apollinaire, Léger, Kisling—in short, everyone who counted. Including Modigliani. "It was the last great

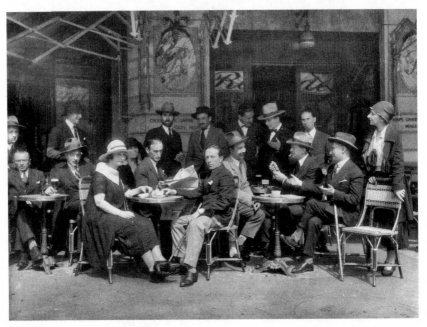

The popular terrace of the Rotonde in 1919–20

At the bar of the Dôme, a group of regulars, among them three who helped "romanticize" the legend of Modigliani after his death. Far left, in profile, Francis Carco. In the foreground, Michel Georges-Michel, and standing, rear, with coat and scarf, André Salmon

expansion of the Parisian café, an enchanted place where, for the price of a cup of coffee, you could spend the day, demand free note-paper with pen and ink, and eat your way through baskets of free bread knobs," Patrick Marnham wrote in his biography of Rivera. "*Venir au café* meant, according to Jean Moréas, to arrive at 8:00 a.m. for breakfast and to be there still at 5:00 a.m. on the following day." The sculptor Chana Orloff recalled that they could spend hours in front of a single café crème, warming up.

The Cité Falguière was around the corner from the Gare Montparnasse and within walking distance of 242 boulevard Raspail, where Picasso, in the first flush of his success, had taken an elegant new apartment. Montmartre was no longer chic. The quartier had not yet become the tourist trap it is nowadays, ankle deep in artists selling themselves as portraitists and exhibiting amazingly identical styles, or shameless imitations of Utrillo's cityscapes, or monkey-faced Mona Lisas and similar conceits. Tourists were not shuffling, shoulder to shoulder in dazed circles around the Place du Tertre hop-

ing in vain for a place to sit down. But there were new faces in the cafés, the rents were going up, and pretty soon the cozy group of artists would not be able to find each other. So one went to the Rotonde to see and be seen.

Newly fashionable it might be, but Montparnasse was hardly virgin territory. Those impeccable historians Klüver and Martin point out that painters and sculptors had been settling there since the early nineteenth century, when great open fields were full of vegetables for the Paris markets. In those days artists could take over workshops and convert them into studios, living comfortably in summer cottages. By 1890, nearly a third lived in Montparnasse, taking classes in the nearby ateliers of Bouguereau, Carolus-Duran, Gérôme, and others. After Picasso arrived in the summer of 1912 that settled the matter for everyone else. But Modigliani, with his usual prescience, was there first.

"Carissimo," Modigliani wrote to Paul Alexandre in May 1910, one of the many short notes now in the Alexandre archive, "The comet has not yet arrived . . . *Terrible.* I'll definitely see you on Friday—*after death* of course." Modigliani was referring to Halley's Comet, named for the seventeenth-century British astronomer who

The center of Montparnasse, the Carrefour Vavin, the winter of 1905

had correctly predicted its return in 1759, 1835, and on May 18, 1910, the day Modigliani wrote.

Comets, small bodies of gases and dust, shooting across the heavens with streaming tails, had been known since ancient times, predicting, it was thought, catastrophe: famine, plague, or war. Thousands that day climbed up to the Butte Montmartre to get a better look at the once-in-a-lifetime event. In Italy, the pope ordered special prayers; in New York, "comet parties" took place in all the big hotels. In Paris the mood was less than superstitious but not euphoric. A newspaper columnist summed up the feeling the next day with the comment that the comet appeared on time but failed to explode and the end of the world was indefinitely postponed—mercifully unaware of how short that postponement would be. Still, 1910 was a strange year, full of signs and portents. By the time the comet arrived over Paris, where the Seine had flooded since time immemorial, the city had been inundated by the worst flood in 150 years. In January, four months earlier, the banks burst, the bridges threatened to collapse, and the water stood seventeen feet (five meters) deep in a train station along the quays, the future Musée d'Orsay. Looters emerged, the Métro and sewer systems were flooded, and boats and rats paddled along the boulevards, although the flood spared Montparnasse.

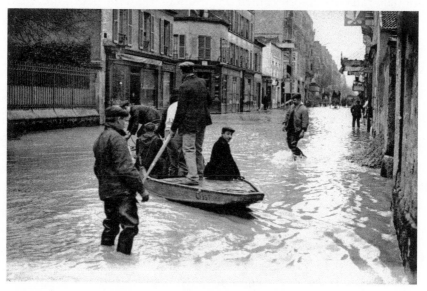

Paris under water after the great flood of 1910, contemporary postcard

A total of fifty thousand people were homeless and were fed in soup kitchens; no doubt Modigliani also took advantage of the free meals.

This was the year when the horse began to vanish from city streets, replaced by omnibuses and the demon motorcar. Traveling up in the air was an even newer idea, thanks to Count Ferdinand von Zeppelin, whose airships were named in his honor. This option also seemed poised for mass acceptance even if two such huge and cumbersome Zeppelins crashed that summer. Then there was the undeniable fact that something strange was happening to women. Encouraged by the great couturier Paul Poiret, they were refusing to wear corsets. The female silhouette, once padded front and rear, was gently deflating like a balloon and women were daring to wear startling V-necks, bloomers, and all manner of similarly immodest garments. But the biggest revolution was in the skirt, which, after centuries of full-length concealment of the female leg, was starting to leave the floor. First, it coyly revealed an ankle. By the end of World War I it had soared to mid-calf and, as everyone knows, reached its apogee a decade later when it hit the knee. It all meant something—but what? Virginia Woolf wrote, "[I]n or about December 1910, the human character changed." This was surely an overstatement, but the old ways were being swept aside and, along with them, the traditional limits placed on women of the kitchen and the bedroom. That, too, would have been disorienting.

In the art world, changes were equally rapid and arbitrary with consequences no one could foresee. Modigliani once told Louis Latourette untruthfully that, Picasso excepted, the only painter he admired was Rousseau. Modigliani was no doubt thinking of Rousseau's painting *The Wedding* that made such an impression when he saw it with Alexandre.

No doubt he felt along with others who loved and shamelessly teased the Grand Old Man of art (he was then sixty-five) that there was something admirable about his childlike directness and his sweet belief that he and Picasso were the two greatest artists. And Modigliani would have shared Rousseau's love of music. That artist played the violin and had a music school where performances were given, although, Warshawsky said with typical frankness, it "took considerable courage" to sit through one of Rousseau's concerts.

In 1908 Picasso, in mock homage, gave a party for Rousseau,

"Le Douanier" Rousseau, 1890

although everything went wrong. The meal never arrived. Rousseau, seated on a thronelike chair, and with too much to drink, fell asleep. Some wag thought it would be a great joke to smear his mouth with a soapy foam to suggest delirium tremens. A small pyramid of candle wax from a nearby candelabra formed itself on his head. The tragic and farcical seemed inextricably mixed in the life of this gullible and bumbling clown. Still, no one was prepared for what happened in 1910. Rousseau had just completed one of his most magical jungle scenes, *The Dream,* and it was on view that March in the Salon des Indépendants. In addition to the predictable lush foliage and hungry wild beasts, it depicted a lavishly curved lady reclining on a sofa. The model was a fiftyish widow who worked in a draper's shop. Rousseau was madly in love with her, even persuading Vollard and Apollinaire to write poetry in her honor. He wanted to make her his third wife, but the lady refused. She is said to have remarked, "His breath smells of death"—and was not even tempted when he offered to leave her his estate.

That summer, Rousseau hurt his leg and infection set in. He was admitted to the hospital, where he spent his days writing letters to his beloved that were not answered. Then, on September 2, 1910, and to general consternation, he died. A great Primitivist had, simply by being himself, attracted the interest of some sophisticated theorists, Picasso among them, showing what could be done to explore dream states. What is the nature of the Self? "For me the essential thing is

to tell our life by any mythological means," Salvador Dalí once said. Rousseau, with his direct line to the unconscious, seemed to have discovered intuitively what the Surrealists, Dalí included, would have to puzzle out painfully in the years to come.

The first writings of Francis Carco, called *Instincts,* were published in 1911. Carco, a poet and novelist, Modigliani's contemporary, was writing about sensuality, alcohol, violence, and *la vie de Bohème.* He continued to publish his observations and reminiscences, many of them fictionalized portraits, for the next thirty years. He saw *la vie de Bohème* from a particular psychological perspective, as the child of a moralistic and often cruel father, who realized how much revolt and revenge underlay his choice of lifestyle. Since he had the gift of detachment he also saw others' choices with particular clarity and discrimination.

For Carco, Bohemia was "a form of social theater . . . for which its ostensibly hostile audience felt an obscure need," Jerrold Seigel wrote in *Bohemian Paris.* Bohemian life often led to nothing, Carco believed, "because its flow was 'a perpetual dispersion.' New possibilities, new temptations, confronted its denizens at every moment. Their minds were beset by contradictory goals and attractions rendered more persuasive by idleness, boredom and poverty." Those on the fringes of a particular artistic movement but without the talent would spend their lives in a fruitless pursuit of the chimeras of their youth. "Between the two wars, Carco found that Cubism had left behind a human debris that reminded him of the earlier ex-companions of Toulouse-Lautrec: 'these endings of generations are horrifying.'"

Carco thought, in common with Baudelaire, that the only escape from the eventual annihilation of the spirit that Bohemia represented was the discipline of work. In those days work was all that Modigliani had. There were very few sales, he still had no dealer, he shifted from one squalid hole to the next or moved in with this week's mistress, and the future was bleak. Although he always expressed complete confidence in his gifts, he must have met those ravaged beings who had bet everything on a throw of the artistic dice and lost, and wondered at some level whether he, too, was chasing a mirage. This

may have strengthened his determination not to follow any movement, relying on his own idiosyncratic vision; better to be ridiculed, but noticed, like Rousseau, than destined for oblivion. Or perhaps—he was, after all, only twenty-four—he never thought of such things. He was simply being true to the vows he and Ghiglia had made seven years before. There was a battle ahead. They must be prepared to suffer every hardship, bend every sinew in pursuit of the ultimate achievement. That goal could not be self-aggrandizement. As for John Keats, another tuberculosis sufferer, so with Modigliani: it was art for art's sake. "Beauty must be a good in its own right, even a metaphysical principle. In serving beauty, Keats came to believe, he was in some obscure way serving the divine."

In the four years Modigliani worked as a sculptor, roughly 1910 to the spring of 1913, he made repeated attempts to sell his work. Besides exhibiting his heads at the Salon des Indépendants he was trying to interest dealers and when this, too, failed, he hit on a scheme to show them himself. He met a young Portuguese artist, then living at the Cité Falguière, De Souza Cardoso, also called Amedeo, whose style resembled his own. "Only Cardoso's more highly coloured use of drawing . . . and the more decorative value of his line allow us to distinguish his works from those of Modigliani," Jeanne Modigliani wrote. Cardoso's family was comfortably off, and after he married and moved into a new and more spacious studio near the Quai d'Orsay, in 1911 the two Amedeos decided to hold their own show. Cardoso's paintings and drawings were hung beside Modigliani's caryatids, and seven of Modigliani's heads were placed, with great care, around the room. It was a bold, even clever, move. Friends came to admire but did not stay to buy. The critics ignored the exhibition. Nothing sold.

The first sale of his sculpture did not take place for four years, and then the buyer, as might be expected, was not a gallery-goer or even a connoisseur but a famous artist. In 1913 Augustus John, over from London, visited Modigliani's studio with his wife Dorelia. He found the floor "covered with statues, all much alike and prodigiously long and narrow" and bought two of them on the spot. The price was a few hundred francs. For a man accustomed to surviving on three

francs a day it must have seemed as if the heavens had opened. Modigliani slightingly described himself as a creator of garden statuary. But he also remarked, "*Comme c'est chic d'être dans le progrès!*" (How chic it is to be in the swim), and the two struck up a friendship. Nina Hamnett, the British sculptor who had yet to meet Modigliani, recalled being told by Epstein that Modigliani wanted to be paid in installments, a request that some in his circle would have found hard to believe.

Modigliani was always sketching portraits of his friends, and once at Montmartre he joined the legions of "café artists" who made the rounds in the hope of finding willing sitters. Their methods varied little, according to Sisley Huddleston, an English writer who wrote about Montparnasse and Bohemia in the years between the wars. The artist, portfolio under his arm, would enter the café, size up the situation, and then wend his way through the tables. He was likely to stop hopefully and smile. At the least look of enquiry he had drawn up a chair and begun work. From long experience he knew the subject would be a lady, preferably wearing a splendid hat to which he would give close attention. If the artist had done his work the portrait would be flattering, the lady delighted, and her escort perfectly willing to buy. Most artists, Huddleston said, were lucky to find three willing subjects a night, and if they all bought he was even luckier.

Modigliani could be seen almost every night at the Rotonde, with his nonchalant walk, his blue portfolio always under his arm, and then "drawing ceaselessly in a notebook the pages of which he was forever tearing out and crumpling up," Carco wrote. Conrad Moricand, a painter, author, and astrologer, often watched him at work. He wrote that Modigliani would look with concentration on the face before him and then begin to draw with an incisive pencil. "His working method was always the same. He would begin with the two essential points, first the nose of his model, which one finds emphasized in all his work, next the eyes, with their different polarities, then the mouth and finally the outline of the face, delicately indicated by cross-hatching." As he began work his handsome face would contort itself into the most frightful grimaces and he would be deaf to everything going on around him, including the constant jokes and teasing. "He was usually good for four or five drawings like this, sometimes more, that were superb. The rest were usually dissolved in drink."

The painting of Jean Cocteau by Modigliani that the sitter took some pains not to own

Maurice de Vlaminck, who also watched him working, said, "I can see him (he was no fool) distributing his sketches to surrounding friends in exchange for a drink. With the gesture of a millionaire he would hold out the sheet of paper (on which he sometimes went so far as to sign his name) as he might have held out a banknote in payment to someone who had just brought him a glass of whisky." Jean Cocteau said, "He used to hand out his drawings like some gypsy fortuneteller, giving them away, and that explains why, although there are some fifty drawings of me in existence, I only own one."

Cocteau, painter, writer, and film director, was also painted by Modigliani. While he sat for his portrait the rain beat ceaselessly on the skylight and Cocteau, who had that reputation, talked without stopping—not that anyone listened, according to the poet Pierre Reverdy, who was there. Cocteau once referred to the resulting portrait as "diabolical" and said he considered it proof that Modigliani detested him. Diabolical is too strong a word, but the painting did

not flatter, as had so many other artists who painted this prominent personality. In any event Cocteau never took the painting home. He bought it for the derisory sum of five francs and then, under the pretext that the painting was too large and he did not have the money to transport it, left it in the studio of their mutual friend Moïse Kisling. Time went by, Kisling gave it to the proprietor of the Rotonde to settle a debt, and it hung in the café over a banquette for several years. The painting went through several hands and was finally sold to a pair of American collectors for millions of francs. Cocteau did not like that much either. "All I have left," he complained, "is a colour photograph."

Foujita recalled, "At that period Modigliani was spending most of his time on sculpture; he did no painting and only made pencil drawings. He always dressed in corduroy, and he wore checked shirts and a red belt, like a workman. His thick hair was usually tousled. He drank a great deal of Pernod and often did not have enough money to pay for it. When people invited him to have a drink at their table, he would do sketches and then give them the drawings by way of thanks. He had a habit of scowling and grimacing a good deal, and he was always saying 'Sans blague!' ('No kidding!') . . . We were both fond of poetry, and every time he came to see me he recited a poem by Tagore."

An English artist, C. R. W. Nevinson, met Modigliani in 1911, for a time shared a studio, and kept up the friendship until he died. Nevinson described him as "a quiet man of charming manners . . . I knew him as well as, if not better than, most men . . . Modigliani should have been the father of a family. He was kind, constant, correct and considerate: a bourgeois Jew." Nevinson added, "[H]e loved women and women loved him. They seemed to know instinctively that though he was poor, they were in the presence of a great man. Painters were two a penny in Montparnasse, yet even the most mercenary of the girls would treat him as the painter and the prince. They would look after him, scrub for him, cook for him, sit for him; and before they went away they would beg him to accept a little gift, 'for art's sake.'" "'Modi was all charm, all impulsiveness, all disdain,' his future dealer Paul Guillaume said, 'and his aristocratic soul remained among us in all its many-coloured, ragged beauty.'"

"For art's sake . . ." There are endless stories, most of them prob-

ably apocryphal, about Modigliani's overnight flights from one miserable hovel to another and the chagrin of landlords who arrived to find a few sticks of furniture and some apparently worthless artworks. "So little did he value the belongings he had seized," is the usual opening sentence, "that the . . ." landlord, in a fury, gives the paintings away, tosses them onto a rubbish dump, tears them up, or burns them. The story concerning Modigliani's overnight departure from the Cité Falguière has the merit of being original, at least. In this case the landlord's wife decides the yards of canvas will come in handy as dust covers for her mattresses, sofas, and the like. The day finally arrives, long after Modigliani's death, that he is famous. A dealer appears at the door. He has heard. He will pay. He flashes a wad of francs. The landlord is overjoyed. Where are those dirty old canvases we were using? His wife produces them. They are blank. Oh, that nasty old paint? She made sure to scrape it all off before wrapping their valuables. Her husband collapses.

A great artist starts all over again, this time in a hut at the bottom of the garden at 216 boulevard Raspail, with a mattress on the floor, a single rickety chair, a jug and a basin, and whatever he has saved of his unfinished sculptures. The cultured man who has willingly embraced the fate of the meanest workman, wearing his clothes, sharing his privations—the contradiction is puzzling only if one discounts the family history, one that began the day he was born. He would have learned from his mother that it was possible to retain one's pride no matter how humbling the circumstances. Thanks to his brother Emanuele, he was well versed in the class struggle, exploitation, and oppression. Although he took no active role in politics, Modigliani considered himself a Socialist. His knowledge of what the working masses endured had made for a special mixture of anger, indignation, and sympathetic understanding that Modigliani would bring to bear on outcasts. In Paris he sought out and befriended at least two unappreciated and vastly talented artists whose situations were as desperate as his own. One of them was Maurice Utrillo.

Utrillo, the illegitimate son of Suzanne Valadon, had been given wine diluted with water from babyhood by Valadon's illiterate mother. By the time he was eighteen he was a hopeless alcoholic and spent the first of many visits in an insane asylum. When he was released his mother, herself an artist, was advised to find him a hobby

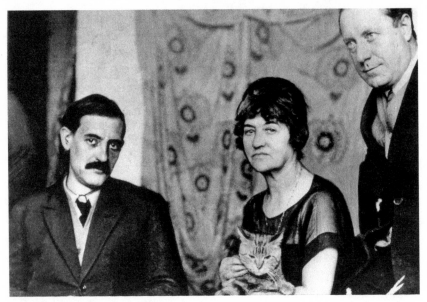

Maurice Utrillo, in the ménage he shared with his artist mother, Susan Valadon, and his stepfather, André Utter, 1920s

and gave him his first box of paints. He turned out to have an astonishing gift, beginning the career that would bring him international fame. Carco wrote of his Montmartre streets and squares, "There shines upon the walls, upon the houses with closed shutters, upon the brown windows of *bistrots* a fixed light which comes from nowhere, except from . . . dream regions." When sober Utrillo was shy, unassuming, and gentle. When drunk he would begin to yell, stare around the room, and start breaking glasses and bottles. For years he was treated as the village idiot, subject to the kinds of humor that makes a staggering man even funnier by being tripped up, or, as he lies comatose in a gutter, stripping him nude. Artists are always the first to appreciate each other's work, and a few were beginning to recognize Utrillo's special qualities when Modigliani met him, but dealers rejected him. Modigliani, whose eye for talent was exceptional, rose to Utrillo's defense.

Michel Georges-Michel, author of the portrait of Modigliani as haunted, hunted, and self-destructive, is hardly a reliable witness. However, in one case, he seems likely to have been close to the mark. He recounts that he was there when Modigliani began painting a

portrait of Léon Bakst, the costume and scene designer, and the conversation came around to the depressing nature of Utrillo's subject matter.

Modigliani responded, "One paints only what one sees," Georges-Michel recalled.

> Take the painters out of their hovels! Yes, art lovers and dealers are shocked that instead of landscapes we paint only ugly suburbs with trees all black and twisted and covered in soot and smoke, and interiors in which the living room is right next to the toilet! Since we are forced to live like rag-and-bone men in such lowly dwellings, these are the impressions which we reproduce. Every age gets the painters it deserves, and the subjects drawn from life which it gives them. During the Renaissance the painters lived in palaces, in velvet, in the sun! And today, just look at the filth in which a painter such as Utrillo must live, at the hospitals he has been forced to attend, then you will no longer ask why he paints only dirt-encrusted walls, disease-ridden streets, barred window after barred window!

Utrillo, that damaged and fragile talent, at least had the desultory ministrations of his mother and her new husband, André Utter, an apprentice tiler on the Butte Montmartre turned artist, who became his stepfather. Father and stepson were the same age—a state of affairs that made both acutely uncomfortable. Valadon and Utter periodically rescued Utrillo, made him paint, tried to ration his wine, and, when all else failed, put him back in the hospital. After Utrillo amazed everyone by becoming commercially successful they gratefully helped him spend his money.

Curiously, no paintings or drawings of Utrillo by Modigliani have come down to us, although the artist memorialized almost everyone he knew, sometimes repeatedly. But another friend often sat for his portrait, Chaim Soutine. This eleventh child of a Russian Jewish tailor, living in a filthy, one-room hut, starved and beaten, was rescued by a rabbi who recognized his talent and sent him to art school, first in Minsk, then the Fine Arts Academy in Vilna. There he met two other talented artists, Michel Kikoïne and Pinchus Krémègne. His gift was

Soutine, in his days at La Ruche when he was
painting flayed carcasses. Paulette Jourdain, one
of Modigliani's models, is seen in a partial view.

clearly evident, but so was his poor health. Years of semi-starvation
had made him almost as dependent on wine as Utrillo. Marevna, who
knew him well, wrote that by the time Soutine arrived in Paris, "his
digestion was already ruined and he had a diseased liver. In addition,
he suffered from a nervous affliction of the left eye and . . . frequent
attacks of some, as yet undiagnosed, malady." Later he would have
an emotional breakdown, painted in unmistakable outline in a series
of contorted compositions.

Krémègne, Kikoïne, and Marevna were staying at La Ruche when
Soutine joined them in 1913. Unlike the Bateau Lavoir and the Cité
Falguière, ramshackle apartments which occasionally kept artists
and sculptors out of the rain, La Ruche ("the Beehive") was specifi-
cally designed for artists by its philanthropic owner, Alfred Boucher,

A recent view of the gated entrance to La Ruche

a wealthy sculptor. The international exhibition of 1900 contained a polygonal wine pavilion designed by Gustave Eiffel, of Eiffel Tower fame. Boucher, who owned semi-rural land on the southern edge of Montparnasse, had the clever idea of turning the building into studios, honeycomb fashion, so that each unit would have its own source of natural light. The building was moved to its new site and further ornamented with happy heedlessness. An enormous Art Nouveau wrought-iron doorway, salvaged from the Women's Pavilion, graced its façade, along with some caryatids from the British India exhibition; the total effect was whimsical, even playful. Then he rented out the studios at cost to up-and-coming young artists like Léger, Soffici, Chagall, Archipenko, and Zadkine.

La Ruche was full of fun but the same discomfort and, once a few feckless tenants had moved in, the predictable camp followers: mice, rats, cockroaches, lice, and the ever-present flies. It had a spe-

cial drawback in that it flanked the slaughterhouses of Vaugirard. To its other idiosyncrasies were added the wafting smells of putrifying flesh and the bellows of dying beasts. Nevertheless, its eighty studios were in great demand and more would be built. La Ruche was "seething with vitality," Marevna wrote.

Soutine made an immediate impression on her. "His clothes, unlike the workmen's blue linen jackets and trousers favoured by other artists, were beige, with red and blue neckerchiefs; I was told that he made them himself. Like the clothes of the other artists they were always covered with paint." She thought he was plain, even ugly. René Gimpel did not have quite that impression: "He is small, sturdy, with a thick crop of hair whirling around his head. He has deep, round, hooded eyes; they are of hard stone." Marevna may have been influenced by Soutine's belittling self-portraits, which always show him with tiny eyes, a bulbous nose, and huge, prominent mouth and ears, distortions which one finds uncannily mirrored in the portraits of Francis Bacon. However, actual photographs give a different impression: that of a sensitive, introspective, even handsome man. As with Utrillo, Modigliani's sympathies were immediately aroused, and for similar reasons. Soutine did not speak French: Modigliani would teach him. This reticent, fearful, unwashed peasant, who slept in doorways and had never used a toothbrush or handled a fork, obviously needed a mentor. And Modigliani, at his most destitute, never looked poor. His suit would be clean, his shirt, which he had washed the night before, rumpled but otherwise presentable, his shoes cleaned, and no one knew how he managed, but every morning, bright and early, he was shaved and ready for work. Modigliani the outgoing, vivacious intellectual and this diamond in the rough took one look at each other and became friends. Soutine said, "He gave me confidence in myself."

Soutine is best known for his depictions of flayed carcasses. But in fact, as an exhibition in Paris amply demonstrated in 2008, these are only a small part of an oeuvre that encompasses portraits, still lifes, landscapes, cityscapes, and much more. In contrast to Modigliani's refined and elegant canvases, Soutine's are noisy and spontaneous. They swivel and pivot with a quality reminiscent of Chagall; once, when alcohol made him dizzy, Modigliani said, "Everything dances around me as in a landscape by Soutine." Soutine's landscapes do not

unroll, they buzz and hum. Cityscapes shatter like kaleidoscopes, portraits seize you by the throat, and still lifes throb with the music of the universe.

The manner in which Modigliani painted hands is often meant as a clue to the initiated. In one portrait of Soutine Modigliani seems to be emulating the model set by Cézanne some years before. In his portrait *La Femme à la cafetière*, Cézanne depicts a lady, stolid, mannish, all in blue, hands limply placed in her lap. She looks formidable, but then one notices that her sleeves stop short to reveal her oddly vulnerable wrists. Modigliani used this device to the same effect in one of his portraits of Soutine, then in his early twenties but looking more like a forlorn adolescent. In another portrait painted the same year (1916), Soutine's right hand, resting on a knee, is oddly placed with a gap between the third and fourth finger. This was meant, Marc Restellini wrote in *L'Ange au visage grave*, to sig-

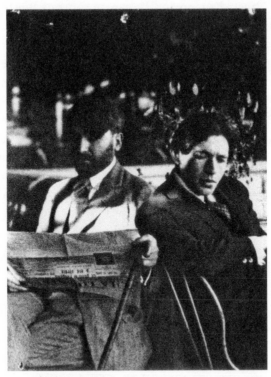

Soutine, early 1920s, with his dealer, Léopold
Zborowski, at left

nify the Jewish priestly blessing. If so, it was a subtle reference to the heritage they shared that many would not recognize. Without minimizing Soutine's prominent eyes and full lips, "Modigliani manages also to convey a kind of poetic beauty in his sitter, that special brand of idealization for which he is justly famous," Kenneth E. Silver wrote. It could have also conveyed the special place Soutine had won in Modigliani's affections. When he was very ill, Modigliani told his dealer that he could not recover. But, he said, "don't worry—I'm leaving you Soutine."

In his study *Circle of Montparnasse: Jewish Artists in Paris, 1905–1945*, (1985), Silver described the unique status Modigliani held among other Jewish immigrant artists and sculptors. They were Ashkenazim, recently arrived from Russia and Poland: Sonia Delaunay, Moïse Kisling, Oscar Miestchaninoff, Simon Mondzain, Marevna, Jacques Lipchitz, Léon Indenbaum, Kikoïne, and Krémègne. Modigliani was a Sephardic Jew but also Italian born, with an important link to the "Greco-Roman and Italianate roots of Western art." In a quick sketch he made of Chana Orloff on the back of an envelope, Modigliani wrote in Hebrew letters, "Chana, Daughter of Raphael," enlightening in its casual cross-cultural references. Silver notes that many religious symbols, not just Stars of David, appear in Modigliani's art. As for his personal beliefs, Modigliani was casually blunt. "Hello, I'm Jewish," was the direct approach to anyone who was not, as Akhmatova and Hamnett have recorded. He was equally ready to start a fight if necessary. A story widely repeated has him berating a group of Royalists at a café table who were overheard making anti-Semitic remarks. Noël Alexandre wrote that in 1910 Modigliani gave his father a drawing, a portrait of himself in a Jewish tunic. He was also wearing a beard, something that Paul Alexandre carefully noted he only kept for a few weeks. As for Orloff, who hailed from Palestine, Modigliani once told her, "I carry no religion, but if I did it would be the ancient Jewish religion of my ancestors."

"I'll definitely see you on Friday—*after death* of course." Paul Alexandre, who was never interested in such things, would have dismissed that reference with a laugh. But for Modigliani the omen of a comet streaking across the sky had just as much possible significance

as the most profound questions about art. "How we used to hammer out the solution of things in those days!" wrote Christopher Nevinson, his sometime roommate. Every night at the cafés there would be endless discussions, on "harmony, and sometimes colour, sometimes drawing, sometimes imagination, sometimes fantasy, sometimes spiritualism, sometimes the unconscious . . . sometimes religion, and sometimes the lack of it." There was a moment when Modigliani was passionately interested in the prophecies of Nostradamus, Ilya Ehrenburg recalled, ascribing to that sixteenth-century savant all manner of predictions, including the unification of Italy, the fall of Napoleon, and the use of airplanes in war.

Léopold Survage, an artist who met Modigliani at the Rotonde before World War I, said, "Like all Italians Modigliani was very superstitious. It was human beings that interested him most of all and the invisible forces that were at work in them. Behind the physical appearance he imagined . . . a mysterious world.

"One evening we encountered a drunk on the street who was walking with great difficulty and who made contortions and was doing amazing acrobatics without ever falling. 'Look,' said Modigliani, 'the evil spirits are calling to him, but he is resisting them and fighting.' "

Modigliani's primitive superstitions, ones that had been handed on through the Garsins, their nurses, and home-based healers, had certainly survived. But, as Survage also observed, "Behind the physical appearance he imagined . . . a mysterious world." All accounts agree that Modigliani was extremely well read. Being related, as he believed, to Spinoza led to an interest in the ideas of philosophers and psychiatrists as well as poets and painters. He could have stumbled across a theory of Arthur Schopenhauer's on the hidden pattern behind the seemingly random event. Schopenhauer's treatise, Jung writes, was the origin for his own article on "Synchronicity," a term he uses to describe either a premonitory dream, vision, or premonition, or the phenomenon of similar dreams, thoughts, and ideas occurring simultaneously in different people. Such a theory of meaningful coincidence would have been as attractive to Modigliani as it was to the nineteenth-century German philosopher. Both were entranced by "the great dream of life."

As has been noted, Eugénie, the witness of so many deaths and cha-

Léopold Survage, 1935

otic reversals of family fortunes, was a spiritualist, as was Rodolfo Mondolfi, her close friend and perhaps lover. Modigliani's subsequent interest in the subject seems perfectly understandable, given his serious illnesses. He may even have had a near-death experience. It is fascinating to speculate about this particularly on the occasion when he almost died of tuberculosis, but there is no evidence one way or the other. It is known that as an adolescent he began attending séances—what Margherita dismissed as "a vulgar fantasy"— and again when he was a student in Venice. Of the earliest drawings in the Paul Alexandre collection, executed in black crayon, Chinese ink, and watercolor, one shows a woman taking part in a séance. The second depicts a male medium with a fixed gaze in the act of "Table-turning," as Modigliani titled the sketch. Certainly his friends were well aware of his interest in the subject. One of the authors of *Artist Quarter* recalled that Modigliani drew him wearing "shorts, an open shirt and bare arms, with a Tirai hat on my head and the head of a hunting dog protruding between my thighs. I am practically certain he couldn't have known that I had spent many years in Central Africa." Beatrice Hastings, their mutual friend, "always insisted that he was a medium."

Modigliani, always a great talker, tended to limit his missives to telegrammatic dimensions. Perhaps by way of compensation he was a sophisticated symbolist, adorning drawings in particular with cryptic references that might be the equivalent of a wink and a knowing nudge, or, by contrast, some quiet, obscure joke he was having at their expense. Or there might be a poem in the latest Symbolist style with oblique personal meaning, rather like the recurrence of the seated nurse theme in Salvador Dalí's works.

One of the few such gnomic statements that have come down to us is from a 1907 sketchbook: "What I am searching for is neither the

real nor the unreal, / But the Sub-conscious, the mystery of what is Instinctive in the Race."

It sounds like a fashionable Surrealist statement. The fact is that Modigliani was toying with such an idea ten years before the word "Surrealism" was coined by Apollinaire, and seventeen years before André Breton's first *Manifeste* in 1924. Both Modigliani and those in the Dadaist and Surrealist movements were making heroic efforts to free themselves from nineteenth-century artistic convention, delving below consciousness to arrive at a new direction. They sought the liberating effects of inspired, random connections,

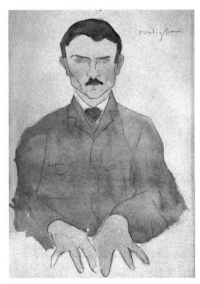

Modigliani's watercolor of *A Table-turning, or, Portrait of a Medium*, in the Alexandre collection, dated 1905–06

what Breton called "Pure psychic Automatism." They were "in open rebellion against all forms of established order, whether intellectual, moral, religious, social or artistic," Noël Alexandre commented. There is no doubt Modigliani, as a Socialist, was just as much in rebellion against the bourgeoisie, but he had a larger goal in mind. Survage recalled him saying, "We are building a new world using forms and colours, but the mind of the Lord will reign over it." His goal in plumbing what Jung has called the collective unconscious was to search for spiritual insights, "the secret truth of the profound being in which he had the originality to believe." Restellini wrote, "Behind the legend of the sole *artiste maudit* of the twentieth century stands a visionary artist with an extremely radical philosophical conception of his art."

Modigliani also liked to quote d'Annunzio's observation, "Life is a Gift: from the few to the many: from Those who Know and Have to those who neither Know nor Have." In the category of those who knew, no one had a better appreciation of life's fleeting beauty and

terrible fragility than he did. In 1910, the night of Halley's Comet and Modigliani's note, Paul Alexandre's mother, the wife of Jean-Baptiste, might just have been feeling ill. In any event she died after a short illness, in 1911. It was tuberculosis. Another shock was to overtake the Alexandres that same year. Jean showed signs of the same dreaded disease and died two years later. Noël Alexandre wrote, "Jean was nursed from the first signs of illness, in 1911, and with all the means at the disposal of a family full of doctors and pharmacists. Nothing worked. The only result was that, perhaps, his agony lasted longer."

That Modigliani was much affected by the death of Paul Alexandre's mother was unlikely, but Jean in danger with an affliction he knew only too well was something else. Jean, the student he had drawn and painted, who emptied his pockets for him, encouraged him, his companion and friend—Jean was as close as a brother and the Alexandres almost Modigliani's second family. Jean's illness continued to develop, and at some point that winter of 1912–13 it must have been clear that he could not recover. Modigliani's tendency to panic at any threat to the collective well-being was almost reflexive, and that winter he began to show signs of distress. Brancusi dropped by one day and discovered him on the floor, unconscious beside a block of stone he was carving. Accounts conflict but it seems likely that this was the same year that the concierge at 216 boulevard Raspail found him similarly unconscious and frozen with cold. The police were obliged to climb over blocks of stone with a stretcher in order to rescue him. Another friend, Ortiz de Zárate, also called in one day and found Modigliani in a faint on the floor. He was so worried, it is said, that he took up a collection to send Modigliani back to Livorno.

Modigliani was emaciated and spitting up blood. Something of his state of mind may, perhaps, be gained from the experience of that fellow sufferer, Keats, after a coughing fit brought up blood. Keats's friend, the artist Charles Brown, recalled one evening that Keats was examining a drop of blood on a bedsheet. "[H]e looked up into my face, with a calmness of countenance that I can never forget, and said,—'I know that colour of that blood;—it is arterial blood;...my death-warrant;—I must die."

———◆———

Maldoror

[D]espair has won his soul and he wanders alone like a
beggar in the alley.

— *Les Chants de Maldoror*

ONE LAZY AFTERNOON a government clerk named Gastone Raz-
zaguta, who liked to call himself an artist, was sitting in the Caffè
Bardi in Livorno eating a macaroon when a stranger walked in. The
man, of average height, had a shaved head. Everybody knew what
that meant, so Razzaguta was instantly on his guard—maybe he was
an escaped convict on the run or something. If so, the man seemed
very self-assured. His walk was nonchalant and Razzaguta relaxed,
concluding that the man had been recently released.

But it was his outfit that commanded even more attention: black-
and-white pinstriped trousers absurdly held up with a belt of string,
a linen jacket, and, shockingly, a collarless shirt at a time when
everybody wore high collars. Furthermore he was in urgent need
of a shave, his beard was growing in white, and he looked around
him in a demanding way. Where was everybody? "Is Romiti here?
Natali? . . ." No reply. "But aren't there any painters here?"

This photograph, much disputed, purports to show
Modigliani with an uncharacteristic crew cut, posing
with one of his sculptures, 1914.

Somebody pointed at Razzaguta, whose long hair qualified him
for the role. "He turned to me with a surprising but cordial invita-
tion. 'Let's have a drink. Who pays?'" Razzaguta bought them each a
glass of Pernod and made a point of noting in his memoir that he was
not given a drawing in return.

It was the summer of 1913 and Modigliani was back in town. The
clerk to the contrary, a shaved head did not necessarily imply a prison
sentence but, more likely, a hospital stay in those days of rampant
head lice. Modigliani must have spent weeks convalescing before
being well enough to travel home in March. Umberto paid for the
trip and Paul Alexandre, at 13 avenue Malakoff in Paris, stored Modi-
gliani's valuables. These included the majority of his finished sculp-
tures and a precious selection of drawings, studies for new sculptures.
There remained a single head, a particular favorite, that had been left
in the studio of the "Serbo-Croat," a joking reference to Brancusi.
Modigliani wanted that transferred into Paul's safekeeping as well.

Modigliani was back on his feet but still frail. Emanuele recalled, "Amedeo returned very ill, and looking like a tramp, to the horror of his poor mother. Naturally he was nursed, well fed, and brought back to a sane health." To feel alive again was to return to work, and Dedo had a particular goal in mind. He was about to create the crowning glory of (one assumes) his Temple of Beauty, although this was not actually mentioned. The keystone, in marble, had been designed and would be achieved in the next few weeks. He was moving to a village where he would literally put up a sleeping tent. He wrote that it had "dazzling light and air of the most luminous clarity imaginable." This may have been the year that Modigliani had his picture taken with one of his sculptural achievements. This is suggested by the fact that an undated and blurred photograph purports to show him, however indistinctly, with very short hair. One of his heads emerges from a block of stone. It is on a plinth; the author stands in the background. In the days when rich food and plenty of it was the only real defense against the ravages of tuberculosis, if this is really Modigliani, he has gained weight. There is a cummerbund around his expanding waistline and a tie around his neck. Both have to have been red. His pride in his work is palpable.

If the marble piece or pieces were ever finished, there is no record. Modigliani did not take them back to Paris when he returned in the summer of 1913 and Noël Alexandre believes this marked the beginning of the end of his work as a sculptor. As for this latest relapse, Modigliani wrote early in May that he had been resuscitated once more. "Happiness," as he wrote, "is an angel with a grave face."

That postcard was sent a few weeks before Jean Alexandre died of tuberculosis at the age of twenty-six. The words may have had a double significance, not just to telegraph cautious optimism but to console his friend for what must happen soon. Heavenly messengers with Janus-like faces: the capriciousness of fate was the price to be paid for earthly happiness. That year Modigliani made another reference to a subject that was much on his mind, as seen in a statement he appended to a drawing:

> *Just as the snake slithers out of its skin*
>
> *So you will deliver yourself from sin.* ☿
> *Equilibrium by means of opposite extremes* △

Man considered from three aspects. ✡
Aour!

The serpent shedding its skin is a common alchemical reference and the statement itself makes most sense when seen in this context. The symbol for Mercury, which follows the second line, is a reference to fluency and transmutation, the "messenger from heaven." To alchemists, all matter was made of three constituents: mercury, sulphur, and salt; matter, being unique and universal, was one in three. The mystical importance of the number three is reinforced by the sign of the triangle. As for the six-pointed star, alchemists considered there to be four theoretical elements, earth, air, fire, and water, and this was the symbol. "But to go further and attempt to understand the meaning of the words—the new skin of the serpent, the deliverance from sin—it is necessary to consider the ultimate goal of alchemy . . . to obtain the Red Elixir . . . or philosopher's stone which (turns) all base metals . . . into gold," Alexandre continues. After numerous complicated procedures the philosopher's stone would reach albification, or whitening, comparable to resurrection after death. "Aour!," a corruption of the Hebrew word meaning light, would seem to be a reference to trial by fire, the necessary purification, without which "the Great Work is impossible." Or, in the poetic terms Keats used to express his own hopes for rebirth, "But, when I am consumed in the fire, / Give me new Phoenix wings to fly at my desire."

Among the habitués of the Rotonde was Ossip Zadkine, son of a Russian university professor who left Smolensk at the age of sixteen to study art in London, became a sculptor, and moved into La Ruche. He met Modigliani in the autumn after the latter returned from Livorno. Modigliani was wearing a handsome gray velvet suit and the sculptor took immediate notice of the leonine head, the distinctive features, high forehead, alabaster skin, and shining, jet-black hair. Modigliani "looked like a young god disguised as a workman out in his Sunday best." Zadkine, mentally modeling, noticed that his "clean-shaven chin had a small cleft in it." Modigliani's smile was delightful, and he began talking immediately about sculpture and the

advantage of direct carving in stone. They first met on the boulevard Saint-Michel and again at the Rotonde. Modigliani had left his canvases somewhere at the Cité Falguière and his sculptures were back in the old greenhouse he called a studio at 216 boulevard Raspail. He invited Zadkine to come and see them.

Zadkine explained that an alley that no longer exists (this comment was made in 1930) led into the back garden of 216. In those days two or three artists' studios were lined up against a wall. There was a piece of open ground behind them, and overhead a few trees threw their black branches protectively over the vulnerable glass roofs.

"Modigliani's studio was a glass box. As I approached I saw him lying on a tiny bed. His fine velvet suit floated forlornly in a wild but frozen sea and waited for him to awaken." All around the walls Modigliani had pinned up dozens of drawings, "like so many white horses in a movie frame of a stormy sea that has been stopped for

Ossip Zadkine posing with his work, 1929

an instant," Zadkine continued. The drawings also fascinated him; a breeze coming through an open window stirred the large white sheets of paper, which were attached by a single pin, and "one would have thought wings were beating over the sprawled painter," so still and silent that he looked as if he had drowned.

Once aroused Modigliani showed Zadkine his perfectly oval stone heads, "on the side of which the nose jutted out like an arrow towards the mouth." Such a lifestyle would not have surprised the visitor, who was also living in similarly uncomfortable quarters. They were so cramped that the wonder was, Zadkine's friends said, that between his sculptures and an enormous Great Dane, there was any room left for him. "Zadkine, at this period, wore a Russian smock and had his hair cut à la Russe and fringed over the forehead, which gave him a startling resemblance to his own images in wood." Zadkine understood Modigliani better than most and knew he would never explain what he was doing. "His only response to my comments as a professional sculptor was a pleased laugh which echoed through the shadows of the lean-to he used for an outside studio."

They were united in all the ways they had invented of managing to eat without paying, "because he quickly blew the money that came from Livorno and I myself, by the twentieth of each month, had spent the advance my father sent me from Smolensk." By common consent they would walk to the corner of the boulevards Montparnasse and Raspail, the center of life in Montparnasse, otherwise known as the Carrefour Vavin, and sit down at a café terrace. There they would patiently wait "like fishermen, for an old friend to rescue us with a loan of three francs so we could eat at Rosalie's." If not they went to Rosalie's anyway, endured her lectures, and perhaps Modigliani forced another drawing on her that ended up in the cellar.

Several reasons have been given for Modigliani's eventual decision to return to painting. It is said that the dust from stonecutting was too damaging for his lungs and the work too arduous; both are plausible. It is also thought he was convinced of the relative ease of selling an easel painting compared to whatever he might create in stone, which was much more likely to be misunderstood, took longer to make, and cost more. This is probably also true. One wonders if there was a

further reason. In terms of exhibiting his sculptures, Modigliani's big opportunity came the year before, when seven heads went on view in the Cubist gallery at the Salon d'Automne exhibition of 1912. A photograph of the room in which they were shown was published in *L'Illustration* and two thumbnail pictures of his heads in *Commoedia Illustré* (Paris). That was a great piece of luck but in other ways his work was being passed over by bigger shows, that year of 1912, in London, Cologne, and Munich, displaying the latest movements in art. Then an even greater opportunity presented itself. Arthur B. Davies and Walt Kuhn, two American artists, were planning an ambitious international exhibition in New York, traveling widely in Europe in 1912 looking for established and rising talents to exhibit at the 69th Regiment Armory the following year. A crowd of four thousand people attended the opening night of the exhibition, technically the International Exhibition of Modern Art, February–March 1913, soon known as the Armory Show and a historic event: the introduction of modern art in America. There were over one thousand paintings, sculptures, and examples of decorative arts, both American and European. The European painting schools, Impressionist, Post-Impressionist, Fauvist, Cubist, and Symbolist, were particularly well represented. There were Cézanne and Matisse, Picasso, Braque and Léger, Redon and Seurat, van Gogh and Gauguin, Kandinsky, Picabia, Dufy, Derain, . . . The list went on and on. Nobody had seen anything like it, and comments, criticisms, and caricatures filled the newspapers for months. "Art students burned . . . Matisse in effigy, violent episodes occurred in the schools," and when the show moved to Chicago, it was investigated by the Vice Commission "upon the complaint of an outraged guardian of morals."

There was no doubt in the daring, ability, and freedom to reinvent, and the years 1910–1913 "were the heroic period in which the most astonishing innovations had occurred; it was then that the basic types of the art of the next forty years were created," the art historian Meyer Schapiro wrote in *Modern Art*. "About 1913 painters, writers, musicians and architects felt themselves to be at an epochal turning-point corresponding to an equally decisive transition in philosophical thought . . . The world of art had never known so keen an appetite for action, a kind of militancy that gave to cultural life the quality of a revolutionary movement or the beginnings of a new religion."

Compared to the enormous range of paintings shown—Marcel Duchamp's *Nude Descending a Staircase* was another work singled out for praise or derision—European sculpture was relatively poorly represented. There were works by Rodin. Alexander Archipenko, three years younger than Modigliani, was invited and showed a cement torso, *Salomé,* 1910. Constantin Brancusi, eight years Modigliani's senior, was beginning to become known and the year before had sold his first work to an American collector, Agnes Meyer. This "arch-modern," as Schapiro called him, showed five works. Among them was the stylized head of a woman, resting on one ear, called *Sleeping Muse.* Another was a highly abstracted bust, *Mademoiselle de Pologany,* in white marble. This particular work was compared to "a hard-boiled egg balanced on a cube of sugar," and his works caused almost as much of a furor as Duchamp's descending nude. But when Brancusi's work was shown that same year in the Salon of the Allied Artists Association in London, the critic Roger Fry wrote that the sculptors were "the most remarkable in the show." Brancusi was on his way.

Modigliani, by contrast, had not been invited. Unlike other artists he had as yet no dealer and there were no Modigliani heads on view in shop windows. True, but Brancusi had been his mentor, and a close friend. In 1912–13 he was storing one of Modigliani's heads in his studio, as we know from the latter's letter to Paul Alexandre. Did he put in a word for his friend? Did he even try? Zadkine said, "Little by little the sculptor in Modigliani was dying."

Some time afterward Zadkine, visiting the boulevard Raspail studio, was saddened to see abandoned stone heads, "outside, unfinished, bathing in the dirt of a Parisian courtyard and merging with the glorious dust . . . A large stone statue, the only one he had carved, lay with its face and belly towards the grey sky." Of the wreckage left behind of Modigliani's dreams of being a sculptor, some twenty-seven works have survived. Seventeen are in museums, among them the Museum of Modern Art and the Guggenheim in New York, the Musée National d'Art Moderne in Paris, Philadelphia Museum, and the Tate and the National Gallery of Art in London. The remaining ten are privately owned. In June 2010, one of these, a sculpted stone head owned by Gaston Lévy, a French businessman, sold at Christie's in London for $52.8 million (see color illustration).

There is in the corridor
A man who wishes me dead
 — MODIGLIANI

Although Cubism, the most important new movement in art just then, would determine much of the painting and sculpture in the future, its main proponents, Picasso and Braque, were poorly represented at the Armory Show. This was not as crucial for Picasso as it had been for Modigliani. He was already on his way critically and financially and, in 1912, was living in his smart new apartment with a new lover, Eva. Fernande Olivier, who had been Picasso's mistress when Modigliani arrived in Montmartre, met Modigliani at one of the cheap restaurants where they could all eat for ninety centimes on credit, and that would include a small glass of something to finish the meal, "often poured by the patron himself." In those early days

Picasso on the Place Ravignan, 1904

Modigliani "was young and strong and you couldn't take your eyes off his beautiful Roman head with its absolutely perfect features," she wrote. "At that time he was living . . . in one of the studios on the bank of the gloomy old reservoir. This was before his *vie maudite* in Montparnasse, and, despite reports to the contrary, Picasso liked him a lot. How could any of us have failed to be captivated by an artist who was so charming and so kind and generous in all his dealings with his friends?"

It was easy to be friendly in the old days when everyone was poor and unknown, drinking cheap wine together, indulging in hashish, and railing against the ignorance of dealers. It was something else when someone like Picasso shot to prominence; Modigliani could not help measuring his efforts against those of the clever Spaniard and finding them wanting. Modigliani also believed Picasso was decades ahead of the rest of them. He was so imaginative, so creative, and so successful. But he was tricky, almost impossible to know, and his reputation for ironic comment, already far advanced, contained a certain cruel humor. One never knew whether it would be turned on one personally. On the other hand he was a natural leader around whom others congregated. He just seemed to *know*. It was useful to

The establishment of artists' suppliers, Lucien Lefebvre-Foinet on the rue Vavin

be somewhere on the fringe if only because Picasso's hospitality was legendary and there would always be a bowl of macaroni for the visitor or even a cutlet. If nothing else. But there was more.

Modigliani resolutely refused to follow Picasso and Braque into Cubism, but there was no doubt he was very much influenced by Picasso's work and, as the comment suggests, measured his own efforts against it. Pierre Daix, an authority on Picasso, believes Modigliani witnessed the transformation the former's work underwent in his *Portrait of Gertrude Stein,* painted just after they met. The original work underwent a radical revision. Picasso "reduces her face to a mask, to contrasts of volume lacking any detail of either identification or psychological expression. That summer, anticipating Matisse, Picasso was the first to take amplification and formal purification to such an extreme. And the faces of all his figure-paintings of the period display a similar reduction to essentials, to structure. Was this what struck Modigliani?"

Daix suggests that in subsequent paintings, particularly *Woman's Head with Beauty Spot, La Petite Jeanne,* and *The Amazon,* Modigliani is experimenting with a similar masklike stylization and geometrical emphasis. The two men certainly had parallel interests, not just their fascination with Negro art. Picasso painted his large canvas *Family of Saltimbanques* in 1905 which Daix believes Modigliani must have seen since it was in his studio for the next three years. In due course Modigliani had portrayed himself similarly, as a traveling player, using the identical palette that Picasso had used: blue-greens, shades of brown, and oranges. That was in 1915, and by coincidence or design, Modigliani painted a portrait of Picasso that same year. It is a curious picture. The paint is almost scrawled across the canvas in a furious fashion, unlike Modigliani's carefully developing style. The subject's penetrating stare is masked, the mouth is small and set, and the expression is secretive, almost cunning. The word *"savoir,"* knowledge, learning, or "to know" has been appended. Restellini suggests that this perhaps refers to Maud Dale's belief in Picasso as a visionary. Was that really meant as a compliment or, as Billy Klüver believed, "an ironic comment about the guy who knows it all?" If Modigliani wanted to remain true to his own vision he would have to, and did, keep a safe psychological distance from this powerful, perhaps even artistically stultifying personality. When asked to what

"ism" he belonged and in what manner he painted, he would always reply, "Modigliani." But for an artist to keep his ideas, even his techniques, a secret was well understood. Everyone went to buy paints and equipment from Lefebvre-Foinet, a family of chemists and artists' suppliers in business since 1872, partly because of their astute awareness that their role was akin to the confessional. Every artist wanted to learn secrets about pigments and techniques that would give him or her an advantage over the rest. So if an artist arrived to consult Lefebvre-Foinet, usually in the lunch hour when everyone else was eating, and if by chance someone else arrived, Lefebvre-Foinet had provided a discreet exit so that the two would never meet.

There was rivalry but also antagonism to at least some degree. It seems likely that Modigliani, ever alert to signs of anti-Semitism, had overheard a certain unkind remark from Picasso. It is claimed—the author is not cited—that in the days when Picasso was poor and Modigliani briefly had some money, Modigliani saw the former passing by his café table, sized up the situation, and offered a loan of five francs. Picasso took the money gratefully. In due course, the situation being reversed, Picasso called on Modigliani one day to return the favor. He presented him with a one-hundred-franc bill. As Picasso was leaving Modigliani remarked that he owed him some change but would not give him any, because "I have to remember I'm a Jew."

Another story concerns one evening in 1917. Picasso, unable to sleep, decided to paint something. Looking through his collection for a fresh piece of canvas, and finding none, he decided to use a painting acquired from Modigliani. He could have chosen to paint on the reverse, which was an almost universal solution. But that had a certain symbolism Picasso would have automatically rejected. Instead, he painted a still life of his own on top: a guitar, a bottle of port, some sheet music, a glass, and some rope. He evidently felt the urge to obliterate the work of someone with whom he was, obscurely or otherwise, in competition.

A further incident bears out this possibility. At the end of World War II, the art historian Kenneth Clark was lunching with a mutual friend in Paris; Picasso was one of the guests. Lord Clark had brought, as a gift for his hostess, the first book ever published on the sculpture of his great friend Henry Moore. "Picasso seized on it in a mood of derision," Clark wrote. "At first he was satisfied: 'C'est bien. Il fait

le Picasso. C'est très bien.' . . . But after a few pages he became much worried." Picasso left the table and took the book over to a far corner of the room. For the rest of the meal, he sat there turning the pages in silence, "like an old monkey that had got hold of a tin he can't open."

In the years to come Henri Cartier-Bresson took a photograph of Picasso's studio on the rue des Grands Augustins in Paris. By then—it was 1942—Modigliani's work had become well known. The picture shows one of Modigliani's paintings, a young girl with brown hair, propped beside the great man's canvases and sculptures.

Fernande Olivier's reference to Modigliani's move to Montparnasse as the start of his *"vie maudite"* (cursed life) reflects a view that, over the decades, has hardened into a certainty. It is axiomatic that Modigliani was a brilliant young artist who ruined his health and died prematurely from drugs and drink. As has been noted, even authors who are aware that he had tuberculosis take the same similarly dismissive attitude. The addiction showed the extent of his self-destructiveness. We judge from the context of our own age, when tuberculosis is curable, rather than from his, when it was not; that dread disease has faded into the background reserved for forgotten scourges like leprosy and the Black Death.

This version is based on a tragic misconception, but it is, unfortunately, one that Modigliani deliberately cultivated. A key to this is contained in his mother's diary, written four years after his death, in 1924. Reading between the lines, she provides the clue. Dedo did not want anyone to know—she used the verb "to flaunt, show off, make a point of"—the terrible shadow under which he was living. Only his closest friends knew he had tuberculosis, for the reason that, if such a fact had been known, he would have been avoided, if not shunned by everyone. He *had* to pretend. Nothing had changed since the days when Chopin's and Keats's landlords had burned the furniture after they moved out. If anything, matters had grown worse because, in 1882, Robert Koch famously demonstrated that tuberculosis was a bacillus and easily transmissible. This medical discovery coincided with the fact that, by 1900, tuberculosis was the leading cause of death in France. In the 1890s the French government mounted what was called a "War on Tuberculosis," and an international congress

was held in Paris in 1905, just before Modigliani arrived, to look for a cure. David S. Barnes, author of an invaluable study of tuberculosis in nineteenth-century France, wrote, "Around 1900 tuberculosis was a national scourge, highly contagious, lurking around every corner and symptomatic of moral decay."

Ordinary people were naturally terrified, often irrationally. Barnes tells the story of a maid who developed bronchitis, so alarming her employers that she was moved out of the house and into lodgings. When she then developed unmistakable signs of tuberculosis she was fired. "Fleeing to the countryside, where her prospects of recovery might have been greater, she sought refuge with her sister. There were young children in the household, however, and the sister refused to have her. The young woman's last resort was the hospital, but even there, the doors were closed to her, because all of the beds were full." Studies soon demonstrated the obvious: that the poorest areas of Paris had the worst infections. When an outbreak of bubonic plague occurred in one of those areas, called "*îlots insalubres*" (unsanitary blocks), the offending buildings around the rue Championnet in the seventeenth arrondissement were demolished. Voices were soon raised demanding that all the *îlots insalubres* be torn down. Weekly disinfection of buildings where there was an outbreak was mandatory. Voices were raised requiring doctors to identify tubercular patients so that they could be isolated. Everyone else's health was at risk.

The fact that doctors had no cures did not prevent them from asserting that they had found *the* cure. The time-honored methods of bloodletting and starvation diets, which further weakened Keats, might have been over, but their replacements were useless, or worse: goat's milk, cod liver oil, lichen, antimony, tannic acid, creosote, arsenic, or the fumes from hot tar. Modigliani knew all about that. Doctors had been experimenting on his suffering body since he was sixteen. They had given him up for dead. He wanted nothing to do with them.

Accounts suggest that, from about 1914 on, Modigliani's intake of alcohol increased. Seen from the perspective of his affliction, this suggests that his symptoms had worsened; the reason is not hard to find. As spitting was considered tantamount to involuntary manslaughter, the urge to spit and cough had to be suppressed. Opium,

usually taken in a preparation called laudanum, was the most effective antispasmodic and was legal, along with morphine and heroin. Failing these, alcohol was the remedy of choice. Cognac, brandy, and whiskey were preferred, but wine would do. The consumptive took a small sip here, another sip there, whenever he or she felt a cough coming. At all costs he must avoid bringing up "a fawn coloured mixture" of blood and phlegm, as Keats did, or spattering his handkerchief with blood—much less choke on a violent hemorrhage. It was primitive self-medication but effective.

Friends attest to the fact that the moment Modigliani arrived at a café he wanted a drink. Nobody mentions spitting or coughing, which indicates a secret successfully kept. People did notice that he always seemed to have hashish with him. That was further proof of his moral decay. For Modigliani (the born actor) nothing was easier than to feign an addiction he did not have, at least at first, in order to conceal a disease that was going to kill him; better to exasperate than to be avoided and shunned. Perhaps only Picasso, that shrewd observer, suspected the truth. "It's very strange," he said, "one never

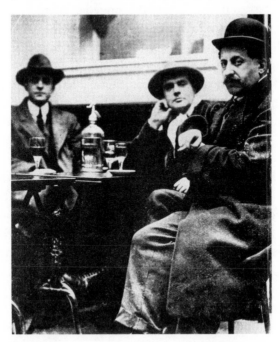

Modigliani, center, at the Dôme with Adolphe
Basler during World War I

sees Modigliani drunk on the boulevard Saint-Denis (where no one ever went), but always at the corner of the boulevards Montparnasse and Raspail!"—where he was sure of an audience.

And if he rapidly became drunk, perhaps a moment came when the intoxication, feigned for so long, became a reality. Or perhaps it was just one more stunt when he began to yell, break glasses, take off his clothes, and insult the waiters. When you are thrown out on your ear, do you have to pay the bill? People began to dread the sight of him coming up the street carrying his eternal blue folio of drawings, trying to sell them for the price of a drink. Hamnett wrote, "Picasso and the really good artists thought him very talented . . . but the majority of people in the Quarter thought of him only as a perfect nuisance." Basler wrote, "He was the scourge of the bistros. His friends, used to his excesses, forgave him, but the landlords and waiters, who hailed from a different social stratum . . . treated him like a common drunk." He might even occasionally bang on his chest and say, " 'Oh, I know I'm done for!' " and no one took him seriously. This, then, was the explanation for the puzzle I encountered when I set out to understand his life, and it changed everything. Here was no shambling drunk but a man on a desperate mission, running out of time and calculating what he had to do in order to go on working and concealing his secret for however long remained. He was gambling, and willing to take the consequences. It must have been a courageous and lonely masquerade. At the same time he was launching himself on the most successful and productive period of his career.

"[M]any tuberculous individuals have dazzled the world by the splendor of their emotional and intellectual gifts and by the passionate energy with which they exploited their frail bodies and their few years of life in order to overcome the limitations of disease," René and Jean Dubos wrote in *The White Plague*. The poet Sidney Lanier used periods of relative health to write feverishly, feeling that his mind was "beating like the heart of haste." Another poet, Elizabeth Barrett Browning's feelings of almost unbearable excitement seemed like "a butterfly within, fluttering for release." John Addington Symonds, who wrote that tuberculosis gave him "a wonderful Indian summer of experience," also felt the passion to create. "For

most sensitive temperaments,"
The White Plague's authors wrote,
"artistic expression is a kind of
bloodletting, and Symonds spoke
endlessly of the relief from his
miseries that he found through
writing."

Modigliani also had another,
particular reason for celebration:
he had finally found a dealer. He
was Guillaume Chéron on the rue
la Boétie, a small, round, fat man
who is portrayed by Modigliani
with a bulbous nose above what
passes for a moustache. Chéron
began life as a bookmaker and
wine merchant in the south of
France and transferred to pictures
after he married the daughter of

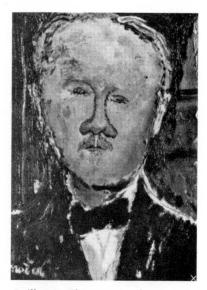

Guillaume Chéron, one of
Modigliani's dealers, as seen by
the artist, 1915

Devambez, a well-known dealer, and moved to Paris. Chéron knew
nothing about art, and most memoirists paint him as boorish as well
as ignorant. But he needed clients, realized the importance of pub-
licity, and sent out booklets extolling the virtues of buying art as a
financial investment. All that Chéron required were paintings, as
cheap as possible. Those were the days when dealers collected stables
of artists and paid daily stipends to get the work. Modigliani received
ten francs a day. Chéron provided a studio, paints, brushes, canvas,
a model, and the necessary bottle of brandy. The studio was in the
basement, leading to several lurid accounts of Modigliani's incarcera-
tion in a dungeon with a single window, locked in like Utrillo until
he had produced a painting. Since the "basement" also contained
a dining room where Chéron and guests lunched every day, the
account seems as fanciful as most of the other reminiscences about
Modigliani. He certainly did not complain about his quarters. He
was absolutely delighted to have a job. "Now I'm a paid worker on
a salary," he told his friends. He and Chéron soon parted company,
which turned out to be a blessing in disguise.

Max Jacob, one of the many fascinating characters in the circle

of Montparnasse in those days, had arrived in Modigliani's life. John Richardson wrote, "The pale, thin gnome with strange, piercing eyes ... was a Frenchman—brilliant, quirkish, perverse—with whom [Picasso] found instant rapport ... [H]e was infinitely perceptive about art as well as literature and an encyclopedia of erudition—as at home in the arcane depths of mysticism as in the shallows of l'art populaire. He was also very, very funny." Jacob, a poet, artist, writer, and art critic, knew and liked Modigliani, and the sentiment was returned. Jacob had studied philosophy, could recite poetry with as much confidence as Modigliani, was addicted to ether and henbane, and was an alchemist. He had introduced Picasso to the Tarot and probably did the same for Modigliani. He was also adept at palmistry and famously had read Picasso's hand and perhaps Modigliani's as well, though there is no record of this. But his main gift seems to have been as a facilitator, with a vast network of friends. Hearing that Modigliani and Chéron had parted ways, Jacob had an inspired idea: he would introduce him to Paul Guillaume.

Like Jacob, Guillaume came from a modest background and, also like Jacob, was born with an innate aesthetic sense, rising like a meteor from an entry-level job as a clerk in a rubber-importing company to a collector of African statues and then an expert on primitive art. He was still only in his early twenties. On the other hand he had met Apollinaire, who immediately sensed his unusual abilities and introduced him to the world of artists and sculptors. Most of them were looking, as was Modigliani, for someone who instinctively appreciated and understood their work and had the wit to promote it. In that respect Guillaume was heaven sent. Aspiring art dealers usually started business in a modest way in the rue de Seine on the Left Bank with the goal of eventually reaching wealthier clients on the Right Bank. Guillaume, who did not have any time to waste, started in the rue de Miromesnil, "a neighborhood dominated by the opulent, historic, institutional galleries," Restellini wrote. It was the maddest folly from a business viewpoint, since artists like Picasso, Matisse, and Derain had already found their dealers, but for unknowns it was an enormous piece of luck. Somehow Jacob, like Apollinaire, was convinced that Guillaume would become famous, as indeed happened with remarkable suddenness, and he decided to introduce the two men. The trick would be to have Guillaume meet

Modigliani as if by accident. There are conflicting versions of this story, but they agree on some details. Jacob set the scene with care. He had a date to meet Guillaume one afternoon at the Dôme. Modigliani, as agreed, would arrive ahead of them and make a show of passing his drawings around. His table would be nearby. Jacob was convinced that Guillaume would soon "discover" him.

All of it happened as Jacob planned. Guillaume drifted over to Modigliani's table, liked the drawings, and sat down. From here the versions differ. The first came from Charles Beadle, one half of the "Charles Douglas" nom de plume of the writers of *Artist Quarter.* Rose describes him as a "down-at-heel English journalist" who collected mostly "scurrilous gossip and half-truths," often the passages most quoted from the book. By accident or design, in these stories Modigliani is invariably seen in a poor light. So in this version, when asked if he had any paintings to show, Modigliani curtly said he did not. No doubt Modigliani thought of himself as a sculptor, but after having gone to all the trouble to stage a rendez-vous it is hardly likely that he would have brusquely rejected the invitation he had been angling for. The second version is more likely. When Guillaume asked the same question Modigliani, who perhaps had been hoping to be asked about sculpture, nevertheless admitted that he did paint "a bit." He complained to Jacob about it afterward. But he did accept the invitation and Guillaume did, indeed, become his new agent.

Like Derain and Giorgio de Chirico, whom Guillaume also represented, Modigliani painted several portraits of his dealer. Guillaume, who dressed with fastidious attention to detail, was as short as Modigliani but not as good-looking. The proportions of his face were against him—cheekbones too wide, forehead much too low— and he had a certain humorless habit of parting his hair strictly in the middle and plastering it down, something that may have made him look older but did nothing to correct the imbalance. He took to wearing hats with sizable crowns, which solved the problem of proportions, and two of Modigliani's portraits show him hatted. On a portrait painted in 1915 Modigliani has appended "Novo Piloto," and that was literally true. Modigliani desperately needed a guiding hand along with the publicity only a clever dealer could provide. A year later, Guillaume is still wearing a hat and an arm rests negligently along the back of his chair. A right hand is visible, and just

below it, Modigliani has signed his name. Did he feel he was under Guillaume's thumb? Was he being sufficiently grateful? An article written by Guillaume some months after Modigliani's death in 1920 offers some clues.

"Because he was very poor and got drunk whenever he could, (Modigliani) was despised for a long time," Guillaume wrote, "even among artists, where certain forms of prejudice are more prevalent than is generally believed . . . He was shy and refined—a gentleman. But his clothes did not reflect this, and if someone happened to offer him charity, he would become terribly annoyed." Who could forget his "strange habit of dressing like a beggar" that nevertheless "gave him a certain elegance, a distinction—nobility in the style of Milord d'Arsouille that was astonishing and sometimes frightening. One only had to hear him pompously reciting Dante in front of the Rotonde, after brasseries closed, deaf to the insults of the waiters, indifferent to the rain that soaked him to the bone."

Paul Guillaume, the dealer who put Modigliani on the map, 1915

To think, only six years before, Modigliani had a hard time sell-
ing his drawings for fifty centimes or one franc. "No one will deny,
I hope, that this sad state of affairs came to an end after he met me.
Nor that I was the only person to provide him with some comfort
from that time onwards." There were plenty of people around nowa-
days, Guillaume commented with some asperity, to find his work
important now that they no longer had to face general ridicule.

Guillaume might have added, but did not, that Modigliani was
not always the easiest person to deal with, quirky, full of changing
moods, and quick to take offense. How delightful Modigliani could
be when he was not drunk, Jacob was said to have remarked. "He
could be a charming companion, laugh like a child, and be lyrical
in translating Dante, making one love and understand him. He was
naturally erudite, a good debater on art and philosophy, amiable and
courteous. That was his real nature, but nevertheless he was just as
often crazily irritable, sensitive, and annoyed for some reason he
didn't know himself." That, too, was part of the general chorus:
Modigliani is angry, but he does not know why.

There are references to what Jacob Epstein called Modigliani's pre-
dilection for "engueuling," i.e., violent abuse of someone or some-
thing that aroused indignation and rage, though Epstein thought the
outburst was usually merited. One never knew when this seemingly
lovable personality might become haughty or rude, spiteful, and even
hostile. The fact is that such mood changes are to be expected and
are common, if not universal, among tuberculosis victims. Keats's
rapid shifts of mood are famously charted in his letters, "where in a
moment he can go from self-mockery and brilliant wit to self-analysis
to depression or indolence," Plumly writes. "Always in extreme,"
one of his classmates said, "in passions of tears or outrageous fits of
laughter." Keats also suffered from "blue devils," black moods that
periodically overwhelmed him; as for Modigliani, the well-known
depressive effects of alcohol would have spiraled him further into
despair. It was no coincidence that his laughter often seemed to have
a demonic edge. One young student, studying at Dartmouth in the
mid-nineteenth century, who was obliged to leave the college when
he developed tuberculosis, wrote, "Shackled and oppressed by the
most tedious and vexatious complaint that ever cursed human nature,
I have been obliged to . . . relinquish my studies and overthrow and
destroy some of my fondest and darling expectations." Modigliani

did not need to put his own feelings down on a page. He carried
them in his pocket.

Les Chants de Maldoror (The Songs of Maldoror) was described
by André Gide as "something that excites me to the point of delir-
ium," and as a work of "furious and unexpected originality by a mad
genius." Part Gothic fantasy, part serial novel and horror story, *Les
Chants de Maldoror* is not a song or even a poem but a kind of inte-
rior monologue. Maldoror is "a demonic figure who hates God and
mankind," Ronald Meyer wrote. Edmond Jaloux called it "a world
with a tragic grandeur, a world that is closed, impermeable, incom-
municable"; a *Divine Comedy* "written by an adolescent of extraor-
dinary intuition, full of darkness and punishment, and centripetal
gloom." In short, Octavio Paz observed, its author "was the poet
who discovered the *form* in which to express psychic explosion."

Les Chants de Maldoror's author was Isidore Ducasse, who styled
himself as the Comte de Lautréamont. Ducasse, born in 1846, was
the only child of a French couple living in Uruguay, where his father
was an officer in the French consulate in Montevideo. He never knew
his mother; she died a few months after he was born. He was sent to
be educated in France, where his classmates described him as "a tall
thin young man, slightly round-shouldered, with a pale complexion,
long hair falling across his forehead . . . At school we reckoned him
an odd, dreamy character."

After school Ducasse moved to Paris to become a poet. This first,
rambling work was published in 1869 but was termed too controver-
sial for general release and remained more or less unknown until it
was rediscovered and republished in 1890. Modigliani seems to have
found a copy in about 1910 and reacted as Gide had done: it was a
life-changing experience. He memorized whole paragraphs and was
willing to be parted from it only briefly by people like Paul Alexan-
dre, who promised to give it back.

Ducasse also seemed to have had a Surrealistic premonition a
good fifty years before anybody knew enough to give the move-
ment a name. His delirious imagination, his grotesque imagery, his
demonstration of what could be created once the mind had dis-
pensed with proper moral feeling, looked more than prescient, but
almost uncanny, as if he had written the first Surrealist Manifesto
in a visionary dream. In particular, images like "the chance meet-

ing on a dissecting-table of a sewing machine and an umbrella" gave
André Breton, the poet and the movement's chief theoretician, a jolt
from which he never recovered. When Breton discovered *Maldoror*
in a Belgian library (a decade after Modigliani had), and in the days
before photocopying machines, he did it the singular honor of copy-
ing it out by hand—it ran to eighty thousand words. Another early
Surrealist, Salvador Dalí, finding in *Les Chants de Maldoror* the most
perfect possible example of his "paranoic-critical" method, devoted
forty etchings to illustrating passages from the book. They are among
the most delicately conceived and imaginative of his works.

What is almost never pointed out about Ducasse, at a time when
the illness was as taboo as AIDS is now, is that he was yet another
victim of tuberculosis. At least some of his pages were written at the
very end of his life, when whatever was feigned about his feverish
state had become all too real. He died a year after it was published, in
1870, at the age of twenty-four.

Like Modigliani, Ducasse "sings" what he did not dare to reveal:
that he was very ill and probably dying. The clues are clear enough.
First Canto: "Feeling I would fall, I leaned against a ruined wall, and
read: 'Here lies a youth who died of consumption. You know why.
Do not pray for him.'"

Second Canto: "It is not enough for the army of physical and
spiritual sufferings that surround us to have been born: the secret
of our tattered destiny has not been vouchsafed us. I know him, the
Omnipotent . . . I have seen the Creator, spurring on his needless
cruelty, setting alight conflagrations in which old people and chil-
dren perished! It is not I who start the attack; it is he who forces me
to spin him like a top, with a steel-pronged whip . . . My frightful
zest . . . feeds on the crazed nightmares which rack my fits of sleep-
lessness." Maldoror, a name probably derived from *mal d'aurore*, a
bad dawn, is being taken for a madman, "who seemed not to concern
himself with the good or ill of present-day life, and wandered hap-
hazardly, . . . his face horribly dead, hair standing on end, and arms—
as though seeking there the bloody prey of hope." He is "staggering
like a drunkard through life's dark catacombs."

Fifth Canto: His body is no more than "a breathing corpse," and
his bed is a coffin. His only pleasure is making others suffer in agony
as he himself is being tormented. It all begins to sound like "engueul-

ing" and also like Eugénie's poem "Fierce Wish," in which she pro-
poses to set fire to her neighbor's barn and burn his child alive: a
frustrated rage and resentment that turns on life itself. Small wonder
that Modigliani memorized page after page. He could hardly avoid
seeing himself in the same light, as one more victim of a malignant
fate. In 1913 he, offering a drawing of a caryatid to a friend, added
the dedication: "Maldoror to Madame."

One spring day in 1914 Alberto Magnelli, an Italian artist four years
Modigliani's junior, who happened to be in Paris studying Cubism,
was strolling along the boulevard Montparnasse in a westerly direc-
tion toward the railway station. It was a beautiful morning and he
was thinking of other things when he realized that the conductor of a
tram, also traveling in his direction, was ringing his bell violently and
simultaneously applying his brakes with a great screeching noise. He
looked up and saw a man on the opposite sidewalk crossing the street
in front of the tram, walking like an automaton straight toward it. He
was bound to be hit. With a start, Magnelli realized it was Modigliani.

In a flash Magnelli had sprinted across the street and flung himself
at Modigliani, whose eyes looked glassy and enormous. He wrote, "I
do not know how I managed to get in front of him in time." He was
so close to the tram that it scraped him as it passed. As for Modigliani,
he had been knocked to the ground and seemed, at that moment, to
have come to his senses. He was helped over to the sidewalk and
the nearest café table, which happened to be at the Rotonde. Mag-
nelli ordered a round of drinks. About his narrow escape from death,
Modigliani did not say a word.

————◆————

Beatrice

Have you noticed that life, real honest-to-goodness
life, with murders and catastrophes and fabulous
inheritances, happens almost exclusively in the
newspapers?

—Jean Anouilh, *The Rehearsal*

BEATRICE HASTINGS, who met Modigliani in the summer of 1914
and with whom he fell madly in love, was a poet, journalist, editor,
and novelist, and an invaluable witness to one of the most important
periods of his life. In contrast to her lover, for whom putting any
words on paper was like pulling teeth, she dashed off a weekly col-
umn about life in Paris: anything and nothing. That included refer-
ences to him, their friends, conversations, and daily life together that
are only sporadically disguised.

Yet even she has said different things at different times, making the
separation of truth from fiction almost as difficult as it is in any other
aspect of Modigliani's life. One version given for the way they met
has been quoted often. In it she said she met him at the Rotonde and
was repelled. He reeked of brandy and hashish and needed a shave;

Modigliani, about the time he met Beatrice Hastings

she thought he was a pig. But when they next met he was clean, neat, shaved, and sober. "Raised his cap with a pretty gesture, blushed to the eyes, and asked me to come see his work." He might be "a pearl" after all.

The "pig" versus "pearl" is not only suspect—a comment made, perhaps, long after they had broken up—but hardly reflects the truth about their relationship or does justice to the subtle evasions of this author whose biography by Stephen Gray, *Beatrice Hastings: A Literary Life,* runs to seven hundred pages. Born in South Africa of British parents, she was as much of a phenomenon in her own right as Akhmatova was in hers, a New Woman emerging from the detritus of the Victorian Age, abandoning her corsets, shortening her skirts, smoking, drinking, and taking lovers. From the start this softly pretty girl with a halo of brown hair and an uncompromising gaze seemed able to *épater les bourgeois* in a way that the women in Modi-

gliani's family, including his sister, could hardly dream of. First of all, she married a boxer, probably while she was still a teenager. Shortly afterward she had divorced him and sailed to New York, where she attempted to become a showgirl. This did not last either, and she was soon in London, where she had the good luck to hit upon her rightful career as a journalist, the literary editor of a progressive weekly magazine appropriately titled the *New Age.* It helped that the magazine's editor, A. R. Orage, was in love with her. But she was a pearl in her own right, as he discovered, nurturing the talents of Ezra Pound and Katherine Mansfield and the intellectual equal of authors like H. G. Wells, Bernard Shaw, G. K. Chesterton, and Arnold Bennett who graced its pages.

The evidence she herself presents about her first meeting with Modigliani suggests that the truth was more complicated. Along the way several people, including Zadkine and Hamnett, claimed to have introduced them. By 1936 she was annoyed enough to contradict them and herself. She wrote to Douglas Goldring, who subsequently coauthored *Artist Quarter,* that she met Modigliani before Hamnett arrived in Paris and not at the Rotonde (after all). The real story was in her book, *Minnie Pinnikin,* an unfinished, semiautographical novel. By 1936 she had written a number of chapters but unfortunately had mislaid it. In those days, "I was Minnie Pinnikin and thought everyone lived in a fairyland as I did." She was shrugging him off with a lame excuse but it was also true that her typescript had disappeared. Subsequent authors, including Pierre Sichel, assumed it had been lost. Then one day the art historian Kenneth Wayne made a sensational discovery in New York. He was doing research at the Museum of Modern Art in preparation for an exhibition, "Modigliani and the Artists of Montparnasse," in 2002 at the Albright-Knox Art Gallery in Buffalo, and there it was in the William Lieberman Papers. Wayne published the first chapter, which he translated from the French, in the catalog for the show.

The name, Minnie Pinnikin, could well be a reference to *Mimi Pinson,* the heroine of a novel by Alfred de Musset written in the 1840s. If so, it is a strange one, since the novel tells the story of a grisette who provides "a perfect answer to the physical and emotional needs of lonely, sometimes idle, and often self-centered young bourgeois," Seigel observes in *Bohemian Paris.* One would expect that since Min-

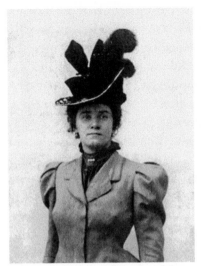

Beatrice Hastings at the turn of the
century

nie Pinnikin represents herself, Hastings would have modeled her heroine on some prominent early feminist. But she always denied being one, among the many curious contradictions of her character. She was not to be labeled. She was simply doing what women had always done, fighting her way to the top with a judicious blend of intelligence, guile, tactics, talent, and charm. And if the price of success included sex she was perfectly willing. It is said that she boasted about how many men she had slept with and kept a running tally of notches on her bedpost. Before she dispensed with corsets, there is a photograph of her in a preposterous hat balanced precariously on an untidy nest of hair. Her tight-fitting jacket clearly shows the outline of her nipples, the kind of absentminded-on-purpose display one rarely sees even in drawings of Toulouse-Lautrec's prostitutes.

In *Minnie Pinnikin* Modigliani has the name of Pâtredor, or Pinarius, and the first chapter is a description of their meeting. He was "fishing men from the street, swinging them with his long hands. 'How beautiful he looks this morning!' It was true he was really beautiful. The sun that danced in his hair leaned forward to look into his eyes." Then Pâtredor becomes aware of Minnie Pinnikin and drops everything to run after her. "One could tell that they would be married one day, but no one ever mentioned it simply because it was not yet time," she wrote. They were "still playing the first love games: jumping from hill to hill, traveling the world without stopping anywhere, drinking rivers of hope as big as the Seine." All of which does not tell us how they met either.

The version that probably comes closest to the truth—which is not saying much—is the one published in the *New Age* early in June 1914. She had arrived in Paris two or three weeks before and they had already met, but he was probably looking disheveled. They met again at Rosalie's one evening. A friend whom she does not identify

except as "an English bourgeoise" "was satisfied when she saw me wake up from a sulk to be very glad with the bad garçon of a sculptor." This is obviously Modigliani, though what she means by being awakened, a sulk, or even "to be very glad" is not explained. Her evanescent and coquettish literary style would give some of her columns such a maddening feeling of evasiveness that the wonder is that they were even published, much less read. She continued, "He [referring to Modigliani] has mislaid the last thread of that nutty rig he had recently, and is entirely back in cap, scarf, and corduroy. Rose-Bud was quite shook on the pale and ravishing villain." Rose-Bud is Rosalie, and almost everyone in Hastings's columns is disguised in such a way as to be understood by the "in" crowd. But then, she loved disguises, the more the merrier. Born Emily Alice Haigh, she soon became Beatrice Hastings. She wrote her column as Alice Morning and was, at various times, A.M.A., E.H., B.L.H., T.K.L., V.M., T.W., Beatrice Tina, Cyricus, S. Robert West, and on and on.

There was nothing elusive about Modigliani when he was in love. Hastings might couch her feelings in coy fantasies, rolling her eyes and fluttering her Oriental fan; he was all masculine impetuosity. If the stories can be believed, and at least one has the ring of truth to it, he might even make a brazen date with a woman he fancied as her husband or boyfriend sat listening in amazement and disbelief. In the years since Akhmatova, he had taken and dropped as many delectable mistresses as Hastings claimed lovers. But he must have done so with exemplary tact, to judge from the willingness of said ladies to tearfully press him with parting gifts instead of the other way around. In all his dealings with women Modigliani was the conventional southern Italian male, as described by Barzini, pursuing tirelessly and then, particularly if he loved someone, jealous and possessive. Modigliani was also a charming suitor, known to offer books, pass beneath windowsills at night, and rob the graves of funerals for a flower to present with the breakfast café au lait. None of that was necessary in this case. What seeps through the recollections of Zadkine and Hamnett, who certainly saw the two together soon after they met, is what is not being said. Could it be that the onlookers jumped back in alarm, for fear of getting burned, when faced with the conflagration they had unwittingly unleashed, what the French call a "coup de foudre"?

There is no doubt that Modigliani and Hastings had an almost

uncanny number of interests in common. Here was the poet he had
lost when Akhmatova walked out of his life. Well, unknown poet as
yet, but of course she would soon be famous. Her name was Bea-
trice, that of Dante's inamorata, another good omen that cannot
have escaped his notice. She was a Theosophist, follower of Helena
Petrovna Blavatsky, in love with painting, sculpture, literature, and
music, and a Socialist to boot, following international affairs with
almost the same close interest as Emanuele Modigliani did. Garru-
lous in prose, she tended to be quiet and terse in conversation, practi-
cal and predictable unless she was drunk, as she sometimes was. She,
too, experimented with drugs. She spoke excellent French and had
arrived in Paris to observe and record cultural life. She was recover-
ing from a seven-year affair with Orage and was now thirty-five, five
years older than "the sculptor." She was not short of money, which
for a man who could barely support himself, let alone a mistress,
must have been a relief. There remained that extra quality, that mys-
terious magnetism of the body and spirit that can never be accounted
for. It just *was,* and it would be the beginning of a tumultuous two-
year affair.

They were meeting on the literal edge of war. At the end of June
the heir to the Austrian throne, the Archduke Ferdinand, and his
wife had been assassinated by a nineteen-year-old Serbian student at
Sarajevo, a seemingly obscure event that set in motion a European
conflagration. Austria declared war on Serbia on July 23 and André
Gide wrote in his diary, "We are getting ready to enter a long tunnel
of blood and darkness." Jean Jaurès, the left-wing French leader, was
dispatched to Brussels on a peacekeeping mission and on his return
was shot in the back as he sat in a café. Russia was mobilizing. On
August 1, Germany declared war on Russia; two days later, France
and Germany were at war. England was about to take part. Gide,
in Normandy, took the last civilian train back to Paris. Gris, in the
south of France, had been advised to leave. Jean Arp took temporary
refuge in the Bateau Lavoir before leaving for Switzerland. Matisse
tried to join the military but was turned down. Picasso drove Braque
and Derain to Avignon, where they joined their regiments. Within
a month the German army would be closing in on Paris, the stock
exchange would have moved to Bordeaux, 35,000 Parisian males
would be conscripted, and as many inhabitants would have fled.

Against this background Alice Morning made bright and inconse-
quential remarks, at least at the beginning.

Hastings had found an apartment at 55 boulevard du Mont-
parnasse. She had "two rooms and real running water and gas and
crowds of chests of drawers and wardrobes, and only sixty-five
francs a month. Anyone will know how cheap that is for Montpar-
nasse." Her concierge was also a gem (she used the word "duck")
and "everything's very joyful except a large rat which is a shocking
thief." She was living opposite Brancusi, who sang at the top of his
voice, and had a view, not of trees, "only ivy and roses, but lovely
old red tiles and air and blue sky." Her Paris—just three streets and
a café—was full of gossip, much of it mean-spirited. "People don't
report on each other's psychological frailties—they try to attack the
spirit. Mention whomever you may, someone will tell you that he
is finished, from Picasso to my friend the poor poet who has not
very well begun. To escape being finished in Montparnasse, the only
way is never to begin really." The "poor poet" reference was to Max
Jacob, whose unpublished French poems she was translating and
sending off to London for publication as examples of the latest trend
in French poetry. Jacob was to become the close friend and eyewit-
ness to the relationship, making it curious that he would dismiss
Hastings later as "drunken, musical (a pianist), bohemian, elegant,
dressed in the manner of the Transvaal and surrounded by a gang of
bandits on the fringe of the arts."

She went to an artists' ball. "Much laughter, much applause for
your frock if it is chic, three hundred people inside and outside the
Rotonde, very much alive!" She started to attend the Tuesday poetry
readings at the Closerie des Lilas where one could hear the last word
in Symbolist verse. She sat in cafés for hours to keep warm, writing
her columns beside an empty coffee cup or a glass of "mazagran" (half
coffee, half milk). The June rain "stupefied" Paris. Madame Caillaux,
wife of the minister of finance, against whom *Le Figaro* had been
waging a scurrilous campaign, shot the editor, who shortly there-
after died. She was now on trial, and opinion was sharply divided
about whether she should be sentenced or acquitted. Beatrice, mak-
ing no bones about her bias, wrote, "Mad women ought merely to
be handed over to their families with powers gently to chloroform
them if necessary." Then the *New Age* author goes into considerable

detail about trying to light up a cigarette at another ball—a shocking
act for a woman in public—and being surprised that she was herded
into a corner by the uniformed attendant (where no one could see
her), without any apparent awareness of the contradiction. That was
the column (June 18 of 1914) when she opened with the news that
"[t]he romantic world seems to have supposed that I kissed the
sculptor last week."

After various hints and transparent disguises, Modigliani appears
under his own name early in July. "What beats me is when, for
instance, an unsentimental artist like Modigliani" approved of Doua-
nier Rousseau, whom she found "bourgeois, sentimental and rusé."
Modigliani really liked him. Speaking of Modigliani's stone heads
(which she wasn't), one was standing below a painting by Picasso,

> and the contrast between the true thing and the true-to-life
> thing nearly split me. I would like to buy one of those heads,
> but I'm sure they cost pounds to make, and the Italian is liable
> to give you anything you look interested in.
>
> No wonder he is the spoiled child of the quarter, enfant
> sometimes terrible but always forgiven—half Paris is in mor-
> ally illegal possession of his designs. "Nothing's lost!" he says,
> and bang goes another drawing for two-pence or nothing, while
> he dreams off to some café to borrow a franc for some more
> paper! It's all very New Agey, and, like us, he will have, as an
> art-dealer said to me, "a very good remember" . . . He is a very
> beautiful person to look at, when he is shaven, about twenty-
> eight, I should think, always either laughing or quarrelling à la
> Rotonde, which is a furious tongue-duel umpired by a shrug
> that never forgets the coffee.

He took her around. "You're only seeing Paris," he said, refer-
ring to the obligatory tour. "Come, leave all these people—let us go
and see Par-ee." They went to the movies and he fell asleep on her
shoulder. He "tutoyed" her "infamously." He told her what to buy.
He told her not to fall in love with him. On the other hand, perhaps
she should. No, not; it's no use, he said. The way she looked at him,
responsively, reminded him of the gaze of his first statue. They were
going everywhere together and eating cheap meals in the right places,

which more or less guaranteed instant gossip and contradictory commentary. The writer Charles-Albert Cingria suggested with perfect seriousness, "he abducted her"—but did not explain. On the other hand others believed she had pounced on him. The sculptor Léon Indenbaum considered her to be Modigliani's "wicked genius." To Paul Guillaume, the fact that she was five years Modigliani's senior made him her protégé. It is almost certain that he soon moved in with her and perhaps she paid for a studio as well. At one point, Guillaume says he rented a space at 13 rue Ravignon, and at others, that Hastings did. From the artist's viewpoint, who paid did not matter, as long as he had a roof over his head and was reasonably sure of his next meal.

Guillaume is a reliable witness, and his suggestion that Hastings played a supportive, if not sheltering, role is persuasive. She had nurtured other artistic careers, after all. Her *New Age* diary shows, time and again, her concern for the helpless. The routine spectacle of horses being beaten, of injured animals, her tolerance for a thieving rat, even her description of a wasp she was nursing back to health: these incidents demonstrate her response to those in need. And Modigliani was very needy indeed. At the start of her Paris columns she refers indignantly to the misery all around her. "But, you know, it isn't all gay in Paris. There are horrible things. I find even more insupportable than the fact of a charlatan like Tagore getting the Nobel prize the sight of artists surrounded with all the refinements which money cannot buy, but unable to purchase the materials for their work."

She made her first trip back to London in July and wrote a column about it. "Modigliani, by the way, was very much [in evidence] when I was coming away. He arrested [stopped] the taxi as it was crossing the Boulevard Montparnasse and implored to be allowed to ride with me . . . But I didn't know what to do with him on the station when he fainted loudly against the grubby side of the carriage and all the English stared at me. I had to keep calm because, if I get cross, I can't remember my French . . . But all this while the English were staring at me and Modigliani was gasping, 'Oh, Madame, don't go!'" With war imminent, it would be natural for him to fear he might not see her again. But the episode of fainting—if Hastings does not exaggerate—suggests something more. A few months earlier, Modigliani

had, by accident or design, almost walked into the path of a tram. Since then he had found an enthusiastic supporter in this unlikely person, who was taking him up and making him her personal cause. Did he fear what might happen to him if he never saw her again?

It was the week before Austria declared war on Serbia. "Women should have nothing to do with war but to speak against it," Hastings wrote. Modigliani may have told friends that he volunteered. But his fear of discovery and the fact that, as an Italian citizen, he was still technically neutral, makes that unlikely. In any case, this particular war did not interest him much. His attitude seems, on the face of it, hard to explain, even though, as Kenneth Clark observed, "great artists seldom take any interest in the events of the outside world. They are occupied in realising their own images and achieving formal necessities." There was a further reason. Giuseppe Emanuele, who kept in close touch and was primarily responsible for supporting Dedo financially all these years, was a pacifist, therefore completely opposed to entering the war. "He was thus a target for the interventionists, becoming one of the most widely detested exponents of what was known as antipatriotic 'defeatism,'" his biographer, Donatella Cherubini, wrote. His view was that "[t]he war had been brought about by the colonialist, protectionist and imperialist aspirations of the European industrial class, which overthrew the existing order in the name of its own interests." G. E. Modigliani himself wrote, "[W]e are witnessing a war between England and Germany for predominance in Europe." To think any good would come from it was "mere folly." If Mené refused to take sides, Dedo would not either. For her part, Beatrice stoutly averred that decent women should also refuse to take part. They were both Socialists. They would sit this one out. Despite the pleas of Orage to stay in England for her own safety, Hastings went back to Paris. She arrived a matter of days before England declared war on Germany.

Paris, as Colin Jones writes in his inimitable history of the city, being closer to the front than any other capital city in Europe, was in the path of immediate danger as soon as war was declared. By early September the Germans had raced through Belgium and were within fifty miles of the capital. General Gallieni, in command, attacked the German advance at the Battle of the Marne, and sounds of the heavy artillery fire could be heard in Paris. At the same time General Gof-

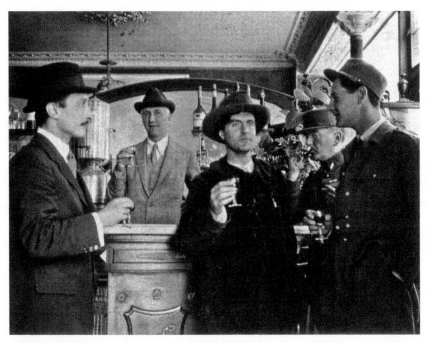

Having a drink with the troops during World War I

frey, bringing up the rear, attacked the weak flank of the German advance. That was the moment when Gallieni requisitioned every taxicab in Paris to get four thousand men to the front. Thanks to these efforts the German advance was halted. By Christmas of 1914, the war had become focused on vast networks of trenches stretching from the English Channel to the Swiss frontier.

Jones wrote, "Many artisans' shops and small businesses closed down altogether, while the flight of capital and the relocation of non-combatants out of the city caused a slump in demand for many manufactured goods. Most museums closed and the Grand Palais became a military hospital. In the early years inflation hit very hard . . . Sugar and coal were the first to be rationed and bread followed." There was coffee without milk in the cafés, and no croissants for the duration.

The months of what would be called the Siege of Paris became Alice Morning's, or Minnie Pinnikin's, or Beatrice Hastings's, finest hour. The tone of archly frivolous chatter vanished, replaced by a straightforward, sober account of what was happening. Her "Siege Diary," as she called it, began with some sardines, bad rice, and six-

teen eggs in the pantry and that was all. Two days later she could report, "Money is a little easier. I managed to change a 50-franc note after three days' vain flourishing of it. But prices of things are ruinous." On about the 5th of August she waited for hours in queues for the required permit to allow her to remain in France but, in the end, left without one. On her way home she bought three pounds of plums, thinking she would make some jam, but "there isn't a quarter of a pound of sugar left in the district." Food would become a daily obsession. On August 20 she wrote, "This morning very little food was delivered to the Montparnasse district, and all was snatched up at once. I got some cooked pork for a franc, an awful diet in this heat, but there was not a vegetable or fruit left. One keeps open house these days on bread and cheese ... One can't dine out here where one's hungry acquaintances are liable to pass by. I tried it once—a very bad half-hour!"

Their circle of friends was dwindling by the day. "People vanish, sometimes without even *sending* to say goodbye. A windfall in the shape of ... Charles Beadle turned up yesterday and we wallowed in a prolonged literary row to get away from the war. But, after all, round we came to it. You couldn't get away from it, even if at bottom you really had a thought for anything else. It comes closer and closer every day. In vain people ransack themselves to change the conversation, even to telling each other their life-stories. A sudden shout from the street breaks attention. You rush out to get the news."

Fortifications were going up around Paris and houses and buildings within the military zone were being destroyed. "The first effect of this seems to be an enormous run on fruits and vegetables which, luckily, are flooding the market just now. Everybody except me went today to see the cattle and sheep in the Bois de Boulogne. Thousands, they say, have been brought in from the fields."

As for the Gare du Lyon, that was overwhelmed with Parisians trying to go south, or anywhere. They arrived, "some sitting bolt upright and clutching the sides of taxis as if to push them along faster," and all of them immobilized by mountains of luggage: household goods, mattresses, chairs ... "One couldn't help laughing to see the taxis, some with six and seven spanking trunks which the least sense of decency would have left behind, considering the common knowledge that many persons will have to wait a couple of days to get half

a seat for the south ... The train yesterday went out with people standing all over the corridors."

There were piteous columns begging for news of relatives in the daily papers—"People seem to have lost each other all over the country"—and another obsession, the course of the war. When Gallieni won the Battle of the Marne, there was a new entry. "We have been waiting all day, more or less feverishly" for the news, she wrote. "Forty kilometres back from Paris. My blessed Montparnasse, we are saved! No cannons coming, no more bombs. Hurray for the Allies! Hurray!!!"

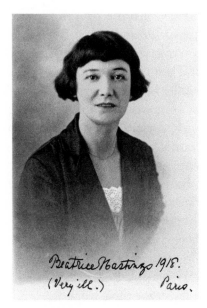

Beatrice Hastings, 1918

It was an awful sight when Belgian refugees began arriving from the Mons district, "hundreds and hundreds, all wet and muddy, lost and beggared and many sick." She went to the Gare du Montparnasse, where the Croix Vert was passing out food and drink to the lightly wounded. "The hour was slack when I arrived. There were only about fifty soldiers on the platform—but they were absolutely starving with hunger and cold. The Croix Vert had to send yesterday for doctors and nurses to give aid to some men, including an English officer, who were in danger of dying at the station from exhaustion ... While I was there, three or four small convoys came, and I talked with one or two soldiers. All those on the way in were lame, halt or blind, but cheerful under sandwiches and cigarettes." Nobody talked about the war.

By now Modigliani's rejection of sculpture in favor of painting was almost complete. There is some evidence for the way he felt about that subject from a conversation he and Beatrice (he called her "Beà") had over a head she had found in the muddle of his studio and which she insisted on calling brilliant, that first winter of the war. She

writes, "I routed out this head from a corner sacred to the rubbish of centuries, and was called stupid for my pains in taking it away . . . I am told that it was never finished, that it never will be finished, that it is not worth finishing." But she loved it. "The whole head equally smiles in contemplation of knowledge, of madness, of grace and sensibility, of stupidity, of sensuality, of illusions and disillusions—all locked away as a matter of perpetual meditation . . . I will never part with it unless it be to a poet; he will find what I find and the unfortunate artist will have no choice as to his immortality." It would be like Modigliani, faced with disbelieving laughter at his expense, to lose faith in himself, even if a few admirers like Augustus John had paid a stupefying sum for his work. As for Beà, how much he cared about her opinion is unclear, but she concludes by complaining that artists do not appreciate the value of writers, "who control the public and try to bring it to a state of culture which will offer the artists great subject for their work."

Beatrice Hastings, with her links to influential intellectuals, provided opportunities for other appreciative comments, as Modigliani would soon discover. Thanks to Jacob Epstein, two of Modigliani's heads were shown in an exhibition at the Whitechapel Gallery in London in the summer of 1914, along with work by Epstein himself, Vanessa Bell, Roger Fry, Henri Gaudier-Brzeska, Mark Gertler, Duncan Grant, Paul Nash, Walter Sickert, and Stanley Spencer, most of them destined to dominate the London scene in the years to come. Then early in 1915, Guillaume pulled his conjuror's strings to give Modigliani his first showcase in New York. It was two years after the exhibition at the Armory, but never mind. The gallery, called the Modern, was on Fifth Avenue, and Modigliani was handsomely represented with twenty-four works, most of them drawings, but there were also a pastel, a painting, and two stone heads. Sometime in the autumn of 1914 he attracted the interest of a new collector, André Level, who began buying his work, paying between fifteen and sixty francs apiece. When one considers that Hastings had rented her apartment for sixty-five francs a month, the sums begin to look respectable by Modigliani's modest standards. Other people, including the dressmaker Paul Poiret, began to collect. Because of the war Modigliani's monthly stipend from Italy had dried up. But he could truthfully tell his mother that his work had begun to sell—at last.

The return to painting had social as well as financial consequences. Basler wrote that Modigliani "was surrounded by an ever-increasing number of admirers from all over the world. Everyone wanted to be portrayed by him." One of the first was the painter and art collector Frank Burty Haviland, who lived near Picasso in the rue Schoelcher. If only for career reasons this was a smart move. Haviland was at the very heart of the inner artistic circles, he was wealthy (his American forebears had founded an important porcelain factory in Limoges),

Modigliani's portrait of Diego Rivera, 1914

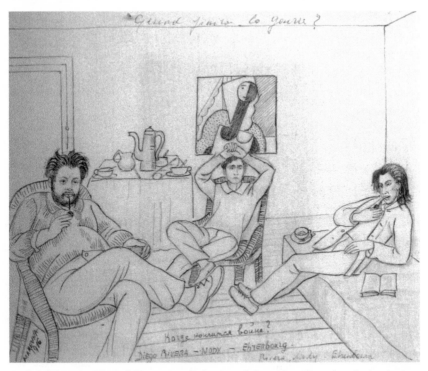

A sketch by Marevna of Rivera, Modigliani, and the writer Ilya Ehrenburg, during World War I

and he was known to be generous. But for Modigliani, who was incapable of being calculating, there was a genuine friendship with this tall, fair, reserved young man, who was quietly serious about art and as fascinated by African sculpture as he was. The Haviland portrait, which Basler once owned, shows the subject in profile and the style influenced by pointillism. Flavio Fergonzi writes that "the broken and choppy brushstrokes generate a vibrant luminous effect" and the conception "is . . . strongly indebted to the months that Modigliani spent working on sculpture."

Modigliani's second success was a portrait of Diego Rivera, the Mexican artist and revolutionary, husband of Frida Kahlo, who spent some turbulent years in Paris and with whom he briefly shared a studio. Rivera, whom he called the "Mexican cannibal," had, according to his biographer Patrick Manham, a chronic liver condition which caused periodic fits. One of several preparatory drawings Modigliani composed for his portraits showed that he had witnessed at least one of them, because Rivera's eyes are rolled up, leaving only the whites visible. The portrait itself, a swirl of off-whites, grays, and charcoal, is as revealing as Picasso's was noncommittal. The small, pursed, full-lipped, fat man's mouth, the narrowed eyes, and the enigmatic half smile, executed in a burst of whorls and scribbles, give one an immediate impression of a man as engaging as he was violently unpredictable.

So many friends had left for the war. Paul Alexandre, immediately attached to an infantry battalion as a military doctor, was not released until the general demobilization in 1919. He wrote, "My regiment was wiped out several times before my eyes." Maurice Drouard, Henri Doucet, and the sculptor Coustillier, all close friends of Alexandre, were killed. Apollinaire, who received a head wound, would die of his injuries. Léger and Braque were wounded and discharged, Jean Metzinger was gassed and Blaise Cendrars, the writer, lost an arm. As for the ever-resourceful Paul Guillaume, he was briefly mobilized and then discharged, opened and closed a couple of galleries, and was back in business by 1915. He had found a new backer, again thanks to the ministrations of Jacob: a wealthy dealer in antiquities named Joseph Altounian. Guillaume, with the field wide open, was full of energy and ideas for promoting the work of painters lucky enough to have attracted his interest.

A dwindling band of artists—mostly foreigners—met each other

in the old haunts. "The wartime lack of cohesion and direction in the art world worked to the advantage of those who had been either outside or on the fringes . . . before the war, creating fresh possibilities and new alliances," Silver wrote. Basler observed,

Just about every Montparnassian had his portrait drawn or painted by Modigliani. And there were a few who did not clink glasses with him at least once. Everyone liked him—the owner of the hotel in which he lived, his hairdresser, the people in the bistros. They all have pictures by him or pleasant memories of him, be it the female Russian painter Vassilyev, who fed him in her canteen during the war, or all the amicable topers in the quartier, or the little Burgundian sculptor X, the North African painter Z, or the Communist philosopher Rappoport, with whom Modigliani seldom saw eye to eye, or even the policeman who locked him up when he got drunk . . . Dear old Modigliani could not have dreamed up a better public than the one he had during the war.

The always hospitable cafés, where "we hung about from morning to night," became virtual living rooms. Marevna wrote,

Where else could we go? Few of us were in the position of [Ilya] Ehrenburg, who lived in a hotel and had heat and hot water during certain hours; but then he earned the right to live like a bourgeois for part of the day by hauling crates and sacks at the [railway] station at night. Most of us were chronically short of coal and gas and had long since fed to the stove all that could be burnt; the water in our studios was frozen. After a night spent shivering under thin blankets, we would rise late and rush to the café, to be greeted by a kind smile and a "Comment ça va, mon petit?" . . . Then we would warm ourselves with hot coffee . . . read the news from the front (perhaps the war was over!) talk about the war, about Russia, about exhibitions . . . But the war was always with us.

Another essential meeting place, the "canteen" mentioned by Basler, had been started by a Russian artist, Marie Vassilieff—or Vassilyev, Vassilieva, Wassilieff—who, in 1958, was living in a retreat

for painters and sculptors at Nogent-sur-Marne. She was then "old and short and solid," her interviewer, Frederick S. Wight, wrote, "something of a dowager queen with a comfortable apartment of her own, and whatever comfort or support has come her way was no more than her due." During World War I she worked as a nurse and conceived the idea of a restaurant cooperative in her studio. This was situated in an alley off the avenue du Maine at no. 21, now the Musée du Montparnasse. The studio was furnished "with odds and ends from the flea market, chairs and stools of different heights and sizes . . . and a sofa against one wall where Vassilieff slept. On the walls were paintings by Chagall and Modigliani, drawings by Picasso and Léger, and a wooden sculpture by Zadkine in the corner . . . In one corner, behind a curtain, was the kitchen where the cook Aurélie

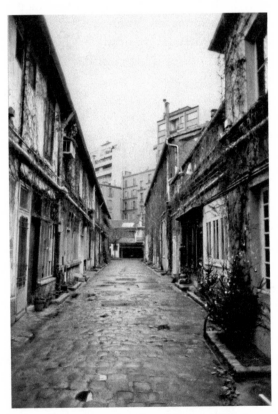

The unprepossessing building, left, in a cobbled alley, where Marie Vassilieff ran a café for artists during World War I

made food for forty-five people with only a two-burner gas range and one alcohol burner. For sixty-five centimes, one got soup, meat, vegetable, and salad or dessert . . . coffee or tea; wine was ten centimes extra."

Marevna, who went there regularly, said that Vassilieff was a "tiny, bandy-legged woman, practically a dwarf, with her round, white, browless face, her thin mouth and small teeth." Everyone else went there as well. Painters, writers, and musicians came to discuss politics, often ending in a fight, to "argue over new art forms, to flirt and to dance to Zadkine's mad music, 'The Camel's Tango.'" What began as an act of charity had evolved into an impromptu arts center which Vassilieff, with her penetrating, screechy voice, her commonsense insistence on good food at low prices, her tolerance for artistic exhibitionism, and her willingness to stay open late throughout the war, happily cultivated. Marevna continued, "Modi was a favoured guest at Vassilieva's canteen, and of course she never charged him anything. Sometimes, when drunk, he would begin undressing under the eager eyes of the faded English and American girls who frequented the canteen. He would stand very erect and undo his girdle [sash] which must have been four or five feet long, then let his trousers slip down to his ankles . . . then display himself quite naked, slim and white, his torso arched."

Being just as much of an exhibitionist as he was, Beà loved disguises and dressing up, or, rather, undressing. So one is inclined to believe, for once, that most unreliable witness to the "scandals" of Modigliani, André Salmon, the man who was even more the helpless pawn of a secret drug habit than his subject, and the writer who adhered to the French conceit that lives should be the starting point for one's wildest fantasies. In his *vie romancée, Modigliani, sa vie et son oeuvre* of 1926, Salmon writes that the artist and the poet were about to go to a dinner, or perhaps a Quatz' Arts ball, or perhaps a party at 21 avenue du Maine, and Beà had nothing to wear. This seems unlikely, but for the moment the reader suspends disbelief. Salmon then asserts that Modigliani, using phrases like, "Let me sort something out," or "Leave this to me," or "No prob," decides to make a dress for her. He begins with one she owns, a dress made of the very finest tussore, a delicate neutral silk. She puts it on and he begins to improvise on his model, shortening the skirt and plung-

ing the neckline. Then, using colored chalks, he appends butterflies, leaves, and garlands of flowers up and down the dress, the skirt, bodice, the breasts, waist, legs, buttocks, thighs, and ankles, melding silk to palpitating flesh in a fine artistic frenzy. The result causes a sensation. Beà, who is obliged to go barefoot as well as half naked because the designer has signed his name to an instep, shivers and smiles bravely. Perhaps it even happened.

Another account often repeated has Beatrice Hastings dressed up as Madame de Pompadour—or perhaps as Marie Antoinette in shepherdess outfit, carrying a crook. As she goes through the streets doing her morning shopping she carries a basket. It is full, not of flowers, fruit, or food but ducklings, quacking their heads off. Assuming one could get the ducklings in a time of food rationing and then somehow keep them all in a basket while one tripped through the streets in a crinoline, the staging seems hardly worth the momentary effect. What is interesting is that people thought her capable of such a stunt. In her way, Hastings was much of a risk taker as her lover, a factor that would even make scenes from the fertile imagination of a Salmon seem conceivable. This characteristic was a considerable factor in bringing their love affair to its sad and reckless finale.

It is also clear that Hastings had worn such a costume for some occasion or other, because *Madam Pompadour* is the title of one of twelve paintings and many drawings that Modigliani executed of her in the years of their relationship. It was shown at the first art exhibition of the Lyre et Palette in 1916. The critic Louis Vauxcelles, for whom Cubism was anathema, wrote, "I look with interest at the new style of Modigliani."

The Lyre et Palette was the invention of Émile Lejeune, a well-to-do young Swiss painter who was using a large studio at the end of a courtyard at 6 rue Huyghens in Montparnasse. For whatever reason, the government had closed the theatres and concert halls so Lejeune, responding to need much as Vassilieff had done, looked the situation over. There was plenty of room for a stage and an audience. He was able to rent a hundred chairs from a source in the Luxembourg Gardens, which they picked up and returned with the help of some capacious handcarts once a week. Blackouts, so omnipresent in Britain in World War II, were already being used in Paris. They taped over the single large skylight and used lantern lights to guide

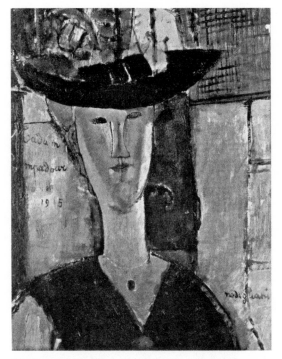

Madame Pompadour, Modigliani's portrait of
Beatrice Hastings, 1915

the audience through the darkness. Then Lejeune started his series
of Saturday-evening concerts with a small group of musicians. That
group would become the nucleus for "Les Six"—six composers and a
poet—which became enormously successful after World War I: Fran-
cis Poulenc, Darius Milhaud, Germaine Tailleferre, Arthur Honeg-
ger, Georges Auric, Louis Durey, and Cocteau. Musical evenings led
to poetry readings with Apollinaire, Cendrars, Jacob, Salmon, and
the omnipresent Cocteau. Since there was plenty of wall space there
were exhibitions as well and Guillaume set up his collection of prim-
itive sculptures. Going to the Lyre et Palette became so fashionable
that the limousines of the wealthy, slumming it from the Right Bank,
would jam the narrow streets.

Moïse Kisling was responsible for introducing him to the Lyre et
Palette crowd. He was working on an exhibition with Lejeune, and,
when he learned that Modigliani did not have a single canvas avail-

From left, Moïse Kisling and his wife Renée with
Conrad Moricand, 1920

able, approached Guillaume. That dealer had the standard arrange-
ment by which Modigliani received a daily stipend, and whatever he
produced went straight to his employer's stockrooms. Kisling per-
suaded Guillaume to show *Madame Pompadour* and several other
portraits. Being Kisling, he probably transported them himself on a
handcart.

With his fringe of hair cut, as it seemed, with the aid of a pudding
basin, the Polish-born Kisling looked like a choirboy, if one with an
impish gleam in his eyes. Born in Cracow of well-to-do parents, Kis-
ling received his art school training in that city and arrived in Mont-
martre in 1910 when he was just nineteen with a single louis d'or in
his pocket. He had a natural gift of gravitating directly to the people
who could help him. Within two years he had his first exhibition at
the Salon d'Automne and gained a dealer the year after that. How
did he do it? The secret, Kisling told Lejeune, was not to wear one-
self out on a single painting but to paint several relatively quickly. He
would then be able to offer a dealer a group of paintings at an attrac-
tive price, so that the dealer could make a tidy profit on each one.
This was a relatively easy way of becoming known and building up

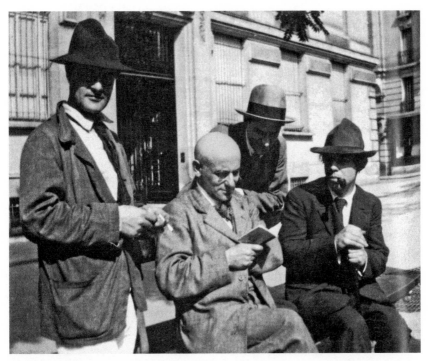

One of a series of photographs taken by Jean Cocteau one summer day in 1916
when a group gathered for lunch. They included Modigliani and Picasso, flanked
by a hatted André Salmon.

some goodwill with dealers. Kisling was clever about getting critical
attention as well. It was a simple matter of making lots of friends.
The critics cost him "at least ten thousand francs a month, not in
money but in lavish meals and free trips." André Salmon, witness
at his wedding and godfather to one of his sons, was a very special
friend. Kisling could count on a nice review from Salmon whenever
he had a show. But Modigliani had no money to spend wooing the
critics, even if he had wanted to. So Salmon, as Czechowska said, did
not waste his time looking at Modigliani's paintings and rarely com-
mitted a word to print—at least during Modigliani's lifetime.

At the outbreak of war Kisling joined the Foreign Legion. He was
wounded, honorably discharged, and received French citizenship in
recognition of his services. His family had helped support him and
Kisling, who followed his own precepts to the letter, worked on four
or five paintings at once and was soon well off. A young American

friend of his, Victor Chapman-Chandler, an architecture student turned fighter pilot, died in an air battle in 1916, leaving Kisling a small fortune: five thousand francs. Claude de Voort, his biographer, noted that the artist had been born under a very lucky star. Kisling was soon ensconced in a comfortable apartment on the rue Joseph Bara, around the corner from the boulevard du Montparnasse. In years to come he would employ five servants and own two American cars.

There was something direct and uncomplicated about Kisling that communicated itself in his art. Work our age now finds shallow and sentimental accorded perfectly with popular tastes, although sophisticates like René Gimpel thought Kisling was a very bad painter. Kisling liked bright and glowing flowers, luscious bowls of fruit, pleasing still lifes, dramatic nudes with high breasts, shining eyes, and short black hair, and his portraits were freshly considered and generous. This marked his character. He was always ready for *un petit verre*, a dinner, a party, or a costume ball, and his door was always open. It was another rue du Delta with another benevolent patron. He became, someone said, "[t]he axis around which everything turned in Montparnasse life." In old age he asked himself, "How was I able to come home more or less drunk every morning at seven and be up at nine when the model arrived? I washed myself and started to work ... It was like that every day: mornings of work, afternoons constantly interrupted by innumerable visitors and evenings of running around that lasted at least until dawn."

A bigger income only meant an excuse for bigger and better parties. Kisling's Wednesday lunches, washed down with plenty of Armagnac, went on into the evening. One never knew whom one might find there: writers, actors, lawyers, politicians, scientists, musicians, architects, and, of course, artists. He once said, "I want life to be beautiful and for desirable women to have their desires and their lives to be colorful." Given his eye for pretty women it is odd that Kisling married a strikingly plain girl. She was Renée Gros, the Catholic daughter of a French military officer, and he seems to have chosen her almost against his will. "Merde!" he told his friends at the Rotonde. "I'm marrying the daughter of an officer." She was slim and strong, a forceful personality with a nose that dominated her narrow face. She also had an innate sense of style that took her into the category of *"jolie laide."* Her hair was cut exactly like her

husband's—it was called the *coupe garçonne* at the time—she wore matching checked American cowboy shirts with overalls, she was an even more ferocious party giver than he was, and she could, it was said, blacken the eye of anyone who had the temerity to leave early. They were seen together everywhere. They were unforgettable.

Their wedding has been told and retold, with ever more embellishments; the best witness, as might be expected, turns out to be the bridegroom himself. The event, Kisling said, got off to a perfectly respectable start with a ceremony in the town hall of the cinquième. In honor of the occasion he wore his Sunday best, that is to say, he put a jacket over his overalls; Renée wore her usual charwoman's outfit. André Salmon was the witness and Max Jacob was equally resplendent as a satanic Pierrot. About a dozen of them lunched at Leduc's on the boulevard Raspail and then repaired to the Rotonde for some serious drinking.

Pretty soon the word got out that the Kislings had just got married and all the drinks were on the house. They arrived in great waves: the small and fat, tall and short, friends, strangers, clochards—the place was seething and all drinking, as they thought, on Kisling's dime. Something had to be done fast. Kisling and friends rounded up about twenty fiacres, the oldest they could find, complete with decrepit horses, and made their escape just as the bill arrived. Their grandiose aim was to visit every whorehouse in Paris. It was doomed to fail, but they had fun trying in the rue Saint-Apolline, the rue de l'Échaudé, the rue Mazarine, and the Quartier Saint-Sulpice. The procedure was always the same: peremptory knocks on the door, startled owners, calls for champagne all round, friendly chats with ladies of the night, and abrupt departures nicely timed to avoid the inevitable moment of reckoning.

Finally the motley band arrived at 3 rue Joseph Bara eight flights up (seventh floor in France). The happy hordes, believing a vast banquet awaited them, made the climb and packed the rooms to the rafters. Kisling mentioned in passing that there were a few friendly scuffles and some knives came out before being sheathed in the general spirit of goodwill. Kind friends went looking for reinforcements: red wine, Calvados, Benedictine, or anything. Pretty soon no one noticed that there was not going to be any food. In fact, all went well until Kisling came upon a young man in a corner who had found a cardboard box full of all his drawings and was industriously tearing them up into

tiny pieces and looking fondly at the growing piles of paper. With the help of a huge Norwegian, the offender was hurled unceremoniously down the stairs. Kisling found out later he had been taken to the hospital but unfortunately survived. What with the smoking and the alcoholic haze, Kisling began to forget things after awhile and apparently did not remember that, at some point, Jacob stood up and started on his famous impersonations that made everybody laugh. Modigliani kept interrupting. Couldn't he play Dante? He knew just how to do it. Please, couldn't he play Dante? The crowd told him to shut up.

Once the name of Shakespeare was mentioned Modigliani was not to be stopped. He must play Hamlet's ghost. "He rushed to the small room adjoining the studio, the 'bridal suite.' He came out again swathed in classic sartorial fashion in a white sheet. At the door he started playing the part of the ghost of Hamlet's father: 'God or man, which art thou?'—with such panache that Max Jacob, at times an outstanding actor, at once ceased his impressions," Salmon recalled.

Now Modigliani was free to shout, now he alone dominated the stage . . . Straight away our Amedeo instinctively found the right words. At first they seemed meaningless, but by pronouncing or screaming them in his own unique way he made them serve his purpose, namely to communicate to the spectators that a dead being can continue to plague the living from beyond the grave . . . And so suddenly he began yelling—I don't think you hear this call nowadays but at the time you heard it every day in the streets in Paris—"Barrels, barrels, have you any barrels?"

The accursed ghost, condemned for all eternity to roll before him his cask full of hideous memories, full of sin, full of pangs of conscience and tears! The brand-new Madame Kisling, née Renée-Jean, broke this awe-inspiring spell with the pained scream of a young bride and dutiful housewife: "My bridal linen!"

Her husband, quite nude, was scooped out of the gutter on the boulevard du Montparnasse four days later, and the party was finally over.

. . .

As the Siege of Paris wore on in November 1914 Modigliani and his new love settled into a routine of comfortable domesticity. On All Saints Day, the cemetery of Montparnasse being just around the corner, they went to pay their respects to the fallen. Their housekeeper had been to the market at five a.m. to buy a wreath, and the boulevard du Montparnasse was packed with flower stalls and so many crowds that one was, Hastings wrote, almost carried along. Once in the cemetery one found small groups huddled around new graves, sobbing. And there was something worse: a woman lying flat on a grave. It seemed her husband had been killed in August and she was going to lie there until she died with him. Every evening, she had to be forcibly ejected. It was all too sad; Hastings left as soon as she could.

Now they were back indoors, drinking tea, watching the flames flicker in the stove and listening to the rain on the roof; it was just like being in London. They read the papers to each other, singling out the sections about corpses, both German and French, rotting in the trenches, and agreed once more about the folly of the war. At least the British working classes had stopped joining up with anything like zeal, having begun to learn the truth about the capitalists' war. What was needed were a few Zeppelins over London to bring the plutocrats to their senses. The same issue contained a satirical verse that she wrote under one of her noms de plume, Cyril S. Davis. It was called "The British Profiteer," and sung to the tune of "The British Grenadier":

> *Some talk of Shaw and Masefield, and some of Begbie, too,*
> *But what of dear old Rothschild? was Briton e'er more true?*
> *For all the world's great martyrs, there's none whom we*
> *revere,*
> *With a cent. per cent., per cent., per cent.,*
> *Like a British Profiteer.*

Warmed by such thoughts they went for a walk to the Porte d'Orléans on the edge of the city, "where the trees and the barbed wire and the sharp iron points still lie about that were to arrest the

onslaught of the German cavalry." Then they indulged in their favorite pastime, hunting for books up and down the bouquinistes along the Seine. There were wonderful cheap editions one could buy for a half penny, or five centimes, of the French memoirists, "Mesdames" de Staël, de la Fayette, des Ursins, Roland, Depinay, de Caylus, de Maintenon, and de Genlis. They would immerse themselves in the past for the duration.

Modigliani had begun to work on preparatory sketches that would result in portrait after portrait of his amour, the most he would execute of any woman except one. Alice Morning, having written her latest column, went for a walk in the rain, got soaked, and was now "half delirious" with influenza. Fortunately, "somebody" had made a very pretty drawing of her. "I look like the best type of Virgin Mary, without any worldly accessories, as it were. But what do I care about it now—my career is nothing but a sneeze." One assumes dozens were finished before Modigliani felt confident enough to commit his ideas to paint. He painted himself as Pierrot during his relationship with Hastings. Complete with black cap and ruffle, one eye socket, the left, was blank, and the other eye looked outward. A year later, 1916, either he or Beà had the notion of painting a companion portrait of her. The portrait is never described as such, but it is so much of a mirror image that the possibility is intriguing. Pierrot's pose, in three-quarter face, is turned to the left of the viewer; in the 1916 portrait of Beà, the pose is to the right. Her features are more delicately drawn but otherwise identical; here are the same highly marked eyebrows, the same upturned nose, the same position of the mouth, the same jawline, and the same neck, turned at the same angle. There are some minor differences; the treatment of the eyes is more conventional and the lips are parted. The color schemes are complementary, and the general effect suggests that the two were meant to be hung together, so that each is looking in the direction of the other, in the middle of a conversation.

As for *Madam Pompadour*, this extraordinary achievement has been admired and analyzed ever since its debut at the Lyre et Palette. Hastings is seen full face and wearing a hat that looks more like a boat. The eyes are steady and direct, the nose flattened, and the lips pursed, almost as if at the end of an argument she has conclusively won. Many of Modigliani's portraits of her lack any sense of her per-

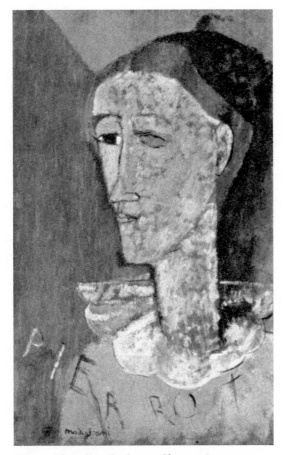

Pierrot, often described as a self-portrait, was
painted by Modigliani in 1915.

sonality but this one, Werner Schmalenbach comments, is one of his
most delightful works, "one example (among many) of the extraor-
dinary formal grace that is so enchanting a feature of the portraits of
1915 and 1916." Modigliani's career as a sculptor had come and gone
but a seminal change had taken place. He was launched on "the series
of major portraits that show the artist immediately at the peak of his
genius."

What was to be done, however, about Maldoror? His shadow
stood between them, and quite soon, because Alice Morning devotes
considerable space to his spectral presence in the autumn of 1914.
This precocious poet Isidore Ducasse, the so-called Comte de Lau-

tréamont, was, as she must have known, her lover's ghost, and his obsession. What a "poor, self-tormented creature" Maldoror was, after all. Had he lived, "no earthly refuge for him was possible but an asylum." Modigliani was just now drawing his portrait, "with the head of an ostrich and a eunuch's flank and trying to hide in the sand!" And how puerile Maldoror's thoughts were. "One would not wonder that the 'O silken-eyed poulp!' and similar sentences of the seventeen-year-old . . . seemed mysteriously ironic to people who will never get past this nebular age." She was using the only kind of exorcism she knew: "Imagine 'Maldoror' in Paris today bleating at seventeen about the war—'This stupid, uninteresting comedy. I salute you, ancient sea!' and so on." Was her lover laughing? Oh well, there was no accounting for an adolescent Frenchman; they were always peculiarly unbalanced. The point to make was that Maldoror had outlived whatever purpose he once served. It was time to bury him.

———————

"A Stony Silence"

To be buried while alive is, beyond question, the most
terrifying of those extremes which has ever fallen to
the lot of mere mortality.

—EDGAR ALLAN POE, *Tales of Mystery and Imagination*

IN DECEMBER 1914, Alice Morning recorded that they were gay
enough to go to a play, even though "only the fittest" could sur-
vive the performances of all the Allied national anthems. They had
adopted, perhaps for the duration, a hungry artist who was turned
away from an American soup kitchen, "so now we have to feed him
between us." There were beginning to be problems with these chari-
table soup kitchens. One, started by a "Swiss-German" (therefore
not Vassilieff), had an uneventful start, "until stray visitors began
to miss things. You couldn't find your own hat at the hour of part-
ing, and your purse was entirely unsafe." Her passport was stolen,
then offered to her for sale. She refused. Luckily, that crucial piece of
identification was turned in at the Préfecture.

One could not go outside without constant daily reminders of
the war. Half the drivers on the road were wearing uniforms, ambu-

lances were everywhere, along with battalions of cavalry horses and sad, drifting, wounded men. She saw two cripples helping each other along the sidewalk and ran after them through the dusk. "Two fractures in the leg, one, and the other—you couldn't say what he had; he laughed it off."

Mesa, the rotund and genial Spaniard who dominated the Montparnasse balls dressed as a sultan, or Bacchus, had volunteered for active duty and been killed. The very idea of the Montparnasse party was dying with him, or so it seemed. That could have been the reason why Alice Morning gave a "mad party" on Christmas Eve. "Half the guests turned out to be mortal enemies of the other half, which meant guitar music, songs, games, cakes, and drinks in propitiation until everyone had forgiven everyone else." Someone named Sylvia, wearing a green hat, arrived, "and we lowered the lights while she recited de Musset's 'Nuit de mai.' And I wept nearly," Alice wrote. "But what a poem!"

The comments were published early in January 1915 and the tone was elegiac. The author prefaced her account by recalling a dream about a friend who had recently died. She had not died, after all, and she was more real than she had been before. Paris was brown and gloomy and one thought of last, unspoken words. Since they lived literally around the corner from the Montparnasse cemetery they could hardly avoid thinking about funerals, and all of Montparnasse turned out if the deceased was interesting enough. This most recent funeral was for an Arab soldier. "Instead of dreadful, boozy, chattering undertakers in front of the hearse, which was hidden with flags and flowers, a troupe of Arabs preceded, chanting all the way!" she wrote. "Behind the hearse marched an escort of French, and then the usual procession. Black is not so absolutely de rigueur at French funerals as at English [ones]. In a long procession many a colour may pick up the hues around the coffin. They have a hideous fashion in bead wreaths and crosses woven and coloured to imitate flowers."

Her friend the poet, Max Jacob, was being painted by Picasso. The style, so it was rumored, is causing "all the little men . . . to say that of course Cubism was very well in its way but was never more than an experiment. The style is rumoured to be almost photographic, in any case very simple and severe." She did not know, having been barred from Picasso's studio for laughing at a Rousseau. "There are

some people in Paris who will tell you that I am simply nothing, nobody, because of my opinion about Rousseau." This portrait, pencil on paper, was subsequently called the first and finest of Picasso's "Ingresque" drawings although when it was published a year later, in 1916, "the more dogmatic cubists inveighed against it as a counterrevolutionary step," Richardson wrote. Max Jacob was merely amused. He looked "simultaneously like my grandfather and an old Catalan peasant," a reference to Picasso's natal province in Spain. Jacob, a close friend of Picasso's as well as a dear friend of Modigliani's, was a direct link between them and repeatedly painted and sketched by them both. Modigliani and Jacob would eventually fall out: in 1943, a year before he died in a concentration camp Jacob wrote, "Modigliani was the most unpleasant man I knew. Proud, angry, insensitive, wicked and rather stupid, sardonic and narcissistic." But in those years of common danger during World War I they saw each other almost daily.

It was a danger Alice Morning tried to make light of. "Now they are going to make us shut all shutters at night for fear of the Zeppelins," she wrote at the end of January 1915. That was ridiculous but only the beginning of inconvenience and downright disaster. The new State cigarettes were made of saltpeter; "and the bacon is old string; and you can't buy a glass of English tongue for love or money; and coal at five francs a bag, all but a halfpenny or so, is all dust and doesn't warm you at all."

People did not seem quite as ill-nourished, but the only customers of restaurants nowadays were American. "Nearly everyone feeds at some or other cantine, either free or for the bare price of food. I see a terrible change in many faces here. People have got suddenly old." It was a ridiculous moment to be thinking about love, but she was. "A creature," meaning Modigliani, whom she also called "the Commissaire," had a cynical theory, which was that lovers ate from the same plate so as to prevent each other from using it as a weapon. Despite her protestations, "he stuck to it that they do eat off the same plate and break it on each other's head afterwards." She gave up trying to change his mind. But a year later she was professing maxims as jaded as anything imagined by George Bernard Shaw: "Both love and work run through the same stages. Both start as a pleasure, continue as a duty, and remain as a necessity."

They expected Zeppelins in May 1915, but in the end "they only got to Saint-Denis [on the northern edge of Paris] where they killed some people. All the street lights were lowered at seven o'clock and half the population went down into the caves, while the other half gladly took advantage of the excuse for staying out of doors to look at the aeroplanes circling round the city. At eleven o'clock the lights went up, so we became very ungrateful to people who had offered to stop the night with us and be killed together, and sent them home."

Glimpses of their life together, as described in "Impressions of Paris," are further described in *Madame Six,* Hastings's short, autobiographical novel about a cancer ward written in 1920. While hinting at the complexities of their relationship they give scant insight into Modigliani's state of mind at this period. The only utterances from him are usually appended to paintings and drawings, and are either cryptic quotations from Dante or other poets, in French, Italian, or Latin. For instance, "Don't say: 'Don't do that'; say, 'Do that.'" Or, "3 designs: 3 worlds: 3 dimensions." Or, on his self-portrait as Pierrot he asked, in Italian, "Will he flower?" None of which takes

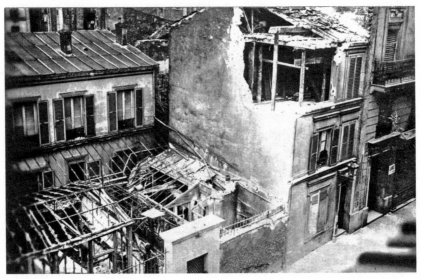

A rare postcard attending to the damage from distant German guns during the bombardment of Paris, 1918

us very far. There is a slightly more revelatory passage in a letter he wrote to his mother in 1916 sometime after his aunt Laure entered an insane asylum.

He wrote, "As to Laure, I am greatly touched that she thinks of me and remembers me even in the state of forgetfulness of human affairs in which she now finds herself. It seems impossible to me that she cannot be brought back to life, that such a person cannot be brought back to normal life." The repetition of "I can't believe it" surely also refers to the recent news that Aunt Gabrielle had killed herself. Modigliani's tactful remarks give no clue to indicate what had happened. Some slight evidence of the events leading up to the joint tragedy is contained in Eugénie's diary for March 1920, two months after Dedo's death. In it she muses about Gabrielle's suicide and Laure's breakdown. Speaking of the former, she wrote, "I was not able to reply to her requests for advice, which was perhaps an appeal, except by affectionate letters meant to make her understand that the harsh words of our final contacts had been wiped out." And how forgiving Gabrielle was, at the end. "She, poor girl, even at the moment of her greatest despair, had left everything to Laure and myself in her will." After the way Laure had behaved one could hardly say that she deserved the generous gesture. "Her air of self-absorption, her ferocious egotism, should have opened my eyes . . . I did not understand, and it was only when she had a crisis of delirium that I understood." Laure had been in her "*maison de santé*" for the past six years, a fate that was worse than death, in Eugénie's view. Now she was "wizened, maniacal, dreaming of reforming the world by some kind of all-encompassing mother love—she who has never loved!"

This relentless assessment provides some insight into the hornet's nest of tangled relationships between the three women that probably existed for decades. What Modigliani must have witnessed in the form of confrontations, simmering resentments, and bitter recriminations cannot be known. But if he had some idea of what, or who, could have driven his aunts to such a state, he never mentioned it.

Alcohol, that ever-available antispasmodic, was blamed by Hastings for the marked change in Modigliani's character that she sometimes saw, especially when "Hashisheus," as she coined the term, was added to "Morpheus." He became "a craving, violent bad boy, overturning tables, never paying his score and insulting his best friends,

including me. I used to burn with rage and the impossibility of leaving him to his fate," she wrote. Her Maldoror (coined from "*mal d'aurore*," or "bad dawn") had now become Pâtredor. Was this a contraction of "*Pas très d'or*," or "Not much money," a joke that was rather going sour? Was Modigliani taking her generous help rather too much for granted and becoming a luxury she could no longer afford? She seemed to mind the cocaine habit rather less. At least he talked stars and strange worlds and sang strange songs, just like her hero in *Minnie Pinnikin*. He never stopped drawing or painting, but "rarely did anything good when drugged."

After a year or so references, direct or otherwise, to their life together peter out in "Impressions of Paris." Beà seems to have transferred them to a notebook which became the basis for *Madame Six*, disjointed comments that nevertheless give a clue, however jaundiced, to the man she was living with. He was always suspicious, she wrote without elaborating. He was always going around telling tales about her. He would say, "Here's another one"; she never knew what he meant and "was too arrogant to ask." As for all the paintings and drawings of her, "I never posed, just let him 'do' me as he pleased, going about the house. He did the Mary portrait of me [not explained] in a café where I sat thinking what a nuisance he was with his perennial need of more pastels" (which she, presumably, also bought) "wondering if I should get my 'Impressions of Paris' written in time for the post, hearing, not listening, to his spit as he lowered his eyebrows on the aesthetic canaille [rabble] who all went to his funeral along with his friends—and next day, beginning to wonder why they had done so, looked around for revenge and advised the world to sell his stuff 'while the vogue lasts.'" With his perpetual complaints, his grievances, and his constant demands of one sort or another, he was no fun anymore. Meantime she had to get something written, or neither of them would eat.

They had moved to a pretty little cottage at 13 rue Norvins just off the Place du Tertre in Montmartre, and very close to Max Jacob. The poet "went to Mass at six every morning, worked all day in his famous den in the rue Gabrielle, and came in between ten and eleven with all the news and ten anecdotes of people who had dropped in on him during the day." She came to depend on his visits.

· · ·

If Max were there when Dedo arrived—he was Dedo to us and no one else—the chances were not altogether against a peaceful conversazione and the witty exit of Modigliani to his own atelier close by. Alone, I could not be depended on to take things lightly. My health was run down. I was getting to dread, therefore hate, therefore ragefully resent the swoop of the Assyrian on my fold. Once, we had a royal battle, ten times up and down the house, he armed with a pot and me with a long straw brush. After that he broke the shutters outside, which interested directly the landlord who stood guard for several nights over his property, finally securing my peace.

The symbolic battle between the brush and the pot might have been a fairy fantasy of Minnie Pinnikin's, but hinted at a darker reality. In "Impressions of Paris," Alice Morning had declared that it was perfectly acceptable for a woman "in a moment of rage" to destroy things; acts done in heat had "little psychic consequence." Modigliani, as a southern Italian male, likely believed that an unfaithful wife/mistress had done serious damage to his honor, not to mention his wounded pride, and that, as the injured party, he had a right to retaliate. Much of *Minnie Pinnikin*, chapter four, has to do with accusations of unfaithfulness and protestations of innocence. One may deduce that in this case art was following life to the letter. Hastings was already involved with someone else. And she had bought a gun.

Charles Eliot Norton, the American scholar and art historian, wrote in the 1860s that he was still haunted by Jane Morris. She was the wife of William, the English designer and entrepreneur, and Norton had visited them at home in London. "A figure cut out of a missal—out of one of Rossetti's or Hunt's pictures—to say this gives but a faint idea of her, because when such an image puts on flesh and blood, it is an apparition of fearful and wonderful intensity . . . Imagine a tall lean woman in a long dress . . . with a mass of crisp black hair heaped into great wavy projections on each of her temples, a thin pale face, a pair of strange sad, deep, dark Swinburnian eyes, a mouth like the 'Oriana' in our illustrated Tennyson, a long neck, without any color . . . —in fine complete."

Jane Morris, one of the models immortalized by Dante Gabriel

Rossetti (another was his wife, Elizabeth Siddal), exhibited the "cadaverous body and sensual mouth" of the Pre-Raphaelite aesthetic. That, as René Dubos wrote, was related, directly or indirectly, to the romantic notion of the consumptive woman. "The fragile silhouette, with long limbs, long fingers, long throat, the tired head leaning on a pillow, with prominent eyes and twisted sensual mouth, became the unhealthy, perverted symbol of Romanticism." Certainly, Rossetti's portrait of Elizabeth Siddal, *Beata Beatrix,* painted a year after her death at age thirty, is one of the high achievements of the Pre-Raphaelite movement in its depiction of the transfiguring effects of illness. Since Pre-Raphaelites were among the painters Modigliani admired, one may safely assume that he knew the painting, dated 1872, and would have appreciated the hopeful ending Rossetti also pictured, that there would be a "Vita Nuova" and that Dante and his Muse would be reunited in Paradise.

The concept of the languishing beauty had been current for at least a century. It began in France shortly after 1800 when so many young women in the Napoleonic era dressed in the flimsiest fabrics, cotton, linen, and silk, no matter what the weather, that the affectation led to an outbreak of influenza in Paris in 1803. That is thought to have caused an epidemic of pulmonary tuberculosis shortly afterward. That, in turn, led to a progressive emaciation: sunken chests, elongated necks, protruding shoulders, pale skin, cheeks and eyes flushed with fever. Edgar Allan Poe's first wife, Virginia, another sufferer, was wont to hemorrhage on her white silk dress as she sang and played the harp, an act that the audience admired for its strange additional charm. How doomed, how tragic; how admirable. Byron, looking in the mirror one day, found that he looked pale. This pleased him. He hoped he would die of consumption so that all the ladies would remark about how interesting he looked. "We wept that one so lovely should have a life so brief . . ."

The elongated neck, the frequent lack of a collar, and the use of a V-neckline for emphasis is invariably seen in Modigliani's portraits of women. It is so characteristic that it led to a quip: Modigliani got his " 'swan-neck' inspiration from glimpsing his mistress through the neck of an absinthe bottle," Charles Douglas joked in *Artist Quarter.* With the exception of the earliest studies there is hardly one that does not show this determined trait. Even his sculptures do not exhibit the

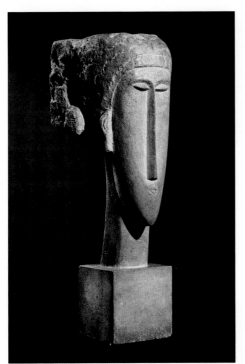

Stone Head, c. 1910

Caryatid, 1913

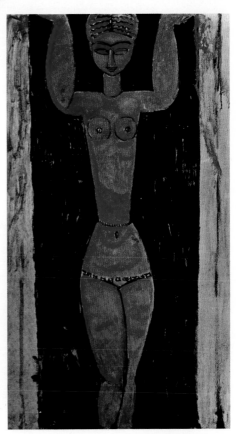

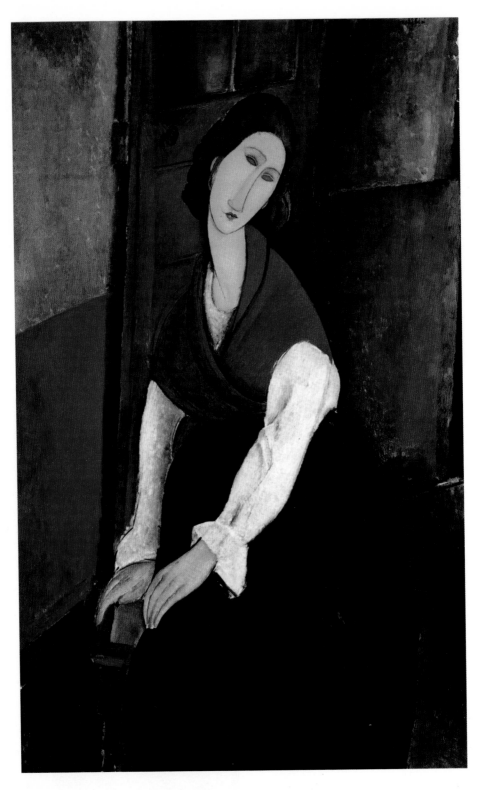

Jeanne Hébuterne (aka *In Front of a Door*), 1919

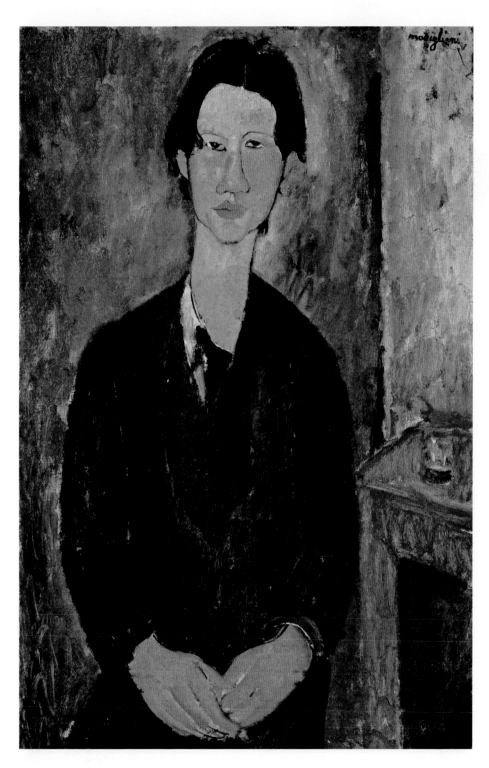

Portrait of Chaim Soutine, 1916

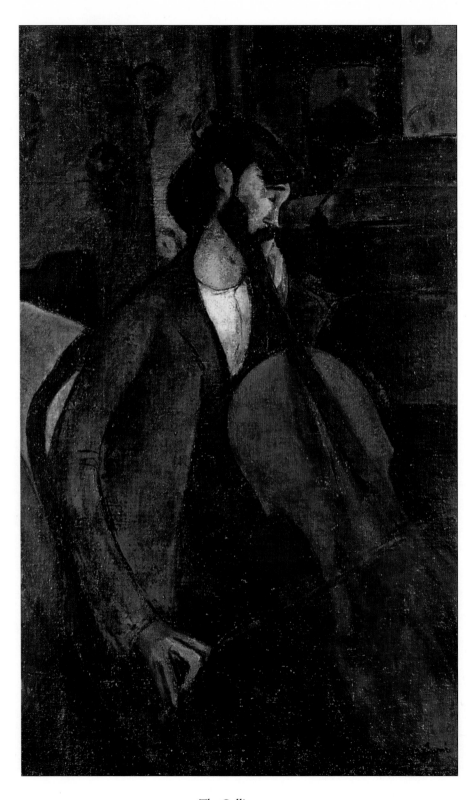

The Cellist, 1909

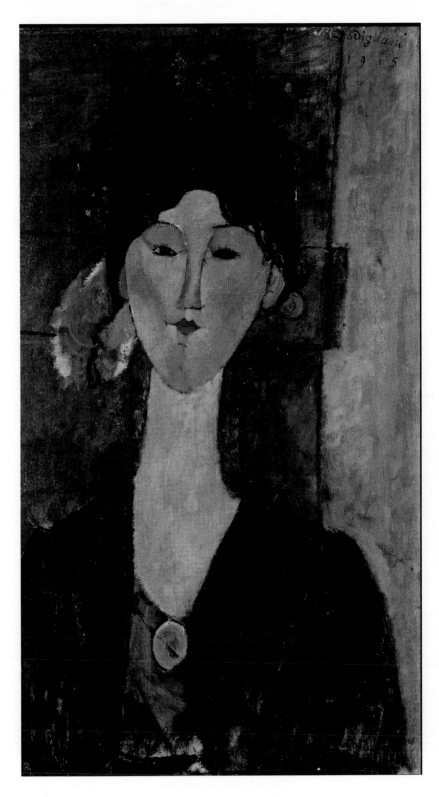

Beatrice Hastings in Front of a Door, 1915

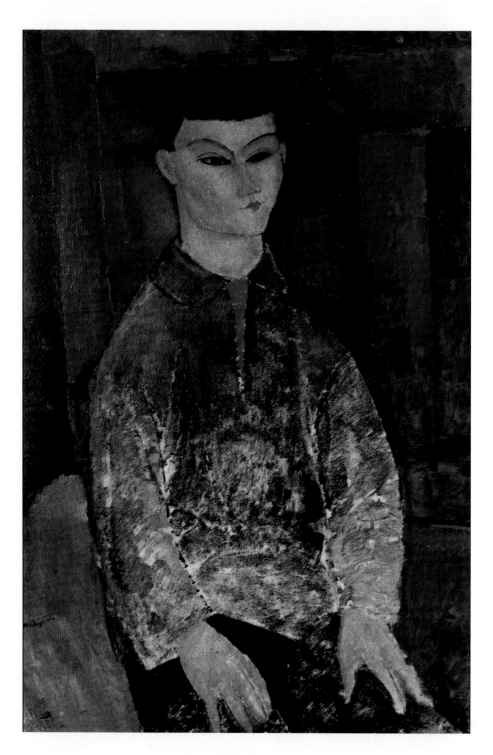

Moïse Kisling Seated, 1915

Frank Burty Haviland, c. 1914

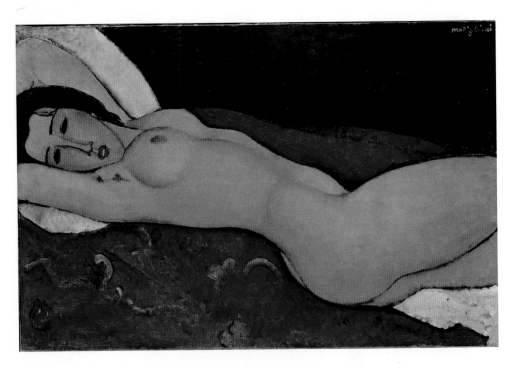

Reclining Nude, 1917

exaggeration that begins to crop up in his caryatid drawings arriving in his experimental portrait of a woman, 1911, whose head is balanced on a column of such formidable length that it looks like an afterthought. No doubt the evolution of the sculptural impulse accounts for this development. Still, it is intriguing to think that the Romantic tradition of the consumptive had something to do with it, if only because it had persisted for a century. There are other hints: eyes that appear to be weeping, as in his portrait of Maud Abrantes and "La Petite Louise," and expressions that are gaunt, emaciated, even tragic. The many portraits of Lunia Czechowska and Hanka Zborowska, in particular, exemplify the long-limbed, languorous, unsmiling, secretly suffering tradition of the heroine marked for death.

If African sculptures were the only models one would expect to find this trait repeated in Modigliani's superb paintings of nudes, where it never appears, or his portraits of children. One would also expect to see it in Modigliani's portraits of men. There are exceptions, but in the main his male subjects are buttoned to the ears with collars, ties, jackets, scarves, and turtlenecks. This, curiously, points to another historical fact: men suffering from consumption notoriously concealed their necks. "A . . . Parisian critic, Véron, director of the Opéra . . . was known to be severely afflicted with scrofula; he always wore a high stock to dissimulate the blemishes caused by the tuberculous glands" in his neck. Modigliani frequently wore neckerchiefs and scarves, and his final self-portrait, executed a few months before his death, shows him similarly bundled up. The French for a man's scarf, *cache-col,* means "hide the neck."

Ideals about feminine beauty that owed their origins to the physical signs of a grave illness, however much they might resonate with Modigliani emotionally and call forth sympathetic reverberations in his work, can only partly explain the paradox of his last great period. The more he paints individuals the more their particular features fade into the background, and the more faces seem encased in a smooth shell as hard as a carapace. As Pierre Daix observed, the comparison between Picasso's revised portrait of Gertrude Stein and Modigliani's mature style is apt. Modigliani, however, never took his

experiment with features further than that. Unlike Picasso, who has already turned his women's faces into beak-like appendages by the time he is working on *Les Demoiselles d'Avignon*, Modigliani's noses stay where they were put, the mouths fall beneath them, there are no double profiles or eyes placed in the middle of foreheads. Picasso's interest is schematic, to see how far he can rearrange facial features and still have them be recognizable. Modigliani's interest is otherwise. He is trying to simplify and reduce to the irreducible minimum the essence of a personality without actually losing it altogether. The masks of the commedia dell'arte wore, as Pierre Louis wrote in *The Italian Comedy*, "an indefinable expression as full of possibilities as of impossibilities, like the Mona Lisa, which every generation interprets differently." Modigliani's self-imposed challenge, to see how far he could venture into abstraction without ending in either anonymity or caricature, must be one of the most difficult any artist since the Renaissance has attempted.

Werner Schmalenbach, who has written extensively about Modigliani's work, observed, "It is possible . . . to ask whether Modigliani was deeply interested in his sitters at all. His commentators answer the question in the affirmative, but this is probably the result of conventional expectations, because the paintings themselves do very little to confirm it. How little he says about, say, his friend Max Jacob. How little about the essence of his mistress Beatrice Hastings. However skilfully he characterizes those whom he paints, how little he penetrates into them. The depiction always remains very much distanced." As if they were wearing masks.

One can only guess at the reasons why the theme of the mask, in sculpture and painting, had such an enduring hold on Modigliani's imagination. One can perhaps suggest that the family's original and calamitous social demotion, stemming from Flaminio's reckless gamble, the long struggle to survive, the disaster and social disgrace of Mené's imprisonment, and the incidence, in the Garsin family, of madness and suicide, would be reason enough for most families to hide their secrets. Eugénie presented the quintessential response of a socially prominent woman who finds herself in such straits: she pretended that nothing had happened. She lifted her chin, went out in public in her best clothes, taught the children of prominent families, she continued her intellectual studies, she maintained a façade of

her marriage: in short, she behaved with perfect decorum. All this, despite the pity and condescension, as Emanuele described it in his letter to Dedo, with which she was being judged. In other words, she wore a mask.

Dedo, that most impressionable of her children, followed the pattern. He affected the same grand manner, fooling everyone he met when he first arrived in Paris by his clothes, his lifestyle, his erudition, and his apparent ability to spend without limit. Such careless generosity continued even once he was in debt. Ludwig Meidner, who met him in 1906, recalled an "immaculately dressed . . . lively, good-looking young man of twenty-two" who, after some months in Paris, was "in the direst of financial straits." But, "although I was not badly off at this time Modi never addressed such requests to me—I don't know why." Meidner put it down to pride, and one could posit that, as a member of a once-wealthy and socially prominent family, that pride was wrapped up in protecting a secret that could not be told. The humiliation would be too much to bear. As had been true since Greek and Roman times, you donned a mask to hide the truth. But you also became Harlequin himself. "For the masks were not mere disguises of the face, but the full expression of a character itself," Pierre Louis Duchartre added. "And it is the soul, in the Latin sense of *animus*, which stamps the features as surely as the thumb models the lump of clay." And so Modigliani "played the mask." He was "our prince," his friends said kindly, although they knew otherwise. And he grandly threw out, or threw away, pearls of his imagination as if they were small change.

Such secrets had to be kept because, as Michelle Perrot writes in *A History of Private Life*, defending one's family honor was essential.

Secrecy [was] the mortar that held the family together and created a fortress against the outside world. But that very mortar had been known to create cracks and crevices in its structure. Cries and whispers, creaking doors, locked drawers, purloined letters, glimpsed gestures, confidences and mysteries, sidelong and intercepted glances, words spoken and unspoken—all these created a universe of internal communications, and the more varied the interests, loves, hatreds, and shameful feelings of individual family members, the more subtle those communica-

tions were. The family was an endless source of drama. Novelists drew on it constantly, and fragments of the rich saga of private life occasionally could be read in the newspapers.

Louis Chevalier wrote, "Not every family is a tragic affair, but every tragedy is a family affair."

During the seven years following Modigliani's arrival in Paris in 1906, according to Ambrogio Ceroni's authoritative *I dipinti di Modigliani* (1970), he completed about forty paintings. After turning away from sculpture in 1914, Modigliani began to paint at an accelerating rate. There were seven paintings that year, according to the same source. In 1915 that figure jumped to fifty-three, on average a painting a week. In 1916, he exceeded that total, completing fifty-eight works, including six nudes. In 1917, there were another fifty-eight paintings, including twenty nudes. In 1918, there were sixty-six, six of them nudes. In 1919, the final year of his life, when he became seriously ill, he still managed to execute fifty-four paintings. This is a conservative estimate; the Ceroni list is known to be incomplete and some scholars put the total at between 425–450 works, small by the standards of a Renoir but still large when one considers that only six years of work remained to him.

Part of the reason why Modigliani was able to continue his rapid rate, even after he became very ill, has to be credited to the constant drawing which took hours of his time every day. Like a great athlete or virtuoso violinist, he was constantly limbering up his fingers so that they would be instantly obedient to the demands of his imagination. The fact that he fell short of his own goals often enough accounts for the exasperation with which he would abandon attempt after attempt. He was, as Max Jacob observed, in search of the perfect line, "a need for crystalline purity, a trueness to himself in life as in art."

In painting after painting Modigliani sought the chimera of the ideal, a form that summed up and personified the secret essence of life itself, a goal he knew he would never achieve. But in an age that was abandoning the idea of line altogether, "his drawing developed from the stylized yet energetic lines of the early caryatids to . . . exquisitely

sensitive and marvelously succinct lines . . . from a line like a sewn chainstitch, cautious and even, to the swinging rhythms of his last years," Agnes Mongan wrote. Modigliani makes it look so simple, effortless even, which has deceived many a would-be forger. Such artlessness testifies to an acute and rarefied mastery of form.

Modigliani's passionate love of sculpture makes the line between the work he abandoned and subsequent paintings and drawings very clear. The caryatids, for instance, which Frederick S. Wight says have the same significance for Modigliani as his reclining figures had for Henry Moore, were a stylistic influence, with their "clearcut sculptural contours." Wight wrote, "the figures are in effect colored sculpture, and the background is a niche that wraps them around." The emphasis on the female form finds its counterparts in the nudes, and also the subsequent portraits, most of which are of women, single figures posed indoors with dramatically simplified backgrounds. "Cézanne's whittling of form with little revolving planes was to give incision to Modigliani's painting, and to work out a coexistence with the linked ovals which he learned from the sculptor Brancusi."

Within his self-imposed limits Modigliani continued to experiment and refine his vision. One of his most interesting experiments was begun with the two portraits he executed of Frank Burty Haviland at the outbreak of World War I. This bravura display of a pointillist technique married dots of softly graded blues and indigos with burnt siennas, rusts, and crimsons. The dappled effect sets off the sitter's aquiline features. But Modigliani must have found the resulting portrait too static, a problem he brilliantly resolved in his whirling portraits of Diego Rivera.

Modigliani often left works unfinished, even in paintings as fully executed as *Gypsy Woman with Baby,* at the National Gallery of Art in Washington, whose infant's foot is only outlined. In his 1915 portrait of Henri Laurens, the artist's predilection for leaving large areas untouched is on display. The seated sitter, bearded and wearing a prominent tie, is missing an eye, a leg, a hand, and most of the background. The portrait is executed in soft greenish and blueish grays, with emphatic touches of dark brown and gray. The shoulders are distorted and the paint is handled like watercolor. Even so, the result is curiously satisfying, as the artist must have realized. It has a unity of vision all its own, and Modigliani was superstitious about spoiling

any study that seemed to have reached a certain stage of completion, even if only fragmentary. As with any drawing, he was immediately ready to abandon the idea and begin again. On the other hand, if he felt the effect was complete except for a certain something, he might, for instance, as in the 1916 portrait of Soutine, add a lock of hair out of place. Or there might be a point of red beside the bridge of the nose, or a mannered rise to the eyebrow that chance alone cannot account for.

An example of this is the solidly completed portrait of Max Jacob with top hat that Modigliani painted in 1916. As Werner Schmalenbach points out, the sculptural influence on the work is almost palpable, from the jaunty angle of the heavy black hat, the stiffly thrusting tie, and the nose, "which looks as if hewn from a plank with an axe." The blocklike stone backgrounds of gray and dark brown, the opaque brown of the jacket, even the diagonal shadows from forehead to eye and cheekbone to chin seem hewn from rock rather than palpitating flesh. As for the eyes, neither has a pupil. One is an indeterminate gray and the other has been inexplicably cross-hatched, one of those tiny details that cannot be accidental. What can this mean? Painting eyes shut, Schmalenbach points out, was not unique to Modigliani, since this kind of detail shows up in Matisse and Picasso and is, furthermore, a feature of the African masks that influenced them all. Survage liked to quote Modigliani, who might paint one eye looking out and another as a blank, to the effect that, "With one eye you look outside, with the other, you look inside." This does not solve the problem of the cross-hatching in the Jacob painting. Could there be some implied reference to Jacob's interests in poetry and alchemy, those of a man seeing life through the prism of other worlds?

Modigliani's paintings of weight and density alternate with other studies in which the concept is full of delicacy and nuance. There is for instance the portrait of Beatrice Hastings in 1916, already described, that could be a companion portrait to his Pierrot. This study in soft blue-grays and browns has a feeling of spontaneity — she said she often walked around ignoring him while he was painting her — that is in contrast to his more studiously realized works, such as *The Cellist* of 1909. Compared with *Madam Pompadour* it is almost a sketch. Yet Modigliani sometimes achieved superior results with this particular approach, which gains in swiftness and subtlety

whatever is lost in monumentality. There are portraits of Moïse Kisling, painted in 1916, with his youthful fringe of hair and irresistibly almond eyes that perfectly mirror his freewheeling personality. There is Zborowski, another friend he would paint repeatedly, in one case with arms folded, his strongly Slavic and rhythmical features delicately distorted by a pastel blotch of green at the corner of one eye.

Then there is Louise, whom he also painted more than once, in one case with head tilted and a shifting kaleidoscope of color patterns crossing her small face. She seems more child than woman, and Modigliani's emotional restraint is particularly evident in his many portraits of children. Another masterpiece is a lifesize portrait of a girl, perhaps aged eight or ten, in a nocturne of soft blues, looking at the viewer with shy directness. Schmalenbach wrote that the painter's delicate understanding of these subjects is all the more intense "because nothing is mannered."

Given Modigliani's perpetual poverty it is odd that he never seemed to look for sitters prepared to pay, cultivating socially prominent people as portraitists routinely try to do. Whether by accident or design, Modigliani's models were sculptors, painters, poets, or the working men and women with whom he would always be in sympathy. On the other hand, if he did not need to portray a flattering image he could please himself, and it is a curious fact that not one of his subjects is ever smiling. They may be thoughtful, wary, staring, withdrawn. They are often sensuous, even poetic. Even so, many of his sitters give one a sense of life on the edge; they seem imbued with a pervasive sadness. That summer of 1913 when he felt himself restored to life one more time brought about his comment, "Happiness is an angel with a grave face." No one who had endured what he had, and survived, could possibly think otherwise.

One morning Paul Guillaume went to meet Modigliani in his studio and found him still asleep; he had to wake him up. Modigliani explained that he had spent most of the night at a boisterous party and invited the guest to sit down while he made himself presentable. He then took out a zinc jug, minus a handle, which he used instead of the humble chamber pot, went out into the corridor, where running

water and a sink were usually to be found, emptied the jug out in the communal sink, and returned shortly with the same jug, full of fresh water. He explained that it was the Jewish custom to wash oneself as thoroughly as possible on rising, and also rinse out one's mouth to clear the mind. Which he did. After these ablutions he was dressed and ready to talk.

Guillaume, the kind of city sophisticate who wore spats, folded his breast pocket handkerchief at the exact angle, and bought his suits in London, was naturally appalled at such dangerously primitive notions of sanitation. But they needed each other. The sophistication shown in Modigliani's work was deeply attractive to Guillaume's refined tastes. On the other hand Modigliani could not possibly break into the art market without the imprimatur of someone like Guillaume. Besides, for a time the dealer believed he alone saw the greatness of Modigliani's work. This was not quite true. But certainly few collectors or dealers took Modigliani seriously. "They laughed at his drawings. They paid no attention to his paintings, and his friends at the time were definitely not those who claimed to be his friends later," Guillaume wrote, no doubt with a meaningful reference to Salmon and others. Guillaume guided Modigliani's career for about two years, from 1914–15 to mid-1917, after which he amiably relinquished that role to Zborowski but continued to sell Modiglianis.

Guillaume recalled that at the start of their relationship Modigliani was living with Hastings and sometimes worked at her apartment, or at Haviland's, sometimes at his own studio or the cottage in Montmartre. Guillaume was in awe: he was painting "with passion, with violence, temperamentally, extravagantly." There is no question that being represented by such a successful young dealer, one about to move into the prestigious rue du Faubourg Saint-Honoré, was an enormous boost to Modigliani's self-confidence. He seemed to have found himself and was dedicating himself "to the most complete and perfect aesthetic transfiguration of his inner imagery."

Basler to the contrary, the painter Léopold Survage always said that Modigliani's biggest problem, at least at first, was finding models, since professional ones, who charged five francs a sitting, were far beyond his means. People made all kinds of excuses. Women would

say they were not pretty enough. Men were too busy. He would sometimes approach strangers in cafés, or even on the streets, with scant success. "But once he got someone to agree to an appointment he would be there waiting, early in the morning, nervously. Sometimes he would go out onto the street to wait for the model's arrival. Sometimes the model did not show up and then his disappointment was great," Survage wrote.

> He usually began by sketching, with a very fine brush, a drawing similar to his well-known pencil drawings; sometimes soft and tender, sometimes hard and violent, according to the character of his sitter and his own mood. The more studied and deliberate elements were combined with a fair measure of improvisation. Starting from an initial conception of main lines and angulations, which represented the sitter and extended outwards to take in surrounding objects such as chairs, tables, wall corners and door and window frames, he scattered, rhythmically and in a strictly geometrical style, a flood of detail that was painted with great delicacy and force. So fond was he of fathoming the unfathomable that it did not weary him to do seventeen or even nineteen portraits of the same person at near intervals.

"This work made for great nervous strain," Survage continued, "for it required an uninterrupted flow of rapidly changing perceptions at the psychological level to be expressed by a procedure that pushed the geometrization of forms to its extreme." "The remedy was close at hand—a glass of red wine and a small glass of grappa, after which he would get right back to work."

Another of Modigliani's subjects was Léon Indenbaum, a sculptor from Vilna, Lithuania. The two became friendly after Modigliani moved in with Hastings—they all shared the same courtyard. Modigliani painted him in 1915. It came about in an interesting way. At about two a.m. one night Modigliani was sitting on a bench outside the Rotonde, apparently drunk, just as Indenbaum was leaving the restaurant. Indenbaum sat down beside him. Modigliani placed a companionable hand on his friend's shoulder and there they sat, for perhaps half an hour, wordlessly. Finally Modigliani turned to him and said, "Do you have any paints?" Indenbaum did. He also had

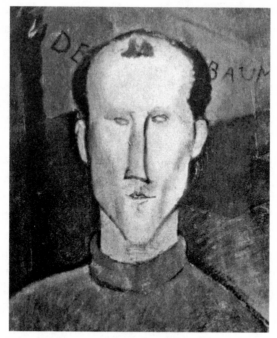

The sculptor Léon Indenbaum, painted by
Modigliani, 1915

some canvases. "Fine," Modigliani replied, "I'll paint your portrait
tomorrow."

Modigliani was there bright and early the next morning, clean and
freshly shaven, wearing a blue-checked shirt and black string tie.
Indenbaum was storing a motley group of paintings that had been
donated as a benefit for a friend of Rivera's who was ill, so there was
plenty of potentially usable canvas to choose from. "Help yourself,"
he offered. Modigliani picked up each painting in turn, looked at it
carefully, shook his head, and replaced it, evidently deciding the pic-
ture was too good to paint over. He finally settled on a small still life
and began work.

It took him three mornings to paint Indenbaum, a young man los-
ing his hair, expressionless, with a curiously pointed chin, his name
strung out in the background. After the third sitting Modigliani
judged it finished, signed it, and gave it to Indenbaum. The sculptor
would not accept it, but the artist insisted: "I shall be really offended
if you don't"; so Indenbaum took it. He decided later that Modi-

gliani's generous offer was in payment of a debt. When he briefly had some money himself he had bought one of Modigliani's heads to help him out, but never claimed it. After a decent interval, Modigliani sold the head to someone else. So he thought no more about it. But the day came when he, with a young baby to feed, needed some extra cash. So he took his portrait along to Chéron, who would buy anything. Just as he was leaving the dealer's premises, whom should he meet but Modigliani in his signature corduroys, head held high. Indenbaum, embarrassed, said, "I've just sold your portrait." Modigliani replied, "Quite right, too," without a moment's hesitation. "Don't worry, I'll paint you another one." But he never did.

Fellow artists were the easiest to persuade because they were the quickest to regard the request as a compliment and always had flexible hours. Modigliani had as many sculptors as artists among his "*copains,*" casual acquaintances, and a few close friends. Jacques Lipchitz became one of them. Born Chaim Jacob Lipchitz in a village on the Niemen River in Russia, like so many other young Jewish émigrés he went to Paris to study art in 1909. On arrival, and for simplicity's sake, he had his name changed to Jacques Lipchitz. His first exhibition drew praise from Rodin and he was on his way to fame when he met Modigliani in 1913. He recalls being introduced by Max Jacob in the Jardins du Luxembourg, where Modigliani had spent so many happy hours with Akhmatova, and perhaps it was no accident that Modigliani promptly launched into excerpts from *The Divine Comedy,* declaimed at the top of his voice. Lipchitz, by nature modest and retiring, was taken aback by this public display of erudition. But, seven years Modigliani's junior, he was immediately intrigued by the older man's romantic appearance—even in shabby corduroys, he exuded a kind of aristocratic elegance—his easy manner, enthusiasm, and passion for art. His was a rich nature, Lipchitz wrote, "so lovable, so gifted with talent, with sensitivity, with intelligence, with courage. And he was generous—promiscuous, even—with his gifts, which he scattered recklessly to the winds."

In 1916 and just married, Lipchitz signed a contract with the dealer Léonce Rosenberg and had a little money to spare. So he and his wife Berthe decided to ask Modigliani to paint their portrait, with

Jacques Lipchitz and his wife in Paris, c. 1920

the idea that the pose would be based on a recent wedding photo-
graph. Modigliani said his price was ten francs a sitting plus a little
alcohol, which seemed perfectly reasonable, so they set a time for the
following day in Lipchitz's studio.

"He . . . made a lot of preliminary drawings, one right after the
other, with tremendous speed and precision." The next day he
arrived with paints and an old canvas and the couple began to pose.
"I see him so clearly even now — sitting in front of his canvas, which
he had put on a chair, working quietly." Lipchitz already knew that
Modigliani was subject to paroxysms of coughing that caused him to
double up. So he had provided a bottle — probably some brandy — to
quiet the spasms and allow the artist to go on working. "From time
to time he would get up and glance critically over his work and look at
his models. By the end of the day he said, 'Well, I guess it's finished.'
We looked at our double portrait which, in effect, was finished. But
then I felt some scruples at having the painting at the modest price of
ten francs; it had not occurred to me that he could do two portraits
on one canvas in a single session." On the other hand Lipchitz knew
Modigliani would be deeply offended if he made any kind of offer
that could be construed as charity. So he demurred, using the excuse
of a higher finish for another sitting, and an extra ten francs. Modi-

gliani shrugged. "Well," he said, "if you want me to spoil it, I can continue." Modigliani went on for another week without appreciably adding much. The painter was happy, the sitters were happy, and the result was, Lipchitz believed, that Modigliani worked on their portrait longer than he did anyone else's.

The painting, now at the Art Institute of Chicago, is one of Modigliani's most self-assured and least ambiguous. Unlike *Bride and Groom* of the year before, which is an experiment in geometrics, resulting in figures that look like blocks of wood, the Lipchitz portrait is a model of relaxed and graceful ease. The sculptor, one hand in a pocket and the other on his wife's shoulder, stands negligently behind his seated bride. The composition is diagonal; the palette, though confined to a limited spectrum of dark greens, browns, and off-blacks, is curiously spritely, even gay, and the expressions of the bride and groom add to the air of quiet contentment. It was the only other wedding portrait Modigliani would paint, and one of his best-known works.

In the final category of sitters are friends of friends, such as Lunia Czechowska. She and her husband knew the Polish poet and art dealer Léopold Zborowski ("Zbo"), who would figure so largely in the remaining years of Modigliani's life. In 1916 Zbo took them to see Modigliani's work on view at the Lyre et Palette exhibition. After leaving they, with a group of painters, walked over to the terrace of the Rotonde and found a table. "I can still see him crossing the boulevard du Montparnasse, a handsome young man wearing a large black felt hat, a velvet suit with a red cummerbund, pencils in his pockets and an enormous folio of drawings under his arm. Modigliani came and sat beside me. I was struck by his air of distinction, radiance and the beauty of his eyes. He seemed to me very simple and very noble. Even the way he shook one's hand was distinctive and unlike anyone else."

She agreed to pose and Modigliani, sleeves rolled up to the elbows, began work. Like Zbo and Lipchitz, Czechowska was among the few who knew how ill he was. Because tuberculosis had reached epidemic proportions it was talked about in whispers. Czechowska's particular circumlocution was that his health was "very delicate" and that "he only drank if tormented by a particular problem," meaning, to soothe his coughing fits. To call him an alcoholic was outrageous.

She thought that very few people penetrated his reserve to arrive at

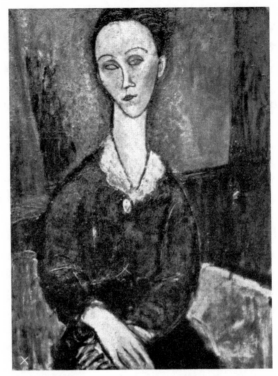

Lunia Czechowska, in one of her many portraits by
Modigliani, 1917

his true personality. "This was a real artist: ordinary people could not
understand such a person and the torments he endured. I am con-
vinced that alcohol was not necessary to his genius but it was a ref-
uge . . . that allowed him to forget his difficulties." Not a vice, but "a
kind of anesthetic." Modigliani would eventually paint her portrait
fourteen times.

Whether Beatrice Hastings also knew Modigliani had consump-
tion is one of the many questions that cannot be answered satisfac-
torily. However, it is difficult to live on close terms with someone
who constantly coughs up blood without suspecting something. Her
comment on the impossibility of abandoning him to his fate clearly
indicates that she did know. She also complains that her health is
not good, which might also be code for her fear that she, too, would

come down with the same affliction. There is a further factor to be considered. One of her friends was Simone Thiroux, a young Canadian, blond and voluptuous, who had inherited a modest fortune from her parents. She was in Paris to study medicine but was fascinated by the art world and spent her time hanging around Montparnasse. Hastings was on such comfortable terms with her that when she took her trip to England in 1914, she wrote Simone a postcard asking her to look after Modigliani if she did not return. Thiroux was also tubercular and it seems inconceivable that she would not recognize the same symptoms in Dedo and not have warned Beatrice. She took the injunction to take care of him seriously, whether Beatrice was around or not. During sittings for the Lipchitz painting she was in constant attendance. It was a wet, dreary winter and every afternoon she would appear with dry shoes, overshoes, extra jackets, and scarves, a model of tender concern. Far from being grateful, Modigliani said she was "a wet chicken," i.e., a softy, and found the whole thing deeply embarrassing. Or so he said.

Another issue that will not be solved is whether Hastings had Modigliani's child. She told Thora Klinköwstrom, later Dardel, a young Swede who posed for Modigliani, that she had carried his child, a little girl, but that the baby had died. It is hard to believe anything from a woman capable of weaving such a moonbeam cocoon of fantasy around herself. Too, one has to doubt whether someone who boasted about the number of her lovers would ever know whose father it was. Still, given that she was telling the truth, and if it is just conceivable that the child she had was Modigliani's, that would help explain his fury when he learned that she had taken a new lover, an even handsomer Italian sculptor, Alfredo Pina, then working as one of Rodin's many apprentices. Beatrice was in love again, and so was Simone—with Modigliani. By then, he and she were already lovers, or not: it hardly matters. Beà "abandoned" Dedo, as she wrote, or was it the other way around? The fact is that such a relationship was bound to end badly.

Hostilities began in earnest one evening in the early summer of 1916 when Hastings caught Modigliani and Thiroux in a tête-à-tête at the Rotonde. She picked up a glass and, true to her publicly stated belief that a woman in a rage can start throwing things with impunity, aimed it, not at her faithless lover, but her friend. The glass

caught Simone just above an eye and shattered, leaving a permanent scar. But at least she could still see.

If one can believe an eyewitness, their worst fight centered around, one assumes, the final months of their life together. Since the cafés closed early it became customary for a group of friends to continue the fun at somebody's house; that evening it was 13 rue Norvins in Montmartre. Marevna, who was in the party, wrote, "To reach the [house] we went up steps from the street, through a little garden and into a well-lighted room on the ground floor, furnished with a bureau, a table, chairs, a sofa, shelves full of books, a mountain of sandwiches and bottles of every kind." Besides Max Jacob there were Ilya Ehrenburg and his wife Katya and a number of others, a list Marevna apparently could still recall fifty years later when she came to write her memoir (in 1972).

She claims that Modigliani and Hastings, who were already drunk, began one of their arguments. Soon they were pommeling and kicking each other. Then, Marevna writes, "The next thing we knew, he had seized her and hurled her through the closed window. A shattering of glass, a scream and all that remained visible of Beatrice Hastings was her legs, dangling over the windowsill—the rest of her was in the garden."

This episode, frequently repeated, is cited as proof of Modigliani's drunken violence toward women. On the other hand, as Simon Gray observes, by the time Marevna wrote she had had a tempestuous affair with Diego Rivera, who had often been violent and abusive. She wanted the world to know "that the women of the great macho painters of the day had a bad time of it and could be sorely abused."

What this account lacks is verisimilitude. It strains credulity to believe that Modigliani, at five feet three or four, and now ill, could have summoned the strength to toss Beà through a window with the necessary force to break glass. But even if, for the sake of argument, this did happen, the assembled crowd would have rushed her to hospital to examine her for concussion, not to mention shards of glass embedded in her body. This was not what happened, according to Marevna. The blood-streaked victim was supposedly covered with a blanket, her lover babbled that it was not his fault and sang songs to distract her. The night wore on. Finally everyone ended up sleeping on the floor among broken glasses, spilled wine, upturned

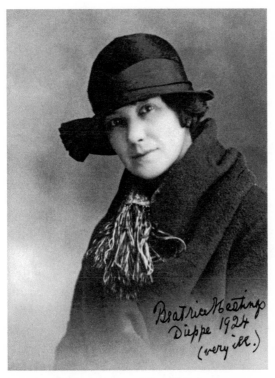

Beatrice Hastings in 1924. "Very ill," she notes,
cause unknown.

chairs, and wallpaper in shreds, with the victim asleep on the sofa. So
Marevna writes; how truthfully is another question. Did she elabo-
rate on a minor incident, the only kernel of truth being that Hastings
fell or was pushed backward and ended up against a window? She
does state that Jacob was there, known to be an incorrigible gossip;
if true, her version of events would have been all over Montparnasse
the next day and would certainly have ended up in that compendium
of gossip, *Artist Quarter,* but it does not appear. By the time Marevna
published her account there was no one left to contradict it, or her.

Minnie Pinnikin, which survives in fragmentary form, takes
extended flight through a world in which Pâtredor, or Pinarius
("Penurious"?), paints, free-associates, engages in numbing gener-
alities with Minnie Pinnikin (who always looks on the bright side),
and then pauses to admire the non sequiturs. They are about to get
married, and they also seem to be on an *Alice Through the Looking*

Beatrice Hastings in later years

Glass edge, passing from reality into a dream landscape, or from a dream landscape into a void. In any event they inhabit the same fantasy and in it Pâtredor is shopping for wedding presents. He gives Minnie Pinnikin a star, a blue flower, a wave from the sea, and "a golden flying snake." He apologizes: "I am not as wealthy as I used to be. I would have offered you a wheel, an elephant, a jewel, and a son. Today I have only small things left but I will work hard to regain the fortune I lost in the cataclysm." Their cloudlike mirage is iridescent, inhabited by children, angels, and bony horses "as light as hope." There are wells, holes through which you fall into a void, and other holes that make you rise up, corridors without end and doors that never open. Arriving at the main door a voice commands them to enter. But then, "as it always happens in dreams," Minnie Pinnikin wakes up.

Their magical vistas, hedged in by some very real, unexamined limitations, had vanished. "How simple things were at the beginning," she wrote later, at the end of another failed relationship, words she might have plausibly said to Dedo. "But we've become too unhappy with one another to be reasonable." Pâtredor was now "a liar and a thief and a thick-skinned, death's-head, bourgeois spirited . . ." He was somebody she no longer recognized. She held no very great opinion of herself either, beneath the studiously cultivated façade of poet. "I feel I'm one of the most foul beings nature ever yet invented." Impossible hopes; unbearable realities; it would all end in an alcoholic haze in a bedsitter in Eastbourne. In 1943 Hastings turned on the tap of a gas fire, lay down beside it, and committed suicide at the age of sixty-four. But just then she had the consolation of Alfredo, who also had talent, was as handsome and perhaps a more receptive candidate for the cobweb bridge she would fling across his mind, as Edith Wharton wrote of Henry James. Whatever

she had told him about Dedo apparently ignited a fury of retaliation that involved a gun, probably hers. Alfredo prepared for vengeance.

The Hastings-Pina-Modigliani imbroglio complicated matters for Marie Vassilieff early in 1917. Braque, like Apollinaire, had been wounded in the head, almost lost his eyesight, and was awarded the Légion d'Honneur and Croix de Guerre for gallantry. Then he, along with Léger, was invalided out of the war. He had survived when so many had died and Vassilieff was determined to give him a welcome-home party in her "cantine" on the avenue du Maine. Everyone who was anyone was being invited, including Picasso, Juan Gris, Cendrars, Matisse, and assorted wives and girlfriends; thirty-five in all. Hastings insisted on bringing Pina. Vassilieff foresaw nothing but trouble if the two lovers were in the same room, let alone breaking bread at the same table.

Something had to be done. It seems Vassilieff routinely gave Modigliani a daily pittance of fifty centimes. He had to be told he could not come. But if he behaved himself and stayed away, he would get three francs.

Vassilieff went to enormous trouble, finding black paper tablecloths and teaming them up with red paper napkins and white plates. Braque, wearing a laurel wreath, sat in the center of a long table. His wife, similarly garlanded, was seated opposite him. Picasso looked uncomfortable in a suit and tie. Matisse, Pina, Jacob, and others were similarly dressed, the ladies wore festive evening attire, and only Léger, in a beret, and Cendrars, his right arm gone, wearing on his head what seemed to be an upside-down basin with a handle, ignored the general trend. Matisse, holding a turkey, and Vassilieff, brandishing a knife, were in the act of carving when the door burst open. Modigliani, hair flying, arms outstretched, raced into the room followed by a sympathetic crowd. In an instant Pina was on his feet and aiming the gun.

We know all this because Vassilieff later drew a detailed sketch of the dramatic moment. Accounts vary from then on. One has it that Pina fired a shot but missed. Vassilieff, who ought to know, does not mention a shot. She says she "seized the gun by main strength, forced [Modigliani] out of the door and he rolled down the stairs." One wants to believe her, but given her tiny build and dwarf-like stature, one is inclined to believe that Picasso and his guest, Ortiz de

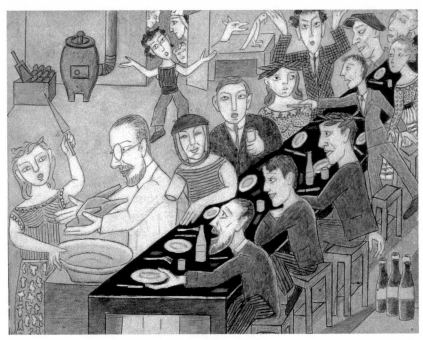

Vassilieff's sketch of the night she gave a party for Braque and Modigliani appeared uninvited. From bottom left: brandishing a knife, she has depicted herself; Matisse is holding the turkey, the one-armed Blaise Cendrars is seated at Matisse's left. Picasso, in shirt and tie, is seated next to Marcelle Braque, wearing a laurel wreath; then there is Walther Halvorsen, Léger in cap, Max Jacob, Beatrice Hastings, and her new lover, Alfredo Pina, aiming a gun at Modigliani. Braque, also in laurel wreath, looks on in dismay. Juan Gris is watching the turkey carving. The man at far right is unidentified.

Zárate, were the ones to take command of the situation. They commandeered a key, made sure Modigliani and friends were safely outside, and then locked the door. The incident should have ruined the party but did not. After a satisfying meal, Vassilieff performed her Cossack dance. Max Jacob did his crowd-pleasing impersonations, and the other guests danced until dawn. Presumably, Hastings and Pina held hands in a corner. Modigliani did not get his three francs. But by then he had already found the last great love of his life.

———

"Nenette"

Every roof is agreeable to the eye, until it is lifted; then we find tragedy and moaning women, and hard-eyed husbands.

—RALPH WALDO EMERSON, "Experience"

LIKE PICASSO, Modigliani fell in love with enthusiasm, drawing and painting the beloved incessantly as if the new relationship were the stimulus that would unlock some unsuspected aspect of himself. But now he also needed someone living with him. After collapsing often enough in his studio, he no longer dared live alone. He needed a special kind of person, and Beatrice had many desirable qualities: an urge to nurture, similar political convictions, a love of literature, music, and art, and, even if her ambition exceeded her grasp, a poetic approach to experience. Losing her was a serious blow, for all the reasons why they loved and misunderstood each other.

One of the stumbling blocks was certainly her quaint notion that, even though she had succeeded in a man's world, and was smoking, drinking, and engaging in free love, she was somehow not a feminist. No doubt she gave an old-fashioned Italian like Modigliani some

very mixed messages. How could he believe her if, indeed, he found her in bed with Pina, as seems likely? Did she not understand he was being cuckolded, made a laughingstock? This to him was treachery; to her, merely annoying proof of his boring bourgeois attitudes. The fact that he immediately replaced her with Simone Thiroux, another kindhearted girl who was even more quietly desperate and promiscuous than his Beà, indicates the extent of his need for somebody just then. That affair also ended abruptly and (one guesses) for the identical reason—but in any case, it was a distraction that had served its purpose. As for the banquet, to confront Pina was a required public ritual, more style than substance. No doubt he was relieved to have been hustled safely out of the room; Pina was probably equally grateful to have been spared the necessity of firing a gun. Having closed one door Modigliani opened another, becoming absorbed by a love who would meet his needs to the letter. Or almost all.

She was Jeannette, or Jeanne, Hébuterne, an art student whom he met at the end of 1916, that is to say, a few months before the Braque banquet. Descriptions of her painted in the last eighty years are in bare outline, hampered by her family's, and particularly her brother André's, refusal to talk about her. Patrice Chaplin, a British novelist and playwright, made a determined effort to uncover Jeanne's story in the 1980s and published her findings in *Into the Darkness Laughing* (1990). The title is an apparent reference to Modigliani's recklessness and its attraction for Jeanne. Chaplin managed to make contact with Frédérique Prud-Hon, daughter of Roger Wild and Germaine Labaye, both friends of Modigliani's as well as Jeanne's. Chaplin was allowed to read letters between Jeanne and Germaine that had been kept in a locked metal box for decades. She also believed she had uncovered another illegitimate child of Modigliani's, a daughter, in the south of France. She met some old friends and visited the apartment in the rue de la Grande Chaumière. In the end, her portrait of Jeanne remained largely speculative, a creation of her novelistic impulses because the Hébuternes would not see her.

However, Jeanne's great-nephew Luc Prunet, a lawyer in Meaux, and Marc Restellini, a museum director in Paris and leading expert on Modigliani, recently collaborated on a study that was published to coincide with an exhibition in Tokyo, "Le Couple Tragique" (2007). Thanks to the release of substantial numbers of hitherto

unknown drawings, paintings, photographs, postcards, and other family memorabilia, Jeanne Hébuterne emerges, not as the passive, compliant figure she has been painted, but a distinctive personality in her own right.

Hébuterne's family came from the area around Meaux, an important agricultural center (famous for its brie) that was established in Roman times, and with a cathedral to St. Stephen dating back to the twelfth century. Once surrounded by fields, the town, some thirty miles to the northeast of Paris, linked by commuter trains, has become something of a satellite for immigrants who cannot afford city rents. Achille, a handsome and promising young executive, moved to Paris with his wife Eudoxie and became chief accountant for a perfume house. Like department stores, parfumeries are intensely focused on presentation and novelty, always on the alert for the latest trends in art. In his photographs Achille looks very much the businessman but one with a well-hidden interest in music, sculpture, and art. He was also a passionate convert to Catholicism and, it was said, would insist on reading Pascal aloud while his wife and daughter peeled the potatoes.

Eudoxie Anaïs Tellier, the girl he married, was not pretty but had a marked sense of style. Known as "Ocze," she wore her black hair to her knees, and favored kimonos with bright and splashy motifs. She covered the walls of their apartment on the rue Amyot in the fifth arrondissement with paintings, fragrant logs burned in the fireplace, a cuckoo clock on a wall marked the hours and quarters, and there was a delicious smell of citron about the place. She played the piano, accompanying herself with a repertoire of songs, painted a bit, and read poetry. A wife who flutters about in butterfly robes, sits sewing at the window, sings to her children (André was Jeanne's senior by four years), and is artistic would have a natural appeal for a husband whose livelihood depends on the art of selling the inessential.

They were well matched in one sense, but in another, there was friction. Georgette-Céline Hébuterne, who married André, said, "Mr. Hébuterne was rather stricter and more severe. His indulgence had its limits, and he wouldn't stand all this arty stuff when it went too far. On the other hand [Eudoxie], in her romantic way, was very much taken with artists and their lives (she obviously didn't at all realize just what 'artistic life' in Montparnasse was like at the time).

This difference in attitude of course led to friction but also to a certain concealment, to hiding things from one another."

With her strongly marked brows, long nose, and full lips Jeanne, like her mother, could not be considered classically beautiful. Her great asset was a ravishing plunge of heavy brown hair, vibrant with red and gold highlights, which she put up in long braids, hair parted in the center and with a bandeau around her forehead. Photographs show her at the age of seventeen gravely facing the camera and looking up from under her eyelashes in a manner reminiscent of the late Princess Diana, a mixture of shy and seductive charm. She was petite, with tiny hands and feet, very much an individualist. In adolescence she began designing and making her own clothes and jewelry. She was intellectually curious and had read Nietzsche, Denys l'Aréopagite, and Léon Bloy. She played the violin expertly and was learning Russian. She had memorized by heart a poem by Ilya Ehrenburg that he had written for a much-loved granddaughter whose health was fragile: "God has many stars in his unclouded Paradise. But I only have you. Stay a little while, do not die. Please don't die."

Stanislas Fumet, French essayist, poet, editor, and art critic, who was two years Jeanne's senior, said that he and his future wife Aniouta saw Jeanne on the streets in the years leading up to World War I, long before they met her. In those days she was

a very young girl with long tresses, always alone, whose bright-eyed, very special quality captivated us. We would make a point of encountering her in the Latin Quarter or the Luxemburg Gardens, which she crossed every day, a sketchbook under her arm. Her manner of walking, with a slow and deliberate glide, even the way she held her head, was irresistibly swanlike. Her forehead was girded around with a ribbon in Veronese green, and two large coppery plaits came down almost to her knees. She invariably wore a dress of duck egg's blue and, on her head, the sweetest little cap in some brilliant color.

She was enchanting; the impression was of a paradoxical beauty with the grace and equilibrium of a Grecian amphora. "Her unique appeal—perhaps her spirit—was that of a rare aquatic plant, brought to life from the alchemical fluid of some magician. As a flower, she would have been a waterlily; as a precious stone, an emerald."

They were eventually introduced by their joint friend Chana Or-
loff, who would execute a full-length sculpture of Jeanne and her
signature braids. "The first time Jeanne and Aniouta went for a walk
it was to talk about suicide. Aniouta has never forgotten it. Jeanne
said she did not pity anyone in the world so much as those who took
their own lives. 'How very much they must suffer to be driven to
that,' she said." She was just seventeen.

At the outbreak of World War I in 1914 André, just twenty, hand-
some and self-assured, was launched on his lifelong career as an art-
ist, mostly of landscapes in the Impressionist manner. It was not
surprising that Jeanne, with her instinctive sense of color and original
style, would have followed André's lead. Her mentor was ebullient,
outgoing; she was quieter and reflective. She often drew his portrait
and he also painted her, although the family has never made these
works public. Jeanne might have measured her words but it would
be a mistake to think she was malleable. André's diary records that
she also argued regularly with an abbé her family knew. Prunet said,
"Here we have a girl who, before 1918, is contradicting an abbé!"
He added, "I can tell you that within her family circle she often went
'head to head' with her father."

At her best, Jeanne was gentle, affectionate, and loyal. However,
whenever she believed herself overruled and misunderstood, she
would become resentful and mulish. Once sufficiently wounded, she
never forgave. Her work reflects this dichotomy, sometimes expan-
sive and freeform, at other times tight and mannered.

Family relations seem to have been, for the most part, fond and
devoted. André and Jeanne had pet names for their parents, "Mémère"
and Pépère," as well as for each other—André addressed his sister
as "titsoeur" and she signed herself as "Nenette." The freedoms given
to Jeanne by her parents are mentioned more than once as evidence
of their unusual permissiveness. But it has to be recalled that before
Frenchwomen gained the vote such social freedoms were relative.
The English artist C. R. W. Nevinson, in Paris in the 1930s, wrote
about

> the appalling tyranny of the average French home life. It is not
> even now realized in England [he wrote in 1938] how dull and
> miserable the existence of a woman can be in the Latin coun-
> tries. My mother and I once met a young girl who was study-

ing at the Sorbonne. Greatly daring, she had dispensed with her
bonne and was trying to live a life *à l'Anglaise;* and the treat-
ment she experienced and the insults which were heaped on her
would simply be disbelieved in England . . . Today France has
not changed much in correct circles. No "nice" girl can sit on a
café terrasse, even with her own mother, and how relations spy
on them!

Bryher, the English author, daughter of a prominent industrial-
ist and financier, wrote, "In 1913 women belonged in the home.
My family were truly frightened of the free-thinking little monster
that had emerged in their midst [herself] . . . It would have been the
same wherever I had been born, in a cottage or a mansion, in Kent
or France. Slavery may be a gentle thing but the threat of the rod is
always in the master's hand."

The little we know about Achille suggests that, despite his indul-
gences, he was in most respects a man of his times and a literalist
where his religious convictions were concerned, something Jeanne at
least found increasingly tiresome. He was the figure around whom
family life clearly revolved and Eudoxie, easily intimidated and eva-
sive, accepted her role. Her solution when confronted was to impro-
vise. Jeanne was similarly constrained to passive defiance, at least
until she found her protector in Modigliani.

An indication of how Jeanne Hébuterne might have felt about her-
self is provided by a series of drawings she made in 1915, just before
she met Modigliani, to illustrate a best-selling novel, *Jours de famine
et misère.* This is actually a memoir by its author, Neel Doff, thinly
disguised, a Belgian author who had, as a child, struggled to over-
come starvation and degradation. Her feckless parents, often unable
to feed their nine children, drifted from one town to another. Neel
Doff became something of a substitute mother, working at menial
jobs and at one time becoming a prostitute. Jeanne drew thirty-three
illustrations based on excerpts from the story, which is told as a series
of vignettes. They are themselves vignettes: a boy spinning a top, a
girl holding a child, children coming down a staircase, a nun, a weep-
ing woman. Their execution is compact, enclosed, and curiously
detached in feeling. It is as if she were describing herself, but from
a very great distance. Still, the penultimate illustration accompanies

the sentence, "Alone I raged and cried, squatting on the ancient sofa which served me as a bed." The artist had certainly never been hungry in that pretty, comfortable apartment on the rue Amyot. But there must have been moments when she could identify with the heroine of Neel Doff's novel, miserably unhappy and with a panicky feeling of being alone in a hostile world, a feeling that, once encountered, is never forgotten. Something had happened to turn a normal child with an eager smile into an unsmiling, almost unreachable adolescent. Why was she drawn, as Marc Restellini writes in *Le Silence éternel,* to this harrowing story about "the destruction of the Self"?

A further puzzle is posed by some almost clinical drawings of herself in the nude. Could a premature sexual initiation have taken place? One cannot know. Nor does one know how much importance to place, if any, on the comment by Foujita, the Japanese artist and member of the School of Paris, who knew her and dismissed her as "vicieuse et sensuelle." Someone from a society like his own would be bound to think of an independent-minded girl in such terms. On the other hand, that there were some stifled resentments under the surface seems undeniable. The artist painted such feelings in glowering self-portraits.

For Modigliani, a quasi-Bohemian who, as Nevinson observed, should have been the head of a bourgeois family, Jeanne Hébuterne, adorably young, inexperienced, impressionable, and plainly talented, would have seemed irresistible. This was the kind of girl one married: discreet, loyal, and quietly deferential, with an unsuspected streak of independent thought and creative accomplishment. As for Jeanne, André had been in the army for two years and she had lost her mentor. Modigliani, as handsome in his dark way as André was in his, had it all. He was a master of his chosen profession. He was charming and gifted, ardent and poetic. He was known everywhere. He knew how to survive on nothing a year. He more than filled the gap in her life.

As for Jeanne, she was all the things he was not: able to manage a household, go on errands, and balance the budget, concealing, behind her self-effacing manner, a quiet dependability. She was young, strong, and had not yet fashioned those complicated connections with other men that can have such disastrous consequences. Those who saw them together agree that Jeanne presented a singularly

interesting appearance and that she sat quietly in the background while he did his star turn, holding his hand. The hand holding is a tiny clue suggesting he had transferred to her that absolute need for loving support that would become essential in the months to come. A few, like Fumet and Dr. Dyre Diriks, a friend of Simone's, sensed the inner resolve behind the stillness. Both she and Modigliani had secrets to hide. Was this part of their bond?

One can safely see her as a crucial emotional anchor in the chaos of his life. One can also see him in a lover's fever of anticipation. They became lovers on or before May 17, 1917, according to Patrice Chaplin in *Into the Darkness Laughing.* Hébuterne wrote to her friend Germaine Labaye that Modigliani took her to the Hotel Dieu and she ended up with her underclothes torn. "A night not without a certain horror," was her laconic comment. Shortly afterward she was in another Paris hotel, they had made love, and she was again writing to Germaine. This letter probably came a month later while her parents were on holiday in Normandy. She had returned to Paris alone, not an easy case to make in the days when respectable unmarried women did not travel without a chaperone. The point of the letter was that she regretted nothing. She then moved in with Modigliani, probably in one of his seedy hotel rooms. Restellini's study of that period states that her parents knew nothing of the affair for over a year. She spent the day with him, returning innocently every evening to the rue Amyot; she explained her occasional overnight stays by pretending that she was staying with friends. It was a performance worthy of Modigliani and proof, if nothing else, of her spectacular ability to keep a secret. Her mother finally guessed the truth in the spring of 1918 when Jeanne could no longer deny that she was pregnant.

If public health authorities in France and elsewhere in Europe were alarmed enough to try to educate the public to limit the spread of tuberculosis that message, at least in Modigliani's case, fell on deaf ears, including the warnings against close contact. His behavior was the height of recklessness as he went from one woman to another, exposing her to tuberculosis and also unprotected sex, that led all too often to the predictable results. Was Maud Abrantes pregnant with his child, and was this the reason she returned to her husband, and had she passed the child off as his? What about Beà, who might or might not have had a child by him and who, in any case, could

have contracted his disease? What about the sweet, doomed, careless Simone Thiroux, who, in August 1916, did become pregnant with a child she said was his? What about Jeanne herself, with her Catholic upbringing, whom he impregnated in the spring of 1918? She could not be expected to protect herself, but prophylactics of a sort were available for men. If so, this was something Modigliani ignored, with the transparently self-serving statement that the greatest gift a man could give a woman was a baby.

In Simone's case, he had to know that she could not live long enough to care for Serge Gérard, the little boy who was born in May 1917. She made no bones about her own serious condition. Coughing, bringing up blood, she would treat it all as a great joke, ignoring the truth until she could ignore it no longer. From Modigliani's point of view it was not his child, could not be, because she was promiscuous. This makes a certain sense if one suspects that he had, indeed, discovered her with another lover. On the other hand he also knew he could not support a wife and child. At least, that is the reason he gave then. Émile Lejeune recalled a conversation on this subject after the birth of Serge. Simone Thiroux, penniless, begged him for work. Lejeune reports that Modigliani said, "It's a shame that I made a kid, but these things can happen to anybody. Isn't that right? Anyway, Simone and I were finished by then.

"So what would I have done with this baby? Someone like me, who has never had a penny, was I made to be the father of a family? It's sad but that's the way it is." Modigliani continued to deny his paternity even though his friends saw a startling resemblance in the two-year-old Serge, and since he refused to acknowledge the boy there was nothing the mother could do about it. He continued to reject Simone's efforts at a reconciliation. She wrote a letter sometime in 1919 begging to see him, presumably just after Jeanne was born. "I loved you too much, and I suffer so much that I ask this as a final plea." She was not asking for recognition for Serge, "just a little less hate from you." Whether or not Modigliani replied is not known.

What was he thinking? Had he no regard for the desperate game he was playing, not just with his own life, but the lives of others? Was he still arguing, as he did with Ghiglia all those years before, that "[p]eople like us . . . have different rights, different values than do normal, ordinary people because we have different needs which

put us . . . above their moral standards"? That would have been pre-
dictable. In fairness, it must be said that he treated Jeanne as any
self-respecting Italian male would have treated a wife, even though
they were not married. His behavior uncannily mirrors the tongue-
in-cheek stereotype drawn by Barzini of the peacock male and his
harem. He is out on the town making contacts and conquests; she
stays in the house, keeping his life functioning smoothly, and min-
isters to his every need. He also made a serious effort to house her.
Thanks to his new dealer they moved into a two-room studio in July
1917, that is to say shortly after they took up life together. There was,
of course, no kitchen, bathroom or toilet, running water, or central
heat. But given the hovels he had inhabited this third-floor walk-up
was almost luxurious. It was on the rue de la Grande Chaumière,
right around the corner from everything in the heart of Montpar-
nasse. At no. 8, it was a few doors from the Académie de la Grande
Chaumière, at no. 14, and next door to the Académie Colarossi, at
no. 10, where Jeanne was studying when they met. She could slip in
and out for art lessons almost without leaving home. The apartment
consisted of two spacious rooms in an L shape, with banks of win-
dows overlooking a pleasant interior courtyard. Once the lease was
signed, Lunia Czechowska and Hanka Zborowska swept, mopped,
painted, and scrubbed it. They found a stove, the universal source of
heat, and a few pieces of furniture. Modigliani decorated his work
space walls in orange and ochre before he moved in. Czechowska
wrote, "His joy was such that we were all shaken by it. Poor dear
friend, he finally had a corner of his own." So did Jeanne Hébuterne.

Like Guillaume, Léopold Zborowski was a young man in a hurry,
one taking maximum advantage of the preeminent position of Paris
in the marketplace of ideas. The better-established artists already
being represented, it was Modigliani's good luck that there were few
artists not at the front at a moment when Zborowski was struggling
to establish himself. His timing was strangely apt. He had arrived
in Paris from Poland to study at the École du Louvre or perhaps
the Sorbonne, a month before the outbreak of World War I. After
a brief period of being interned he was released with no means of
support. He showed his resourcefulness along with superior con-

Modigliani's art dealer, Léopold Zborowski, 1918

noisseurship—he was in his early twenties—by buying books and manuscripts their unsuspecting owners did not realize were valuable, and selling them at a tidy profit. He had a sensitive appreciation for art and, since he was friendly with Kisling, was soon offering to help him sell. That was another success, and before long he was representing Utrillo and joined the Kislings in the same apartment block at 3 rue Joseph Bara. Kisling had a studio up under the roof and the Zborowskis were in the apartment below. This turned out to be the best idea of all because, as a neighbor of the sociable Kislings, Zborowski had automatic entry into the inner circles of Montparnasse, its streams of artists, sculptors, poet-critics, dealers, and eccentrics. Zborowski, who by then had met Hanka, an honorary wife, was just the kind of person the crowd loved, a businessman with a poetic streak who wore his hat at a jaunty angle and was ready to take on anyone. This was good, because Utrillo was a hopeless alcoholic, Modigliani had been turned down by everybody in the past, and his

dear friend Soutine, painting his hideous writhing canvases in rags, was not fit for decent company. No doubt everyone was soon quoting Zborowski's poetry: "Maintenant silence / et subitement avec la brume tombante / l'accordéon parle d'amour aux filles de cuisine et au balayeurs de la rue."

Zborowski was also a gambler, and when he became rich in years to come lived on a princely scale with fur coats and chauffeurs. Perhaps something about Zborowski's confidence, his largesse, and his splendid self-assurance reminded Modigliani of his much-loved uncle Amédée. At any rate, he was ready to leave Guillaume, who now had canvases of his own to unload, and being courted by Zborowski was a definite plus. Whether or not he was ever helped in negotiations by Jeanne, who was, after all, a businessman's daughter, he bargained for and got favorable terms. Guillaume had paid for a studio; now he wanted Zborowski to pay for one, and got it. He also received a daily stipend of fifteen francs, which included canvas, paints, and models, and his contract further stipulated that Zborowski also represent Soutine. Zborowski even threw in a room in his own apartment. His rather large dining room was expendable, so it was appropriated by Modigliani as a studio, and most of his portraits and nudes were painted there during the next two years. Zborowski, not knowing how valuable this contact with Soutine would prove to be, agreed with reluctance, and Hanka would not have him in the house.

In turn Zborowski wanted Modigliani to start painting nudes. This made the best possible business sense. It was all very well to paint portraits, but if the subjects did not buy them the chances of encountering someone else who would were small, as Romaine Brooks found when the time came to stop exhibiting and start selling—and she never did. Nudes were bound to make people stop and look. Modigliani had frequently drawn nudes but never painted them; still, he seems to have agreed readily enough. They are now among his most famous works; a reclining nude sold at Christie's in New York in 2004 for $26.9 million.

One can admire any of Modigliani's nude studies for its painterly qualities, its air of assurance, its bravado sweeps of the brush that, with great economy of means, convey the weight of a coverlet, a flash of light in the background, or those tiny, pleasing details that echo the main theme so satisfyingly. One admires most of all the lyrical

loveliness of line. Years after he began a search for the simplified line, which Mauroner saw as "a solution to his search for the essential meaning of life," he perfected it in his magnificent nudes. The female form, idealized, stretches itself out across his canvases in "all the lineaments of gratified desire," as William Blake wrote. This is innocent pleasure and acceptance, "generous, natural and calm." One thinks of the painter himself, removing his clothes and arching his back in an unself-conscious celebration of life.

For in fact these works are "as simple, sensuous and passionate as the poetry of Keats," to quote Kenneth Clark in *The Nude*. Masks disguise truths; his nudes reveal the essential nature of Modigliani himself. The rage and terrible resentments revealed by Maldoror are the mirror images of a rapturous response to the beauty of life, as revealed by the female form. One might say that this deeply feeling person, crippled by illness, terribly wounded in the past, was fashioning a poetic tribute, a salute to the life he was leaving. He hardly seemed to need a moment's doubt or hesitation. He just began.

Modigliani's nudes are all the more remarkable in the context of his time, when measured against Cézanne's awkward, bulging figures, Matisse's pseudo-abstractions, and, especially, Picasso's *Demoiselles d'Avignon*. Clark wrote of Matisse's *Blue Nude*, "The enjoyment of continuous surfaces, easy transitions, and delicate modeling which had seemed such an essential factor in painting the nude is sacrificed to violent transitions and emphatic simplifications." As for Picasso's monumental painting of 1913, his "relation to the nude has been a scarcely resolved struggle between love and hatred," and this painting "is the triumph of hate. Starting from a brothel theme . . . it developed into an enraged protest at everything involved in the conventional notion of beauty." In *Modigliani,* Werner Schmalenbach writes that the Futurists, an Italian movement in literature and the fine arts that Modigliani never joined, decreed on its founding (1909) that no one paint nudes for the next ten years.

"The futurists . . . had no moral objections," Schmalenbach wrote; "they disapproved of the female nude because it was the epitome of tradition in painting." They might have disapproved less if, at that date, Modigliani's nudes already existed. These, as it turned out, shocked the bourgeoisie, one of the main aims of the new movement. Schmalenbach thought Modigliani's position, bridging con-

temporary trends and the art of the past, was anomalous. "No other painter, in our century or in any other, has painted the female human body as he did. And yet his nudes evoke involuntary associations of Classicism. They are a continuation of a great tradition of European painting, not only thematically but also in the 'spiritual' interpretation of the theme, insofar as they constitute a celebration of beauty, immaculateness and perfection, and thus an idealization of physical Nature." For a sensualist Modigliani's nudes are naturalness personified, the opposite of the vulgar or obscene. For a classicist they are interpretations, not of ideal form, but naked human flesh. Lovers of Victorian nudes shudder at the indecency of it all. For everyone else, here is the work of a master of finesse, exhibiting sensitive appreciation and a delicacy of understanding.

Having two dealers with some sort of stake in his future enormously improved Modigliani's chances of getting exhibited. He showed three portraits at the Salon d'Antin exhibition in the summer of 1916, but no nudes. By then he was working on his first six paintings, and these are uneven in quality. As illustrated in Ceroni, one or two look stiff and labored and it took time for Modigliani to develop his sureness of approach. The National Gallery's reclining nude, now one of the treasures in the Chester Dale collection, is by far the best of this group, a forerunner of his superb series of seated and reclining nudes in 1917–18. The majority make references to the reality of underarm hair and contain decorous hints of pubic hair. These were among the thirty-seven works shown when Modigliani had his first one-man show late in 1917, including many portraits and drawings. Because Zborowski did not yet have a gallery of his own, the show was held at the Galerie B. Weill, 50 rue Taitbout in the ninth arrondissement. Weill was a "prickly, peppery schoolmarm of a woman," according to Richardson, who had learned how to sell by working for an antique dealer and, once she had a gallery of her own, would display Lautrec and Daumier prints by hanging them like laundry on a clothesline. She had befriended, and sold, Picasso when he was poor, treating him with scrupulous fairness and declining to be offended when he ditched her for a bigger dealer as soon as possible. She sold Matisse as early as 1902, supported Dufy, helped promote Utrillo, and was now out to put Modigliani on the map.

There was a police station across the street, as Weill well knew

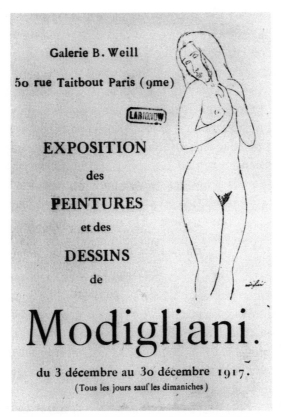

Berthe Weill's provocative poster for Modigliani's
first one-man show at her gallery, 1917. The police
were called. The model for the poster was Jeanne
Hébuterne.

when she put one (or more) nudes in the window. No doubt it was
meant as a publicity stunt. She invited a few carefully chosen people
to a vernissage on Monday, December 3, 1917. Unlike the pattern of
most such events the guests came and stayed. The door was open and
before she knew it passersby joined the throng, there were crowds
looking into the windows, and traffic was stopped in the street.
Shortly thereafter a plainclothes policeman arrived and asked softly
to have the nudes removed from the window. When Weill declined
she was escorted across the road and into the office of the chief con-
stable himself.

Again she was asked to remove the objectionable objects. She vol-

unteered there were lots more inside. The chief constable was visibly alarmed. Either she removed them all or he was going to impound them. It was an offense against public morals. How could that be, she asked, knowing perfectly well but making him say it. "They've got ppppubic hair!" That, for the moment, was that, and Zborowski only sold two drawings at thirty francs each. Weill, evidently realizing she had made a tactical error, bought five paintings so that the artist would not be too discouraged. Modigliani returned temporarily to portraits and when he tackled other nudes the offending areas were covered, as they had been since time immemorial, by lingerie, draperies, or a hand in the right place. His was the dilemma common to every artist, i.e., how to be true to his inner vision and at the same time reconcile himself with what the market wanted to buy, or was ready for at that moment. Walking such a tightrope was something he never mastered, even though he was aware that others were making a success of it. He was poised somewhere in the background, too much of an innovator to capitulate, too short of money not to hope that small concessions would induce someone to buy something. As it happened, public morals capitulated first, and sooner than he could have imagined. Five years later one of his forbidden nudes was sold at the Salle Drouot in Paris for twenty-two thousand francs.

The writer Francis Carco was an early admirer of Modigliani's nude canvases. He went to see them one day at 3 rue Joseph Bara in a dark empty room, canvases stacked up around the walls. Zborowski, illuminating each in turn by candlelight, rhapsodized over his treasures, stroking them, lingering over their details, and heaping scorn and vengeance on those unwilling or unable to see their worth. Just that very morning he had offered a dealer fifteen canvases, free, if he would just hang them in his gallery. The wretched man refused.

When Carco asked to buy one Zborowski shouted with joy. He would give the painting to Carco willingly because he loved it. The writer argued in vain. "He came with me to my house, carrying that magnificent picture and refusing even at the very last minute to accept a very small sum which, not being rich, I tried to force upon him." Zborowski waved the money away. He was about to sell some clothes and expected to raise twenty francs. That would be enough.

Zborowski, Carco wrote, "never doubted Modigliani's genius for one second. To help him live he would have sold his clothes, his

watch, his shoes, slept outdoors in the midst of winter and would have borrowed money from anybody." The day would come when discriminating collectors would begin buying Modiglianis. "Meanwhile they would not listen to Zborowski, they laughed in his face, or else they did not receive him, offended that anyone should try to mock them in that way. Zborowski did not mind. He would leave the painting, come back, and talk, and talk."

Zborowski's refusal to take no for an answer puts one in mind of the great international art dealer Joseph Duveen. He was similarly immune to insults, never lost his sense of humor, and was capable of reducing hard-headed businessmen to such a state that they would buy anything just to get rid of him. Among the collectors Zborowski successfully introduced to Modigliani was Jonas, or Jones, Netter, who represented some of the best-known French manufacturers in an import-export business. Gérard Netter, his son, believed that his father became a sophisticated collector entirely by accident. "One day someone took him to Zborowski's, somewhere in the outskirts of Paris, and when my father saw two Utrillos and a Modigliani hanging in his salon he bought them immediately. It was a 'coup de foudre,'" Gérard Netter said. "He kept going back to Zborowski's and ended up buying the whole School of Paris." Relations between the two men did not always run smoothly. One was inclined to believe this poet and charmer, who had such extraordinary taste, because "he was an extremely attractive, seductive personality who said he was a Polish nobleman (I'm not at all sure he was noble, but he certainly was Polish)." Zborowski turned the full force of his charm on Netter, persuading him to become a financial backer of his enterprise, and kept breaking his contracts, most of which were verbal, at least at first. Gérard Netter recalled one time when Zborowski went to call on his father, and his father, enraged, would not let him in. Then Zborowski said, "Monsieur Netter, I cannot live without you. I love you!" and Jones Netter relented. "That very same day Zborowski began to cheat him again."

Roger Dutilleul is another major figure, a businessman in cement with the soul of an aesthete whose instinct to buy avant-garde artists began in 1907 when, being young, he had barely any money. Eventually he would own so many works that they were plastered all over the walls, stacked up around the rooms, and under the beds—he

lived with his brother, a print collector, and never married. Between 1918 and 1925, thirty-four of Modigliani's paintings and twenty-one of his drawings went through Dutilleul's hands.

In a 1948 interview, Dutilleul said that early in his collecting career he bought a painting by Braque from Berthe Weill for a hundred francs. But most of all, he visited Picasso's agent, Kahnweiler, who had opened a boutique when he was just twenty-one. "Sensitive and intelligent, he and I would have long conversations and he encouraged me in my emerging tastes. He was the one who introduced me to Picasso, Gris and Marcoussis. In effect, I became his disciple." Kahnweiler wrote that Dutilleul was "(t)he quintessential French haut bourgeois, very enlightened, very fastidious, belonging to a vanished era but profoundly sympathetic.

In those days, Dutilleul continued, anyone in Paris with a bit of taste and flair could find bargains. That is how I came to add drawings by Daumier and Corot to my collection, which were an even better buy than contemporary works; just before the war I bought a study by Corot, unsigned, for 175 francs. And I found a very pretty little ceramic piece by Rouault on the quays for thirty francs.

My contacts with Modigliani began in the same way. I had seen one or two of his paintings in the window of Paul Guillaume's and a bit later, visiting the gallery Lepoutre, I was offered one of his canvases for a hundred francs, which I accepted enthusiastically. I bought a great many from Zborowski, right up to the day when, having nothing to sell, he suggested that Modigliani paint my portrait. [In 1918] I accepted with some reservations and Modigliani came to see me. As he stood looking at my canvasses by Picasso and Braque, he was agonized. He said, "I am ten years behind them," and I had a lot of trouble convincing him this was not so.

He finished the painting in three weeks, very glad not to have to go looking for a model. I paid Zborowski five hundred francs. He divided the sum into five parts, three for him and his numerous relations, one for his associate and, finally, one [a hundred francs] for the painter!

Nevertheless one has to recognize that dealers did this gen-

eration of painters an enormous service. I saw my first Chagall
at Berthe Weill's; my Légers at Rosenberg's. Dealers smoothed
our path, helped educate our tastes and also, one forgets how
many financial risks they took, what kind of investment they
had in hundreds of pictures in their storerooms.

I have lived now for many years with this collection from
which I was never parted and which I have succeeded in enrich-
ing a little. The experience has taught me how much painting,
especially at difficult moments of my life, and in the silence of
an empty room, can be an inspiration, an escape.

In the days when Zborowski was trying to support both Modi-
gliani and Soutine he was often reduced to selling whatever he could
lay his hands on, as was attested to by Lunia Czechowska, one of the
few reliable observers of Modigliani's last years. In a lengthy account
written in 1958 she recalled that, when her husband was drafted, she
moved in with Hanka and Zbo on the rue Joseph Bara. She therefore
saw at first hand their daily struggles to make ends meet and took
part herself. Since she almost certainly knew of Modigliani's illness,
Zbo would have known of it himself. This might explain the heroic
efforts the dealer undertook to keep him in funds and under daily
surveillance in his own dining room.

As for Jeanne Hébuterne there is no way of knowing whether she
had guessed, or been told, that Modigliani was consumptive. But
given her ability to keep secrets one can safely assume she would
never have revealed a fact he was at such pains to conceal himself.
She would have deferred to him in any event as her mentor and lover.
Indenbaum, who was interviewed by John Olliver for Pierre Sichel's
biography, said, "Modi was just everything to her: father, brother,
husband, fiancé . . . Modi with his arm around Jeanne's shoulders is a
typical scene: he protected her, she felt 'à l'abri,' sheltered in his arms,
and just looked up at him in a silent and ecstatic worship." Inden-
baum recalled one evening, around two a.m., when Modigliani had
thrown the usual chairs and wineglasses around at a café. "Well, after
such a row he would find himself on the sidewalk, and would go to
a bench and sit down. Jeanne would then come, sit next to him and
Modi would put his arm around her shoulders. And they would stay
sitting like that for hours, without a word."

Indenbaum said that Modigliani never received friends at the rue de la Grande Chaumière. "Not that he refused to do so, but one just didn't go 'chez Modigliani.'" There are no clues to their life together but plenty of insights into the way they lived, thanks to Jeanne. Restellini wrote, "Just as Modigliani's art does not ever reflect a single concrete reality and is situated in a kind of time vacuum, that of Jeanne, on the other hand, reflects their daily reality in quite a feminine way. The life of the couple is seen through her drawings . . . the surroundings in the studio, the objects standing on the table." In one of them a drawing hangs in a frame. It is a young man with strongly marked eyebrows; could it be Dedo? There is a china bowl and pitcher on the washstand, a candelabra against the wall, a pair of gloves thrown on a table which, one notes, is covered by that bourgeois nicety, the tablecloth. Such details point to an instinct to record these humble cherished objects, to frame and capture the kind of emotion Des Grieux describes in his aria, "*Adieu, notre petite table,*" in Massenet's *Manon.* Wherever she looked, Jeanne found subject matter for her quietly observant eye. One of her best paintings, a gouache on cardboard, shows her mother sitting before an open window. Her mother is resplendent in a yellowish-green kimono bordered with bright orange flowers. Her figure, outlined in mauve, reflects a bold background in mauve and violet. Similar adept and unexpected color choices enliven three of her early still lifes and must have been one of the reasons why Modigliani found her interesting: her talent is evident. She also had gifts as a delineator, making unsparing self-portraits and repeated studies of her parents and brother André on his military leaves. Her confident line is reminiscent of Modigliani's, with some Cubistic flourishes of her own; her paintings, never merely pretty, indicate her strength of personality. Her style is one she would have learned at the Académie de la Grande Chaumière, that is to say, that of the Nabis, a late-nineteenth-century group of artists who followed Gauguin's use of heightened colors and drastically simplified forms. How she would have developed from a young woman of promise to an artist of maturity and individuality is one of the great unanswered questions.

However, in recent years Jeanne Hébuterne's work has sold for handsome sums. In May 2009 two of her drawings: a self portrait, and one of Modigliani sporting a pipe, each sold at Christie's in

Paris for more than $17,000. Another drawing, this one of Jeanne by Modigliani, now in the possession of the Hébuterne Archive, sold at the same sale for $132,296. The previous December, Hébuterne's painting of Chaim Soutine also sold at Christie's in Paris for the surprising sum of $92,367. In the space of six months, December 2008 to May 2009, Hébuterne's archives realized a gross of $258,759.

In March 1918 the war again intruded on Modigliani's world with sudden and dramatic force. The Germans had invented an enormous cannon, called "Big Bertha," capable of sending missiles the (then preposterous) distance of 121 kilometers, or seventy-five miles. Restellini writes that two of these monstrous machines were trained on the center of Paris, specifically the Palais de Justice on the Île de la Cité. There is no proof that Big Bertha's aim was ever that accurate, but no doubt that shells reached Paris. On March 23 the first round was fired at seven a.m. and fell on the Place de la République, which was central enough. Fifteen minutes later another immense shell hit the rue Charles V, then a third outside the Gare de l'Est. Another shell would hit the church of Saint-Gervais in the Marais (fourth arrondissement); the roof fell in and at least fifty people died. Before the war's end more than 250 Parisians had been killed and another six hundred injured. A new and frightening phase had begun.

The shelling was the prelude to a German offensive. A peace treaty had been signed with Russia and troops released from the eastern front were massing against the French lines; it was a repeat of the 1914 invasion scare. There was a third, grave danger on the horizon in the form of a particularly virulent and devastating form of influenza. Misnamed the Spanish flu, it began in the U.S. in an Army camp in Kansas that same month, March 1918. American troops brought it to Europe, and by the autumn of 1918 it had mutated into a lethal form, rivaling the Black Death in its pestilential advance. In the Paris region alone it would kill thirty thousand people; worldwide, eventually thirty million died.

Although the really severe period of the epidemic was yet to come, the immediate danger was bad enough. Zborowski was determined to get Modigliani out of Paris. Restellini writes that Jones Netter provided the funds to take Zborowski, Hanka, Modigliani, and a group

of friends that included Soutine and Foujita, to safety, that is to say, Nice and Cannes.

Throughout the nineteenth century the worst thing an unmarried girl from a respectable family could do was to get pregnant. "Illegitimacy was scandalous," Michelle Perrot wrote, "for it was the visible sign of an offense against virginity . . . hence a threat to the social order. The guilty woman and those closest to her thought of nothing but hiding the offense . . . Mothers often abetted their daughters in infanticide. Frequently a neighbor or even a household member would denounce the crime. Sometimes a persistent rumor was enough to attract the attention of mayor and gendarmes." So when Eudoxie learned of Jeanne's pregnancy her shock and horror may be taken as read. One can imagine her immediate response: the couple must marry immediately.

On the other hand, was a penniless Italian artist sixteen years Jeanne's senior quite the right person? She and her husband could hardly object to his being an artist, since their own son was on his way to becoming one, assuming that he survived the war. But they surely would have wanted someone more suitable in age and background, and, if possible, well off. This was the moment when nine couples out of ten who are madly in love would have married anyway. Curiously, they did not. Was Modigliani, who told Lejeune that he was not cut out for that kind of role, full of inner doubt? Was Jeanne's mother convinced that her husband would never accept him as a son-in-law? What role, if any, did his Jewishness play, given that this was a devout Catholic family? Did Eudoxie find out about his illness? If so, was that another secret she kept from her husband?

A photograph of Eudoxie, date unknown, gives the best insight into the feelings she must have been experiencing during this period. Her expression is set into one of chronic anxiety and dread, the kind seen on the face of a woman who is driven out of her mind by the behavior of her children. Coupled with this is her certain knowledge that she will be blamed and judged by her husband, not to mention her son. There was the prospect of telling Achille the awful news. At that point, the arrival of Big Bertha and the threatened German advance began to look like the best possible pretext to mother and

daughter. They would not tell anybody. They would just leave; everyone else was leaving, after all. She would have the baby, give it up for adoption, and no one need be any the wiser. If that is what they thought. A month later, by April 23, 1918, they were in the south of France. They were gone for a year.

As for Modigliani the last few years had taken a toll, physically and emotionally. Zadkine, who was discharged from military service in December 1917, around the time of the Berthe Weill show, met Modigliani soon after his return to Paris. "He was thin and emaciated and could no longer take much alcohol—one glass was enough to make him drunk. But he continued to sit with friends at the table and draw. Occasionally he sang in a hoarse voice; he could hardly get his breath." For years he had been having difficulty with his teeth, something Paul Alexandre had known about years before, one of the many debilitating consequences of tuberculosis; eventually he would lose them all. But now his energy was leaving him and Zborowski was deeply concerned. A photograph taken in Nice that summer of 1918 shows a rapidly aging man with a receding hairline and deep shadows under his eyes.

John Olliver conducted a long and penetrating interview with Léopold Survage—who was already in Nice when Modigliani arrived—noting that the latter served as consultant, drinking companion, and wiser friend. They worked together every day in Survage's small, two-room apartment, Survage in one room and Modigliani in the other. Modigliani was often invited to dinner. According to Germaine Survage, who sat for her portrait, one of their rooms was "literally wallpapered with Modigliani's pictures that Zborowski had lent us, hoping we could help sell them." Her brother-in-law managed to sell one for fifty francs. They bought another which, some years later, they sold for twelve thousand francs.

In the summer of 1918 Modigliani had a bad case of the flu—whether or not it was the Spanish variety is not clear—and was not painting much, according to Survage. Although committed to four paintings a month he was seldom able to manage more than three. He would paint a canvas during a two- or three-hour stretch, after which his energies would be exhausted. As Marc Restellini notes, some of them have the appearance of being turned out by rote but there are several examples of his best work; one, Léopold Zborowski in

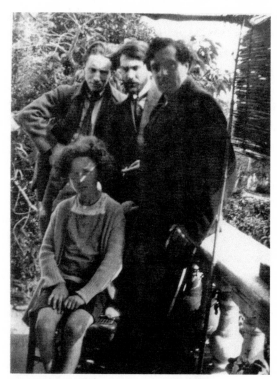

Modigliani in Cannes in 1918, with Zborowski
behind him, and his host, Osterlind, in the
background. Osterlind's sister is seated.

Cannes that was bought by Dutilleul, a portrait of a Zouave and sev-
eral portraits of Jeanne Hébuterne, with her direct gaze and mass of
reddish-brown hair.

Survage stated that Modigliani always brought a bottle of marc
with him, a kind of brandy made from the residue of olives, grapes,
or apples. After awhile, he would begin reaching for the bottle. "He
worked with spirit, in fact even with rage, spending a lot of physi-
cal energy. And so at the end he was usually quite tight." Olliver
added, "Survage told him he should paint landscapes and in fact he
did two landscapes . . . The point of this was that, in Nice, it was dif-
ficult to find models. But Modi was not interested; he saw nothing in
landscapes."

Zborowski, who returned to Paris after a short stay to try to sell
some more paintings, sent him a monthly stipend of about six hundred
francs, considered a handsome sum. But as soon as the money arrived

Modigliani and Soutine would go off to the avenue de la Gare in Nice and start drinking. "And when he drank it took him like a madness: he used to throw his money to the soldiers, and there were always soldiers on leave in the cafés. After a few days of this, he was broke."

On one famous occasion Modigliani wrote to Zborowski with the news that his wallet had been stolen and he had lost his month's allowance. Somebody's wallet had been stolen, but it was not his. He and Survage were walking along the avenue de la Gare one day when they fell into conversation with a group of soldiers, including some Arabs. The next thing they knew, a wallet was gone—belonging to Survage. Survage was always puzzled about that.

On another occasion Guillaume arrived in Nice. He had brought a collection of engravings which he intended to present to Renoir in the hope the great man would take him on as a dealer. In that he was not successful, but he did go for a walk along the Promenade des Anglais and he and Modigliani, along with a woman friend, were photographed by one of the commercial photographers who could always be found there. When they met again the next day Guillaume asked Modigliani to reimburse him for the pictures, which infuriated the artist. Survage commented that this penny-pinching side of Guillaume's was one of the reasons why "they did not get on very well."

Modigliani, at right, on the Promenade des Anglais in Nice, accompanied by Paul Guillaume and, possibly, the wife of the sculptor Alexander Archipenko

Survage was always concerned about Modigliani's drinking and, in an effort to stop him, told him he was an alcoholic. Modigliani reacted with indignation, but for three days he drank nothing. On the fourth, he rolled in, completely drunk. Survage, trying to get him to see reason, persuaded him to make the arduous walk to Ville- franche, a village along the coast, which Modigliani did. They had a delicious dinner and drank a moderate amount of wine. Whether the lesson had the intended effect is not recorded.

Modigliani, Jeanne, and Eudoxie first took an apartment together on the rue Masséna. The author of *Le Silence éternel,* the compan- ion volume for the exhibition "Le Couple Tragique," believes that Modigliani and his future mother-in-law began on the best of terms. A drawing, by Modigliani and Hébuterne, along with a watercolor by her, takes the theme of lovers in a garden, and at lunch, watched over by her mother. This idyllic scene did not last long, if we are to believe Jeanne Modigliani, who was scrupulous in such matters. She writes that Amedeo then moved into the first in a series of hotels, the Tarelli, on the rue de France. According to Survage, he was not there long, but kept moving, using his time-honored, fail-safe method of avoiding a bill by making so much noise that he was evicted. Modi- gliani moved because, according to Jeanne Modigliani, "relations between [him] and [Eudoxie] became more and more strained." It seems likely, even inevitable, that, given all that had happened and all the secrets she had been forced to hide, Eudoxie would have expressed anger and frustration at what she would have considered a major family crisis. In any event Survage claimed that not only did he himself see little of Jeanne, but that at one time Modigliani also saw her rarely. "He took a coffee with her and then put her on the tram so she could go back to her mother. He never saw the mother." The explanation for that was simple, according to Survage. For Modi- gliani everything was secondary to his art, even Hébuterne. "He had no other attachment."

The military threat to Paris was slowly receding. The Germans won two battles in April against the British and the French, which were followed by a French counterattack in July, and in August the Brit- ish broke through the German lines. Paris must have looked safer

and safer but Jeanne and her mother stayed on in the south. André, just twenty when the war started, joined the infantry, was wounded, was decorated twice, and kept a war diary. From it Marc Restellini was able to chart his leaves home. On one of those visits, in October 1917, when Jeanne was already secretly living with Modigliani, André makes no mention of the fact, a sign that he was as unaware of the true nature of affairs as his parents. However, when his next leave came, in the summer of 1918, he went directly to Nice, but Jeanne was nowhere to be found, which naturally upset him very much. As for the coming birth, that, too, was a closely guarded secret.

René Gimpel, whose *Diary of an Art Dealer* begins in 1918, was out on the Paris streets the day of the Armistice, November 11. "The crowd had doubled; incredibly, the joy had multiplied a hundred-fold," he wrote a day later. "Women were going wild but keeping their heads. I did not see a single drunk. Kissing, much kissing, but only a birds-of-passage sort of thing. The American soldiers are the most feted." Baby Jeanne, Jeanne Hébuterne and Amedeo Modigliani's firstborn, was on the point of entering the world. Yet little about the circumstances surrounding her arrival is clear. Lunia Czechowska states that Modigliani returned to Paris in the summer before she was born, which would suggest that he was not in Nice for the birth. But from other details it is clear that the usually reliable guide is off by a year. *Artist Quarter,* misleading in this as in much else, claims that Eudoxie, in a fit of final exasperation at Jeanne and her fiancé, slammed the door on both and took up residence alone in the "California" area of Nice. Whereas Jeanne Modigliani has established that her father was long gone. Furthermore the address given for Jeanne Hébuterne on her baby's birth certificate is 155 avenue de la Californie; obviously, she and her mother were living there together.

Artist Quarter also tells a story, repeated by Sichel, that on the night little Jeanne was born her father, ecstatic, rushed out of the hospital on his way to the Mairie. But somehow he had to have a drink first and never got there. When he thought of it again, it was too late, and the next day he forgot.

It makes a good story, one more nail in the coffin of this feckless drunk who cannot even manage to register his own daughter's birth. The truth is otherwise. Contrary to published statements a birth

certificate does exist. It was issued three days later, on December 2, 1918, in the presence of the baby herself. She was taken to the town hall by a nurse, Rose Villars, who provided the necessary information. This same document was carefully annotated for decades and charts the future legal and marital status of the little girl who, for the moment, was simply "Jeanne," the daughter of Jeanne Hébuterne.

So much speculation and outright invention has grown up around the Hébuterne story that even today, details are sparse, and if further amplification does exist it is closely guarded. What is known is that André went to Nice as soon as he could, arriving on December 16, 1918. Only then did he discover that his unmarried sister had given birth two weeks before. "He saw that as proof"—of her disloyalty?— "and did not hide his anger," Restellini wrote. One can imagine what this confrontation with her brother did to Jeanne's state of mind. What was said: That she had brought shame and dishonor on her family? That she had committed a crime? How could she choose between her brother and her lover? As for her mother, the collapse of her plan to avoid having her husband find out must have been a crushing blow. What seemed to have upset André particularly was that he was the one who had to write to tell his father about the birth. The lengths both women went to in order to avoid a confrontation speaks volumes about their fear of what would happen if the truth were known. After the men found out anyway the uproar went on for months. A trust had been broken that never would be restored. Restellini reported, based on André's diary, that relations between brother and sister continued to deteriorate, reaching their nadir during four days at the end of April 1919. Was he physically violent? Was Jeanne told, as rumor has claimed, that her family wanted nothing more to do with her? Luc Prunet said that for the rest of his life his grandfather "would close up like an oyster" whenever the subject of Jeanne was mentioned. Perhaps he felt that too much had been said already. "But he also told me, 'If I had been there at the time this never would have happened.'"

———◆———

"Life Is a Gift"

Quelle est cette île triste et noire? — C'est Cythère
— Charles Baudelaire, "Un Voyage à Cythère"

THE PERSON who did welcome the arrival of baby Jeanne was her father. Lunia Czechowska recalled, "Modigliani was absolutely thrilled. He adored this baby and nothing else in the world existed for him except her. He never stopped talking about her beauty and charm. He did not exaggerate; I've never seen such a pretty baby, blonde, plump, ravishing eyes a nutty brown, long curly eyelashes and a delicious little mouth." Writing back to his mother, to whom he had sent the news of Jeanne's birth, he said, "The baby is well and so am I. You have always been so much of a mother that I am not surprised at your feeling like a grandmother, even outside the bonds of matrimony." It was not so long ago that unwanted babies, especially illegitimate ones, were bundled off to wet nurses in obscure villages who could be depended upon to starve them until they died. Modigliani must have been well aware of this common practice because he went to very great trouble, according to Czechowska, to find a genuinely loving substitute for Jeanne's mother.

This was necessary because when she was three weeks old her mother claimed she could do nothing with her and neither, she said, could her mother. She was inexperienced, the birth had been tiring, and someone subjected to such a drumbeat of disapproval could be forgiven if she was not particularly delighted by the new arrival. She was "not much of a mother," Jeanne told Aniouta. With a half smile she rated herself as a zero, indicating the score with her fingers. On the other hand, "As a husband Modigliani was very good," her mother said. André began referring to his sister as their "lost ewe" and wrote a note in his diary about how his dear little mother had kept all of her sorrow and resentment bottled up for so long. How sad it all was.

Modigliani, by contrast, was full of new energy. At the end of May, leaving Jeanne still in Nice, he returned to Paris. According to Lunia Czechowska, he was looking better, had stopped drinking, and was being careful about his health, because he had a daughter to live for. He was living a normal life. She wrote, "I have kept a lovely souvenir of our long conversations while I was posing for my portraits." (He painted her repeatedly.) "He talked about anything and everything, his mother, Livorno and above all his darling baby. He had this simple and touching dream, to go back to Italy, live near his mother and get his health back. He would not be completely happy until he had a proper apartment with a real dining room, and his daughter beside him, in short, living like anyone else. His exuberant imagination spun endless dreams."

Meanwhile he was working at top speed. Modigliani painted as many portraits of Hanka, Zborowski's companion, servants, adolescent boys, mothers with babies, and, in particular, small girls. There is an unusually large, almost lifesize painting of an eight- or nine-year-old that perfectly expresses his enchanting ability to paint adorable subjects without ever descending into sentimentality. She just stands there, looking at the viewer, her hands clasped, wearing a long blue dress, a ribbon in her hair, and an appealing expression. Could he have been thinking of the little girl Jeanne would one day become? Canvas after canvas was finished with lightning speed because, that summer, something stupendous was about to happen. He was going to show nine paintings and fifty drawings in London.

. . .

Paris in 1919 was "sad and beautiful," Margaret MacMillan wrote in *Paris 1919*. "Signs of the war that had just ended were everywhere: the refugees from the devastated regions in the north; the captured German cannon in the Place de la Concorde and the Champs-Elysées; the piles of rubble and boarded-up windows where German bombs had fallen . . . The great windows in the cathedral of Notre-Dame were missing their stained glass, which had been stored for safety; in their place, pale yellow panes washed the interior with a tepid light. There were severe shortages of coal, milk and bread."

On the other hand the weather was perfection. Encouraged by a heavy rainfall the grass was lush and spring flowering bulbs were at their peak. "Along the quais the crowds gathered to watch the rising waters, while buskers sang of France's great victory over Germany and of the new world that was coming." After a year in the south of France Jeanne was at last ready to return. A close dating reveals that Modigliani returned to Paris on May 31. Three weeks later, on June 24, Jeanne sent him a telegram, care of Zborowski, asking for her train fare home. That apparently came quickly because she returned a week later, accompanied by her mother. Curiously, André's diary does not record that the family was back together again until July 13. It was a Sunday, at seven in the morning. "The father seemed thrilled to recover his family," Restellini wrote. "André described an apartment in total chaos." There was no mention of a baby in the family gathering and none either of what Jeanne must have known by then, that she was expecting another child. However, the discovery must have precipitated a curious note that Modigliani signed on July 7, promising to marry "Mlle Jane Hebuterne" (sic), "as soon as the documents arrive." (This was, presumably, a reference to legal papers from Italy.) Marevna, who saw him shortly after he returned, thought he had gained weight. He seemed in good spirits and was joking about becoming a father for the second time. "It's unbelievable. It's sickening!"

During the month before Jeanne and the baby returned, Modigliani would take Lunia for long walks in the Luxembourg Gardens—it was very hot that summer. Sometimes they went to the cinema and ended up dining at Rosalie's. He was always talking about returning to Italy and the little girl he would never see grow up. He was also talking about London. The great international world of art and artists was coming back to life. In particular, the most important exhi-

The English artist-critic Roger Fry, c. 1925

bition of French art in London in almost a decade was taking place that summer. The location was, curiously enough, in a department store, Heal's, that had opened an art gallery two years before. Since the gallery was just underneath its mansard roof it was named the Mansard Gallery. Some thirty-nine artists—Dufy, Kisling, Léger, Matisse, Picasso, and many others—were represented. Modigliani, with fifty-nine works, had the most in the show. He was becoming as well known in London as in Paris; examples of his sculpture, shown at the Whitechapel Gallery five years before, had been singled out for special mention in avant-garde circles. It is also clear that British critics saw his worth long before the Paris critics did. (One wonders: was it because, being less corrupt, they did not have to be paid?) The first real discussion of Modigliani's art was not published in Paris but in London by the discerning artist and critic Roger Fry. Furthermore the catalog for the Mansard Gallery was written by the well-known writer Arnold Bennett, who remarked, "I am determined to say that the four figure subjects of Modigliani seem to me to have a suspicious resemblance to masterpieces." Other glowing comments followed. The *Observer* wrote, "Modigliani stands in front . . . and shows a

strong alliance with the early Florentine painters." The *Burlington Magazine* recorded, "Modigliani's uncommon feeling for character finds expression through an extreme simplification of colour and contour and the most astonishing distortions."

The critics in London were not alone in appreciating Modigliani. Osbert Sitwell wrote that he and his brother, Sacheverell, had organized the Mansard Gallery show in collaboration with Zborowski. Sitwell wrote, "With flat, Slavonic features, brown almond-shaped eyes, and a beard which might have been shaped out of beaver's fur, ostensibly he was a kind, soft businessman, and a poet as well. He had an air of melancholy, to which the fact that he spoke no English, and could not find his way about London . . . added." Sitwell continued, "Rather than the great established names, and famous masters, it was the newcomers, such artists as Modigliani and Utrillo, who made the sensation in this show." As a reward for their services Zborowski offered them a single picture from the show at a wholesale price. The Sitwells chose Modigliani's "superb" *Peasant Girl*, which they bought for the very great bargain of four pounds. The average gallery price for one of his paintings at the time was between thirty and a hundred pounds.

It was Modigliani's moment of triumph. Suddenly everybody who was anybody wanted a Modigliani. Bennett bought a nude and a portrait of Czechowska. Years later all kinds of collectors would claim to have been the first to appreciate his work. One of them was Hugh Blaker, a painter, writer, art critic, and collector who records in his diary that Zborowski appeared in London in 1919 (apparently before the show) carrying several oils stripped of their stretchers and frames to avoid freight charges. He unrolled them on the floor and Blaker immediately bought four; one, *Le Petit Paysan*, is now in the Tate Gallery collection. "So far as I know I was the only man in London to care a tuppeny damn about 'em." Another pair of eyes spotted *Le Petit Paysan* and appreciated it before Blaker did. He was the young Kenneth Clark, future British art historian, author, television personality, and museum official. Clark, then aged sixteen, had been given the handsome present of one hundred pounds and told to buy a picture. This painting of a young peasant boy caught his interest. "It seemed ridiculous to buy the first picture I saw, but after a long search I could find nothing I liked so well, so I timidly asked the

price. It was sixty pounds and the painter's name was Modigliani."
But when he got back to his parents' elegant flat in Berkeley Square
he realized that the choice was never going to fit among all their gilt-
framed Barbizon paintings. As he recorded, Blaker bought it instead
and eventually sold it to the Tate. In the end everyone was better off,
except, of course, the young collector.

That August of 1919 Modigliani should have been in London but
had contracted another bout of influenza and was too ill to travel.
The Sitwells were then given a firsthand demonstration of the cut-
throat world of the Paris art market. "I recall how, during the period
of the exhibition, when Modigliani, recovering from a serious cri-
sis of his disease, suffered a grave relapse, a telegramme came for
Zborowski," Osbert Sitwell wrote. Zborowski then came to the Sit-
wells with a message that all sales should be put on hold. In this case,
he was doing the bidding of Paul Guillaume, who owned most of
the works in the show and knew the prices would double and triple
if and when Modigliani died. It seemed callous in the extreme, but as
Guillaume's biographer, Colette Giraudon, pointed out, it was a kind
of compliment; the market had now decided that whether Modi-
gliani lived or died was a matter of some importance. In any event,
as Sitwell drily concluded, "Modigliani did not immediately comply
with the program drawn up for him."

Time and again Modigliani had cheated death, but this time the
odds were hopelessly stacked against him. Few people know that
tuberculosis, a bacillus that primarily attacks the lungs, can migrate
anywhere in the body and can infect the spine, lymph nodes, geni-
tourinary tract, gastrointestinal, or peritoneum, and so on. In Modi-
gliani's case the bacillus went to the brain. Tubercular (or tubercu-
lous) meningitis, the cause of death cited on his death certificate, is
an infection of the meninges, the membrane covering the brain and
spinal cord, and was, in the early twentieth century, the most wide-
spread form of meningitis. Nowadays it can be rapidly cured with
antibiotics, but if left untreated it leads to blindness and death. In
adults it is an outgrowth of pulmonary tuberculosis, exacerbated
by malnutrition, excessive alcohol and drug use, or other disorders
that compromise the immune system. The British Medical Research
Council has identified three stages in the development of the disease,
going from headaches, general apathy, irritability, fever, and loss of
appetite to delirium and coma.

So it is easy to see how Modigliani could have attributed his declining health, that autumn and winter of 1919, to a slower-than-usual recovery from the attack that laid him low in August. Before X-rays came into common use Paul Alexandre would have known the only way to suspect tubercular meningitis was atypical behavior. He would have been aware that this terrible infection, attacking the brain itself, killing cells, caused swelling, pressure, massive lesions, and all kinds of bizarre changes in personality. But Dr. Alexandre, returning from the hell of war, had his own family problems to deal with, Modigliani's trail of addresses would have confounded anybody, and getting in touch was not a pressing issue for him at that particular moment.

Modigliani had a devoted companion, but a young and inexperienced one. If anyone had urged him to see a doctor his response would have been predictable. Whatever Modigliani knew or sensed about his illness would have been drowned in a bottle of rum—anything rather than face the terrible ministrations of the medical profession. Yet he somehow knew. Among his final words was a kind of apology: "You know, I only have a little bit of brain left." One suspects that most of the out-of-control behavior described, but not dated or documented in such biographies as *Artist Quarter,* is actually attributable to the last months of his life.

Some thirty-five years later, in 1956, Moïse Kisling, now in retirement at Sanary-sur-Mer in the Midi, struck up a friendship with his doctor, also a psychologist, who became a close friend. Eventually he spent many hours with the doctor, Tony Kunstlich, describing Modigliani's symptoms and behavior and asking for a diagnosis.

"To judge from the meagre evidence available, I am led to believe that it was an attack of cerebral meningitis of a tubercular nature," Dr. Kunstlich wrote.

> We know that the deplorable conditions in which the painter lived in Paris, and the combination of his unwholesome lodgings, his irregular meals, his turbulent sexual life, and his addiction to alcohol and drugs, quickly destroyed the delicate balance of health which had been maintained so long as he remained with his family.
>
> We know that tubercular meningitis in adults is very different from the kind which spreads rapidly throughout the bodies

of younger victims. Once it takes hold in an adult, it develops gradually over a period of months or even years without giving rise to any outstanding symptoms. Sometimes the only signs of tubercular encephalic disorder are headaches, visual and auditory disturbances, and, in particular, modification in the patient's character, as evidenced by extreme irritability, violent outbursts of anger, unsociability, withdrawal into the self, and so on.

It is only in the final phase that the classic symptoms of meningitis supervene in the form of paralysis, rigidity, comatose states.

In the first flush of the success of his London show Modigliani did something uncharacteristic: he asked for a present. Would Zbo bring him back a pair of shoes from London? Zborowski would. He also included a magnificent English wool scarf. The flurry of attention and the sales were heartening but the praise meant most. Indenbaum recalled that sometime after the show, meeting Modigliani at the Rotonde, the latter brought out a Jewish newspaper published in Britain for him to read. "It was an article full of praise for Modi. 'C'est magnifique,' he said . . . and was so moved that he kissed the paper before putting it back in his pocket. It just shows how terribly he needed, and looked for some praise, some comprehension." Modigliani was working as hard as ever, this time for the exhibition of the Salon d'Automne at the Grand Palais that was opening for a month's stay on November 1, 1919, where he showed four paintings. But his energy was flagging—no doubt the early stages of tubercular meningitis were making themselves felt—he had started drinking again to quiet his nerves, and alcohol is known to help reduce pressure on the brain. That he was suffering from headaches is likely. He had always been restless and this nervous trait seemed to have increased. Lipchitz had repeatedly tried to draw him but Modigliani "fidgeted, smoked," and moved around so much—in short, he never succeeded. Vlaminck, one of Modigliani's admirers and a close observer, noticed that during the last year of his life the artist was "continually in a state of febrile agitation. The least vexation would make him wildly excited."

Vlaminck recalled that Modigliani was sketching at the Rotonde one day when an American woman visitor agreed to have her portrait made. The sketch completed, Modigliani graciously offered it to her, without signing it. She liked it very much. She wanted a signature.

"Infuriated by her greed, which he sensed immediately, he took the drawing and scrawled a signature across the whole sheet in enormous letters." Marie Vassilieff happened to meet him on the street not long before he died and said, "I couldn't believe the change in him. He had lost his teeth; his hair was flat, straight; he had lost all beauty. 'I'm for it, Marie,' he said."

Still, he worked on. After painting everyone in sight in the Zborowski household Modigliani turned his attention to one of its new arrivals. She was Paulette Jourdain, just fourteen, working as a live-in maid in that chaotic world of works in progress, constant arrivals and departures, bargaining, and the ever-present smell of turpentine. She was slim and pretty, scared but shrewd. She stayed on as a model, became Zborowski's lover, and in due course gave birth. Hanka, who was childless, and the art dealer, ever resourceful, adopted the baby and raised it as their own. Eventually Paulette Jourdain became an art dealer herself and was constantly being interviewed in the years to come for her reminiscences about Montparnasse.

The interviewer Enzo Maiolino, who visited her in 1969, was amazed to find her apartment full of Modigliani memorabilia: books, photographs, one of his palettes, and a rare copy of his death mask. She was like that, quiet and careful, not missing much.

Paulette Jourdain seems to have realized, young as she was, when she agreed to sit for her portrait, that she was in the presence of a remarkable man. She was nervous but by now Modigliani was a master at putting people at their ease. She was to sit however she liked as long as she was quite comfortable, so she sat easily, her hands in her lap. He talked freely and fluently while he worked and whatever she said seemed to make him laugh. He would say that someday they would all go to Rome. She would want to know where they were going to find the money. He would concede she had a point, and look thoughtful. He never got angry and was polite and attentive; she concluded that he was a refined, likable man.

Sometimes he talked to himself in Italian, or recited Dante, or sang

The young Paulette Jourdain, who joined Zborowski's household when she was fourteen and ended up inheriting his art gallery business

the toast from *La Traviata*, "*Libiamo, libiam nei lieti calici...*" His voice, she recalled, "was rather light, almost feminine and yet more modulated," so distinctive that if she heard it anywhere she would immediately know who it was. His brother, Giuseppe Emanuele, so much Modigliani's opposite in build and appearance, had the same voice. Sometimes she went on an errand. There was a "*bougnat*," or charcoal seller, across the street on the rue de la Grande Chaumière. She would be sent there with an empty flat-shaped bottle, the *bougnat* would fill it with measures of rum, and when she got back to the top of the stairs Modigliani would be waiting with a glass in his hand.

"But in the studio Modigliani was never drunk, and he was never drunk in Zborowski's house. But he didn't know that I happened to see him drunk all the same. Then I would hide or change streets. And the next day, referring to his 'weaving around' from one side of the street, I had the impudence to say to him:

"'Yesterday it seems the street was not wide enough.' He knew what I was talking about but was not offended."

Zborowski also sent her on errands, either to Modigliani's studio or the Rotonde whenever he had some money for Modigliani. If to the Rotonde, as soon as other painters in his stable saw her coming they would pounce. "Is the money for me?... Is it for me?," and she would point to Modigliani and reply, "It's for the little one." The proprietor of the café, M. Libion, would chalk up each artist's running account on a slate and as the money changed hands the call would go up, "Modigliani, are you going to settle your slate?," a pertinent question the answer to which is not recorded.

If she was taking the money to Modigliani's studio she often found him in bed. Sometimes he would break a date for a session, saying

The young Swedish girl Thora Klincköwstrom, whom
Modigliani painted, 1919

that he felt too tired. He never once said he was ill. She believed him;
it was December 1919, a month before he died.

Thora Klincköwstrom, a young Swedish girl who arrived in Paris
that autumn to study sculpture, was another of Modigliani's last
models. She was introduced to the painter by her future husband,
Nils Dardel, at the Rotonde. Nils told her, "He is a genius. When I
was here four years ago he was one of my friends and you couldn't
find a more beautiful young man than he. Now he is no longer
young and in addition completely drunk." Before long Modigliani
joined them at their table. Thora described him as "rather small,
weather-beaten, with black tousled hair and the most beautiful hot,
dark eyes. He came in his black velvet suit with his red silk scarf

Modigliani's portrait of Thora, 1919

carelessly knotted around his neck." He was talking loudly and laughing a lot. For once he had not come prepared, so the waiter found him some pieces of squared paper and he drew her portrait there and then. On one of the sketches he added his favorite maxim:

> *La vita è un dono,*
> *dei pochi ai molti,*
> *di coloro che sanno e che hanno*
> *a coloro che non sanno e che non hanno.*
>
> *(Life is a gift, from the few to the many,*
> *from those who know and have*
> *to those who do not know and do not have.)*

He graciously offered her the drawings, but she hesitated to take them. Her lack of French or Italian was a major barrier, but she was a bit afraid of him as well and thought he had made her look ugly. Still, when he wrote his address on the inside cover of a box of Gitanes cigarettes and invited her to pose for him, she agreed.

With her friend Annie Bjarne acting as chaperone they climbed the steep staircase to his top-floor flat at 8 rue de la Grande Chaumière and found two large, bare rooms and huge windows. "It was very cold that winter and the fumes from the one stove had completely blackened the wall behind it. No curtains, just one large table with his painting materials on it along with a glass and a bottle of rum, two chairs and an easel." She was shocked to find the floor littered with coal, charcoal, and matches. But when she offered to give it a quick sweeping he seemed quite offended and said he liked it that way.

While Annie Bjarne sat in a corner Modigliani was constantly on the move, looking at his work from a distance, eyes half closed, or inspecting its surface minutely. He would back up, stare at Thora, then begin whistling and hissing, singing snatches of songs in Italian and, every once in awhile, look at her young friend ruminatively and in fact he ended up painting her as well. From time to time he stopped to drink the rum, "and he really did cough a lot." While she was posing Jeanne Hébuterne made a discreet appearance. She seemed self-effacing "and I could not discern what fire and passion might be concealed behind her air of very great reserve." Her girlish plaits made her seem very young; she looked tired and not particularly happy to find visitors. Modigliani explained that Jeanne was expecting their second child and that their baby was staying with a nurse in the countryside outside Orléans. Then Thora noticed that there was a photograph of him pinned to the wall near the easel, that had been taken a few years before. She asked if she could have it. He said that unfortunately it was the only one left and the negative had been destroyed. "If you won't give it to me I'll just help myself," she insisted. So he did.

Not surprisingly she did not like the painting any more than she had the drawings but was too polite to tell him. So she did not buy it and lost track of its whereabouts until it went on sale in Stockholm in the 1970s. But she never forgot Modigliani.

. . .

Modigliani was also working on his final series of nudes at his studio in the Zborowski apartment on the rue Joseph Bara. He worked there for practical reasons having to do with keeping his models comfortable—an impossibility at the rue de la Grande Chaumière, where it was always either too hot or too cold. So his last great series of nudes was painted in the relative comfort of the Zborowski dining room. Since the days when he had painted Jean Alexandre's *Amazon*, he had been alert to the sensibilities of his female sitters, especially those in need of a change of costume, or nude, who would expect to dress and undress with a minimum of privacy. Anyone else intruding on the scene was not wanted, and Zborowski could not resist popping in and out to see how things were going. At any point Modigliani would have found the interruption irritating; at this stage in the progress of his disease it was intolerable.

As Lunia Czechowska records, one day his dealer arrived unannounced for the umpteenth time just as Modigliani was finishing another nude portrait. She was "a ravishing blond [the painting, a rose nude, was bought by Carco] and Zborowski, who could not contain himself, opened the door." Modigliani exploded. Zborowski went for a walk with Hanka in a hurry. "But a moment later I heard the patter of bare feet and discovered the poor girl, in a panic, running through the house clutching her clothes looking for somewhere to get dressed. I went into the dining room and found Modigliani attacking his canvas with furious slashes of the brush. I had a lot of trouble convincing him that Zbo came in by accident and to please not destroy this work of art."

Modigliani characteristically washed himself from head to foot, using a basin, whenever he finished a painting. That same afternoon, the painting repaired, he disappeared. Suddenly Czechowska heard the sound of falling water and then, breaking china. Modigliani had balanced his washbasin on the edge of an open window. It fell into the street below, and the concierge was beside herself. As for Modigliani, he sat himself down precariously on the edge of the window and began singing at the top of his voice. Czechowska had visions of seeing him crashing into the street as well. It was then early evening. She lit a candle and invited him to stay for dinner, an invitation that was sure to be accepted, and he gradually calmed down. While she was in the kitchen preparing the meal he asked her to look up for a moment. By the light of a candle he drew an admirable por-

trait, embellishing it with his favorite aphorism of these final months, "Life is a gift . . ."

Czechowska wrote, "I remember another story about Modigliani's adventures with water. Kisling had a bathtub [a luxury in those days] which he invited Modigliani to use whenever he liked." One day, taking advantage of their absence, Modigliani went upstairs for his usual bath; Czechowska could hear him singing. What she did not hear was water overflowing; Renée Kisling returned to find her apartment completely flooded. Modigliani had forgotten to turn off the taps. The next thing she knew, a nude Modigliani was out on the landing clutching his clothes and Renée Kisling was hurling curses and threatening eternal damnation. They all had a good laugh about it later. "Renée did not hold a grudge, Modigliani went on using their bathtub and the whole story ended up being the subject of some good-natured teasing."

Once Jeanne and Dedo were back in Paris, and until they found a satisfactory replacement for their nurse, baby Jeanne stayed with Lunia. It seems odd that the notion that Jeanne might care for her own infant was dismissed by everyone, herself included. Lunia did not know how to handle a baby either but was willing to try. So this was one more reason for Modigliani to haunt the rue Joseph Bara, although Lunia was at pains not to let him in at night. One evening they heard a familiar voice singing at top volume as he came up the rue Notre-Dame-des-Champs and knew there was trouble ahead. It was late. He was with Utrillo and they both wanted to come in but the concierge would not let them and told them to go home. Lunia heard the whole exchange, but did not dare to intervene because she knew the Zborowskis would be angry. So she, like they, pretended to be asleep. The next thing she knew, Modigliani and Utrillo were sitting on the sidewalk opposite and Modigliani was calling her name, begging for news of the baby. Again, she did not respond. He was there for several hours and she listened, in anguish to think how unhappy he must be. Finally the two of them left. "If I had been alone I would certainly have let him come in." That happened occasionally. He would come up the stairs and sit down beside his child, looking at her so fixedly that he would end up by falling asleep beside her. "Poor dear friend," she wrote, "these were the only moments when he had his little girl to himself."

Sometime that autumn Czechowska decided to leave Paris for the

south. It was necessary for her health, she wrote, although she did
not explain why. There are plenty of hints in her narrative that she
and Dedo were more than just friendly, although she resists calling it
a love affair. She simply states that he wanted to accompany her and
Zbo and Hanka were all for it. But Jeanne, by now heavily pregnant,
did not want to travel and did not want to be left alone in Paris either.
The impression left is that this was a wasted opportunity. Had Modi-
gliani been able to go with her, he might have survived. (This, of
course, was unlikely.) But her hands were tied because he had a wife
to look after him. So what happened subsequently was Jeanne's fault.
This is not stated but it is very much implied. Lunia left alone. She
and Modigliani promised each other they would meet again soon.
But, "hélas," she wrote, they never did.

Reliable witnesses record that Jeanne went to visit her baby once a
week, but what else she did with her time can only be conjectured. It
is clear that she remained in the apartment when Modigliani went out
at night. She discreetly disappeared whenever he was painting there.
She must have been drawing and painting, perhaps making clothes,
or out buying food and painting supplies. The stairs to the floors of
this annex at the end of the courtyard, which contains artists' quar-
ters, are much longer than the usual flights, owing to high-ceilinged
studios, and full of twists and turns. They are of bare pine and some-
how forbidding, devoid of paint and looking much as they must have
done eighty years ago. Now, as then, there is no elevator between
floors. As one climbs one notices the scuffed wood, worn thin, the
narrowness of the tread, the peeling walls and high, small windows
that seem to cast a perpetual gloom. A very pregnant Jeanne would
not have particularly wanted to go out at night, and carrying heavy
loads up those stairs would have been an increasing burden. Some-
where under the eaves was a princess, safe, hidden, and marooned in
her tower.

 In *Montparnasse vivant* the author, Gabriel Fournier, writes that
Jeanne attempted to reconcile with her parents but that the reconcili-
ation was brief. It must have been an enormous disappointment. A
self-dramatizer like Modigliani will command the attention and the
quiet girl in his shadow is ignored. Yet her dilemma was, if anything,
as desperate as his. If and when he died, he left her a young woman

with two children. Judging by her attitude toward her first preg-
nancy, the second child was unlikely to have been any more wanted.
She and her children had already run the considerable risk of con-
tracting tuberculosis themselves. She would naturally want to marry.
In the early spring of 1919, Modigliani wrote to tell Zborowski that
his brother Emanuele was arranging for the needed legal papers and
that the business was almost finished. Yet, six months later, they were
still not married.

Jeanne had no status except as a common-law wife, that is to say,
none. The possibility that she would be destitute was real unless her
parents took her back. Would they? Did they even know Modigliani
was ill with tuberculosis? (Luc Prunet doubts they ever did.) How
much would they have intervened? More to the point, how wounded
had she become? Would she ever go back?

There is a further question of how comfortable the two were with
each other in the day-to-day intimacy of a close relationship. Marc
Restellini, who has made a study of the final six months of Modi-
gliani's life, believes that, by 1919, a sense of disillusion with Jeanne
can be deduced from the increasingly unflattering portraits he paints
of her. A postcard he sent her while they were living separately in
Nice provides a clue: "Bonjour Monstre." The teasing tone reveals
some sense of exasperation. There was something unsettling in her
eerie silences, her reserve, her determination never to reveal a chink
in her emotional armor. To someone with exacerbated nerves and a
steadily declining health, perhaps nursing a hangover and feverish,
such stoicism would seem unbearable. He wanted a Lunia at home,
someone to soothe him, distract him, gloss over his tormented feel-
ings, excuse his erratic behavior, and coax him into a good mood. In
short, a maternal solicitude. But the evidence suggests that Jeanne
was too much his follower, and he too dominant, to allow this to
happen. She could only follow with a kind of terrible patience.

His original response to her as a sitter had been rapturous. An
early drawing, which incidentally dates their meeting to the end of
1916, if not before, has her in hat and coat, two long pigtails fram-
ing her face. Portraits, the first of many, came soon after. Although
Modigliani's stylistic simplifications are still evident (the emphasis
on the nose, the endlessly attenuated neck), the early portraits and
drawings give a vivid sense of the sitter. In one she is shown three-
quarter face, as if in the act of turning toward the artist, her look alert

and questioning. In another she is seen full face, looking directly up at the viewer with a grave, penetrating stare; in yet another, a study of her profile reveals the same look of serious-minded concentration. Jeanne Modigliani observed that "the composition becomes more flowing and takes on a calligraphic elegance; the canvas is visible between the thin brushstrokes and the color recalls the luminous freshness of a Persian miniature." In Modigliani's portraits of Jeanne we see her with shoulders bared only once, and only two drawings exist of her in the nude; she is dancing in the first and serves as a model for the Berthe Weill exhibition poster in the other. Since it is almost axiomatic that nude models slept with their artists, before or after, it is interesting that none of the subjects in Modigliani's great nude paintings can be identified as Jeanne. One can speculate about the reasons why. The fact is that Jeanne had no inner inhibitions, sketching herself repeatedly in the nude as she looked into a mirror.

In that year of 1919 the series of portraits, which have shown Jeanne in every possible permutation—hatted, bareheaded, hair up, hair down, hair short, hair long, pose natural, pose self-consciously modeled on the antique—focus increasingly on Jeanne as she grows heavily pregnant and puts on weight. The neck is still swanlike and her glorious hair still full of reddish highlights. But the nose is blunter and even more elongated, she now has a double chin and sits slumped in a chair or a bed, fat-bellied and bulging. These works verge on caricature.

Even so there is evidence that the long-suffering Jeanne had her limits, suggested by a poem Modigliani wrote while they were living together:

> *un chat se gratte la tête*
> *comme un poête*
> *qui cherche une rime*
> *ma femme*
> *pour un prêtre*
> *me jette un verre à la tête.*
>
> *(a cat scratches his head*
> *like a poet*
> *searching for a rhyme*

my wife
for a priest
throws a glass at my head.)

Could this be an oblique reference to the marriage that never took place?

Modigliani's great painting, only the second self-portrait known, is considered a late work, probably in the autumn of 1919. He is posed in three-quarter face, with a palette in his right hand, his left resting on a knee. His expression is indecipherable—the art historian Sara Harrison likened it to a mask—and his eyes are narrowed, their sockets blanked out with gray. The autumnal colors of fawns, ochres, and reddish browns, the grayish-blue scarf tied around his neck, provide the elegiac proof, if such were needed, that Modigliani knew how little time was left.

Kenneth Silver writes that the painter took from Cézanne his technique of

thinly applied paint laid down in a repeated hatchwork; the warm/cool palette of earth and sky (or water) tones so beloved of the master from Aix; and even the characteristic and poignant tilt of the head, by which Cézanne evokes a sense of melancholy in the portraits of certain sitters. Yet it is in the tilt as well that we strongly sense Modigliani's predilection for the Italian Renaissance and especially for the art of Botticelli, for whom the tilted head is a sign of spiritual buoyancy . . . Italianate too . . . are both the attenuated linear style and the idealization of the form, which is at the crux of Modigliani's art.

The perfection of form and the conundrum it posed for an art historian was one of Kenneth Clark's recurring themes. In "Apologia of an Art Historian," he argued that an art historian must believe in the greatness of a work before he could understand, let alone appreciate it. "I well remember a time when the Giottos in the Arena chapel meant nothing to me . . . But I went on looking in hope; and almost without my being aware of it, I found myself experiencing before them the same emotions which I felt in reading the plays of Shake-

speare. Through some perfection of form I was enabled to share and
to transcend experiences of which, in actual life, my feeble spirit
would never have been capable." The self-portrait and other works
by Modigliani, with their increasing subtlety, rigor, and air of inevi-
tability, are witnesses not only to a maturing sensibility but call up
an answering echo in the viewer because they are somehow so right.
Something rare has been accomplished, and the more one looks the
more one finds.

The last known photograph of Modigliani, taken in 1919, shows
eyes full of a painful awareness. Yet this extraordinary man, who had
days when he could hardly get out of bed, was not only painting at
the height of his powers but astonishing his friends by his mental and
physical resilience. Sometime during the Christmas holidays, Chan-
tal Quenneville, a friend of Jeanne's, ran into him at a little all-night
café on the boulevard de Vaugirard near Vassilieff's former "cantine."
He was buying a double helping of sandwiches and consuming them
with relish. He explained, "Overeating—that's the only thing that
can save me." Seeing him arrive at Zborowski's early on New Year's
Day, so drunk he could hardly stand, clutching a bedraggled bunch
of flowers, needing urgently to be put into the nearest bed, Paulette
Jourdain could only marvel at his stamina. "It was astonishing how
he kept up physically, in appearance, considering the amount he
drank and drugged." The received wisdom was that he drank himself
to death. The reverse is the case; alcohol and drugs were the means
by which he could somehow keep functioning, the necessary anes-
thetic, as well as hide the great secret that must be kept at all costs.

To casual observers like the critic Claude Roy, the feverish haste,
the irritability, the rages, the search for oblivion could only mean one
thing. But in the context of the truth that Modigliani kept hidden so
successfully the facts appear in an entirely new light. Noël Alexan-
dre, Paul Alexandre's son, author of *The Unknown Modigliani*, said,
"The popular version of Modigliani as a drunk, with women and
drugs—people have invented a personality that didn't exist. The one
that did exist was so much more admirable. A man who lived his life
nobly. An artist, highly original, who looked for another path, dif-
ferent from Picasso, from Matisse. He is unique in his genre, unique
in his nobility of intent."

Alexandre observed that, as he died, Mozart is thought to have
said, "I was just beginning to learn how to compose," and Modigliani

could have said the same, "I am beginning to learn how to paint." He concluded, "Great artists like these go to the end of themselves, and the beauty of their work is a reflection of themselves, after all. They are courageous, to the edge of death."

"Feeling I would fall, I leaned against a ruined wall, and read: 'Here lies a youth who died of consumption. You know why. Do not pray for him.'"

Like most Italians Modigliani was on easy terms with cemeteries, which for him, as with other European cultures, had the quality of a theme park. Whether or not he took walks in Père Lachaise it is certainly true that he often strolled around the Montparnasse cemetery with Beà and may even have had picnics there. He took the same interest in drama and spectacle as the average Parisian flâneur whenever a particularly grand funeral cortège passed by. He thought nothing of raiding a fresh wreath whenever he needed a flower or two, his favorite offering to a pretty woman. So it is not particularly surprising that he made enthusiastic invitations to friends to go for walks in some nearby cemetery, as he did, raining or not. Whether or not he said that "he liked contemplating death" is a moot point. He certainly knew his own death was not far off.

A more persuasive anecdote is related by André Utter, Valadon's husband. He states that he, his wife, and friends were dining one night at Guérin's when Modigliani joined them. He had been drinking but was not drunk and uncharacteristically subdued. He sat down beside Valadon and leaned his head on her shoulder. She was, he said, the only woman who really understood him. Then, huddling close to her, "like a child who is afraid of the dark," he began to sing a dirge. Jeanne Modigliani, who also wrote about the incident, believed it must have been the Kaddish. This prayer is, according to Leo Rosten, an ancient doxology in Aramaic glorifying God's name that in time became known as the Mourner's Prayer. It is recited at the grave of the deceased for eleven months and each year on the anniversary of the death. Modigliani, in other words, was reciting a prayer for himself, mourning his own death.

That night Modigliani stumbled his way home. Somehow he was still on his feet when he was certainly feeling the second-stage effects of tubercular meningitis, with increasing headaches plus the mental

confusion which is an indication of the deadly progression of the disease. Anyone could see he was not well but, like Claude Roy, they knew why: he was drinking himself to death. Even as perceptive an observer as Indenbaum was sure of it.

He said that he saw Modigliani a matter of days before he died. He was out and about along the rue de la Grande Chaumière at eight one morning when he heard someone behind him coughing in "a heart-rending manner." It was Modi, who opened his arms wide; his jaw dropping with surprise and pleasure. They shook hands warmly. Indenbaum said Modi was "very pale, very pulled down and hardly recognizable." With what was left of his voice he said he was leaving for Italy. It was too bleak and gray in Paris; he urgently needed some sun. Indenbaum believed he was destitute, but that is another common misconception. In fact, for the first time since his arrival in Paris fourteen years before he was actually making some money from his art. In addition to his stipend from Zborowski the sales percentages were rolling in regularly. The month he died he asked Louis La-tourette, who was a financial reporter, for some advice about money. It is also known that he sent back the family allowance at about this time, saying he no longer needed it. One of the most painful rumors to arise, three or four years later, was that his family had abandoned him and he had died destitute. That, Eugénie wrote in her diary, was almost more than she could bear.

What is clear is that his friends, who were by now used to shrug-ging off Modigliani's exploits, ignored the warning signs. They could well have dismissed him as an alcoholic. On the other hand, they might have learned the truth at last: that he had tuberculosis. If this is so, and it is clear that Zborowski, Guillaume as well, knew what the trouble really was, the news would have spread in the small circle in Montparnasse like wildfire. This is the most plausible explanation for what happened when he was dying and for days left alone.

Beatrice Hastings and Simone Thiroux were nowhere to be found, perhaps for understandable reasons. Moïse and Renée Kisling, who saw Modigliani on a daily basis, did not appear. No sign of Guil-laume, Utter and Valadon, Lipchitz, Orloff, Jacob, Survage, Soutine, Brancusi, Zadkine, or any of the subsequent chroniclers, Latourette, Salmon, Carco, Michel Georges-Michel, and all those who would

later claim to have witnessed the hourly drama of Modigliani's final days. Zborowski and Hanka did indeed appear but, as he confessed later, did not realize that Modigliani was seriously ill because, he said in self-justification, Modi was walking, talking, and eating, apparently in the best of spirits, just before. As luck would have it, the painter Ortiz de Zárate, whom Modigliani had met in Venice, was also living at the rue de la Grande Chaumière with his family and could be relied upon to keep him supplied with coal. But he was away for a week and that was the week Modigliani got ill.

The last photograph of Modigliani, 1919

Not long before he died of cancer in 1982, David Carritt, then fifty-five, whose acumen as a London art dealer was equaled by his erudition and knowledge of the Italian Renaissance, was invited for a weekend. He apologized. He could not go, he said, because friends were about to take him on a voyage to Cythère. This poetical reference to an island off the southernmost coast of Greece, seemingly distant enough to be in another world, is a metaphor for the soul's ultimate journey. It was celebrated by Charles Baudelaire in his poem "Un Voyage à Cythère."

> *Quelle est cette île triste et noire? — C'est Cythère,*
> *Nous dit-on, un pays fameux dans les chansons,*
> *Eldorado banal de tous les vieux garçons.*
> *Regardez! Après tout c'est une pauvre terre.*
>
> *(What is that sad, dark island? — It is Cythera,*
> *They tell us, a country famous in song,*
> *Banal Eldorado of all the old bachelors.*
> *Look! After all, it is a poor land.)*

A voyage as a metaphor for death is so common that it is curious that commentators missed the reference in another anecdote that was told by the Vicomte de Lascano Tegui, an Italian artist acquaintance of Modigliani's. Tegui recounts that it was a rainy night (as it always is in stories of this kind). Modigliani insisted on joining Tegui and a group of friends who were on their way across town to visit another Italian, a draughtsman. Aware that he was in no state to make the trip, they attempted to dissuade Modigliani. But, trailing an overcoat that he refused to wear, already soaked to the skin, Modigliani could not be dissuaded. So they shrugged and set off. He followed a short distance behind, muttering to himself. They realized how tenuous his hold on reality had become when he stopped in front of a thirty-six-foot monument of a lion and started cursing it as if it were alive.

When they finally arrived at the draughtsman's quarters they tried again to persuade Modigliani to do something he was determined not to do. At least come inside, they said. He fought them off. He sat down on the sidewalk and was still there several hours later. It was, of course, still raining. Saving such a man from himself is such a thankless task that the wonder is that anyone did anything. According to one report, they managed to bundle him into a taxi and send him back to his studio. Accounts of the incident dismiss as mere raving what happened before he left. Modigliani explained to anyone who would listen that he was seated on a quay on the edge of a miraculous sea. There, coming toward him, was a phantom boat.

Soon after that, perhaps the next morning, Modigliani went to bed for the last time. The legend has him dying on a filthy pallet while Jeanne, stoical to the end, sits surrounded by empty liquor bottles and opened cans of sardines, their only source of food. In other embellishments Modigliani is on a rampage, refusing food, screaming whenever visitors attempt to enter, and refusing, according to Sichel, to see a doctor out of sheer childish pettiness. No one has quite dared to give an imaginary dialogue to Jeanne, who is usually treated as if she was not there.

The only more-or-less reliable account is contained in a letter Zborowski sent to Emanuele Modigliani after Modigliani died. It is entirely possible that, as is claimed, they ran out of coal and the studio was freezing. Tubercular patients often do not feel like eating. Modigliani had lost most or all of his teeth. Whether he had, as

some claim, a set of false teeth at that point is unclear, but when his death mask was taken it is clear he had none. What is known is that he liked a particular Livornese dish of tiny sautéed fish, and sardines might have seemed like the closest equivalent; in any case, they are easy to swallow. On the other hand, Chantal Quenneville, the first to arrive after Modigliani's death, makes no mention of them. As for empty bottles, one imagines Modigliani would be looking for something, anything, to dull the pain. There would have been continuing headaches, with increasing sensitivity to light, diarrhea, night sweats, trembling muscles, and stomach pains. What he complained of most in the beginning were pains in his kidneys. He had had them before, but this time the pain was acute. Jeanne went to find Zborowski, and he called a doctor, who diagnosed an inflammation of the kidneys. Curiously enough, Keats was subjected to the same myopic medical diagnosis when, as he was spitting blood, his doctor diagnosed stomach trouble. Thanks to Modigliani's doctor's almost willful refusal to see the obvious, he struggled on alone. Whether he received a daily visit from the same doctor, as Zborowski claimed, seems doubtful.

The now demolished, imposing entrance on the rue Jacob, Paris, of the Hôpital de la Charité, where Modigliani died

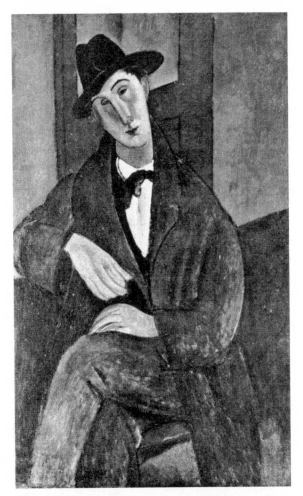

The portrait of the Greek composer Mario Varvogli, which was still unfinished on an easel in Modigliani's apartment when he died early in 1920. Modigliani wrote on it, "Hic incipit Vita Nuova," i.e., "Here begins a New Life."

On the sixth day Zborowski "became sick" himself (not explained) and Hanka was sent. Modigliani was now coughing up blood. Again the same doctor was called. He was now considering hospital but cautioned that Modigliani should not be moved until "the bleeding had stopped." Another bitter piece of bad advice. As they all said later, "If only he had been helped in time . . ." The bleeding never did stop. Two days after that, Modigliani lapsed into a merciful coma. The third and final stage of tubercular meningitis had arrived.

The most puzzling aspect of these last days is Jeanne's curious inability to act. True, she had a secret to be kept at all costs and so she might have listened to a doctor making a partial diagnosis without comment, out of loyalty to Modigliani. True, being within days of giving birth, she would have had trouble getting up and down those stairs, but she went to fetch Zborowski and also make refills to Modigliani's brandy bottle that would have served him as the only available painkiller. It is clear she could, and indeed was, eating something else besides sardines. She had girlfriends she could have called on for help. André was back. Her parents lived close by. Yet she made no move to contact anyone. Restellini believed that she was, by then, completely under Modigliani's malign control. All his life he had thought of death, philosophized about it, railed against it, and fought to stay alive until he identified completely with Maldoror. In close relationships he was demanding and authoritarian. Loving him would mean giving up everyone and everything for him, as Lunia noted. (*"Il éprouva aussi . . . une sentiment si vif qu'il aurait voulu que j'abandonne tout pour le suivre."*) She was not willing to make that sacrifice. Jeanne Hébuterne was.

Ortiz de Zárate reappears at this point. He writes that he went to see Modigliani after a week's absence and was horrified to find him in such a state. He had the concierge bring up a pot-au-feu, certainly something Jeanne could have done had she not been so transfixed. He claimed to be the one who summoned another doctor and got the unconscious Modigliani to the hospital. This claim is at variance to Zborowski's, who implied he had been the one to come to the rescue. "His friends and I did everything possible."

Modigliani died without regaining consciousness at the Hôpital de la Charité in the Latin Quarter, at 37 rue Jacob on the corner of the rue des Saints-Pères. It was demolished many years ago and replaced by the École de Médecine, but at that time it was a group of buildings with an imposing entrance that encircled a large courtyard and the solution of last resort for the down-and-out, the penniless and starving who were too ill to walk and too poor to go anywhere else. Contemporary photographs show vast wards of fifty or sixty patients. Even that was better than the rue de la Grande Chaumière. The Sisters of Charity who acted as nurses would have provided at least some palliative care as Modigliani sank into death. He died there two days later, at 8:45 p.m., his eyes closed and his half-open mouth

twisted to one side, as a drawing by Kisling shows. He was alone. Jeanne must have given the information for the death certificate. She testified that she was his wife.

As long as he could still stand—Zborowski claimed until three days before his death, although this seems unlikely—Modigliani was at work. The painting, unfinished, on his easel was a portrait of Mario Varvogli, a Greek composer with whom he had been out drinking as recently as New Year's Eve. Its inscription, "Here begins a New Year," would have been appropriate. Instead he wrote, "Hic incipit Vita Nuova," that is to say, "Here begins a New Life."

The biographer of Moïse Kisling, Claude de Voort, echoed the familiar argument that Modigliani's sudden death took everyone by surprise, which has, on the face of overwhelming evidence to the contrary, to be a rationalization. Be that as it may, Kisling, Ortiz, and Zborowski seem to have called a meeting within hours. They sent an immediate telegram to Emanuele Modigliani but there was no hope that he could get a visa in time to attend. So the reply came back that if they would arrange for the funeral he would reimburse them. They should cover Modigliani with flowers. The legend adds they were to "Bury him like a prince." Charles Daude, the firm of undertakers whose establishment on the rue Bonaparte was nearby, received from Kisling the handsome sum of 1,340 francs. Those were the days when fifteen francs would buy a burial service of sorts and, until recently, Modigliani was living on a hundred francs a month. Given that kind of outlay a floral mountain was practically guaranteed. As for a princely burial, someone somehow got the idea that Modigliani ought to be buried in the famous Père Lachaise, the final resting place of France's glorious dead in all the arts, and succeeded in getting permission. Only the best was good enough—belatedly.

Between his death on Saturday night and the funeral on Tuesday afternoon, Kisling and company bent every effort to send their Modi off in style. Kisling's uninspired but competent sketch would have been made within hours of his death. Then Kisling and Moricand decided to make a death mask even though, being artists and not sculptors, their knowledge of method was rudimentary at best. They had to act fast because the nuns wanted the body out of the hospital's

amphitheatre and into the morgue; there was always a desperate need for beds. In a rush to hasten the process, and thinking the plaster had hardened, they removed the mold. But it came away in chunks taking, to their horror, bits of skin and hair with it. Lipchitz was called in to rescue the cast and produce a dozen copies in bronze, which he subsequently did. Presumably he or someone else did the necessary cosmetic repair to the corpse.

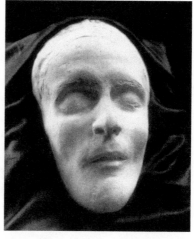

The death mask that Kisling and Moricand began and Lipchitz finished

The long and winding procession that transported Modigliani's earthly remains from the rue Jacob to the Père Lachaise that Tuesday has been famously described as attracting a cast of thousands. This seems to be another of those

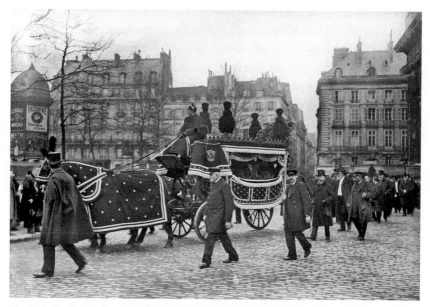

Typical of a fancy funeral of the period like the one which was accorded Modigliani on its way to Père Lachaise

doubtful rumors that has attained the status of fact. Still, to have seen liveried attendants, carts groaning under the weight of flowers, black-plumed horses, and an ornate casket would have been a novelty coming from that particular hospital. No doubt doctors hung out of windows and nuns watched as the cortège swung out of the inner courtyard and made its way down the rue Jacob. No doubt the original crowd of perhaps a few dozen was joined rapidly enough by passersby, who are always curious about a good show. No doubt policemen saluted and held up traffic. It was five miles to the cemetery on the eastern edge of the city and perhaps a few hundred had joined the parade as it swung slowly through the streets. It is said that, as the numbers grew, speculators in art ran up and down the ranks, offering to buy for thousands of francs what no one would pay fifty for while he was alive.

It was said that Zborowski was offered forty thousand francs for fifty pictures, eight hundred francs apiece. It was also said that, as Modigliani lay on his deathbed, the infamous Louis Libaude, known for his predatory abilities, and anticipating the rush, bought up dozens of canvases at rock-bottom prices. Then he went from café to café boasting about the deals he had made. What is true is that at some point during that hectic week Modigliani's studio on the rue de la Grande Chaumière, with its collection of canvases (perhaps some sculptures as well), in various stages of execution, was cleared of all its contents and that there was nothing left for Modigliani's heirs to claim. By some further irony of fate, the Galerie Devambez on the Place Saint-Augustin on the Right Bank opened a show of twenty Modigliani paintings—mysteriously acquired, no one knew quite how—the very day of his funeral. There would have been many old friends in the procession: Picasso, Survage, Moricand, Kisling, Lipchitz, Soutine, Ortiz, Léger, Jacob, and many others. The principal mourner, however, was not there. Jeanne Hébuterne was already dead.

——◆——

The Cult of the Secret

Life never presents us with anything which may not be looked upon as a fresh starting point, no less than as a termination.

—ANDRÉ GIDE, *The Counterfeiters*

ONE OF Modigliani's many paintings of Jeanne Hébuterne reproduced in *Le Silence éternel* dates from their last months together. She is sitting on a stool in front of a door in a corner of the room. Her swollen stomach is hidden under an opaque black skirt and a kind of scarf or stole is wrapped around her shoulders. The theme is heavily red, from the vivid crimson of the bodice to the vermilion wall paint and door to the reddish browns of the wooden stool and blackish browns of the floor. Her skin tones, which are pinkish in earlier paintings, have been drained into a sallow, uniform yellow. The boldly stressed silhouette, annotated in black, gives a feeling of foreboding, even menace, to what should have been an occasion to celebrate by the father-to-be. However, if one theorizes that perhaps Modigliani is making a reference to the idea of alchemical transformation the painting, far from being an anomaly, takes on an interesting new dimension. It can be read as a clue to unlock the mystery of Jeanne Hébuterne's death.

In alchemical symbolism the colors red and black signify stages

in the process of transfiguration. Joseph Campbell writes, "Black is the color of the first stage, the *nigredo,* in which the substance to be transformed must first be broken down into a *prima materia,* or primordial mass . . . Red, on the other hand, signifies the third stage, the *rubedo,* or reddening, which is the spiritual goal of the entire alchemical opus: gold is produced as the direct product of the fusion of the opposites sulfur and mercury, or Sol and Luna." It is tempting to think that Modigliani had convinced Jeanne that death was as easy as walking through a door and that it would lead to their reunion in a higher sphere. Ortiz de Zárate writes that after Modigliani died he went to see Jeanne, who said calmly, "Oh! I know that he's dead. But I also know that he'll soon be living for me." If there was a secret pact one would expect each of them to have left a coded message, and they did. Modigliani's portrait, as read symbolically with a door behind it, would seem to suggest death and rebirth. Hers is full of significantly similar color symbolism and only the message differs slightly. The watercolors by Jeanne which Chantal Quenneville said she found when she went to the apartment after Jeanne's death have recently been made public, thanks to Luc Prunet. These are four lightly sketched works telling the story in comic-book sequence. But their purpose is anything but frivolous; Restellini calls them Hébuterne's last will and testament.

The first is a drawing of an interior. A table covered with a blue cloth stands before a fireplace with a mirror above it. There is an empty wine decanter on the table, a glass, and in recognition of one of Jeanne's major interests, a volume of sheet music labeled "Les Chansons." Restellini believes the watercolor describes the Hébuterne apartment at the moment when Jeanne and Modigliani met. André has left for the war, and there is a tiny but unmistakable picture of him in uniform on the mantelpiece. Restellini finds death foreshadowed in the fact that the clock is painted black and the inky fireplace opening is reflected, in miniature, on the wine decanter's surface. The colors are, however, pretty pastels: blue, apple-green, gold, and off-white.

The second watercolor recalls their stay in Nice with Eudoxie. It could be lunchtime. The couple are seated at a table facing the viewer; Eudoxie, in profile, sits opposite. The color scheme includes blues and blueish greens, but red has entered the theme in the form of a

skirt, red wine, some background flowers, and her mother's reddish-brown dress. So has black. Modigliani's jacket and tie are black and the sockets of his eyes are painted black. Her hand is placed protectively over his and to the right of her plate is a black knife. There is even a black-and-white cat at her feet. Presentiment can be no clearer than this; Restellini writes, "[M]ore and more, death is making its presence felt."

In the third painting a naked girl with long tresses is asleep in a single bed. Her features have been left unpainted but the reference is clear enough, as is the figure all in black that stands at the open doorway. It could represent Maldoror or perhaps a priest, or simply a personification of Death. The themes of black and red, in the visitor's clothing, the mat on the floor, and the crimson towel hanging over the door, make the meaning clear. In the fourth and final frame the heroine, on her red bed and white sheets, having thrust a dagger into her heart, lies head downward, her russet hair streaming behind her. The dripping dagger, the scarlet skirt, the vermilion blood, even her necklace and bracelet, repeat the overwhelming theme. Only the skirt that covers her unborn child retains its traces of green, hemmed around in black. Her intentions could not be more specific. The only issue left was exactly how and when.

As luck would have it Stanislas Fumet and his wife passed "Jeannette" on the street very shortly after Modigliani died. "We were on our way back home to our apartment in the rue Gay-Lussac that Sunday evening," he wrote. "We were just going down the rue Pierre-Curie when we saw, at a distance, Jeannette on her father's arm heading towards us. We had only just learned about Modigliani's death that morning. Jeannette, heavily pregnant, was moving slowly, like a somnambulist, her eyes glassy. My wife made a move to embrace her but she changed her mind as she realized that Jeanne did not even see her. Her father came over to us and said quietly, 'You know, Modigliani is dead . . .' Jeannette kept on walking and he caught up with her."

Fumet and his wife stopped for a moment to watch them disappear. Jeannette and her father were returning from the hospital, where, after a search, she had found Amedeo, he wrote. "Her father had not wanted to go into the room where he was lying. Two witnesses, friends of Modi, were already there. They told us that they

saw Jeannette bend over his face, looking at him intently for a long time without saying a word, as if her eyes were reliving each moment of his suffering. Then she backed away, still looking at him until she reached the door. We concluded that she was holding onto that image of him and refusing to see anything else . . . We were the last 'strangers' she saw."

The Saturday night that Modigliani died, rather than have her return to the rue de la Grande Chaumière alone, Zborowski found her a small hotel room on the rue de Seine. The night of Sunday, January 25, when the Fumets met her she was returning to sleep at her parents' apartment on the rue Amyot. The four watercolors were discovered later in the studio she had shared with Dedo. How concerned the Hébuternes were about their daughter's emotional state is not clear. In one version, they took her home because they feared she was suicidal. In another version there is no indication that they had such concerns. If they had not yet seen the drawings they might not have appreciated the depths of her despair.

Several recent studies of suicide make the point that a successful suicide requires not just the will but the means and the opportunity. It is a statistical fact that states with high rates of gun ownership have suicide rates that are more than double the rates in parts of the country where gun ownership is low. In a fascinating article Scott Anderson describes how the phasing out of coal gas in Britain had a direct bearing on the suicide rate. Unburned coal gas releases very high levels of carbon monoxide, and an open valve in a closed space induces asphyxiation in a matter of minutes. "Sticking your head in the oven" became the preferred method of suicide in Britain until the 1970s and the arrival of natural gas, which does not release carbon monoxide.

As a result the national suicide rate dropped by nearly a third. Dying was no longer as easy or convenient. Once the immediate means were no longer available, the nature of the act itself became clearer.

Richard Seiden, a clinical psychologist at the University of California, traced the history of would-be suicides who had been stopped by the police from jumping off San Francisco's Golden Gate Bridge. He found that a mere 6 percent went on to kill themselves at a later date. Seiden believed the key to understanding the phenomenon was the role played by impulse. "They were having an acute temporary

crisis, they passed through it and, coming out on the other side, they got on with their lives." A psychiatrist who had interviewed nine people who had made the leap and survived, commented, "[N]one of them had truly wanted to die. They wanted their inner pain to stop; they wanted some measure of relief; and this was the only answer they could find. They were in spiritual agony, and they sought a physical solution."

Although Jeanne had wanted to die she could, nevertheless, have been the victim of a momentary impulse that night in her parents' home. She could have thought, as one survivor commented of his leap from the bridge, "It's watching my hands come off that railing and thinking to myself, 'My God, what have I just done?' . . . All of a sudden [I] didn't want to die, but it was too late." At three a.m. the following morning Jeanne found the means and opportunity. She opened the windows of her sixth-floor bedroom and jumped to her death.

Because of the Hébuternes' staunch determination to keep their private tragedy private, what happened next has never been explained, and now André, the one person who might have cleared up the mystery, has died.

Some accounts state that André was in her bedroom watching over her, that she waited until he nodded off and then jumped. If so he would certainly have awakened when the window banged open. It was January. There would have been a sudden blast of cold air and a thump. Tradition has it that a workman in the street below found the body and loaded it onto a wheelbarrow, not her brother. Jeanne Modigliani's cautious account makes no mention of André at all. If André had not been watching over his sister it would be reason for him to feel such pain and self-reproach that he would never want to talk about it. He was not the only person grievously wounded that night. As William Maxwell wrote, "The suicide doesn't go alone; he takes everybody with him."

There are obvious inconsistencies in the version of what happened next. The accepted account has the workman taking the dead girl to the sixth floor, where the Hébuternes slammed the door in his face. Leaving aside the question of slamming doors, that any workman made it up six flights with a wheelbarrow containing a dead body is very unlikely. Even if the rue Amyot apartment building had an

elevator it was also unlikely to have held more than two people at its most capacious, given the times. That there was any such confrontation can be confidently discounted.

Second, a death notice first had to be filed in the appropriate town hall, in this case the sixth arrondissement. Then the family had to wait for the coroner's arrival to obtain a burial permit. Funeral arrangements came last. Assuming that Jeanne Hébuterne died at three a.m., there was at least a six-hour interval before the town hall offices were open and her death could be recorded.

Perhaps the concierge was taken into the family's confidence and sheltered the body somewhere on the ground floor. Secrecy would have been vital to the Catholic Hébuternes, whose shame at their unmarried daughter was now compounded because suicide was a sin in the eyes of their church. And to kill a full-term baby has always been a crime. In their horror and grief, one thought would have been uppermost. Somehow, they had to keep it quiet.

The death certificate was issued in the sixth arrondissement at nine that morning. It was based on information provided by two employees of 59 rue Bonaparte. As it turned out, this was the address of Charles Daude, the funeral home that was, at that very moment, planning Modigliani's funeral. This led to the logical assumption that André Hébuterne had contacted, first Zborowski, then Charles Daude's establishment, before the town hall opened. Two men and a handcart were then dispatched to the rue Amyot to transport the body. This, then, is the probable origin of the legend citing a laborer with a wheelbarrow. The two men declared the death and conveyed the pertinent details. The same information then had to be recorded in the town hall where Jeanne lived, in the fifth arrondissement. This took place at two that afternoon. By the time these formalities were concluded, Jeanne had been moved to the rue de la Grande Chaumière and could be visited at the right psychic and literal distance.

Repulsing the suggestion that Jeanne be buried with Modigliani, the Hébuternes took her body to the distant cemetery of Bagneux two or three days later. The ceremony was held at eight in the morning and they begged people not to come, but a few did anyway. Chantal Quenneville and a friend, Jeanne Léger, were the first to arrive at the apartment on the rue de la Grande Chaumière, where Jeanne's body lay under a coarse coverlet. While Jeanne Léger went looking

for a nurse to dress the body Chantal did what she could to tidy and sweep up the studio. There was a box of charcoal, there were empty bottles of preserves, presumably fruit and vegetables, wine bottles littered about, and a general air of desolation. Most of all there was Jeanne, her skin dead white, curiously patched with greenish stains, her stomach bulging under its loose coverlet, and one leg seemed to have been broken by the fall. The portrait of Varvogli, unfinished, still stood on an easel. Much has been made of the fact that the concierge refused to accept the body at first, on the grounds that Jeanne was not the actual tenant, but was overruled. It may be true. Many years later the daughter of Ortiz de Zárate recalled returning from school and finding the concierge in hysterics. It seems that, as Jeanne's body was being carried up the endless flights of stairs, some of her brains spilled onto the floor.

The sad irony of Modigliani's death just as he was becoming recognized, the ostentation of his burial, and its tragic sequel seemed to be taken by everyone as a personal reproach. Some who knew the truth about his health could have consoled themselves, knowing that death, in any case, could not have been far off. What no one could have foreseen was that this quiet, self-effacing girl had been driven to kill herself and take her baby with her. The event took on the dimensions of a Greek tragedy. If they could have done something to help Modigliani they certainly should have anticipated this, and now she had repaid them for their indifference; "every suicide is perhaps a repressed assassination," as Gustave Flaubert commented. Feelings of guilt and remorse are inevitable, to be buried beneath a desire to deny and forget.

Lunia Czechowska returned to Paris in September 1920. While she was away Zbo wrote often enough and claimed that Modigliani had returned to Livorno. On arriving she was told that Modigliani had ceased to paint because of poor health. Zbo and Hanka were hoping perhaps that this would satisfy her and they could gradually prepare her for the worst. Somehow Lunia was not convinced and asked the same question from other friends. But they had all rehearsed the same answers. "I was struck by the fact that they seemed to avoid referring to him. I found that bizarre and accused them of having forgotten him"; to which, presumably, there was no reply.

Lunia's first night back in the rue Joseph Bara was spent sleeping

in the dining room, where Modigliani had painted so many master-pieces. That night she had a strange dream. She was in a little park surrounding the spa where she had been staying. It was autumn and the grass was carpeted with chestnut leaves. The park was deserted except for Modigliani, and they were making a leisurely tour of the grounds. He was carrying something that looked like a magazine. At some point he opened it and said, "Look at this, Lunia. They say in here that I've died. Don't you think this is a bit much! I'm not dead. You can see it for yourself." Just then she saw Jeanne Hébuterne on her way toward them and said, "There's Jeanne. Let's call her." He held her back. "No, no, in a minute." But she was so pleased to see Jeanne that she called out her name in a loud voice. At that moment she woke herself up.

The adorable baby girl, now an orphan at thirteen months, was somewhere on the outskirts of Paris with her nurse. A letter from that lady, stating that the baby had cut her first tooth and that she herself had not yet been paid, was found after the deaths. One would expect the Hébuternes, the Paris family, to have taken an active part in the baby's future, but this does not seem to have happened. The one who went to fetch baby Jeanne and pay off her nurse was not her grandmother Eudoxie, but her father's dealer. Meantime, there was Hanka to help. Where was baby Jeanne going to live? Not with the Hébuternes, apparently.

Fortunately the Modiglianis, now in Florence, wanted her, and the sooner the better. Emanuele would undertake the tedious formalities involved in getting the baby across the border. In the meantime she was sent to Uncle Albert Garsin in Marseilles, Eugénie's youngest brother, who was declared her guardian ad interim. Emanuele would come for her as soon as the papers were in order. This seems to have happened in June 1920. She is *ours*, Emanuele would subsequently write triumphantly.

By now Eugénie was sixty-five, an age her generation would consider old. It would have been reasonable for her not to want the complication of a baby. But apart from losing Dedo she had other reasons for taking in Jeanne just then. Luci, her son Umberto's baby, had just died of meningitis, and her mother, Ida, could not have any

more children. Emanuele was also childless. That summer of 1920 he would be attacked and badly beaten while trying to defend the printing press of a Socialist newspaper. He would bear a large scar on his forehead for the rest of his life. Eugénie's diary in March of that year describes the period of waiting for baby Jeanne to arrive and hoping to find in her a resemblance to her "dear lost one."

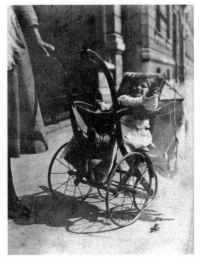

Thank heavens for Margherita, who immediately urged her mother to bring the baby to Florence to live with them. Life was worth believing in, after all, Eugé-

The baby Jeanne in her Victorian perambulator, aged about fifteen months

nie wrote, when it presented such a moment of consolation and joy. A photograph taken just after the arrival of Nannoli, as she was called, shows a chubby baby with delicate features in a frilly hat, coat, and bib, in her delighted grandmother's arms.

But the real heroes of Jeanne's childhood odyssey would be her uncle Emanuele and aunt Vera in Rome. In letters home Emanuele emerges as an enormously helpful figure, always positive and hopeful even as he was fighting a losing battle against Mussolini and his Fascist thugs. His common sense never deserts him even at his worst moments. His warmth, loyalty, and good humor are unfailing. He is sympathetic, funny, even ribald, and wonderfully resourceful.

The first issue, to legitimize Jeanne's birth, bothered his mother, who kept writing to him about the problem. Although Jeanne's parents did not marry an acknowledgment of paternity on the father's side and enough evidence from both directions would legitimize her and she could legally take her father's name under French and Italian law. Had her father not accepted responsibility no such legal process could have been started. In this case the Hébuternes could point to Modigliani's signed statement in the summer of 1919 and his frequent assurances that he would marry their daughter. The Modiglianis were more than willing to begin the effort. Eugénie was

sure the Hébuternes would not cooperate. But, Emanuele wrote, she was "wrong, wrong, wrong." That was on March 23 of 1923 and five days later they made a declaration in Paris supporting the project. At the age of three and a half, Jeanne finally became a Modigliani.

The Hébuternes must have devoutly wished that this was the end of the matter, but they had reckoned without Eugénie. She wanted Jeanne moved from her grave in Bagneux and reburied with Dedo at Père Lachaise. This project took rather longer to accomplish but, as before, Eugénie was not an easy person to discourage. Quite when the idea came about is not clear. But assuming that she thought of it soon after Jeanne's legal status was assured, and if she made the proposal sometime later in 1923, it was at first rejected. One imagines that Achille was the one who resisted. After all, his daughter was a suicide and a baby killer. How could she deserve a place of honor? But in 1925, at the early age of fifty-eight, he died. That left the decision up to Eudoxie and the objections melted away. It was also a help that Emanuele and Vera were exiled to Paris a year later. After Mussolini came to power in 1926, Emanuele's life was in danger. He, along with Filippo Turati, the head of the Italian Socialist Party, escaped across the border just in time. Plans moved ahead and by the time he wrote to Eugénie in February 1927, Jeanne had been moved to the Père Lachaise and was sharing Dedo's grave. Her memorial, significantly, in Italian, not French, reads, "Jeanne Hebuterne, Nata a Parigi il 6 Aprile 1898, Morta a Parigi il 25 Gennaio 1920, Di Amedeo Modigliani Compagna Devota Fina All' Estremo Sacrifizio."

"There is still some masonry work to be done," Emanuele wrote. "But there are some well-tended plants that bloom for weeks and also . . . a bunch of violets placed there by someone. One of the thousands of signs of the cult that has formed in his memory." He had just read, with considerable admiration, a new book about Modigliani's life. It was written "without the usual idiocy." He would keep the book for Nannoli to read once she was old enough to understand and would "pardon her maternal grandparents for their lack of understanding in the face of tragedy." The author had noted this fact in a brief sentence but, he added, "correctly."

It is likely that Eugénie never saw the grave, and she died in Florence six months later.

Another orphan, this time a boy, was not so lucky. When he vis-

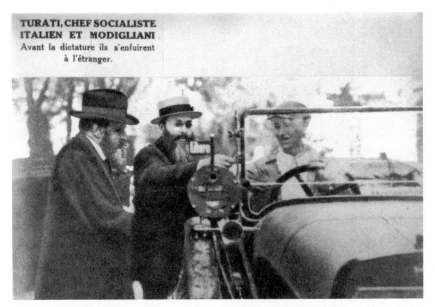

TURATI, CHEF SOCIALISTE
ITALIEN ET MODIGLIANI
Avant la dictature ils s'enfuirent
à l'étranger.

A French newspaper photograph of G. E. Modigliani fleeing with Turati, chief of the Italian Socialist Party, after Mussolini came to power, 1926

ited Paris in the summer of 1920 Emanuele met Simone Thiroux and her son Gérard, a bright and lively three-year-old. Jeanne Modigliani was always told he was "much prettier than she was." She said that Emanuele almost took Gérard to Italy with him and always regretted that he had not. He did not, because Dedo had never mentioned Simone or the baby in letters home. No doubt Emanuele was even sadder when he learned the following year that Simone had died of tuberculosis. Gérard, now aged four, was at first cared for by two of Simone's friends and then put up for adoption. He spent years in an orphanage before being adopted by the Carlinots, a childless couple, in June of 1931. His adoptive father, who at the time was running a small business in cardboard boxes in the rue Réaumur, had been a government employee in the colonial administration in Indochina. The couple apparently divorced within months of adopting Gérard, because his new father soon left for Indochina, taking the boy with him. Once there Gérard was unhappy and smuggled himself onto a boat back to Paris, where he went to live with his new mother. She told him then who his real father was, but he made no effort to contact the Modiglianis or lay claim to that name. Conflicting stories

Eugénie Modigliani at Carlsbad, c. 1925

about his fate circulated for years. He was finally discovered by a reporter for a Paris newspaper in 1981. He had taken the name of Thiroux-Villette and was curé of a little church in Milly-la-Forêt. By then he was sixty-four, portly, wearing glasses, gray-haired, and, by his own admission, with no artistic talent whatsoever.

For the first seven years of her life Jeanne Modigliani's principal caregiver was her grandmother Eugénie. "She was divine. A great beauty," Jeanne told an interviewer for the French magazine *Elle* in 1958. "Gifted for everything. She was the lackey [*nègre*] of a bad writer for whom she wrote novels and she also published a very good study on Goldoni . . . A truly grande dame of the nineteenth century, with her gray eyes, her queenly carriage, and her white headbands under a black or white mantilla. I kept the little heart-shaped orna-ment in sandalwood that she always wore between her breasts."

After Eugénie died, Aunt Margherita assumed Jeanne's care. "Tante Marguerite was a large, dried-up lady who taught French. Violent, passionate, she took to wearing the enormous, flat-heeled shoes of the suffragettes and carried a cane. She was so difficult, when my father was living in Paris, that grandmother had to hide from her that she was sending him money. Tante Marguerite was furious at the

idea that she was working to keep 'that scoundrel of an artist' alive."
It seems clear that Margherita genuinely loved her small niece but
could not resist a close supervision in order to nip in the bud what-
ever she might discover in the way of her brother's irresponsibility
and selfishness, as she saw it. As she grew older Jeanne found such
supervision intolerable. She even called her a sadist, and escaped as
soon as she could. Uncle Mené and Aunt Vera had taken up resi-
dence in Paris at 8 boulevard Ornano in the eighteenth arrondisse-
ment, so as soon as she was twenty, in 1939, she joined them there.
She was studying to become an art historian and had ambitions to
write her father's biography, but her timing was unfortunate, to say
the least. Within months Emanuele and Vera had escaped to Switzer-
land. Jeanne might well have joined them there, but instead moved to
the Vichy area of France. She had married Mario Cesare Silvio Levi,
an Italian economist and journalist on the run from Fascist Italy.
Jeanne's daughter Anne believed it was a marriage of convenience
but other friends doubt that this was the case, at least at first. The
consensus is that it was a genuine love affair.

Like her husband, Jeanne was fluent in French and Italian. She
had her father's green-flecked eyes and her mother's lustrous, heavy
brown hair with its gleaming red and gold highlights. She was also
tiny, barely five feet tall, though perhaps an inch taller than her
mother, with a narrow nose, tiny hands and feet, and a long neck.
According to Jean-Pierre Haillus, for whom she was almost an aunt,
she missed her calling. She should never have taken up art. She was
born for the theatre, a "cabotine," strolling player, full of panache.
"She was very droll and amusing, with a wonderful sense of humor
and she had this amazing voice, with a slight Italian accent. 'Mon
coco!' she would say."

She had these large theatrical gestures and an original way of
dressing. Haillus recalled one occasion when he was asked to accom-
pany her to the train station in Marseille. Arriving there they joined
the queue to buy tickets. While they were waiting she saw a hippie,
looking as if he had spent the night in a ditch. She regarded him with
awe. "Isn't he beautiful!" she exclaimed. Arriving at the ticket win-
dow she was asked where she wanted to go. "Listen, monsieur," she
replied in her compelling voice, "give me a ticket for some country
that's civilized!"

Jeanne Modigliani in Paris aged thirty-five, 1953

Dominique Desanti, the historian and novelist who met her just
after World War II, said that Jeanne had to invent a memory of her
parents whom she lost when she was too young. "Evidently she had
a great deal of trouble forming a personality. Why? Because she had
invented a myth of Amedeo and Jeanne, and in this history she could
not see a place for herself."

Put another way, Jeanne's genuine pride in one parent had to be
shadowed by her awareness of his reputation as dissolute and self-
destructive. As for the other, the taint of a suicide compounded
the image of a mother who had abandoned one child and died with
another. Who were they really? She was doomed to see them through
other people's eyes and in a chaos of contradictory impressions.
Nothing was certain for someone who had compelling needs for a
faith she could depend upon. She found that certainty in Commu-
nism, with its convictions about the absolute betterment of mankind

and the birth of an idyllic new order. "She deeply believed in this. We all did, for a time," said Dominique Desanti. It was a short step from belief in a better world to an active role in the Résistance. And if she was looking for a parental figure she found it in the unlikely person of Valdemar "Valdi" Nechtschein, alias Victor Leduc, alias any number of other identities with false papers. He was nothing much to look at: short, fat, soon bald, and with a pair of the coldest blue eyes in the world. Born in Berlin in 1911 of Russian Jewish revolutionaries who emigrated to Paris, Valdi coupled high intelligence and erudition with a ferocious distrust of all authority, a sense of mission, and an infinite capacity to deceive.

Jean-Pierre Vernant, who wrote the preface to a reissue of Valdi's memoir about his years as a Resistance fighter, *Les Tribulations d'un idéologue,* met him in 1935, when he was twenty-four. He recalled that it was something to hear Valdi reciting the poetry of Mallarmé by the hour or discoursing learnedly on philosophy and political theory. (He taught until 1940, when the anti-Semitic laws of the Vichy government forced him to resign.) Vernant continued that it was also something to see him in the 1930s, already a Communist, wading into a Paris street fight with fists flying, making up in sheer determination what he lacked in height and build. René Glodek, another companion of the Resistance, described him as a "man of great energy and persistence" who was still lashing out even as he was being loaded into a police wagon. More than once he ended up being so badly battered that he had to be hospitalized. Valdi was famous for going out to do battle in the streets wearing a beret well stuffed with newspapers so as to cushion the blows from the policemen's batons.

By the time Jeanne and he met, Valdi had moved to Toulouse and joined Vernant's underground network. Vernant had formed a successful Resistance cell that continued until the end of the war. All the while he acted as a professor of Greek studies in Toulouse (he never missed a day of teaching) and was never betrayed. Glodek described it as a "secret army" soon joined by Levi and Jeanne, who he thinks knew Vernant in Paris before the war. They were a tight little group of friends united in their hatred of Germans, acting as liaisons between British intelligence and the Maquis—they would arrange, for instance, for parachute drops of weapons and supplies. Vernant wrote, "In the work of the organization as in the midst of a

fight, Valdi showed the same tranquil courage, patient tenacity, never defeated, and utter modesty."

One can see the attraction for Jeanne of this older man, her senior by eight years, already in a responsible position as editor of an underground newspaper, *Action.* He was interested in everything: literature, the arts, sciences, philosophy, and the ongoing debate about the future of Marxism. It is fascinating to observe the extent to which she, who never knew her father, chose someone whose inner qualities uncannily resembled his. True, Modigliani, although a Socialist and supporter of Emanuele's causes, was never politically active. But he and Valdi had the same omnivorous intellectual curiosity, the same love for poetry, the same impulsive ability to jump into the middle of a losing fight, and the same gift for keeping up a false front. Speaking of his Resistance years Valdi wrote, "We were like actors wearing masks," performing a life-or-death drama in broad daylight before a public that did not know and would not have cared. Modigliani could have said the same.

Valdi was also married to Hélène and had two young sons, Maxime and Alain. In wartime nothing like that stood in the way of people who were deeply in love. Desanti said that the relationship for Jeanne was "determinant, crucial." As for Valdi, he wrote, "Her rebellion was full of verve. The exuberance of her intelligence, her vivacity, her frankness and her charm bowled me over. I was seduced. Our union, begun in a moment of common danger, lasted for thirty years."

That a life of high adventure is not only exhilarating but can bring out the very best in people is a truism that applied to Jeanne Modigliani in particular during the German occupation of France. François Vitrani, who became one of Valdi's pupils, called her a "grande Résistante," i.e., a model of courage and "unbelievable audacity." She and Valdi shared, not only the constant fear of being captured and tortured, but missions calling for resourcefulness and the ability to improvise. But the organization Vernant put together had mastered the art of creating forged papers that were persuasive enough to rescue Valdi several times. Similar documents were also used to free Jeanne from prison. She was arrested in October 1943 and released in January 1944. Glodek said, "During the liberation of Paris she was in the middle of things and always fearless." He recalled one day when

they—meaning himself, Valdi, and Jeanne—had a rendez-vous on the Left Bank that required them to walk in front of a heavy German field battery, installed behind fortifications on the Place Saint-Michel. At the least sign of fear or haste the suspicious Germans might have opened fire. But Jeanne was magnificent. "She looked the Germans straight in the eye and calmly crossed the square, just like that," he said.

Jeanne's defiance sometimes bordered on recklessness. Jean-Pierre Haillus tells the story about one time, during the German occupation, when she and Valdi happened to enter a restaurant full of members of the Gestapo. Jeanne took in the scene, then ordered from the menu. In a loud voice, she would have some "Résistance soup," or words to that effect. Valdi kicked her hard under the table and hustled her out of there.

Les Tribulations d'un idéologue, written in 1984 under his alias of Victor Leduc and recently reprinted, is a fascinating account of this French intellectual's Communist beliefs and his slow disenchantment as the truth about Stalin's repressive regime became clear. It was written partly to explain to a new generation how someone like himself, so hard to deceive, could have taken up the cause at great personal risk and continued to believe in its tenets until post-Stalinist revelations made such a belief impossible. At the same time it is a kind of admission that life spent in a clandestine world exacts a high personal price. Being with Jeanne on cloak-and-dagger missions during the war was one thing. Setting up life with Jeanne in a Paris apartment was something else. By 1946 Jeanne had divorced Mario Levi but Valdi had gone back to live with his wife. In his memoir he told the story haltingly, with the kind of understatement one would expect. "After the Liberation my family moved to Paris with me. I had not broken my liaison with Jeanne. I suffered very much in this situation because I was very attached to Hélène, I loved my sons . . . and we were about to have a baby girl to whom I had given my mother's name of Olga. But I love Jeanne, by whom I also had a daughter, Anne." What Valdi did not mention was that both babies were born in the same month, May of 1946.

Maxime Nechtschein said that during the war he seldom saw his

G. E. Modigliani in America, 1935

father and when he did Valdi was always on the run. He was often obliged to lie for him, something he did not like at all. His father never talked about Jeanne, politics, his work in the Resistance, or anything personal. He was "not much of a talker." However, "he was a very good organizer, very passionate, indefatigable but not practical at all. He had a double life. It was 'la culte du secret.'"

Finally, Valdi moved in with Jeanne. Even then he never talked about her, his son said, and Maxime only met her once or twice. Valdi spent his weekends with Hélène and the children, as if he had been away on some secret mission and returned for a brief holiday. That their father had two other children was something Maxime and his brother did not learn for many years.

One of the reasons for Valdi's decision to move in with Jeanne had to do with the state of Anne's health. When she was only sixteen months old she had a cerebral hemorrhage that left her partially paralyzed, with brain damage. Years of therapy and operations would follow before she was able to lead a normal life. All this was happening in 1947, which would have been a terrible year for Jeanne for another reason: her uncle Emanuele had died. After leaving Switzerland at the end of the war, he and Vera returned to Italy in triumph. But his health was fragile and he died there in October 1947, a few days before his seventy-sixth birthday. No doubt Jeanne felt overwhelmed; in any event, this was when Valdi moved in.

Ten years later Valdi divorced Hélène and married Jeanne. By then they had a second daughter, Laure, born in 1951. Their father belatedly acknowledged his two illegitimate daughters a year or so before his death in 1993. That would have been in character. Dominique Desanti said, "It is true that the two of them lived only for politics. Militants of that epoch essentially abandoned their children. The best thing was if there was a grandmother on the scene . . . It was a

A rare photograph of Valdi and Jeanne together,
postwar, in the countryside with cat

Bohemian household; they all were. If you wanted to eat, well, you
went to a restaurant. Otherwise it was ham and frites or you bought
something at a delicatessen. I don't know if Jeanne ever cooked but
I'd be astonished if she did. Of course they were very poor. Com-
munist journalists were very poorly paid, considered working class."

Jean-Pierre Haillus agreed. He recalled one time when he was liv-
ing in Guadeloupe and Valdi arrived there for a conference. They
met at the airport. Valdi was in complete sartorial disarray. Every-
thing was unbuttoned and his sole covering above the waist was an
undershirt. "A completely Bohemian lifestyle. Jeanne was capable of
leaving the house wearing one red shoe and one blue one. It didn't
bother her at all. Possessions didn't exist for them. If they had a car
it needed repair and wouldn't run. Their apartments were full of old
furniture and covered with dust. Books and magazines all over the
place." At home they often walked around in the nude, in a curious
repetition of Modigliani's fondness for disrobing.

Living with Jeanne meant constant theatrical arguments, "very
Italian," and family crises played out against a chaotic lifestyle in
which parents came and went at unpredictable hours. Jeanne was, as
it were, all for her husband, with nothing much left for her children,

particularly Laure, in an echo of her mother's attitude. Laure went on to study psychology; her doctoral thesis was the incidence of death among psychotic infants, and also the very rare condition that causes children to mutilate themselves. She is not married and has a daughter, Sarah, now in her twenties. She is unemployed and lives in a working-class quarter of Paris. Haillus believes that Christian Parisot formed a charity and a group of art collectors helps provide for Laure. Her sister Anne, who now lives on a small state pension and is cared for by Haillus, her guardian, does not share in this largesse.

One of the reasons why Emanuele fought for Jeanne's legal status had to do with her artistic inheritance. Zborowski and Guillaume had the usual financial arrangement: four-fifths of a work's sale price went to them and one-fifth to the artist or his heirs. Once an artist died it was axiomatic that prices shot up. But when Gerald Reitlinger, author of *The Economics of Taste*, visited Zborowski's quarters on the rue Joseph Bara in 1922, the Modigliani works were still modestly priced. He found portrait heads for sale from fifteen to twenty pounds. Half-length portraits went for more, from fifty to sixty pounds, and "two or three life-sized odalisques," unframed, sat on the floor for about eighty each. These tantalizing, if brief, descriptions of lifesize works reveal aspects of Modigliani's oeuvre that have since disappeared. The whole stock "might have been worth" about one thousand pounds, Reitlinger wrote. In 1961, when his book was published, Modigliani's oeuvre was then worth half a million pounds. Reitlinger added, "No modern painter's works have advanced so fast."

Emanuele could not have known how quickly Modigliani's works would become valuable but he was concerned enough to safeguard Jeanne's legal right to royalties and percentages if any were to be had. What was left to inherit, apart from a few drawings and juvenilia? Quite a bit, as it turned out, in the form of consultant's fees. In France, the artist's heirs could legally pronounce on a work's authenticity. The experts might strenuously disagree, but the family had the last word, and that translated into a tidy percentage.

What was authentic and what was not? Most artists, with an eye on sales, kept a running list of what they did when, and some gave

their work an inventory number. Modigliani, that least practical of men, never bothered.

A further complication, before the advent of reliable color repro-ductions after World War II, was the matter of making stylistic com-parisons. Early catalogs are maddening for their laconic entries of *Head of Woman*, with no dimensions and usually no photographs either, and if there are, they are of poor quality black-and-white. There was the matter of Modigliani's distinctive style as well. Michael Findlay, director of Acquavella in New York, said, "Modigliani left a body of highly stylized work, an image, a logo. They may look superficially like his work and may not survive close inspection. Nevertheless for a faker this is a dream come true."

Gil Edelson, cofounder in 1960–61 and retired executive direc-tor of the Art Dealers Association in New York, believed that Zborowski had hired people to finish Modigliani's unfinished works and pass them off as originals. Moïse Kisling's son Jean was sure his father had been one of them. He stated that both artists had often worked on the same canvas and even, occasionally, signed each oth-er's work for a joke. Art historians have, however, expressed doubts on stylistic grounds. It is true that among the miscellany of paint-ings and drawings being offered to an increasingly curious public were paintings that have since been identified as fakes. In 1925, the Hôtel Drouot auction house in Paris sold a head and shoulders, titled *Young Woman*, that was supposedly listed by the respected Ambro-gio Ceroni in his catalogue raisonné; the attribution given was false. A few years later René Gimpel noted that the expert on Modigliani for the same auction house of Drouot, a M. Hessel, had bought a Modigliani from his own employer for fifty-five thousand francs. Hessel then showed the painting to Zborowski, who had to tell him that it was not "right." In other words, a fake. Hessel was furious but in order to safeguard his own reputation there was nothing he could do. Three years after that, in 1932, Jeanne was thirteen and Mar-gherita was in charge of authentications. She wrote to tell Giovanni Scheiwiller, Modigliani's first biographer, "that the number of fake Modiglianis grows by the day; there must be a factory making them in Paris. The last note of sale made in Paris stated that I had certified a painting called 'Étude in Tunis.' The only catch was that poor Dedo was never in Tunis!"

The British artist John Myatt, one of whose specialties
is painting fake Modiglianis

So just how easy was it to fake a convincing Modigliani? John
Myatt had a successful career in Britain as a forger of over two hun-
dred works by Braque, Matisse, Chagall, Giacometti, and other
modern masters before being unmasked ten years ago. After serving
a prison term Myatt turned his versatile facility into the legitimate
business of painting what he calls "genuine fakes." Myatt said he had
seen Modigliani's work at a touring art show when he was at college
in the 1960s. "I can remember standing there and thinking, 'What a
superb line.' The speed and confidence of the line almost made me
shiver."

What makes the work seem easy to fake is the fact that Modi-
gliani's style simplifies facial features and does not articulate ana-
tomical details, such as cheekbones, shoulders, and rib cages. It looks
so simple that a child could do it. But on close inspection, the work
reveals the brio of a master—Modigliani worked very fast—along
with a dramatic energy that was uniquely his. One could reproduce
this artist at the height of his powers exactly and still not have caught
that animating spirit, that rapturous response that makes his work so
compelling.

Given the size of the problem—Modigliani is one of the ten most

faked artists in the world, along with Corot, Dalí, van Gogh, Utrillo, and Giorgio de Chirico—the actual paintings themselves have been subjected to remarkably little study. One of the most important was undertaken in Paris almost thirty years ago when the Musée d'Art Moderne de la Ville de Paris launched an exhibition of Modigliani's work for its twentieth anniversary in 1981. Bernadette Contensou, then conservateur en chef, and Daniel Marchesseau, conservateur, decided they would subject a few doubtful works to a battery of technical tests to see what could be learned. To make sure there could be no question about the validity of the conclusions, the chief investigator would be Madeleine Hours, chief of the research laboratory at the Louvre. They studied several paintings but paid particular attention to three. One was a doubtful portrait in their own museum, *La Femme aux yeux bleus* in the Dr. Girardin collection, the second, a known fake in the National Gallery of Modern Art, Edinburgh, and the third, a puzzling portrait of Diego Rivera in a private collection.

The most interesting discovery followed an investigation of the underpainting, i.e., how the artist prepared his composition. They discovered that details of the face, nose, mouth, and eyes were uniformly drawn in "large and violent" rings of brown paint. These circular brushstrokes were so unvarying that this was a conclusive way to identify Modigliani's hand. Genuine works always showed this artistic signature; faked works never did. Using this analysis along with other indications made it easy to identify the Diego Rivera portrait as atypical, but genuine, and the French and Scottish portraits as fakes. Most museums, presumably secure about the provenances of their works, or less curious, do not subject them to technical analyses. Gary Tinterow, curator of nineteenth-century and modern paintings at the Metropolitan Museum of Art in New York, told the author that the museum has never subjected its Modiglianis to technical analysis.

Paintings are not the only works by Modigliani that are faked. Drawings are very easy to forge and can be so convincing that it is almost impossible to tell whether or not they are "right" unless the provenance is absolutely ironclad, as in, for instance, the case of the Dr. Alexandre collection. Modigliani's caryatids are another popular target but marginally easier to detect. In a landmark study, "Fakes and Forgeries," by the Minneapolis Institute of Arts in 1973, among

the works on view were four caryatids in pencil, crayon, pen and ink, gouache, or watercolor. One was genuine. The three others, masquerading as by Modigliani, could be rejected on stylistic grounds. The genuine caryatid showed the "artist at his best, combining an essential and graceful curvilinear line with an overall feeling of solid, stable support which is the very basis of the caryatid figural type." The forgeries, with their lumpen limbs and stylistically mangled heads, belonged to figures unable to sustain anything, much less a resemblance to the work of the man whose name they had appropriated.

The high point for fake Modiglianis—Restellini estimates there are at least one thousand on the market—took place during the thirty years after World War II, the 1950s through the 1980s, when everyone was in the game for easy money. Among them was an art historian named Alberto d'Atri, whose ostensible role as critic and writer about art was a front for his much more lucrative role of salesman and authenticater of Modigliani's paintings. Or, as was said of another so-called authority, when asked to authenticate a work he would reply that if the owner would let him sell it, meaning for a handsome percentage of the profits, the painting would become whatever he wanted it to be. Conflicts of interest are nothing new in the art world, but some of the d'Atri howlers are so outrageous one cannot believe that anyone would offer them for sale with a straight face. They are now on deposit at the Archives of American Art in Washington, which is open to the public.

But even reputable auction houses like Parke-Bernet, Christie's, and Sotheby's were offering paintings for auction in which one would have to express serious doubts. A portrait of a woman sold by Parke-Bernet in the winter of 1958 came up again for sale at Christie's in London in the summer of 1974. It was supposedly a portrait of Jeanne Hébuterne, with a Modigliani signature upper left and a certificate of authentication from Hanka Zborowska dated 1956. It was said to have come from the collection of "Mme. Hébuterne" in Paris and then to have belonged to a Mrs. Martin Baer of Paris, "the sister of the sitter." This flagrant invention of a nonexistent sister should have sent up immediate warning flags for the specialists at Christie's but, presumably, the sale went ahead.

Since this was the period in which certificates of authentication were appearing from all directions, one would expect Jeanne Modigliani to make some of the same mistakes. The evidence is that she did.

As Marc Restellini wrote in the catalog of his exhibition "Modigliani: L'Ange Mélancolique," at the Musée du Luxembourg in 2002–03, "the question of Modigliani's authenticity has plagued Modigliani's corpus, putting many people off, and constituting a major impediment to the appreciation of his oeuvre . . . In the 1950s, the often incongruous certificates of authenticity made out by Hanka Zborowska and Lunia Czechowska cast doubt over his entire corpus. For them, it was an answer to their dreams, an unexpected financial resource . . . Having written a very interesting

The art historian and museum director Marc Restellini, author of a definitive catalogue raisonné on Modigliani

work on the father that she scarcely knew . . . Jeanne Modigliani too permitted herself to certify the authenticity of certain works."

What Jeanne Modigliani inherited was called the *"droit morale,"* or moral right, over her father's work. Mark Spiegler wrote in *Artnews,* "The droit morale was intended to ensure that an artist's heirs would have significant control over their ancestor's legacy. In practice it often proves nettlesome; the children of an artist are not automatically experts in his work."

For instance, Jeanne was legally allowed to make eight copies each of her father's sculptures. Although all of them were in stone there was no requirement that the copies be in the same material. So Jeanne licensed them to be made in bronze. There is also a *Tête de caryatid* now at the Amedeo Modigliani Foundation in Rome that has been reproduced in wood. Many scholars, Restellini among them, believe the practice of reproducing an original work in any other material "runs directly counter to the creative philosophy" of the artist. Marc Blondeau, an art adviser and private dealer in Geneva, said, "Jeanne Modigliani was impossible because she signed authentication certificates in a very subjective way, without doing serious research." She also certified works that have since been identified as fakes.

In Clifford Irving's book *Fake,* about the masterful forger Elmyr

de Hory, who painted over a thousand fakes of everyone from Picasso to Renoir and Matisse, there is a reference to the fact that he collaborated with Jeanne. Irving wrote that the forger "brought some Modigliani drawings to the representative of Mlle Modigliani, the painter's daughter, secured an affidavit that they were genuine and then sold them to a prominent dealer on the Avenue Matignon." De Hory worked with Fernand Legros, a Paris art dealer who also sold fakes manufactured by his friend Réal Lessard, an equally successful forger of nineteenth- and twentieth-century art. Lessard subsequently published a tell-all book, *L'Amour du faux,* placing the blame for his nefarious career on his former friend, and publishing three of his Modigliani fakes. All were sold with certificates from Jeanne Modigliani because, he wrote, Legros wanted her imprimatur to silence the critics. Jeanne Modigliani "was a passionate admirer of the paintings of the father she had never known," preparing "to admire indiscriminately anything that looked plausible." Still, when he sent her a photograph of Lessard's not-very-convincing *Portrait of Jeanne Hébuterne,* Jeanne demurred. She wanted to see the actual work. Eventually she was allowed to inspect it with her lawyer, a Maître Hauert, and Legros in attendance. The negotiation was brief, Lessard wrote. Legros and Hauert immediately understood each other and the matter was settled to the mutual benefit of all concerned.

Nowadays certificates from Jeanne Modigliani have been thoroughly discredited. For the past several years prominent dealers and auction houses have refused to accept paintings without a cast-iron pedigree or an entry in the catalog published by Ambrogio Ceroni in 1958 and updated in 1970. Ceroni, who only listed works he actually saw, omitted at least eighty that did not compare well with paintings he believed to be authentic, a total of 337. His listing does not include many Modiglianis now in the U.S. that he never saw. The provenances also do not include the past history of the paintings but only their whereabouts at the time of publication. Still, Ceroni is considered the reigning authority. Spiegler wrote, "Unless a Modigliani has a perfect provenance, not being listed among Ceroni's 337 paintings will slash its market value by half or even two-thirds."

. . .

Christian Parisot is a convicted forger who has published numerous volumes on Modigliani's paintings and drawings. He met Jeanne Modigliani in 1973 when he was working on a doctorate in art history, and they became friends. Parisot has curated numerous exhibitions and written catalogs and books about aspects of Modigliani's life and work as well as a sourcebook, *Modigliani*, published in 2000. Now a professor at the University of Orléans, Parisot claims that the *droit morale* was passed to him by Jeanne Modigliani before her death in 1984. This repository of several thousand letters, diaries, documents, and photographs that had been assembled by Jeanne and her daughter Laure was now titled the "Archives Légales Amedeo Modigliani." A prominent authority on Modigliani whom I interviewed said, "How these can be called 'Legal Archives' is an absolute mystery." His understanding, along with that of many other historians, is that the legal right devolves upon the natural heirs and that Laure and Anne could have asserted this right but never have.

When questions were raised by the police in 2006 about the authenticity of some paintings and drawings with attributions from Parisot, it led to a police raid in search of the "Archives Légales." According to the official website these could be consulted at the Musée de Montparnasse, 21 avenue du Maine. The director, Jean Digne, told the police this was not true. His museum had never housed the archives, he said. In any event the same archives are now housed at the via di Monte Giordano 36 in Rome. Now that the "Archives Légales" have moved to Italy, the French police "will have to work through European authorities if they wish to access them," *Artnews* reported in September 2006.

Another case involving attributions by Parisot went to court in the spring of 2008. The problem began in 2002 and involved more than seventy drawings by Jeanne Hébuterne that Parisot had borrowed for an exhibition about Modigliani and his circle, held in Venice in October 2000. The drawings were lent by Luc Prunet but he became dissatisfied with aspects of the exhibition and uncorrected errors in the catalog. So when Parisot asked for permission to include the Hébuterne drawings in a new exhibition that would travel in Spain, it was refused. The drawings were returned and Prunet assumed the matter was closed.

Prunet was subsequently astounded to learn that a sizeable group

of drawings and watercolors purporting to be by Jeanne Hébuterne were being exhibited in Spain. The modest value of work by an unknown French artist was not the issue. At issue for Prunet was the patent inferiority of what was being shown as his great-aunt's work, along with the deception involved. The case took several years to move through the French courts. When it was eventually heard, in 2007, Parisot claimed he had bought the drawings at a flea market in Paris, but his explanations were not convincing and sentence was passed.

The sentence was appealed and the case reheard in November 2009. That second hearing took on the flavor of a Feydeau farce when, as Parisot prepared to leave the courtroom, he was arrested on a new charge of selling fake certificates for Modigliani drawings. A final verdict on the Hébuterne issue was handed down two months later, in January 2010. The original sentence had included several months in jail. This was suspended, but the appeals court greatly increased the cost of damages, to fifty thousand euros, and Prunet's original award of one euro was also increased to fifty thousand euros. Although only tangentially related to Modigliani's work, the Hébuterne case, involving as it did an expert on Modigliani, was bound to call into further question the still thriving trade in Modigliani fakes, of which the presiding judge who had given the original verdict was evidently well aware. Parisot, the judge said, had "used his well-known role as expert and archivist of Modigliani" to invent fraudulent provenances.

Osvaldo Patani, who has also published his opinions in several volumes, stopped work in 1999. He explained, "I am disappointed, demoralized and also annoyed. I am an honest man and nowadays I have to reckon with too many vested interests and too many fakes in circulation." The same problems have dogged Marc Restellini, who originally planned two volumes of his catalogue raisonné, one of paintings and the other of drawings. When a prominent collector of Modigliani's drawings learned that Restellini did not plan to include them in his new volume, he embarked on a campaign. One day Restellini received a phone call from his mother. "Marc, what have you done?" she asked reproachfully. "I haven't done anything, maman," he protested. It turned out she had just received a very large check in the mail. Meantime, he was receiving anonymous death

threats. Lawyers were contacted, the check was returned, and the idea of a drawings catalog was dropped.

There is a coda to this subject. It seems that about ten years ago the art expert and museum director Daniel Marchesseau was contacted by a department dealing with forgeries in the Police Judiciaire. The police had seized a Modigliani painting, quite unlike his usual style, in which a man wearing a hat and a moustache sits at a café table with a carafe of wine and a glass. It is no. 275 in Ceroni's list, painted in 1918 and listed as being in a private collection. Marchesseau had known about it for years but had never seen the original. In due course he was sent documentation by mail and invited to police headquarters to discuss his findings.

He told them, "This has to be a complete fake and a bad one at that." He was interested because "problems appear when fakes are very well done and forgers are usually pretty talented. But this one was just bad, muddy and amateurish."

After a minute or two, other officers, who had apparently been observing his testimony through a two-way mirror, suddenly appeared. They said, "What you are telling us is pretty interesting." After about half an hour it transpired that they were part of a companion unit investigating currency fraud. The fake Modigliani was being offered for sale by a criminal gang. The prospective buyers were from another gang, they were paying with fake money, and the sellers were quite indignant about it. That reality, in the world of art, can triumph over illusion is the rarest of all.

Throughout the 1940s and 1950s the lives of Victor Leduc and Jeanne Modigliani centered around their ardent belief in Communism. All the pain, the sacrifices, poverty, imprisonment, the secrets, subterfuges, and lies—it would all have been worthwhile because of the future that lay ahead, idyllic and serene. That faith would receive a shattering blow. It came in 1956, three years after the death of Stalin. Speaking at the Twentieth All-Union Party Congress, Nikita Khrushchev, who had succeeded Stalin as premier, delivered a supposedly secret report that was immediately leaked, "The Personality Cult and its Consequences." It was a denunciation of Stalin, his character, politics, rule, and role in the mass imprisonment and execu-

tion of thousands of political prisoners, the so-called gulags, that had been rumored and were now being acknowledged for the first time.

This was painful for Valdi, but even more agonizing for Jeanne. It was a betrayal of her dearest hopes, one more way that life had let her down. She abandoned politics to concentrate on her art. She had been painting for several years and won a scholarship to work on a study of Vincent van Gogh. She wrote, "The contrast between his own ideas and artistic aims . . . and the myth of the ill-fated painter whose genius was conditioned by his madness, led me to examine the crystallization of this type of legend." In her refusal to be misled she wrote with so much restraint that, John Rewald commented, "her portraits of Modigliani and his friends actually lack warmth and life."

Although Jeanne Modigliani's biography makes frequent references to her father's family there seems to have been little or no contact with her mother's, a curious omission given that they all lived for many years in the same city. For explanation one need not look much further than the personality of her uncle André. Whatever anger was left for his sister's actions quickly dissipated. Sometime early in 1920 he left Paris for a painting trip through the countryside. He wrote to his mother ("Ma chère Petite Me' "), "You know from experience how difficult it is to drive from one's mind sad memories which overwhelm one sometimes." As soon as he started painting he thought of Jeannette, and "it seems to me that she is just about to appear and I will soon be showing her what I have done and imagining what she is going to say." In years to come André would keep a memento of hers close at hand.

After André Hébuterne died in 1992 at the great age of ninety-eight Georgette Hébuterne did try to explain, in an interview with Parisot, what she had not been able to discuss for decades, but perhaps it was all too long ago. She did, however, indicate one reason for her husband's silence, and Anne Modigliani offered the same explanation. The family's anger, no longer directed at Jeanne Hébuterne, had turned itself on her baby. That was in keeping with the popular view that if there was one thing worse than having an illegitimate child, it was being one.

At the time her book was published Jeanne Modigliani was professor of Italian at a lycée in Lille. She had her first exhibition as an artist at a

gallery on the rue des Francs Bourgeois in the Marais, showing some splashy, Abstract Expressionist paintings. The name of Modigliani ensured a few sales. But her efforts were not a critical success. Jeanne had once worn her hair upswept off her forehead in a flirtatious little bun that lent an impish gaiety to her appearance. In later years she cut her hair within inches of her scalp and combed it forward. The result was monkish and not becoming at all. At the same time Jeanne, a moderate drinker to this point, became a compulsive one.

Dominique Desanti said, "She had an inner conviction that she was responsible for the gulags. She found out about them the same time we did, but for her it was unbearable to think she had supported this. After that, in order to paint and forget the fact that she was personally responsible for the gulags, she began to drink. She would say, 'You know, we are all mass assassins, serial killers' and, 'Nobody has the right to live after that.'"

Jeanne was repeatedly treated at programs for alcoholics that helped for a time, but she always started again. Valdi, who had given up so much to be with her, burdened by continuing financial responsibilities for his two families, in poor health, finally despaired of ever helping Jeanne and asked for a divorce. That came in Sep-

Jeanne Modigliani, not long before her death in 1984

tember 1980. Valdi and Laure joined forces; Jeanne and Anne moved in together into an eleventh-floor studio apartment in a complex of high-rise buildings owned by the city of Paris on the Place d'Italie. It was comprised of a single large room with a kitchen and bathroom. It was then that Jeanne's compulsion, lacking any remaining restraints, plunged her into the depths. One day Anne returned to the apartment unexpectedly to find her mother, completely drunk, completely naked, in the company of two or three men she had picked up off the street. Desanti said, "Everything in her life fell to pieces. Anne was ill. Laure had emotional problems. Certain people appreciated her paintings but they did not sell. She had the sense of guilt we all shared, and then Valdi left her."

Jeanne's history, Glodek concluded, was very hard. "It is the story of a woman difficult to describe, of a superior intelligence, but everything she wanted to do failed. Someone of enormous capacity and abilities, yet she suffered great hardships. One does not understand such a life." Alcohol was her path to oblivion and she drank, Valdi said, "until she finally lost her mind." One morning in July 1984, a young civil servant who had an appointment to see Jeanne about her state pension arrived at her door. There was no reply and so the concierge was summoned with a set of master keys. They discovered Jeanne Modigliani lying on the floor. She had been dead for three days.

Epilogue

Rien n'est beau que le vrai.

—Brancusi

I went looking for Modigliani's grave one morning on the first of May, a public holiday. It was raining fitfully, the sky was leaden, and against the stone grays, metallic blacks, and feathery greens, red umbrellas bobbed up and down like so many props from *Les Parapluies de Cherbourg*. Unlike that famous film the actors in this scene were not singing their lines but there in their hundreds, buying tiny sprays of lilies of the valley or splashier flowers in rapturous bundles, jostling and chattering. I had not realized that the famous cemetery of Louis XIV's confessor, Père Lachaise, had been built on what was once his own rolling hillside overlooking the city. The idea that what had become a cemetery was still a park in disguise had taken hold and become engrained in a happily haphazard way. All that was needed now was a riverbank, a few picnic baskets, and an accordion at the gates to turn the arrival into Seurat's *A Sunday on La Grande Jatte*.

I found Modigliani at length in one of the outer alleys, where single slabs of stone had to satisfy less wealthy families bidding for immortality. He was in the Jewish section, placed next to a comedian called Maurice Nasil, and next to a small grove of arborvitae. Someone had placed a bouquet of white daisies upon the grave, secured with aluminum foil, and someone else, a cryptic arrangement of small stones and twigs. I suspected a disappearing group of young Americans in blue jeans and hooded jackets. I was reflecting on the irony that this unknown artist had been catapulted into eternal prominence by the

circumstances of death, one he would have been the first to appreciate. Someday, a young man in blue jeans would come along and place a talisman of stones and twigs in a secret message that (he knew) a dealer in esoteric mysteries would understand and appreciate.

I thought, too, of Modigliani's death mask, which did not resemble him or even the drawing Kisling made hours after he had died. The sunken cheeks and elongated jaw—this "half-ecclesiastical patina of authority," as P. D. James wrote—had made a mockery of the belated attempt to preserve a likeness. In his journal, Odilon Redon observed that to enter these cold and silent alleys and contemplate the deserted tombs gave one a sense of spiritual calm. But, if others had found such calm, I could only think of the hollow mockery of the mask, which seemed to sum up and exemplify the persistent distortions of the Modigliani legend. How could such a memento mori have anything to do with the vibrant, energetic man it supposedly represented? How could anyone have thought, when Modigliani died and had to be buried by the friends who had deserted him, that their hypocritical eagerness to "cover him with flowers" would atone for their betrayal? They might as well have tipped his body over the side of a cliff and let scavangers do the final honors. How cruel his life was, Zborowski concluded.

> *Dreadful, stony silence,*
> *Are you blind, mankind?*

There remained the apartment on the rue de la Grande Chaumière. Some atavistic impulse kept me returning to that small, pretty street. Perhaps I could commune with the apartment's ghosts or at least imagine what it had felt like to live there. But I could not get inside. When Kenneth Wayne visited a few years before the street door had been open. Now it was protected with a lock to be opened by a special code and I did not know where to begin. But then Michèle Épron, my Parisian friend, found she could get an introduction to an artist who lived there. With the appointment went the door code.

Charles Maussion was living in a second-floor apartment directly below one of the rooms that had once housed Modigliani, his studio. We were ushered into what seemed like an all-white room crowded with mostly all-white canvases. Our host was of medium height,

wearing glasses, a crewcut, and a beard, a former mathematician and philosopher who had lived there for fifty years and never left because the light was so perfect. His apartment had once belonged to Survage and although not identical to Modigliani's, often appeared in films because it was neat and well kept, in contrast to the latter's. This had not prevented numbers of intrepid visitors from climbing the stairs and trying to get into Modigliani's old quarters. One of them was Patrice Chaplin, author of *Into the Darkness Laughing.* She related she had tried to encourage a companion to pick the lock with a credit card, then heard footsteps coming toward the door, stop, and start again. Supposedly, no one was in the apartment. Was it haunted, Maussion was asked? He smiled dismissively.

By then I knew, thanks to interviews conducted by John Olliver, that among those in the background when Modigliani died was Waclaw Zawadowski, a penniless Polish artist. Later, he boasted that he had moved in so soon after the funeral that Modigliani's last portrait, of Mario Varvogli, was still on his easel and drawings littered the floors. Fairly soon after that, Nina Hamnett moved in with him. Her memoir, *Laughing Torso,* is considered highly unreliable and at least one author, Simon Gray, has called it "an alcoholic shambles." So one has to view with caution her story that she found a one-hundred-franc note stuck inside one of Modigliani's books on philosophy, proving (to her) that Jeanne Hébuterne would hide their money to prevent Modigliani from spending it all. They helped themselves to Modigliani's shelf of books, reading French classics to each other at night as they sat around Modigliani's battered table, warming themselves beside the stove painted by another acquaintance, Abdul Wahab. Perhaps it was true, as "Zawado" told Olliver, that he found a way to make money out of Modigliani's memory one day when an American came to visit. Hearing that the palette hanging on a wall had belonged to Modigliani, the visitor immediately bought it. Sometime later another visitor noticed another palette, well smeared with the plausibly hardening remains of Modigliani's colors, hanging on the same wall. As soon as he heard the story he bought that one as well. Zawado's business in Modigliani palettes continued at a satisfactory pace.

Maussion's belief that the apartment was uninhabited, however, was somewhat out of date. It was true that the apartment had been

little used in the intervening eighty-odd years. At one point the rooms, at right angles, each about twenty-five or thirty feet long and some eight or ten feet wide, were divided into two apartments and rented separately. One had never been used; the other was used occasionally as an office. All that had changed recently.

One evening Marc Restellini and I went visiting the agent for change, Godefroy Jarzaguet, a direct descendant on his mother's side of the Delaunes, who had owned the building since it was constructed following the demolition of the international exposition in Paris of 1889. So the Delaunes had been the landlords when Modigliani lived there but Jarzaguet had known very little about Modigliani and implied had not thought much about him, either. He was looking for an apartment and that top-floor two-room space was very tempting. Besides, it was owned by his grandfather, Roger Delaune. If he was willing to do the work of restoration, could he rent the apartment? His grandfather said yes.

"Everything was a mess," he said. "When you came in there was a tiny hall with two doors, one coming left into the living room, where a stove sat on a small marble stand. This was the side that was rented. The other went straight ahead into what had been Modigliani's stu-

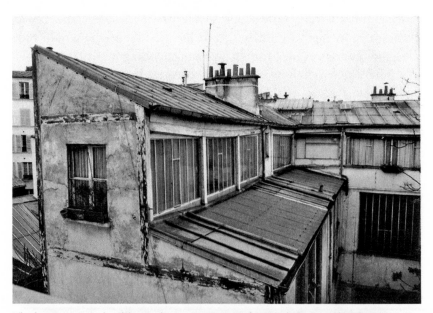

The long, narrow, boxlike studio apartment on the rue de la Grande Chaumière

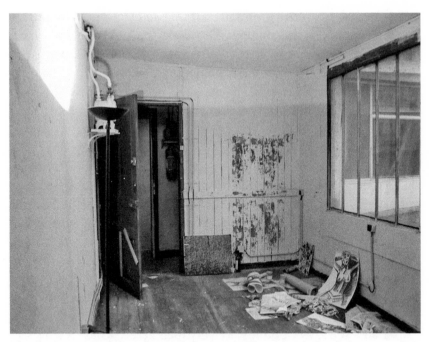

The derelict apartment on the rue de la Grande Chaumière before being renovated in 2007 by Godefroy Jarzaguet

dio and since there was no source of heat, nothing had ever been done to it."

The apartment, besides having no heat (apart from the stove), had no water either until somebody brought up a toilet in the intervening decades. Jarzaguet immediately removed the hallway and one of the doors, making every effort to return the apartment to its original state. Even so, a kitchen area had to be introduced and a bathroom partitioned off. The studio's floor had completely disintegrated; new supports had to be put in place and pine flooring installed. The ceilings were dropped about six inches and the walls brought in for insulation purposes. New, insulated windows were installed on the bedroom side. New cupboards and bookshelves followed. All of this took a couple of years. How did the materials get upstairs? "Most of them came up on my back," Jarzaguet said.

The far corner of what is now a bedroom faces another building that is directly on the street. By coincidence it is at eye level with an apartment that was being rented by Alexandra Marsiglia; her bath-

room, in fact. Jarzaguet would be working and she would be watching at her window and smiling. He would smile. They would meet on the stairs or the hallway at street level and smile. Still, neither of them said a word. He was already a little in love with her. "I had this fantasy about her," he said. "I imagined her life. I knew she lived alone as a student but that is all I knew."

Then one day he was on his roof deck sunbathing when she opened her window and called out. "How do you get up there?" He invited her to his recently finished apartment. When she arrived he showed her a small, unobtrusive trap door in his living room ceiling and a handy rope ladder. They went out to dinner that night. She was studying art history and one of her creations in décollage now hangs over the dining table. There are Andy Warhol soup cans over the sofa and plenty of art books on the shelves, but no sign of a Modigliani, let alone a Hébuterne. He talks about heating, lighting, and construction. She talks about the brief, last hours in the apartment shared by Amedeo and Jeanne, and the legend that the apartment is haunted. "After all," she says, "nobody actually died here," which is true.

The bedroom faces a blank wall where a Virginia creeper has grown upward until it is almost at eye level. Godefroy said, "It's so quiet here. You could be at the end of the world." Sometimes tendrils of mist cling to the chimney pots. Or, on a starry night, the moon rises up over the bedroom, in gold and red. "It's magnificent." The fact that the renovation of this particular apartment led to a marriage—they had just returned from their honeymoon in Sicily—seemed serendipitous, almost poetic justice. "I feel," he said, "I have brought it back to life."

In *Modern Art,* Meyer Schapiro's seminal work on art of the nineteenth and twentieth centuries, Modigliani's name does not appear. He is not even a footnote in *The Visual Arts, a History,* by Hugh Honour and John Fleming, that otherwise learned and authoritative account of the major historical trends and their minor tributaries. In *Great Private Collections* Douglas Cooper, the persuasive author and critic, limits his praise for a Modigliani portrait to its elegance of line and retrogressive references to the Sienese art of the *trecento.* Kenneth Clark's monumental study *The Nude* makes no reference

to Modigliani's masterful studies of the female form despite the fact that the author clearly admired him at an early age. In the catalog for his enormously successful exhibition of 2002, "L'Ange au Visage Grave," Marc Restellini wrote about the paradox of Modigliani's vast popularity and his representation in discerning private and public collections, versus the disdain historically shown for his work by academic and art historical circles. "The universities where Picasso or Matisse are much studied deem Modigliani a facile painter devoid of innovation," he wrote.

Part of the problem may have been that, Restellini added, "Forgeries appeared almost from the day he died." Another issue had to do with the artist's stubborn insistence on his difference. He did not follow Fauvism, Cubism, Surrealism, Futurism, or any of the other "isms," making him harder to categorize. He was another of those unclassifiable characters like Stanley Spencer, Henry Fuseli, Albert Pinkham Ryder, or even William Blake, who have no effect upon chroniclers in the world of art. With apologies to Robert Hughes, there was nothing shocking about his newness. There were no distorted features, à la Picasso, no Robert Ryman white on whites, no Mondrian blocks and diagrams, no canvases pulsating with color, like Mark Rothko's. There was only the perverse insistence of an unknown artist putting down paint on canvas as if to say, "This is what I see."

Well, as Cocteau used to say, "Ne t'attardes pas avec l'avant-garde," and that Modigliani certainly never did. His vision was cool without being clinical, elegant without being mannerist, an art of harmony, balance, and Renaissance humanism. In an age when Beauty, that reigning ethos, had been pronounced dead, Modigliani lived for it. When shape was being deconstructed, he exalted it. When the human form divine was being belittled, even uglified, he celebrated it. His very existence as an artist challenged the theoreticians of the time. It is interesting that long before American reviewers and critics, or French (with the possible exceptions of Warnod and Carco) discovered his work the British, and particularly Roger Fry, recognized Modigliani's importance. Fry shared the same passions for the Italian Renaissance, African sculpture, and Cézanne; a climate of intellec-

tual open-mindedness, along with a tradition of artistic independence, allowed Fry to admire those very qualities being dismissed elsewhere.

Werner Schmalenbach wrote that if the criterion was the extent of Modigliani's influence on the art of his own time, "the answer has to be that there was no such influence." However, if one judged by Modigliani's artistic impact, that had continued to this day, "and this is the impact that counts, since it rests solely on the individuality of the artist and his work." It might even be considered an advantage to be outside the ruling trends, the implied moral of Cocteau's maxim, since whatever is never "in" is never exactly "out," either. "This independence," Schmalenbach wrote, "which never makes him look merely dated, is undoubtedly part of his greatness." Another part of that greatness, as Restellini showed, had to do with Modigliani's "metaphysico-spiritual" beliefs. "Behind the legend of the sole 'artist maudit' of the twentieth century stands a visionary artist with an extremely radical philosophical conception of his art."

Authors have marveled at the contrast between the confidence and control of Modigliani the artist versus the chaos of his personal life and concluded that there is no connection. I have suggested that his lifelong, losing battle with tuberculosis was one aspect of his art's covert subject matter and that the psychic scars he endured found a kind of sublimation in the expression of his mystical and philosophical beliefs. Another was the theme of the mask. Coherent and guiding principles can be glimpsed in his life as well as his art, despite appearances. In short, the apparent chaos of his private world threw an essential veil over the truth, buying time for him to go on developing as an artist. He hid behind this façade with such success that he fooled most of his contemporaries and a great many people since. He was prepared for life to be a battle. Perhaps he also thought, like E. M. Forster, that it was a romance, and that its essence was romantic beauty.

One of the first art historians to divine the man behind the accepted view of Modigliani was John Russell. Writing in 1965, he observed, "Where myth and anti-myth take over from history, as has been the case with Modigliani since the day of his death, it is never easy to cut back to incontrovertible fact. It may even be unpopular, for the notion of Modigliani's life as a chaos of unrelated inspirations

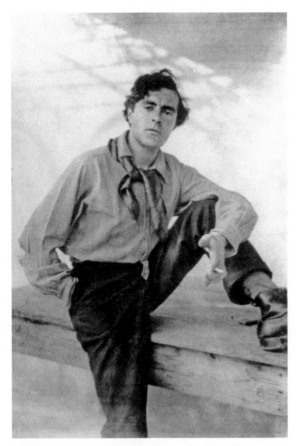

Modigliani in 1909, wearing the "artistic" style he
affected shortly after arriving in Paris

is a fancy widely cherished." He continued, "Modigliani had great
natural gifts, admittedly; but they were not at all precocious . . . and
only a profoundly serious and coherent artist could have brought
them to the degree of fulfilment which he attained in the months
before his death." His art, Lionello Venturi wrote, could be seen in
two aspects: "as an art of the free imagination in so far as his poetic
vision leads him to transmute natural forms, but also as a very human
art that bodies forth a world in which the life of men is depicted in its
essential purity and grandeur."

NOTES

ABBREVIATIONS

BAR *The Italians,* Luigi Barzini, 1965.

BTM *Modigliani: Beyond the Myth,* Mason Klein, ed., 2004.

CR *Modigliani: Les Femmes, les amis, l'oeuvre,* Jean-Paul Crespelle, 1969.

FL *Le Figaro Littéraire,* Saturday, May 17, 1958.

GE *Dietro La Facciata di un Combattente,* Giuseppe Emanuele Modigliani, 1971.

GRA *Beatrice Hastings: A Literary Life,* Stephen Gray, 2004.

HOM "Homage à Modigliani," *Paris Montparnasse,* August 1927.

JM *Modigliani: Man and Myth,* Jeanne Modigliani, 1958.

KIS *Kisling,* Claude de Voort, 1996.

MAL *Maldoror & the Complete Works of the Comte de Lautréamont,* Alexis Lykiard, trans., 1994.

MP *Minnie Pinnikin,* Beatrice Hastings, in manuscript, Lieberman Papers, Museum of Modern Art; in partial translation, *Modigliani & the Artists of Montparnasse,* Kenneth Wayne, 2002.

NA *The New Age, 1912–1938.*

PAR *Modigliani: Biographie,* Christian Parisot, 2000.

PL *A History of Private Life,* vol. IV, Michelle Perrot, ed., 1990.

PLU *Posthumous Keats,* Stanley Plumly, 2008.

QFC *Quest for Corvo,* A. J. A. Symons, 1966.

RA *Modigliani and His Models,* Royal Academy of Arts, 2006.

RE *Modigliani, the Melancholy Angel,* Musée de Luxembourg, Marc Restellini, 2002.

SCH *Amedeo Modigliani,* Werner Schmalenbach, 2005.

SE *Le Silence éternel,* Marc Restellini, 2007.

SI *Modigliani: A Biography,* Pierre Sichel, 1967.

SII Interviews by John Olliver for *Modigliani: A Biography,* Sichel.

TRIB "Montparnasse à l'Époque Heroïque," Émile Lejeune, *Tribune de Genève,* 1964.

UM *The Unknown Modigliani: Drawings from the Collection of Paul Alexandre,* Noël Alexandre, 1994.

VEN *Modigliani in Venice, Between Leghorn and Paris,* Christian Parisot, ed., 2005.

WAY *Modigliani and the Artists of Montparnasse,* Kenneth Wayne, 2002.

CHAPTER ONE · THE PROBLEM

6 "Modigliani manages . . . to convey": Kenneth E. Silver and Romy Golan, *The Circle of Montparnasse*, p. 31.

7 the religious power: RA, p. 140.

8 "this young Tuscan": RA, p. 20.

8 "something like a curse": RA, p. 23.

8 "The little Jew": RA, p. 23.

9 "so many inaccuracies": SII, p. 67.

9 "One marvels": "the truth held": CR, pp. 11–12.

10 synonymous with eccentricity: SE, p. 346.

10 "tormented garret dweller": *New York Times*, March 1, 1961.

10 "extremely vulgar": Ronald Meyer, trans., *Anna Akhmatova: My Half-Century*, p. 83.

10 "art historical mindset": BTM, p. 81.

11 "Drunken, ranting and stoned": *Guardian*, July 4, 2006.

11 "the most mythologized": RA, p. 19.

12 "those compound faces": QFC, p. 9.

CHAPTER TWO · THE CLUES

13 "Les démons du hasard selon
Le chant du firmament nous mènent
A sons perdus leurs violons
Font danser notre race humaine
Sur la descente à reculons."
 —*Alcools: Poèmes 1898–1913*, p. 36.

13 "Frustration and poverty": QFC, p. 31.

14 "self-tortured and defeated": QFC, idem.

14 "a built-in, shock-proof": *The Writer's Quotation Book*, p. 55.

17 their partner was another Englishman: RA, p. 66.

18 "a little foolish": PAR, p. 10.

18 wearing only a shirt: PAR, pp. 7–8.

20 confessed to the crime: PAR, p. 9.

20 a gentle manner: PAR, p. 10.

21 pervasive sadness: PAR, p. 15.

21 waves of cholera: *Encyclopædia Britannica*, p. 617.

21 "human waste disposal": PL, p. 372.

21 the cumulative effects: In *The Big Necessity*, Rose George wrote that cholera victims who do not have access to clean water or salts, as is still common, are subject to stomach and muscle cramps, can lose up to 30 percent of their body weight within hours, will turn blue, their eyes will film over, and death follows.

21 life expectancy in 1850: PL, p. 331.

22 "a personal remedy": PAR, p. 20.

22 "so many figs": PAR, p. 20.

22 their miracle worker: PAR, p. 20.

23 "article of faith": PAR, p. 20.
23 "a magical world": Meryle Secrest, *Being Bernard Berenson*, p. 275.
24 "phlegmatic temperaments": UM, p. 28.
24 "to enjoy life": UM, p. 28.
24 but ran an agency: JM, pp. 4–5.
24 managing a lead mine: Adrio Bocci, *Bulletin of the Orobic Mineral Group*.
24 "crawling" with servants: PAR, p. 15.
24 "en grand tralala": PAR, p. 15.
25 His authority was absolute: PAR, p. 16.
26 a school for peasants: VEN, pp. 27–8.
26 "intellectual stupor": PAR, p. 21.
26 both knew she was dying: PAR, p. 21.
26 "all the more agonizing": PAR, p. 21.
27 "a persecution complex": SI, p. 29.
27 equally unbalanced: SI, p. 55.
28 "give his property": BAR, p. 201.
28 "early morning conversations!": PAR, p. 22.
29 She was pregnant again: PAR, p. 27.
30 in the year 5644: PAR, p. 52.
30 "tears and anguish": PAR, p. 27.

CHAPTER THREE · "DEDO"

33 was very cultured: PAR, p. 67.
33 "her gruff, but faithful": GE, p. 120, September 24, 1928. Flaminio Modigliani died on September 21, 1928, and is buried in the Jewish Cemetery in Livorno.
33 "solitary by nature": PAR, p. 25.
33 "to get rid of you": PAR, p. 26.
34 "she is happier": PAR, p. 29.
34 "A bit spoiled": PAR, p. 29.
35 They "played freely": PL, p. 204.
36 "exchanges of affection": PL, p. 208.
36 "my deepest gratitude": PAR, pp. 32–33.
37 "an embittered, irascible": JM, pp. 13–14.
37 "the best merchandise": Leo Rosten, *The Joys of Yiddish*, p. 405.
37 "He understood me": PAR, p. 13.
38 "a breeze of fantasy": JM, p. 15.
38 "How many impossible": BAR, pp. 84–85.
38 "The last thing": Idem, p. 88.
39 Her essays were good enough: June Rose, *Modigliani: The Pure Bohemian*, p. 25.
41 Caught telling a joke: Photograph in VEN, p. 40.
41 "Perhaps an artist?": PAR, p. 59.
43 individual curricula: VEN, p. 39.
44 report card is blank: PAR, p. 56.
44 "a terrible fright": PAR, p. 59, on April 20, 1896.
44 "an impossible ideal": PAR, p. 39, on May 26, 1897.

44 "My poor father": PAR, p. 39, on April 20, 1896.

44 passed his bar mitzvah: PAR, p. 40, on August 10, 1897.

44 already an artist: PAR, p. 42, on July 17, 1896.

45 "a private tragedy": PL, p. 160.

45 "arbitrary decisions": PL, p. 160.

45 "Fierce Wish": Quoted in *Modigliani*, p. 22.

48 son of workers: GE, pp. 25–29, no date.

48 he was a windbag: GE to Margherita Modigliani in 1896, p. 24.

48 "We don't know why": PAR, p. 42, on June 30, 1898.

49 "mad with fear": PAR, p. 42.

49 offering to pay: SI, p. 37.

49 symptoms of typhoid: *Encyclopædia Britannica,* pp. 646–47.

50 He spoke of Segantini: Giovanni Segantini (1858–1899) was an Italian painter
 of Alpine landscapes and Neo-Impressionism; Peter and Linda Murray, *Art &
 Artists,* p. 381.

50 " 'When you are cured' ": UM, p. 29.

50 lessons had begun: SI, p. 37.

51 "he will neglect": PAR, p. 42.

51 "The sick boy": UM, p. 29.

51 back on his feet: PAR, p. 62, December 3, 1898.

CHAPTER FOUR · THE BLOOD-RED BANNER

52 We met in a desperate cellar
 In the days of our ill-dressed youth
 And smoked and talked until sunrise
 Caught up in those words—those words
 Whose meaning will have to be changed;
 Solemn young men and erroneous.
 —Poem read at the marriage of André Salmon. Guillaume Apollinaire,
 Alcools: Poèmes 1898–1913, p. 91.

52 in the via delle Siepe: PAR, p. 65.

54 "the sight of laundry": Silvestra Bietoletti, *The Macchiaioli,* pp. 10–26.

54 "Dedo was doing a charcoal drawing": JM, p. 24.

54 small and sickly: PAR, p. 67.

54 "introverted and very shy": PAR, p. 67.

54 his anger was unpredictable: PAR, p. 67.

55 "his favorite Old Masters": PAR, p. 68.

55 "a dead-end art": John Russell, *Modigliani,* Arts Council of Great Britain, p. 5.

55 discovered a signature: VEN, p. 34.

58 "a look of agony": Kenneth Clark, *Another Part of the Wood,* pp. 181–82.

58 willing chambermaids: UM, pp. 29–30.

58 "shiftless and idle": UM, pp. 29–30.

58 "The tone of voice": JM, p. xiii.

59 "he was distinguished": PAR, p. 69.

59 "draws very well": JM, pp. 20–21.

60 as a punishment: UM, p. 30.

60 half the population: René and Jean Dubos, *The White Plague,* p. 9.

61 "started a suit": *The White Plague*, pp. 43–44.
61 "[a] mouse gnawing": *The White Plague*, p. 40.
61 "delicate in modeling": Thomas M. Daniel, *Captain of Death*, p. 34.
62 "wonderful aesthetic hair": *The White Plague*, p. 57.
62 dead of consumption: *The White Plague*, p. 40.
62 "Detach the delicate": *The White Plague*, p. 247.
62 "Since early tuberculosis": *Encyclopædia Britannica*, p. 75.
63 "Different phenomena": Sheila M. Rothman, *Living in the Shadow of Death*,
 pp. 16–17.
63 "the hemorrhage returned": *Living in the Shadow of Death*, p. 29.
64 "Father said again": Sue Prideaux, *Edvard Munch*, p. 25.
64 "its blood-red banner": *Edvard Munch*, p. 24.
64 "I cough and cough": John Middleton Murry, ed., *Journal of Katherine Mans-
 field*, p. 155.
65 did not come until World War II: Dr. Ann Medinger. Tuberculosis is still
 the second largest cause of death by infection, with 1.6 million deaths a year
 (the first is AIDS). Worldwide, a third of the current population is believed
 to be infected, although most cases are not full-blown. (*Harvard Magazine*,
 March–April 2009, p. 23).
65 "a violent hemorrhage": UM, p. 30.
65 there was no treatment: Dr. Ann Medinger; *Captain of Death*, p. 197.
67 "gazing 'on and on' ": Thomas Mann, *The Magic Mountain*, p. 189.
67 He was gaining weight: UM, p. 30.
67 he would sit transfixed: Idem.
67 He was fascinated: JM, pp. 188–89.
68 "You must paint": UM, p. 31.
68 "the 'beatific vision' ": *New Yorker*, April 20, 2009.
68 Ghiglia was the one: SI, p. 48.
69 "as if in a mystic garden": SI, p. 51.
69 "a springlike place": April 1, 1901; SI, pp. 51–52.
69 "the beauties of Rome": SI, p. 53.
69 "I will try": SI, p. 54.
70 "a fertile stream": SI, p. 53.
70 "strong forces": SI, p. 53.
70 "flies to wanton boys": Shakespeare, *King Lear*, Act IV, Scene I.
70 " 'Why me?' ": *Edvard Munch*, p. 26.
70 "He fights for": Walter Kaufmann, ed., *The Portable Nietzsche*, p. 53.
70 "The ordinary man": Meryle Secrest, *Frank Lloyd Wright*, p. 212.
70 "People like us": SI, p. 55.
70 "I am a wild bird": *Frank Lloyd Wright*, p. 213.
71 "maximum creative power": SI, p. 56.
71 "facing the risks": SI, p. 53.

CHAPTER FIVE · THE PERFECT LINE

73 "a button in your pants": PAR, p. 68.
73 "would always turn back": Aldo Santini, *Maledetto dai Livornesi*, p. 58.
73 "It greatly amused him": SCH, p. 197.

73 "A public man": PL, p. 252.

74 "Watch him promenade": BAR, p. 208.

74 its short average life span: PL, p. 331.

75 "without any complications": UM, p. 31.

76 Margherita was not pleased: UM, idem.

76 Modigliani moved to Venice: BTM, p. 190.

76 daily museum visits: BTM, idem.

76 "looked older": SI, p. 58.

77 "Painting only *faute de mieux*": JM, p. 31.

77 "oblique placing of the heads": JM, idem.

77 "I can't see yet": PAR, p. 44.

78 "eating fried fish": SCH, p. 20.

78 "He would spend": SCH, p. 197.

78 "a vague abstract": PAR, p. 82.

78 "Venice, head of Medusa": SII, p. 56.

79 "He immediately began": PAR, p. 82.

79 "he could never be happy": February 1905, PAR, p. 43.

79 a small allowance: PAR, p. 79.

79 His sister also believed: VEN, p. 44.

80 a last-ditch effort: SCH, p. 197.

80 "The gesture grew": Richard Ellmann, *Oscar Wilde*, p. 504.

81 "a strange fatality": Idem, p. 92.

81 "I am a reflection": April 20, 1896, PAR, p. 37.

82 "What a dream": Patrice Higonnet, *Paris*, pp. 244–45.

82 "too gorgeously hot": John Dos Passos, *The Fourteenth Chronicle*, p. 250.

82 gasoline and roasting chestnuts: November 24, 1908, Abel Warshawsky, *Adventures with Colors and Brush*, manuscript, Archives of American Art, p. viii.

82 arriving in the autumn: SII, interview, p. 1.

82 "atrociously delightful": *The Fourteenth Chronicle*, p. 102.

83 a city of art: Brian N. Morton, *Americans in Paris*, p. 11.

83 Cézanne had just died: Alistair Horne, *Seven Ages of Paris*, p. 297.

83 "there were more artists": Colin Jones, *Paris, Biography of a City*, p. 426.

83 ruined all sense of form: *Adventures with Colors and Brush*, p. III.

86 "Toutes les rues": "All streets are tributaries / when you love this river in which all the blood of Paris flows," Philippe Soupault, quoted in *Paris*, p. 389.

87 "they had just disembarked": Marevna, *Life with the Painters of La Ruche*, p. 28.

87 "The acrid smell": *Americans in Paris*, p. 70.

88 looking for the next style: *Adventures with Colors and Brush*, pp. xxxii–xxxiii.

88 very small portraits: SCH, p. 197.

89 a blond washerwoman: PAR, 110.

89 "He drew from life": SCH, p. 198.

89 "a certain smile": PAR, p. 97.

89 He admired Whistler: SCH, p. 197.

90 Modigliani's search for style: SCH, pp. 200–01.

90 "our conversations": SII, interview, p. 1.

90 "From the rue Lepic": SCH, p. 201.
90 "wretched huts": PL, pp. 395–96.
91 "a vast space": PAR, p. 101.
91 "wild disorder": Charles Douglas, *Artist Quarter,* pp. 84–85.
91 "a tumbledown shack"; "For four sous": SCH, p. 197.

CHAPTER SIX · LA VIE DE BOHÈME

93 "under the lamps": Francis Carco, *The Last Bohemia,* pp. 104, 108.
94 Picasso's mural: Philippe Jullian, *Montmartre,* p. 173.
94 "his special cocktail": Idem.
95 "too good to be true": John Richardson, *A Life of Picasso,* vol. 1, p. 374.
95 the café's charm: *The Last Bohemia,* p. 108.
96 "full of imagination": SCH, p. 197.
96 "freshness of perception": SCH, p. 191.
96 "pure Roman profile": SCH, p. 204.
96 "full of interest": SCH, p. 112.
96 a rash of early imitators: Charles Douglas, *Artist Quarter,* p. 46.
96 Clesinger's outfit: Nigel Gosling, *Nadar,* p. 165.
96 the suit of faded velvet: PAR, p. 288.
97 "colour harmonies": *Artist Quarter,* p. 112.
97 "a gentleman and a parvenu": PAR, p. 290.
97 "our aristocrat": PAR, p. 274.
97 living in Montmartre: PAR, p. 97.
97 "[T]he huge building": *Montmartre,* p. 163.
97 "so jerry-built": *A Life of Picasso,* vol. 1, p. 298.
99 "the artistic manner": *Montmartre,* p. 34.
99 "a society of friends": Idem.
99 sometime in 1907: *Artist Quarter,* p. 89.
100 "your rotten junk": Idem, p. 90.
100 "spells of fasting": Nigel Gosling, *The Adventurous World of Paris 1900–1914,* p. 59.
101 "enough left for luxury": *The Last Bohemia,* p. 129.
102 "her god": Ambrogio Ceroni, "Les Souvenirs de Lunia Czechowska," *Amedeo Modigliani, Peintre,* p. 28.
102 "dishes and glasses" Billy Klüver and Julie Martin, *Kiki's Paris,* p. 66.
103 "He was very proud": SCH, p. 197.
103 poets and philosophers: Arthur Pfannstiel, *Modigliani et son oeuvre,* p. 8.
104 "I would often go": Vanni Scheiwiller, ed., *Modigliani vivo, testimonianze inedite e rare,* p. 140.
104 might even have been disoriented: *Modigliani et son oeuvre,* p. 8.
105 "You can't imagine": Idem, p. 11.
105 "Everything in Dedo": SCH, p. 195.
105 "Picasso would kick": *Modigliani et son oeuvre,* p. 11.
105 "Painting is too complicated": H. S. Ede, *Savage Messiah,* p. 27 (May 24, 1910).
105 court the masons: *Artist Quarter,* p. 85.
106 a total spectacle: SII, interview, p. 2.

106 "and kiss it": Alfred Werner, *Modigliani the Sculptor*, p. xvi.
107 "Although friends sympathized": John Richardson, *A Life of Picasso*, vol. 2, p. 17.
107 "How great he is": *Modigliani the Sculptor*, p. xvi.
107 "If I give": June Rose, *Modigliani, the Pure Bohemian*, pp. 56–57.
109 "My parents had": Interview with author.
110 "I was called out": UM, p. 43.
111 "The consumption of alcohol": PL, p. 636.
111 drugs a way of life: *A Life of Picasso*, vol. 1, p. 320; Max Jacob was "so addicted": Idem.
111 "drinking strange concoctions": *The Adventurous World of Paris 1900–1914*, p. 74.
112 "it was believed": PL, p. 633.
112 "Montmartre, at this time": *Artist Quarter*, pp. 94–95.
112 "We ate the paste": Marevna, *Life with the Painters of La Ruche*, p. 116.
113 "Late one night": UM, p. 53.
113 "Modigliani charmed": Idem, p. 59.
115 "his visual memory": Idem, p. 62.
115 "extraordinary freshness": Idem, p. 65.
116 "We never saw her": Idem, p. 54.
116 a moderate drinker: SCH, pp. 197, 201.
116 "Certainly he drank": Idem, p. 189.
116 Vouvray or Asti: *Modigliani et son oeuvre*, p. 9.
116 "You know when": To author.
116 he experimented: UM, p. 53; "It was as if": Idem.
117 "one of the most original": *The Yale Dictionary of Art and Artists*, p. 97.
118 "irreducible organic form": Herbert Read, *A Concise History of Modern Painting*, pp. 101–102.
118 "like a Russian muzhik": *The Diary of Anaïs Nin*, vol. 2, p. 47.
118 "a born aristocrat": *Modigliani et son oeuvre*, p. 59.
119 a fierce argument: UM, p. 60.
119 "a taste for danger": Idem, p. 59.
120 "Bohemia has nothing": SE, p. 4.
120 dominated the evening: PAR, p. 307.
120 did not seem to matter: UM, p. 60.
120 He had found: *Modigliani et son oeuvre*, p. 13.
120 "a queer mystic group": *Savage Messiah*, p. 27. (May 24, 1910.)

CHAPTER SEVEN · THE SERPENT'S SKIN

122 "in desperate straits": UM, p. 75.
122 "instability you were aware": UM, p. 80.
122 "usual credit system": Idem.
123 "I don't need to tell": Idem, p. 78.
124 experiment with Fauvism: RE, p. 112.
125 an early profile: RE, no. 2.
125 "sulky little face": JM, p. 45.
125 "cool purposefulness": Alfred Werner, *Modigliani the Sculptor*, p. xv.

127 "fairground stalls": UM, p. 67.

127 "elegantly stylized figurines": SCH, p. 186.

127 "magical objects": RE, p. 24.

127 the protective mask: PL, p. 251.

128 "majesty and greatness": *Modigliani the Sculptor*, pp. xxiv–xxv.

128 "an endless whole": Hugh Honour and John Fleming, *The Visual Arts: A History*, p. 567.

129 He was looking: UM, p. 65.

130 "It was characteristic": SCH, p. 196.

130 "Our enquiries": SII interview.

130 "I can see him": *Modigliani the Sculptor*, p. xxiii.

131 "affected me deeply": Idem, p. xviii.

131 "He seems very well": Dated July 3, 1909.

131 "one slash of the scissors": JM, p. 48.

131 "I don't give a hoot": Charles Douglas, *Artist Quarter*, p. 124.

132 all expenses paid: Idem, p. 125.

132 at Romiti's atelier: PAR, p. 130.

132 "a *divine* day": UM, p. 95. On September 5, 1909.

132 "like a ghost": Aldo Santini, *Maledetto dai Livornesi*, p. 78.

133 They had to be real: *New York Times*, July 26, 1984.

133 The sculptures were "treasures": BTM, p. 76.

134 "It's easy to be talented": Idem.

135 powerful preparatory sketches: UM, pp. 433–36.

135 "the cool harmonies": JM, p. 49.

135 Cézanne's influence: SCH, p. 38.

136 "a costumed servant": Vanni Scheiwiller, ed., *Modigliani vivo, testimonianze inedite e rare*, pp. 139–46.

136 "a legendary beauty": *New York Times*, March 19, 2006.

138 "a sort of gloom": Ronald Meyer, trans., *Anna Akhmatova: My Half-Century*, p. 77.

139 soft, relentless shower: Juliet Nicolson, *The Perfect Summer*, p. 183.

139 "the knock of his mallet": *Anna Akhmatova*, p. 77.

141 Laure was appalled: JM, p. 50.

141 "He went out, reeling": Stanley Kunitz, trans., *Poems of Anna Akhmatova*, p. 43.

141 "the tragic consequences": *Anna Akhmatova*, pp. 76–83.

142 "For several years": *Modigliani the Sculptor*, p. xxiii.

143 a curious motif: RE, p. 27.

143 the *Endless Column*: Pontus Hulten, *Brancusi*, p. 20.

143 "Was Modigliani the originator": RE, p. 27.

143 "a frightened child": SII, interview.

143 a sacred space: *Modigliani the Sculptor*, p. xii.

CHAPTER EIGHT · "WHAT I AM SEARCHING FOR"

144 Alexandre bought a balustrade: UM, p. 43.

145 "large red figures": Idem, pp. 43–44.

145 "had a wide entrance": André Salmon, *Modigliani, A Memoir*, p. 129.

146 "a flimsy affair": Abel Warshawsky, *Adventures with Colors and Brush*, manuscript, Archives of American Art, p. III.

146 "the last great expansion": Patrick Marnham, *Dreaming with His Eyes Open*, p. 87.

147 "*Venir au café*": Idem; they could spend hours: Idem, p. 88.

148 the nearby ateliers: Kenneth E. Silver and Romy Golan, *The Circle of Montparnasse*, p. 69.

148 "*—after death* of course": Written on May 18, 1910.

149 the flood spared Montparnasse: *Adventures with Colors and Brush*, p. xxxxi.

150 fed in soup kitchens: Nigel Gosling, *The Adventurous World of Paris, 1900–1914*, p. 161.

150 "the human character": Michael Holroyd, *Augustus John*, p. 349.

150 "considerable courage": *Adventures with Colors and Brush*, p. xxv.

151 a great joke: *Artist Quarter*, p. 50.

151 "smells of death": CR, p. 157.

151 unanswered letters: *The Adventurous World of Paris, 1900–1914*, p. 162.

152 "any mythological means": Meryle Secrest, *Salvador Dalí*, p. 124.

152 "boredom and poverty": SE, pp. 342–43; "endings of generations": p. 343.

153 "Beauty must be a good": Adam Kirsch, *New Yorker*, July 14 2008, p. 94.

153 years as a sculptor: UM, p. 106.

153 "Only Cardoso's": JM, p. 58.

153 around the room: June Rose, *Modigliani, the Pure Bohemian*, pp. 91–92.

154 paid in installments: Nina Hamnett, *Laughing Torso*, p. 59.

154 three willing subjects: Sisley Huddleston, *Back to Montparnasse*, p. 58.

154 "drawing ceaselessly": PAR, p. 270.

154 "His working method": Conrad Moricand, *Quand le diable l'importe, souvenirs 1888–1935*, manuscript, p. 100.

155 "I can see him": SCH, p. 204.

155 "I only own one": Cocteau, *Modigliani*, no pagination.

156 it was finally sold: Francis Steegmuller, *Cocteau*, p. 150 note.

156 "a colour photograph": Jeanine Warnod, *La Ruche and Montparnasse*, p. 84.

156 "At that period": *A Memoir, Modigliani*, André Salmon, p. 129.

156 "[H]e loved women": *Modigliani, the Pure Bohemian*, p. 86.

156 "all charm": Marevna, *Life with the Painters of La Ruche*, p. 18.

157 "So little did he value": *Artist Quarter*, p. 197.

157 Her husband collapses: Idem.

157 considered himself a Socialist: *Life with the Painters of La Ruche*, p. 18.

158 "There shines upon": Francis Carco, *The Last Bohemia*, p. 121.

158 in a gutter: Robert Coughlan, *The Wine of Genius*, pp. 45–46.

159 "Take the painters": SCH, p. 193.

159 acutely uncomfortable: *Artist Quarter*, p. 89.

160 "a diseased liver": *Life with the Painters of La Ruche*, p. 17.

161 salvaged from the Women's Pavilion: *The Circle of Montparnasse*, p. 25.

162 "His clothes": *Life with the Painters of La Ruche*, p. 19.

162 "He is small": *Diary of an Art Dealer*, René Gimpel, pp. 309–310.

162 sensitive, introspective: Restellini catalog.

162 "He gave me confidence": SCH, p. 201.

162 exhibition amply demonstrated: "Soutine," Pinacothèque de Paris, 10 October 2007–27 January 2008, curated by Marc Restellini.

162 "Everything dances": SII, p. 231.
164 "poetic beauty": *The Circle of Montparnasse*, p. 31.
164 "Greco-Roman": BTM, p. 86.
164 berating a group of Royalists: *Artist Quarter*, p. 88.
164 wearing a beard: UM, p. 92.
164 "I carry no religion": *Modigliani, the Pure Bohemian*, p. 132.
165 endless discussions: C. R. W. Nevinson, *Paint and Prejudice*, p. 53.
165 prophesies of Nostradamus: PAR, p. 258.
165 "Like all Italians": *Modigliani vivo, testimonianze inedite e rare*, pp. 63–68.
165 He could have stumbled" C. G. Jung, *Collected Works*, vol. VIII, p. 427.
166 "a vulgar fantasy": PAR, p. 81.
166 "Table-turning": UM, pp. 120–21.
166 "he was a medium": *Artist Quarter*, p. 227.
167 "in open rebellion": UM, p. 91.
167 "the mind of the Lord": RE, p. 22.
167 "the secret truth": Idem; "an extremely radical philosophical conception": Idem.
168 "Jean was nursed": UM, p. 82.
168 unconscious beside a block: *Modigliani, the Pure Bohemian*, p. 90; he took up a collection: Idem.
168 spitting up blood: *Artist Quarter*, p. 203.
168 "[H]e looked up": PLU, p. 206.

CHAPTER NINE · MALDOROR

170 not given a drawing: Aldo Santini, *Maledetto dai Livornesi*, pp. 8–9.
170 rampant head lice: SII, p. 214.
170 a single head: UM, p. 104.
171 "a sane health": *Artist Quarter*, p. 124.
171 "dazzling light": letter dated April 23, 1913; UM, p. 104.
171 phase of sculpture ending: UM, p. 106.
171 "an angel with a grave face": UM, p. 109.
171 Jean Alexandre died: June 8, 1913.
171 "Just as the snake": UM, p. 92.
172 unique and universal: UM, p. 93.
172 "the Red Elixir": UM, p. 92; resurrection after death: Idem; "Aour!": Idem; "the Great Work": Idem.
172 "when I am consumed": PLU, p. 70.
172 "disguised as a workman": SI, p. 222.
173 "a wild but frozen sea": SI, p. 221.
173 "like so many white horses": SCH, p. 205.
174 "one would have thought": SI, p. 221.
174 as if he had drowned: SI, idem.
174 "Zadkine, at this period": *Artist Quarter*, p. 209.
174 "His only response": SI, p. 222.
174 "a loan of three francs": SI, p. 221.
175 "the heroic period": Meyer Schapiro, *Modern Art*, p. 138; "About 1913": Idem.

176 "the most remarkable": *The Yale Dictionary of Art and Artists,* p. 98.
176 no Modigliani heads: BTM, p. 96.
176 "Little by little": SI, p. 233.
176 "bathing in the dirt": SCH, p. 205.
176 a sculpted stone head: Associated Press, June 14, 2010.
177 "There is in the corridor": SCH, p. 189.
178 "At that time": Fernande Olivier, *Loving Picasso,* p. 195.
179 a bowl of macaroni: *Artist Quarter,* p. 85.
179 "reduces her face": RE, p. 63.
179 Picasso as a visionary: RE, p. 210.
179 "an ironic comment": RE, p. 72.
180 he would always reply: SI, p. 220.
180 the two would never meet: SII, interview.
180 "I'm a Jew": HOM, p. 14.
180 the urge to obliterate: John Richardson, *A Life of Picasso,* vol. 3, p. 74.
181 "like an old monkey": Kenneth Clark, *The Other Half,* pp. 71–72.
181 the terrible shadow: PAR, p. 47.
181 the leading cause of death: David S. Barnes, *The Making of a Social Disease,* p. 13.
182 "a national scourge": Idem.
182 "Fleeing to the countryside": Idem, p. 92.
182 "*îlots insalubres*": Colin Jones, *Paris, Biography of a City,* p. 417.
182 Everyone else's health was at risk: *The Making of a Social Disease,* p. 105; fumes from hot tar: Idem, p. 99.
183 "a fawn coloured mixture": PLU, p. 107.
183 "It's very strange": Adolphe Basler, *Modigliani,* p. 12.
184 "a perfect nuisance": Nina Hamnett, *Laughing Torso,* p. 49.
184 "He was the scourge": SCH, p. 185.
184 "I'm done for!": *Artist Quarter,* p. 203.
184 "emotional and intellectual": René and Jean Dubos, *The White Plague,* p. 61; his mind was "beating": Idem; "a butterfly within": Idem, p. 62; "a wonderful Indian": Idem, p. 61.
185 "artistic expression": Idem, p. 63.
185 also contained a dining room: SI, p. 239.
185 "a paid worker": PAR, p. 291.
186 "the arcane depths": *A Life of Picasso,* vol. 1, p. 203.
186 "a neighborhood dominated": RE, p. 169.
187 curtly said he did not: *Artist Quarter,* p. 200.
187 he did paint "a bit": June Rose, *Modigliani, the Pure Bohemian,* p. 113.
188 "Because he was very poor": Paul Guillaume, *Les Arts à Paris,* November 1920, no pagination.
189 "crazily irritable": *Artist Quarter,* p. 201.
189 "depression or indolence": PLU, p. 129; "always in extreme": Idem, p. 241.
189 "Shackled and oppressed": Sheila M. Rothman, *Living in the Shadow of Death,* p. 30.
190 "point of delirium": SI, p. 200.
190 "furious and unexpected": Rémy de Gourmont, quoted in *Dalí* catalog, Philadelphia Museum of Art, February–May 2005, p. 211.

190 "a demonic figure": Ronald Meyer, ed., *Anna Akhmatova: My Half-Century*, p. 366.
190 "extraordinary intuition": MAL, p. 6; "a pale complexion": Idem, pp. 268–69.
191 "Here lies a youth": MAL, p. 33.
191 "fits of sleeplessness": MAL, pp. 63–64; "who seemed not": Idem, p. 76.
192 "a breathing corpse": Idem, p. 169.
192 saved from death by Magnelli: *Modigliani vivo, testimonianze inedite e rare*, pp. 103–05.

CHAPTER TEN · BEATRICE

194 He might be "a pearl": SI, p. 267.
195 first meeting with Modigliani: She wrote on September 17, 1936.
196 He was "fishing": MP, "On the Boulevard Edgar Quinet," p. 207.
196 They met again: NA, June 14, 1914.
197 listening in amazement: Ambrogio Ceroni, "Les Souvenirs de Lunia Czechowska," *Amedeo Modigliani, Peintre*, p. 21.
197 jealous and possessive: BAR, p. 208.
198 "a long tunnel": As quoted in Nigel Gosling, *The Adventurous World of Paris, 1900–1914*, p. 230; the last civilian train: Idem, p. 231.
198 Parisian males would be conscripted: Colin Jones, *Paris, Biography of a City*, p. 435.
199 "two rooms and real running water": GRA, p. 276; "never to begin": Idem.
199 "surrounded by a gang": John Richardson, *A Life of Picasso*, vol. 2, p. 368.
199 "Much laughter": NA, May 28, 1914.
199 shot the editor: *The Adventurous World of Paris, 1900–1914*, p. 221.
200 "[t]he romantic world": NA, June 18, 1914.
200 "No wonder he is": NA, July 9, 1914.
201 "he abducted her": SCH, p. 189.
201 "wicked genius": Idem, p. 194.
201 Guillaume's contradictory testimony: *Les Arts à Paris*, November 1920, no pagination.
201 "it isn't all gay": NA, June 11, 1914.
201 "don't go!' ": NA, July 16, 1914.
202 "Women should have": GRA, p. 296.
202 "realising their own images": Kenneth Clark, *The Other Half*, p. 72.
202 "He was thus a target": Marta Petricioli and Donatella Cherubini, eds., *Pour la Paix en Europe*, p. 310; "[W]e are witnessing": Idem.
202 a matter of days: GRA, p. 289.
203 "Many artisans' shops": *Paris: Biography of a City*, pp. 435–39.
204 "I managed to change": GRA, p. 296; "there isn't a quarter": Idem, p. 297; "This morning very little": GRA, p. 298.
204 "People vanish": GRA, p. 301; "The first effect": Idem, p. 302.
205 "all over the corridors": Idem, p. 302; "lost each other": Idem, p. 305.
205 "we are saved!": NA, September 10, 1914.
205 "all wet and muddy": GRA, p. 300; "sandwiches and cigarettes": Idem, p. 308.
206 "I routed out": NA, February 11, 1915.

206 "a state of culture": Idem.

206 Poiret began buying: WAY, pp. 176–77.

208 "the broken and choppy": Flavio Fergonzi, *The Mattioli Collection*, p. 260.

208 "My regiment was": UM, p. 47.

208 lost an arm: *Life with the Painters of La Ruche*, p. 55.

208 briefly mobilized: Colette Giraudon, *Paul Guillaume et les peintres du XXe siècle*, p. 29.

209 "The wartime lack": Kenneth E. Silver and Romy Golan, *The Circle of Montparnasse*, p. 36.

209 "Just about every Montparnassian": SCH, p. 186.

209 "Where else could we go?": Marevna, *Life with the Painters of La Ruche*, pp. 36–37.

210 "old and short and solid": Frederick S. Wight, "Recollections of Modigliani by Those who Knew Him," *Italian Quarterly*, 1958, p. 41.

210 "with odds and ends": Billy Klüver and Julie Martin, *Kiki's Paris*, p. 71.

211 a "tiny, bandy-legged": *Life with the Painters of La Ruche*, pp. 60–61.

211 Quatz' Arts ball: GRA, pp. 311–12; André Salmon, *Modigliani: A Memoir*, pp. 266–74.

212 basket of ducklings: GRA, p. 313.

212 "I look with interest": *Kiki's Paris*, p. 222.

213 slumming it: *The Circle of Montparnasse*, p. 74.

214 Kisling gave advice: TRIB, February 17, 1964.

215 "at least ten thousand": Idem.

216 a small fortune: KIS, p. 86.

216 five servants and own two American cars: Interview with Jean Kisling.

216 a very bad painter: René Gimpel, *Diary of an Art Dealer*, p. 349.

216 "[t]he axis around which": *Kiki's Paris*, p. 162; "How was I able": Idem, p. 236.

216 "I want life to be beautiful": *Kiki's Paris*, p. 236.

216 "I'm marrying the daughter": SI, p. 386.

218 "He rushed to . . . 'My bridal linen!'": SCH, p. 200.

218 out of the gutter: KIS, pp. 105–07.

219 It was all too sad: NA, November 12, 1914; a few Zeppelins. Idem.

220 "Virgin Mary": NA, November 5, 1914.

221 "formal grace": SCH, p. 31; "series of major portraits": Idem, p. 34.

222 time to bury him: NA, November 5, 1914.

CHAPTER ELEVEN · "A STONY SILENCE"

223 "only the fittest": NA, December 17, 1914.

223 "until stray visitors": NA, December 24, 1914.

224 brown and gloomy: NA, February 4, 1915.

224 "flags and flowers": NA, May 6, 1915.

224 "almost photographic": NA, January 28, 1915.

225 "the more dogmatic": John Richardson, *A Life of Picasso*, vol. 2, p. 374.

225 "an old Catalan peasant": Idem.

225 "the most unpleasant": June Rose, *Modigliani, the Pure Bohemian*, p. 130.

225 "shut all shutters": NA, January 28, 1915; "Nearly everyone": Idem.

225 "Both love and work": NA, December 19, 1916.

226 "half the population": NA, May 20, 1915.
226 "Will he flower?": *Modigliani, the Pure Bohemian*, p. 128.
227 "As to Laure": Idem, p. 129.
227 "She, poor girl": PAR, p. 44.
227 "a craving, violent": *Madame Six*, GRA, p. 343.
228 " 'while the vogue lasts' ": GRA, p. 340.
229 "securing my peace": GRA, p. 346.
229 "little psychic consequence": NA, January 7, 1915.
229 "A figure cut out of": Fiona MacCarthy, *William Morris*, pp. 229–30.
230 "cadaverous body": René and Jean Dubos, *The White Plague*, pp. 56–57.
230 strange additional charm: Idem, p. 55.
230 hoped he would die of consumption: Idem, p. 53.
230 "a life so brief": Idem, p. 53.
230 "glimpsing his mistress": *Artist Quarter*, p. 97.
231 "severely afflicted": *The White Plague*, p. 58.
232 "an indefinable expression": Pierre Louis Duchartre, *The Italian Comedy*, p. 42.
232 "It is possible . . . to ask": SCH, p. 33.
233 "immaculately dressed": SCH, p. 197.
233 "For the masks were": *The Italian Comedy*, p. 42.
233 "Secrecy [was]": PL, p. 139.
234 "Not every family": PL, p. 678 note.
234 "crystalline purity": SCH, p. 195.
234 "his drawing developed": Agnes Mongan, *Modigliani—Drawings from the Collection of Stefa and Léon Brillouin*, Fogg Art Museum, 1959, pp. 7–12.
235 "The figures are": Frederick S. Wight, *Modigliani Paintings and Drawings*, Museum of Fine Arts, Boston, p. 18; "Cézanne's whittling": Idem, p. 16.
236 "hewn from a plank": SCH, p. 26.
236 "With one eye": SII, interview.
237 "nothing is mannered": SCH, p. 44.
238 dangerously primitive notions: *Les Arts à Paris*, November 1920, no pagination.
238 "They laughed at": To Vanni Scheiwiller, April 6, 1932; *Modigliani Vivo, testimonianze inedite e rare*, pp. 39–40.
238 "with passion, with violence": *Les Arts à Paris*, November 1920, no pagination.
238 rue du Faubourg Saint-Honoré: According to his biographer, Colette Giraudon, Guillaume moved there in October 1917.
238 "the most complete and perfect": Alfred Werner, "The Eternal Modigliani," *Amedeo Modigliani, October 14–November 13, 1971*, Acquavella Galleries, no pagination.
239 "He usually began": SCH, p. 203.
239 "The remedy was": SII, interview.
241 "I'll paint you another one": SII interview.
241 Born Chaim Jacob Lipchitz: SI, p. 208; "so lovable, so gifted": SI, pp. 207–08.
242 "He . . . made a lot of": SI, p. 209.
242 "two portraits on one": SI, p. 196.
243 "radiance and the beauty": Ambrogio Ceroni, "Les Souvenirs de Lunia Czechowska," *Amedeo Modigliani, peintre*, p. 20.
244 "This was a real artist": Idem, p. 28.
245 "a wet chicken": SI, p. 337.
245 the baby had died: PAR, p. 300.

246 a permanent scar: GRA, p. 389.
246 "To reach the [house]": Marevna, *Life with the Painters of La Ruche*, p. 117; "A shattering of glass": Idem.
246 a tempestuous affair: GRA, p. 345.
248 a dream landscape: MP, p. 209.
248 "bourgeois spirited": GRA, p. 388; "the most foul beings": Idem.
248 the cobweb bridge: John Bartlett, *Familiar Quotations*, p. 804a.
249 Pina fired a shot: GRA, p. 414.
249 "seized the gun": Frederick S. Wight, "Recollections of Modigliani by Those Who Knew Him," *Italian Quarterly*, 1958, p. 42.
249 Picasso took command: *A Life of Picasso*, vol. 2, p. 427.

CHAPTER TWELVE · "NENETTE"

253 A description of the Hébuterne apartment is given in a letter from Odette Lasserre to Anne Modigliani, May 21, 2005.
253 "in her romantic way": SII, interview.
254 at the age of seventeen: In April 1914.
254 "Please don't die": FL.
254 "a precious stone": Idem.
255 "they must suffer": Idem.
255 "she often went 'head to head' ": Interview with author.
255 "the appalling tyranny": C. R. W. Nevinson, *Paint and Prejudice*, pp. 62–63. This comment was written in 1938.
256 "women belonged in the home": Bryher, *The Heart to Artemis*, p. 155.
256 *Jours de famine et misère*, the original title, was subsequently retitled *Jours de famine et de détresse* when it was reissued in 1970.
257 Why was she drawn: SE, p. 74
257 "vicieuse et sensuelle": Phyllis Birnbaum, *Glory in a Line, A Life of Foujita*, p. 115.
258 They became lovers: Patrice Chaplin, *Into the Darkness Laughing*, p. 54.
258 her parents knew nothing: SE, p. 93.
259 "It's a shame that I made a kid": TRIB.
259 "a little less hate": JM, pp. 115–16.
260 They moved in July 1917: SE, p. 101.
260 "His joy was such": SI, p. 358.
262 "Maintenant silence": Now silence / and suddenly with the falling mist / the accordion speaks of love to the kitchen maids and street sweepers..." (author's translation).
262 Zborowski had to represent Soutine: *Paul Guillaume et les peintres du XXe siècle*, p. 128.
263 "generous, natural and calm": Kenneth Clark, *The Nude*, p. 124.
263 "violent transitions": Idem, p. 360; "an enraged protest": Idem, p. 361.
263 "no moral objections": SI, p. 47.
264 "his nudes evoke": Idem, p. 47.
264 "prickly, peppery": John Richardson, *A Life of Picasso*, vol. 1, pp. 163–64.
265 the objectionable nudes: SCH, pp. 204–05.
265 sold at the Hôtel Drouot: Francis Carco, *The Last Bohemia*, p. 231 note.

265 "He came with me": Idem, pp. 234–35; "was about to sell some clothes,":
 Idem; Zborowski "never doubted": Idem, p. 235.
267 "That very same day": Interview with author.
268 "I became his disciple": *A Life of Picasso,* vol. 2, p. 302.
268 "In those days": Roger Dutilleul, "L'Art et l'Argent," *Art Present,* 1948
 (author's translation).
269 "Modi was just everything": SII, interview.
270 "Just as Modigliani's art": SE, p. 14.
271 the roof fell in: Colin Jones, *Paris, Biography of a City,* p. 440; the killed and
 injured: Idem.
271 thirty million died: *Washington Post,* December 22, 2006.
272 "a persistent rumor": PL, p. 145.
273 They would just leave: Luc Prunet to author.
273 "thin and emaciated": SCH, p. 205.
276 "relations . . . became more . . . strained": JM, p. 89.
276 "He had no other attachment": SII, interview.
277 "The crowd had doubled": René Gimpel, *Diary of an Art Dealer,* p. 70.
277 next day he forgot: *Artist Quarter,* p. 280; SII, p. 421.
278 André discovered the baby: Luc Prunet to author.
278 "He saw that as proof": SE, p. 156. Restellini notes that André Hébuterne kept
 a diary of his World War I experiences and that he was given access to this
 vital testimony so as to date the movements of, not only André, but Jeanne,
 Amedeo, and Jeanne's mother more exactly. The author was not given permis-
 sion to see this journal. André broke the news to his father: Luc Prunet to
 author. The atmosphere worsened ("s'ensuivront des explications orgueuses
 entre André et Jeanne"): SE, p. 156.
278 "close up like an oyster": Prunet to author.

CHAPTER THIRTEEN · "LIFE IS A GIFT"

279 "Modigliani was absolutely thrilled": Ambrigio Ceroni, *Amedeo Modigliani,
 Peintre,* p. 26.
279 "The baby is well": Undated letter, JM, pp. 91–92.
280 could do nothing with her: Idem, p. 89.
280 "As a husband": FL.
280 "lost ewe": André Hébuterne diary.
280 "I have kept": *Amedeo Modigliani, Peintre,* pp. 26–27.
281 "sad and beautiful,": Margaret MacMillan, *Paris 1919,* p. 26; "Along the quais":
 Idem.
281 "The father seemed thrilled": SE, p. 156.
281 "Mlle Jane Hebuterne": JM, p. 112.
281 He seemed in good spirits: Marevna, *Life with the Painters of La Ruche,*
 pp. 148–49.
282 newspaper reviews: *Modigliani and His Models,* Royal Academy of Arts,
 July–October 2006, p. 70.
283 "With flat, Slavonic": Osbert Sitwell, *Laughter in the Next Room,* pp. 164–65;
 the average gallery price: Idem, p. 167.
283 "a tuppeny damn": Hugh Blaker diaries, University of Wales, March 31, 1932.

283 "It seemed ridiculous": Kenneth Clark, *Another Part of the Wood*, pp. 78–79.

284 the prices would double: Colette Giraudon, interview with author.

284 "Modigliani did not immediately comply": *Laughter in the Next Room*, p. 177.

285 "a little bit of brain": *Artist Quarter*, p. 298.

286 "It is only in the final phase": André Salmon, *Modigliani: A Memoir*, pp. 207–08.

286 a magnificent English wool scarf: *Amedeo Modigliani, Peintre*, p. 30.

286 "he kissed the paper": SII, interview, p. 8.

286 "fidgeted, smoked": SI, p. 337.

287 "I couldn't believe": *Italian Quarterly*, 1958, p. 43.

289 a month before he died: *Modigliani vivo*, pp. 77–86.

291 he had made her look ugly: PAR, p. 298.

291 a box of Gitanes cigarettes: Billy Klüver and Julie Martin, *Kiki's Paris*, p. 88.

291 "cough a lot": Idem.

292 "a ravishing blond": *Amedeo Modigliani, Peintre*, p. 30.

293 "Life is a gift": Idem; "Renée did not hold": Idem, p. 32; "Poor dear friend": Idem, p. 29.

294 they never did: Idem, p. 33.

294 attempted to reconcile: SI, p. 482.

295 the needed legal papers: JM, p. 111.

296 "un chat se gratte la tête": SI, p. 484.

297 likened it to a mask: *Modigliani and His Models*, Royal Academy of Arts, pp. 42–43.

297 "thinly applied paint": Kenneth E. Silver and Romy Golan, *The Circle of Montparnasse*, pp. 18–19.

298 "Overeating—that's the only thing": SI, pp. 485–86.

298 "It was astonishing": SI, p. 488; *Artist Quarter*, pp 414–15.

299 "Great artists like these": Interview with author.

299 "he liked contemplating death": *Artist Quarter*, p. 232.

299 "like a child": SI, p. 491.

299 an ancient doxology: Leo Rosten, *The Joys of Yiddish*, pp. 162–63.

300 believed he was destitute: SII, interview.

300 advice about money: SI, p. 490.

300 more than she could bear: PAR, p. 47.

302 a phantom boat: SI, pp. 496–97.

302 out of sheer childish pettiness: SI, p. 497.

302 a letter Zborowski sent: On January 31, 1920; JM, p. 114.

305 He claimed to be the one: SCH, p. 198.

305 "His friends and I": JM, p. 114.

306 he could still stand: PAR, p. 220.

306 called a meeting: KIS, p. 130.

308 eight hundred francs apiece: *Artist Quarter*, p. 301.

308 boasting about the deals: John Richardson, *A Life of Picasso*, vol. 1., p. 352.

308 mysteriously acquired: PAR, p. 221.

CHAPTER FOURTEEN · THE CULT OF THE SECRET

310 "Black is the color": Joseph Campbell, *The Mythic Dimension*, p. 305, note 59.

310 "he'll soon be living": SI, p. 499.

310 Quenneville said she found: PAR, 329.

311 "[M]ore and more": SE, p. 188.

311 It could represent Maldoror: Idem, p. 190.

312 "the last 'strangers'": FL.

312 rates of suicide: *Washington Post*, July 7, 2008.

313 "in spiritual agony": *New York Times Magazine*, July 6, 2008.

313 makes no mention: SI, p. 56.

314 Jeanne had been moved: From the death notices.

315 the portrait of Varvogli: PAR, p. 239.

315 some of her brains: From interviews conducted by Klüver and Martin.

316 she woke herself up: Ambrogio Ceroni, *Amedeo Modigliani, Peintre*, p. 34.

316 not yet been paid: *Elle*, April 1958, p. 95.

316 She is *ours*: GE, October 1923, p. 56.

317 Life was worth believing in: PAR, p. 45.

318 they made a declaration in Paris: March 28, 1923.

318 "some well-tended plants": GE, February 18, 1927, p. 104.

318 she died in Florence: GE, July 27, 1927, p. 105.

320 "She was the lackey": *Elle*, April 1958, p. 97; "Tante Marguerite": Idem.

321 called her a sadist: Victor Leduc, *Les Tribulations d'un idéologue*, p. 64.

321 green-flecked eyes: *Elle*, April 1958, p. 97.

321 "She was very droll": Interview with Jean-Pierre Haillus.

324 "like actors wearing masks": *Les Tribulations d'un idéologue*, p. 66.

324 "determinant, crucial": Interview with Dominique Desanti.

324 "Her rebellion": *Les Tribulations d'un idéologue*, p. 64.

324 arrested . . . released: Dates of October 18, 1943, and January 1944 respectively, courtesy of René Glodek.

325 "She looked the Germans": Interview with René Glodek.

325 "Resistance soup": Jean-Pierre Haillus to author.

325 had divorced Mario Levi: By April 1, 1946.

325 "by whom I also had a daughter": *Les Tribulations d'un idéologue*, p. 92.

326 "He had a double life": Interview with author.

326 married Jeanne: On August 14, 1957.

327 "they were very poor": Interview with author.

328 does not share: Haillus, interview with author.

328 still modestly priced: Gerald Reitlinger, *The Economics of Taste*, p. 393.

329 "a dream come true": Interview with author.

329 Zborowski had hired people: Interview with author.

329 signed each other's work: Interview with author.

329 nothing he could do: René Gimpel, *Diary of an Art Dealer*, p. 385. (December 13, 1929.)

329 "'Étude in Tunis'": *Modigliani vivo, testimonianze inedite e rare*, p. 48. (December 12, 1932.)

332 four caryatids: *Fakes and Forgeries*, Minneapolis Institute of Arts, 1973, figures 207–10.

332 A portrait of a woman sold: January 15, 1958, and at Christie's for sale July 2, 1974. Further information was requested in 2006 from Guy Bennett, then director of Impressionist and Modern Painting at Christie's, for this and two other queried Modiglianis sold by Christie's. No reply was received.

333 "the question of Modigliani's authenticity": RE, p. 12.

333 "The droit morale": *Artnews,* January 2004.

333 "runs directly counter": RE, p. 12.

333 "she signed . . . certificates": *Artnews,* idem.

334 Elmyr de Hory collaborated with Jeanne; "brought some Modigliani": Clifford Irving, *Fake,* p. 134.

334 "a passionate admirer": Réal Lessard, *L'Amour du faux,* p. 99.

334 "not being listed": *Artnews,* idem.

335 "is an absolute mystery": Interview with author.

335 archives are now in Rome: As of January 1910, the address of the archives is: "Modigliani Institut Archives Légales Paris-Rome," Palazzo Taverna, via di Monte Giordano 36, Rome. Tel: 39-069826220, www.modigliani-amedeo.com.

335 "will have to work": *Artnews,* September 2006.

336 court of appeals sentence: Agence France Presse, January 11, 2010.

336 "used his well-known role": *Le Monde,* December 19, 2008.

336 "I am disappointed": *Art Newspaper,* May 2002.

336 "Marc, what have you done?": Interview with author.

337 buying a fake painting with fake money: Interview with author.

338 "The contrast between": JM, xvii.

338 "her portraits of": *New York Times,* November 30, 1958.

338 "it seems to me": On July 15, 1920.

338 would keep a memento: Luc Prunet.

338 The family's anger: Christian Parisot, *Modigliani e i suoi,* p. 16.

339 "an inner conviction": Interview with author.

340 nude and completely drunk: Jean-Pierre Haillus.

340 "Everything in her life": Interview with author.

340 "One does not understand": Interview with author.

340 "until she finally": Patrice Chaplin, *Into the Darkness Laughing,* p. 144.

EPILOGUE

342 "half-ecclesiastical": P. D. James, *The Lighthouse,* p. 5.

342 spiritual calm: Nina Hamnett, *Laughing Torso,* p. 159.

342 "stony silence": SCH, p. 206.

343 found a one-hundred-franc note: *Laughing Torso,* idem.

344 "Everything was a mess": Interview with Godefroy Jarzaguet.

346 "nobody actually died": Interview with Alexandra Marsiglia.

346 limits his praise: Douglas Cooper, *Great Private Collections,* p. 286.

347 "The universities where": RE, p. 11; "Forgeries appeared": Idem.

348 "no such influence": SCH, p. 53; "the individuality": Idem.

348 "extremely radical . . . conception": RE, p. 22.

348 "Where myth and anti-myth": "Modigliani," Arts Council of Great Britain, introduction by John Russell to the exhibition at the Tate, London, September 28–November 3, 1965, p. 5.

349 "the free imagination": Lionello Venturi, *Italian Painting from Caravaggio to Modigliani,* p. 159.

INDEX

Page numbers in *italics* refer to illustrations.

PHOTOGRAPHIC CREDITS

Acquavella Galleries: 155
Anne Modigliani: 25, 166, 318, 323, 328, 340
Archives of American Art: 4, 5, 34, 59, 74, 81, 98, 102, 146, 147, 261, 274
Author's Collection: 84, 93, 98, 108, 109, 128, 140, 145, 149, 170, 178, 210, 226, 282, 301, 303, 331, 334, 345, 350
Billy Klüver and Julie Martin Archive: frontispiece, 14, 29, 32, 46, 104, 148, 158, 160, 177, 188, 194, 203, 215, 250, 265, 275, 288, 289, 307
Godefroy Jarzaguet: 346
H.P.B. Library: 196, 205, 247, 248
Italian State Archives, G. E. Modigliani Collection: 47, 48, 320, 327
Jean-Claude Kaltenbach: 214
Museums of the City of Paris: 95
Michele van de Roer: 161
Noël Alexandre: *The Unknown Modigliani*, Harry N. Abrams, New York, 1993: 43, 110, 111, 112, 114, 122, 134, 167
Photofest: 11
Roger-Viollett: 173, 242, 307

COLOR INSERT

Acquavella Galleries: *Frank Burty Haviland, Moïse Kisling*
Christie's Paris, London, and New York: *Stone Head, The Cellist, Beatrice Hastings*
Metropolitan Museum of Art: *Nude on Red Sofa*
National Gallery of Art, Chester Dale Collection: *Chaim Soutine*
Sotheby's, New York: *Jeanne Hébuterne, Caryatid*

A NOTE ON THE TYPE

This book was set in Garamond, a typeface originally designed by the famous Parisian type cutter Claude Garamond (c. 1480–1561). This version of Garamond was modeled on a 1592 specimen sheet from the Egenolff-Berner foundry, which was produced from types thought to have been brought to Frankfurt by Jacques Sabon (d. 1580).

Claude Garamond is one of the most famous type designers in printing history. His distinguished romans and italics first appeared in *Opera Ciceronis* in 1543–44. While delightfully unconventional in design, the Garamond types are clear and open, yet maintain an elegance and precision of line that mark them as French.

Composed by North Market Street Graphics, Lancaster, Pennsylvania

Printed and bound by Berryville Graphics, Berryville, Virginia

Designed by Maggie Hinders